PASSIONATE HOBBY

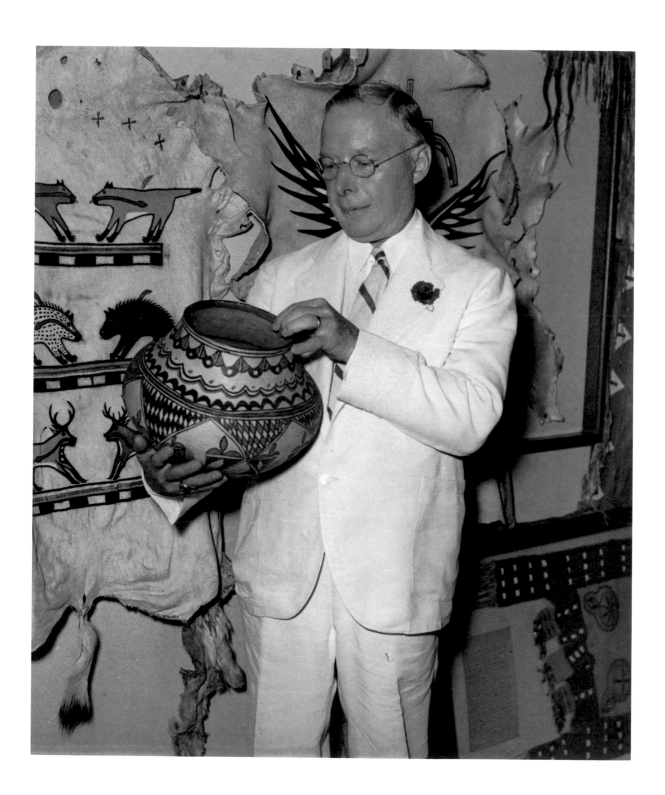

Passionate Hobby

RUDOLF FREDERICK HAFFENREFFER
AND THE KING PHILIP MUSEUM

EDITED BY SHEPARD KRECH III

HAFFENREFFER MUSEUM OF ANTHROPOLOGY

BROWN UNIVERSITY

HAFFENREFFER MUSEUM
OF ANTHROPOLOGY,
BROWN UNIVERSITY

STUDIES IN ANTHROPOLOGY
AND MATERIAL CULTURE, VOLUME VI

Object photography by Cathy Carver except as noted: figs. II-1, 11, 17, 22, 23, 25, 26, 30; III-6, Danielle Toth; figs. II-4, III-3, 10, 22, Rip Gerry; figs. III-7, 9, 13, David Gregg; plate 31, Richard Hurley

Maps from drawings by Tuija Rankama

Copyright 1994 by Haffenreffer Museum of Anthropology, Brown University

Library of Congress Catalogue Card Number 94–076006

ISBN 0-912089-09-1

Distributed by Haffenreffer Museum of Anthropology, Brown University, Mount Hope Grant, Bristol, Rhode Island 02809
TEL: 401 253-8388 FAX: 401 253-1198

and The University of Washington Press, P.O. Box 50096, Seattle, WA 98145

COVER
Bowl (fig. III-8), Nipmuc or Mohegan, Southwick, Mass., early 17th c. Wood, metal. L. 39 cm. Purchase, Drake 1928. 1/1424

FRONTISPIECE
Rudolf Haffenreffer holding San Ildefonso polychrome water jar obtained in the Southwest, ca. 1934. Mount Hope Farm.

ENDPAPERS
Exhibit board (detail of fig. III-1), made before 1923. 123 x 60 cm. Artifacts from Bigelow and Anthony collections.

Table of Contents

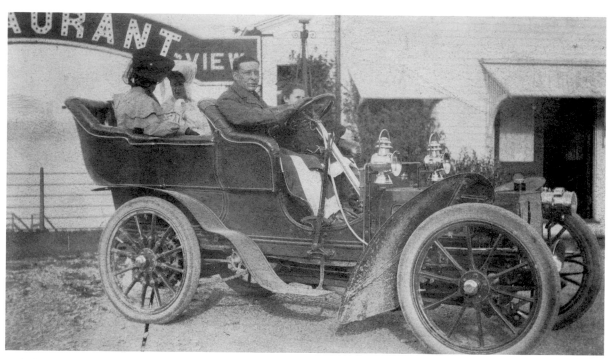

Rudolf Haffenreffer in his Rochet-Schneider touring car in
Fall River ca. 1915. Mount Hope Farm.

Foreword

SINCE 1975, the Haffenreffer Museum of Anthropology, Brown University, has published five major catalogues in its series, *Studies in Anthropology and Material Culture,* all in conjunction with the opening of major exhibitions at the Haffenreffer Museum. *Passionate Hobby: Rudolf F. Haffenreffer and the King Philip Museum* becomes the sixth number in the series and, as did the others, it accompanies a major exhibition at the Haffenreffer Museum.

Like *"Out of the North": The Subarctic Collection of the Haffenreffer Museum of Anthropology, Brown University,* the most recent number of the series published in 1989, *Passionate Hobby* is concerned in part with the relationship between the Museum's artifacts and the people responsible for their collection. In this it draws upon one of the strengths of its immediate predecessor. But *Passionate Hobby* also sets off in a new direction. Unlike all other catalogues in this series, it focuses rigorously neither on determining the techniques of fabrication, meaning, or function of particular artifacts in the Museum's collections, nor on the identification of the raw materials used in producing particular objects, nor on a particular region's collection. Its focus is rather on the life of the Museum's founder, Rudolf Frederick Haffenreffer, and the processes whereby both his collections and what he called the King Philip Museum formed.

Passionate Hobby continues the strong tradition of the Haffenreffer Museum as a teaching museum. Most earlier numbers of *Studies in Anthropology and Material Culture* have included contributions from graduate students in Brown University's Department of Anthropology, and this current catalogue is no different. David Gregg and Ann McMullen, who are both doctoral candidates in anthropology, have not only made their own specific contributions to this volume; they were also responsible for carrying out certain collections and archival management projects which, as explained in the Introduction, made this project feasible. The Museum first identified these projects as priorities and, in seeing them through to completion, Barbara Hail, Deputy Director and Curator, who has also contributed to this catalogue, has been intimately involved at every step.

In the course of writing our essays, each of us has incurred specific debts which we acknowledge. I wish to thank here a small number of people without whose support the volume would not have taken shape as it has. Especially important were four people who agreed to read the manuscript under extreme pressure of time, and who made innumerable valuable suggestions for ways it might be strengthened: Diana Fane, Curator of African, Oceanic, and New World Art, The Brooklyn Museum; Curtis M. Hinsley, Professor of History,

Northern Arizona University; Nancy Parezo, Curator of Ethnology, Arizona State Museum, and Professor of American Indian Studies, University of Arizona; and Russell M. Peters, President, Mashpee Wampanoag Indian Tribal Council. They have our lasting thanks. For photography, we wish to thank Cathy Carver, Rip Gerry, Richard Hurley, and Danielle Toth; for copy-editing and proofreading, Joseph Becker, John Landry, and Rochelle Rosen; and for design and production, Joseph Gilbert of Gilbert Design Associates.

We keenly appreciate the trust the Haffenreffer family has placed in us to interpret the activities of Rudolf F. Haffenreffer, the founder of the King Philip Museum. Seldom does one have the pleasure of writing in full detail and openness about a museum founder and his collections. That we have been able to, and to publish our results, is due to the generous support of the family. Over the years, the Haffenreffer Family Fund has assisted many of the Museum's efforts not just in publications – this current one included – but in exhibitions, education programs, research and acquisitions. I am personally grateful to Carl W. Haffenreffer for our many discussions concerning his father and for his support. It is only proper to present *Passionate Hobby* to him and other members of the Haffenreffer family in gratitude, and to dedicate our effort to the memory of his father, Rudolf F. Haffenreffer, mother, Maude Haffenreffer, and brother, Rudolf F. Haffenreffer 3rd, for their support of museums and anthropology at Brown University.

SHEPARD KRECH III
Professor of Anthropology and
Director, Haffenreffer Museum of Anthropology

Introduction

by Shepard Krech III

BIOGRAPHICAL STUDIES OF men and women who built private collections of painting and sculpture, and occasionally museums, are common, but the sustained analysis of the processes whereby these collections and museums took shape is not.[1] Moreover, rarely if ever has the analytic focus been on one whose collections were almost exclusively the artifacts and imagery of Native people of North America. This catalogue addresses these gaps in our knowledge through an intense examination of Rudolf F. Haffenreffer and his private museum of artifacts and imagery of North American Indians, the King Philip Museum, in Bristol, Rhode Island. *Passionate Hobby: Rudolf F. Haffenreffer and the King Philip Museum* is published in conjunction with the opening of a major exhibition of the same name at the Haffenreffer Museum of Anthropology, Brown University. In essays about Rudolf Haffenreffer's life, his ethnographic and archaeological collections, and his relationships with Native people and organizations, we seek primarily to understand why Haffenreffer became fascinated with Native America; to place his museum activities in the context of his life; and to determine the precise processes through which his collections formed and his museum took shape, as well as how he used the King Philip Museum once it was built. Because Haffenreffer collected the art and artifact of Native

America, we hope furthermore to reveal what he thought about and how he interacted with the indigenous people who made the objects he displayed in his museum.

In retrospect, the genesis of this catalogue and the exhibition it accompanies was in projects undertaken to systematize and inventory archives and archaeological materials in the Haffenreffer Museum of Anthropology, as well as in discussions which my graduate students and I have had over the last few years on the processes whereby collectors and museum founders become interested in indigenous people and their artifacts. As a result of the archival and collections management projects, the documentary and artifactual basis for a sustained focus on Rudolf Haffenreffer emerged, and as a result of discussions both in and outside class, a context for this analysis gradually took shape. My students, especially Ann McMullen and David Gregg, joined by Barbara Hail, Deputy Director and Curator of the Haffenreffer Museum, have played a fundamental role at every stage of this process, from the development of the critical ideas which inform this project to the purely practical and time-consuming work of the organization of archives and archaeological collections, for which McMullen and Gregg, respectively, deserve credit.

The essays of all three appear in this catalogue. Following this "Introduction" is "Rudolf F. Haffen-

reffer and The King Philip Museum" (for which I am responsible), which begins with a biographical synopsis of Haffenreffer and is intended to reveal the underlying and proximate causes of Haffenreffer's interest in American Indians, the development of the King Philip Museum, his involvement with Boy Scouts, and his thoughts about Native people. Next come two analytical essays on the collections which began to take shape after the turn of the century: "The Ethnographic Collection," by Barbara Hail, and "The Archaeological Collection," by David Gregg. These two contributions are structured by the processes through which Haffenreffer's collections were formed but are also designed to discuss in detail the major objects and collections within archaeology and ethnography. The fourth major essay is "'The Heart Interest': Native Americans at Mount Hope and The King Philip Museum," in which Ann McMullen details Haffenreffer's involvement with both individual Native people and pan-Indian organizations. Finally, an "Epilogue" discusses the donation of the King Philip Museum to Brown University and the role this gift played in the birth of anthropology at Brown.

The brief remarks in this Introduction serve both to preface some of the principal findings of our examination of Rudolf Haffenreffer and his King Philip Museum, and to broach certain comparative issues raised by our analysis on which research would be timely.

RUDOLF HAFFENREFFER, HIS MUSEUM, AND HIS TIMES

Rudolf Haffenreffer, born in 1874, became an industrialist and brewer of note. His father, a German immigrant, was also a successful brewer, but Haffenreffer made his own way when he came of age. During his years as president and chairman of the board, Narragansett Brewing, a large but struggling concern when he assumed control, became one of the largest breweries in the nation (and Narragansett became the beer of Red Sox baseball). Haffenreffer also rescued the yachting world's most prestigious name from financial oblivion, was appointed receiver of a toll bridge, and owned

mines in the West. Like many successful men of his day, he possessed a country estate which was also a working farm. Located in Bristol, Rhode Island, this property increasingly became the focus of Haffenreffer's life, and his secure position in the surrounding community came not simply from ownership or control of Bristol institutions but from political independence and numerous (and often quiet) acts of philanthropy. And he had a "passionate hobby": the collection of archaeological and ethnographic artifacts – "relics" in his day – cigar-store Indians and other sculpture and images; artifacts of and about Native North America. The phrase, "passionate hobby," appeared in *Time,* and referred to Haffenreffer's cigar-store Indian collection; but we can see that it applied to all of his collections, as well as to the King Philip Museum.

During his life, Haffenreffer focused on ensuring the vitality of his various business interests. For him, both the collection and the Museum were diversions. But compared with other distractions, they occupied his attention especially as his North American Indian artifact collecting and didactic interests converged with another decades-long focus, the Boy Scouts. Nevertheless, the King Philip Museum remained for him a hobby.

Haffenreffer began collecting Indian artifacts late in an era marked by global competition for ethnographic and archaeological collections among major museums in the United States and Europe. Haffenreffer and many others were small players on a scene dominated by major museums that involved collectors, dealers, and massive quantities of artifacts. It was during this era that the Peabody Museum of Archaeology and Ethnography, the American Museum of Natural History, the Smithsonian Institution, and other national, regional, and university museums of anthropology and natural history amassed the bulk of their collections. This worldwide quest for artifacts was fueled by the convertible nature of artifacts and by patronage, and altered indigenous art styles, economies, and systems of ethics. As traditional objects assumed fresh shapes and entered new markets, they stretched and blurred accepted conventions of what constituted a genuine or authentic artifact.[2]

Legions of individual collectors – dealers, tourists and other souvenir hunters – got into the act alongside the big institutions. Some had been collecting for years, focusing first on what was at hand, which for many began with arrowheads and stone tools turned over in the plowed fields where they lived. Europeans and European-Americans were fascinated throughout the nineteenth century by the question of who the ancestors of Native Americans were and where they came from. Some argued – not Haffenreffer, however – that the Moundbuilders whose prominent sites could be found throughout the Midwest and Southeast could not have been the ancestors of Indians then living in the same regions, who seemed incapable of such works, but must have been people from elsewhere – Phoenecians, Hittites, or the Welsh perhaps. Local archaeology, and antiquarians and relic collectors, were in their long heyday.

In New England the interests of local archaeologists were focused on the northeast. Other collectors, as David Gregg argues, could fit Rudolf Haffenreffer into a regional network of archaeological collecting, and Haffenreffer himself was intensely interested in artifacts people discovered in their backyards. Haffenreffer's interests probably began with local archaeological finds. Like others of his day, he was fascinated by what were called relics and excavated on his own land. As his ideas crystallized and the King Philip Museum took shape, his ethnographic and archaeological collections formed further as a result of trips to the West, the employment of an intermediary to collect for him, and the reputation of his Museum as a "sanctuary." Gregg and Hail describe in greater detail these processes as well as the objects which came to the Museum. They also reveal a process of professionalism in the King Philip Museum: changes in cataloguing, a concern for documentation, and so on.

Haffenreffer's ideas about local Native people and their history formed at the same time that his collections grew in the teens and early 1920s; by the time he acquired the bulk of his collections in the late 1920s, his ideas were fully mature and in print. Haffenreffer was deeply concerned about the history of the local Wampanoag and Narragansett Indians, and especially of the people who had made their home at Mount Hope, his Bristol property. He was passionate about the importance of Native perspectives on history and refashioning seventeenth-century history. The most direct insight on his thoughts about Native people comes from a speech he gave to the Fall River Historical Society in 1923, which is discussed in "Rudolf F. Haffenreffer and the King Philip Museum."

As with much else in his life, the development of Haffenreffer's thoughts on race and history can be traced in part to his status as an American of German ancestry, as well as to the formative influence of a rigorous education during his youth. His ideas about Native people developed in part also through contact with a number of people who, like him, were interested in American Indians, and in part through familiarity with published works on Native Americans. Haffenreffer knew people who had conducted ethnographic and historical work on Native America, as well as artists like Cyrus Dallin, whose bronze statuette, *Appeal to the Great Spirit,* complemented other romantic representations of the Native American past in the King Philip Museum. Although not active in the movement to reform treatment of the American Indian, Haffenreffer shared occasional company or exchanged correspondence with several people who were, especially Warren K. Moorehead, and he openly admired Helen Hunt Jackson's *Century of Dishonor.* Haffenreffer was also affected by what he read in his extensive library on the archaeology, material culture, history, and ethnography of North American Indians.[3]

In writing about Haffenreffer, we have chosen to stay close to our sources – written, visual, artifactual, and oral – in order to reveal not simply what we think motivated him to collect artifacts and then build a museum, but also the perspectives that others had on him. We have attempted to put Haffenreffer into the context of his time as fully as our data allow; to understand the major aspects of his biography which influenced his collecting and thoughts about Native people; and to comprehend how he assembled his collections. When we have had to

speculate on the reasons behind Haffenreffer's actions, we have chosen to be cautious rather than bold. We harbor no illusions that we have written the complete story or absolute truth about Rudolf Haffenreffer and his King Philip Museum, but we believe that our particular interpretive strategies have enabled us to remain faithful to our sources and construct a rounded picture of this man and his hobby.

THE COMPARATIVE CONTEXT

Passionate Hobby raises numerous questions pertaining to the history of collecting and the analysis of museums, collections of American Indian art and imagery, collections formation, exhibitions of the art and artifacts of indigenous people, and the activity and thought of museum founders during the late-nineteenth and early-twentieth centuries. Those questions are not analyzed comparatively in this volume because our aim, which we do not wish to dilute, is to scrutinize them for Haffenreffer alone. Nevertheless, to judge from the current lively debates in anthropology, history, art history, literature, and cultural studies, as well as in museums, these questions are important to contemplate. Scholars argue over how best to imagine the history of collection and display; over how to speak sensibly of the actions of museum founders who (like Haffenreffer) belonged to the economic elite and collected the artifacts of people distant in economic and cultural terms. I wish to touch on some of these issues, if only to signal our awareness of them and to point to directions for future comparative analysis.[4]

George Gustav Heye and Clara Endicott Sears

In the essays in this volume, the names of two collectors and museum founders recur: George Heye and Clara Endicott Sears. That they are mentioned repeatedly is for good reason: Haffenreffer knew Heye for decades, and he was linked to Sears through their mutual quest of an artifact known as King Philip's Club, which Haffenreffer considered iconic to his King Philip Museum (Hail, this volume).

Haffenreffer had a more intimate relationship with Heye than any other collector or museum founder; the two were on a first-name basis. Heye was a German-American whose omnivorous collecting style and willingness to commit a fortune to the effort resulted in the monumental collections of the Museum of the American Indian as well as financial difficulty. Legendary for his acquisitiveness, Heye bought and built on an entirely different scale than Haffenreffer. Both men were born in the same year, but Heye was "seized" by the "collecting bug" at an earlier point in his life and with a fortune inherited from his father, he quickly established a reputation for buying artifacts in massive quantities on annual trips around Indian Country. By 1929, the year he first visited Haffenreffer's Museum, Heye had sponsored archaeological excavations and ethnographic collecting and had hired anthropologists to catalogue and organize artifacts numbering in the hundreds of thousands. He also attracted a patron willing to donate land and the cost of a museum and separate storage facility. Heye hired and fired at will and continued to collect despite financial setbacks. For him, the beginning of the end was the stock market crash of October 1929, and it was no coincidence that he sought out Haffenreffer for financial advice as well as to share interests in Native American artifacts and German-American beer. Haffenreffer was a member of the Board of the Heye Foundation for over two decades.[5]

Unfortunately we know little about Haffenreffer's personal relationship with Heye. The extent to which they influenced each other needs exploration. The scale of their operations was so very different but, like Heye, Haffenreffer sponsored excavation, hired an agent to collect for him, became interested in concrete replicas, possessed rare books and manuscripts, and emphasized the serious study of artifacts.[6]

In her essay, Hail discusses further the relationship between Haffenreffer and Heye, especially the nature of transactions recorded as "exchanges." The two men were linked through a shared interest in artifacts, as were Haffenreffer and Clara Endicott Sears. Sears built three museums at her home in Harvard, Massachusetts. One she called the Ameri-

can Indian Museum, which celebrated the romantic and ethnographic past of the American Indian and was intended on one level as a memorial to King Philip. There were certain similarities between Haffenreffer's and Sears's museum activities. Both had in their Museums similar ethnographic materials from the Plains and archaeological relics, as well as Dallin's *Appeal to the Great Spirit;* and both evidently sought the King Philip Club (Hail, this volume). But the architecture, location, and interiors of their museums were all quite different. Sears's colonial stone building was on a manicured green with only romantic sculpture of the American Indian interrupting one's gaze to trees and horizon; Haffenreffer's Museum, in contrast, was in a flat-roofed cement structure at the heart of a working farm, whose prominent natural features were seen between and beyond buildings used for dairy cows and other purposes.

The uncluttered central spaces inside Sears's American Indian Museum also set it apart from the King Philip Museum, which was increasingly taken over by sofas, tables and other furnishings – and late in its history, by cigar-store Indians. Sears's exhibits included both dioramas and displays of life-sized figures with faces modeled from living Indians, clothed both in authentic (Plains) and inventive (Northeast) garb. In designs engraved on the floor, she celebrated a mystical and romantic conception of the Indian which reportedly interested her even more than historical accuracy. Haffenreffer's interest in authenticity and context, in contrast, was shown in displayed documents, a card catalogue, and books. In the end, Sears was far more interested than Haffenreffer in creating a mystical aura for the American Indian; and Haffenreffer far more than Sears in educating students about practical aspects of Indian life though card catalogues and texts that afforded access to information on artifacts and their makers.[7]

The Wider Context

While only three of many who assembled collections of Native American artifacts and imagery large enough to house in private museums, Haffenreffer, Heye, and Sears were among the few who

actually managed to build museums.[8] All together, these collectors and museum founders were a remarkably varied lot with differing intentions.[9] The rhetoric they used to talk about what they were trying to accomplish, or what they thought they had, ranged from self-congratulatory to apparent near-silence. Many of them assumed that the "real" Indian was disappearing or gone, or would soon be if the reformers, in whom most believed, were correct in their assumption that civilization and assimilation were inevitable. Some collected to salvage what was left. Some harbored sentimental thoughts about a lost time when Indians were as noble as James Fenimore Cooper's representations of Delawares and Pawnees, Dallin's sculptures, Edward Curtis's manipulations for the camera, or Charles Eastman's lyrical prose. They varied both in the degree to which they held these sentiments and in their acquisitive drive. Some were obsessive about objects. Milford Chandler, who once said he was "driven" to collect, and George Heye both seemed that way, though each sought quite different meanings in their acquisitions. Chandler, who never had a fraction of Heye's financial reserves but nevertheless collected many fine Plains and Eastern Woodlands artifacts, thought that he must preserve what he could before it disappeared. "He believed that these things were national treasures and it was his mission to help preserve them," Richard Pohrt said of him.[10]

Haffenreffer shared with several collectors an active business life that overshadowed most other interests. One such collector was Rowland G. Hazard II, president of a textile mill, whose archaeological and ethnographic artifacts were displayed in a building in Peace Dale, Rhode Island that also held the town's music hall and library. Another was Louis Warren Hill, Sr., whose Native American objects obtained from the Blackfeet and many other Indians were the property of the Great Northern Railway, of which he was president. Hill's artifacts were incorporated into the Great Northern's publicity and educational agendas, which included Glacier National Park, for which the Great Northern was the major concessionaire. No matter how much passion these men expressed

for American Indian artifacts or prehistory, collecting remained an avocation to be pursued when one could take the time away from running a railroad, mill, or brewery. Not uncommonly, their avocations could progress because they were able to delegate to others certain tasks like the actual collecting or cataloguing. Information on original ownership, provenance, and cultural meaning was much less a certainty for collectors like these than for others whose patrons – major museums – preferred or demanded objects with context.[11]

With the exception of Heye, these collectors and museum founders were small players on the stage dominated by the major museums in the western world. The decades just prior to the moment when Haffenreffer began collecting in earnest were marked by intensive collecting and accelerated changes in the distribution and meaning of cultural property. Artifacts were commodified to a degree they had never been; various innovations which emerged in response to market demands had become traditions; western appetites to collect Indian objects powered mass productions; and inauthentic objects were exchanged as authentic. The new owners of objects fit them seamlessly into settings influenced by the hand-crafted emphasis of the Arts and Crafts movement. And as the bulk of collectible material culture was transferred from native communities to museums, an occasional Indian voice rose in protest.

In museums (and other settings), the objects of course acquired new meanings. Museums which acquired the artifacts of the world's indigenous people were metropolitan and rural; large and small; public and private; accessible and inaccessible; and in their scope tended to be interested in natural history (including people who were placed in "nature") or to be dedicated specifically to the artifacts of tribal people and small-scale societies. In none did objects "speak for themselves." Museums, in the name of their founders, trustees, or the public, possessed the artifacts they had acquired; appropriated, usually following payment, these objects were literally taken over by museums as their own. Within its structure and form, a museum's architecture both framed how artifacts

were to be experienced and embedded authority; in large museums, the framing was monumental, the structure classical. In exhibitions inside, and in cases within exhibits, artifacts were arranged in some manner, perhaps taxonomically by category like basket, arrowhead, pestle and mortar, etc., or perhaps on and around life-size mannequins in "realistic" settings. In all instances, displays were undergirded by tacit assumptions about culture, nature, evolution, gender, science, and race, as well as by assumptions about authenticity. These indelibly influenced the educational agendas in each museum. In no museum was power absent, but how power was deployed varied by museum type and purpose, and how it was perceived by those who visited depended in part on their positions in society.[12]

These thoughts are spawned by the essays in *Passionate Hobby* as well as by a growing number of other studies, and are the proper subject of a separate volume. This case study of Rudolf Haffenreffer and his King Philip Museum would surely contribute to this enterprise to the extent that it is focused on the collector and founder, the processes by which collections and museums formed, and the meanings and functions of those museums as well as the re-contextualized artifacts they contained. What we have tried to provide here is a context adequate to asking and answering comparative questions about collectors and museum founders in addition to the artifacts and the societies from which they come. Those questions include, finally, consideration of one legacy of museums of ethnography and archaeology and their patrons. Like George Peabody's gift of endowment to Harvard University, which was used to found the Peabody Museum of American Archaeology and Ethnology for which curatorial and professorial positions were eventually sought, and like Phoebe Apperson Hearst's donation of collections and a museum to the University of California, which led to the establishment of a Department of Anthropology at Berkeley after her further financial involvement, the gift of the King Philip Museum ushered in anthropology at Brown University.[13] But that story is reserved for the Epilogue.

ACKNOWLEDGEMENTS

I wish to thank David Gregg, Barbara Hail, and Ann McMullen for their criticisms of an earlier draft of this essay.

NOTES

1. Recent exceptions include Lynda Roscoe Hartigan, "Collecting the Lone and Forgotten," in *Made with Passion* (Washington, D.C.: Smithsonian Institution Press, 1990), 1–81; and Jane Hancock, Sheila ffolliott, and Thomas O'Sullivan, *Homecoming: The Art Collection of James J. Hill* (St. Paul: Minnesota Historical Society Press, 1991)

2. See especially Douglas Cole, *Captured Heritage: The Scramble for Northwest Coast Artifacts* (Seattle: University of Washington Press, 1985) and Curtis Hinsley, *Savages and Scientists: The Smithsonian Institution and the Development of American Anthropology, 1846–1910* (Washington, D.C.: Smithsonian Institution Press, 1981).

3. Helen Hunt Jackson, *A Century of Dishonor: A Sketch of the United States Government's Dealings with Some of the Indian Tribes* (Boston: Roberts Brothers, 1888). On Moorehead, see Warren K. Moorehead, *The American Indian in the United States, Period 1850–1914* (Andover: The Andover Press, 1914); John W. Weatherford, "Warren King Moorehead and His Papers," *Ohio Historical Quarterly* 65: 178–90; Douglas S. Byers, "Warren King Moorehead," *American Anthropologist* 41 (1939): 286–94.

4. For representative examinations of these issues, see selected essays in George Stocking, Jr., ed., *Objects and Others: Essays on Museums and Material Culture* (Madison: University of Wisconsin Press, 1985); James Clifford, *The Predicament of Culture: Twentieth-Century Ethnography, Literature, and Art* (Cambridge: Cambridge University Press, 1988); Susan Pearce, ed., *Museum Studies in Material Culture* (Leicester: Leicester University Press, 1989); Sally Price, *Primitive Art in Civilized Places* (Chicago: University of Chicago Press, 1989); Ivan Karp and Steven Lavine, eds., *Exhibiting Cultures: The Poetics and Politics of Museum Display* (Washington, D.C.: Smithsonian Institution Press, 1991); Peter Vergo, ed., *The New Museology* (London: Reaktion Books, 1991); Janet Berlo, ed., *The Early Years of Native American Art History* (Seattle: University of Washington Press, 1992); Eilean Hooper-Greenhill, *Museums and the Shaping of Knowledge* (London: Routledge, 1992); Michael M. Ames, *Cannibal Tours and Glass Boxes: the Anthropology of Museums* (Vancouver: University of British Columbia Press, 1992); and Ivan Karp, Christine Mullen Kreamer, and Steven Lavine, eds., *Museums and Communities: the Politics of Public Culture* (Washington, D.C.: Smithsonian Institution Press, 1992).

5. F. W. Hodge, ed., "Aims and Objects of the Museum of the American Indian Heye Foundation," *Indian Notes and Monographs* 33 (New York: Museum of the American Indian, Heye Foundation, 1922); "The History of the Museum," *Indian Notes and Monographs Miscellaneous Series* 55 (New York: Museum of the American Indian, Heye Foundation, 1956); S. K. Lothrop, "George Gustav Heye – 1874–1956," *American Antiquity* 23 (1957): 66–67; Kevin Wallace, "Slim-Shin's Monument," *The New Yorker* (September 19, 1960); Barbara Braun, "Cowboys and Indians: The History and Fate of the Museum of the American Indian," *Village Voice*, 31 (April 8, 1986), 31–34, 36,

38–40. The quotations in the text are from Wallace, "Slim-Shin's Monument." See also references in Hail (this volume) to archives of Haffenreffer Museum of Anthropology and Museum of the American Indian.

6. Hodge, "Aims and Objects"; "The History of the Museum."

7. For Sears, see Harriet E. O'Brien, *Lost Utopias* (Harvard, Mass.: Fruitlands and The Wayside Museums, Inc., 1947); Cynthia H. Barton, *History's Daughter: The Life of Clara Endicott Sears Founder of Fruitlands Museums* (Harvard, Mass.: Fruitlands Museums, 1988). Both Haffenreffer and Sears wrote essays on the seventeenth century: for comments on Haffenreffer's uncompromising essay on New England history, see Krech, this volume; Sears's more poetic work, which nevertheless compares favorably with Haffenreffer's, was called *The Great Powwow: The Story of the Nashaway Valley in King Philip's War* (Boston: Houghton Mifflin, 1934).

8. Other collectors who did not found museums include Milford Chandler, Stewart Culin, Rowland G. Hazard II, and Louis Warren Hill: Diana Fane, Ira Jacknis, and Lise Breen, *Objects of Myth and Memory* (New York: Brooklyn Museum, 1991); Ann T. Walton, John C. Ewers, and Royal Hassrick, *After the Buffalo Were Gone: The Louis Warren Hill, Sr., Collection of Indian Art* (St. Paul: Northwest Area Foundation, 1985); Sarah Peabody Turnbaugh and William A. Turnbaugh, *The Nineteenth Century American Collector: A Rhode Island Perspective* (Peace Dale, R.I.: Museum of Primitive Art and Culture, 1991); David Penney, *Art of the American Indian Frontier* (Seattle: University of Washington Press, 1992). See also the essays in *Early Years,* on figures who were patrons of Native artisans or who themselves collected the art and artifacts of Native Americans during the late-nineteenth and early-twentieth centuries. For Richard Pohrt, a museum founder, see Penney, *Art of the American Indian Frontier.* An early-nineteenth century example was William Clark's museum: John C. Ewers, "William Clark's Indian Museum in St. Louis 1816–1838," in *A Cabinet of Curiosities: Five Episodes in the Evolution of American Museums,* Whitfield Bell et al, (Charlottesville: University of Virginia Press, 1977), 49–72.

9. Although varied, these collectors were certainly not "all... eccentric" – see Edwin L. Wade, Carol Haralson, and Rennard Strickland, *As in a Vision: Masterworks of American Indian Art* (Norman: University of Oklahoma Press, 1983), 13.

10. Richard A. Pohrt, "A Collector's Life: A Memoir of the Chandler-Pohrt Collection, in Penney, *Art of the American Indian Frontier,* 299–322; 301.

11. See J.C.H. King, "Tradition in Native American Art," in *The Arts of the North American Indian: Native Traditions in Evolution,* ed. Edwin Wade (New York: Hudson Hills, 1986), 65–92; Charles L. Briggs, "The Role of *Mexicano* Artists and the Anglo Elite in the Emergence of a Contemporary Folk Art," in *Folk Art and Art Worlds,* eds. John Michael Vlach and Simon Bronner (Ann Arbor: UMI Research Press, 1986), 195–224; Nancy J. Parezo, "The Formation of Ethnographic Collections: The Smithsonian Institution in the American Southwest," *Advances in Archaeological Method and Theory* 10 (1987), 1–47; Beverly Gordon with Melanie Herzog, *American Indian Art: The Collecting Experience* (Madison: University of Wisconsin, Elvehjem Museum of Art, 1988); see also the essays in Berlo, ed., *Early Years.*

12. See especially Donna Haraway, "Teddy Bear Patriarchy: Taxidermy in the Garden of Eden, New York City, 1908–36,"

in *Primate Visions: Gender, Race, and Nature in the World of Modern Science* (New York: Routledge, 1989), 26–58; Simon J. Bronner, "Object Lessons: The Work of Ethnological Museums and Collections," in *Consuming Visions: Accumulation and Display of Goods in America, 1880–1920,* ed. Simon J. Bronner (New York: Norton, 1989), 217–54; Jay Mechling, "The Collecting Self and American Youth Movements," in *Consuming Visions,* 255–85; Ames, *Cannibal Tours and Glass Boxes;* James Clifford, "On Collecting Art and Culture," in *The Predicament of Culture,* 215–51; Clifford, "Four Northwest Coast Museums: Travel Reflections," in *Exhibiting Cultures,* eds. Karp and Lavine, 212–254; Clifford, "Objects and Selves – An Afterword," in *Objects and Others,* 236–46; Charles Suamarez Smith, "Museums, Artifacts, and Meanings," in *The New Museology,* 6–21; Brian Durrans, "The Future of the Other: Changing Cultures on Display in Ethnographic Museums, in *The Museum Time Machine,* ed. Robert Lumley (Comedia/Routledge, 1988), 144–69; Nicholas Thomas, "The European Appropriation of Indigenous Things," in *Entangled Objects: Exchange, Material Culture, and Colonialism in the Pacific* (Cambridge, Mass.: Harvard University Press, 1991), 125–84; Hooper-Greenhill, *Museums and the Shaping of Knowledge;* James A. Boon, "Why Museums Make Me Sad," in *Exhibiting Cultures,* 255–77; Curtis M. Hinsley, "Collecting Cultures and Cultures of Collecting: The Lure of the American Southwest, 1880–1915," *Museum Anthropology* 15, 1 (1992): 12–20.

13. Curtis Hinsley, "From Shell-Heaps to Stelae: Early Anthropology at the Peabody Museum," in *Objects and Others,* 49–74; "Historical Introduction," in Phoebe Apperson Hearst Memorial Volume, *University of California Publications in American Archaeology and Ethnology* 20, ed. A. L. Kroeber (Berkeley: University of California Press, 1923); T. H. Thoresen, "Paying the Piper and Calling the Tune: The Beginnings of Academic Anthropology in California," *Journal of the History of the Behavioral Sciences* 11 (1975): 257–75; Winifred Black Bonfils, *The Life and Personality of Phoebe Apperson Hearst* (San Francisco: John Henry Nash, 1928).

Plate 1
Pouch, triangular flap, Southeast, early to mid-19th c. Glass beads, wool, muslin. L 80 cm incl. strap. Bradford House collection. 81-70

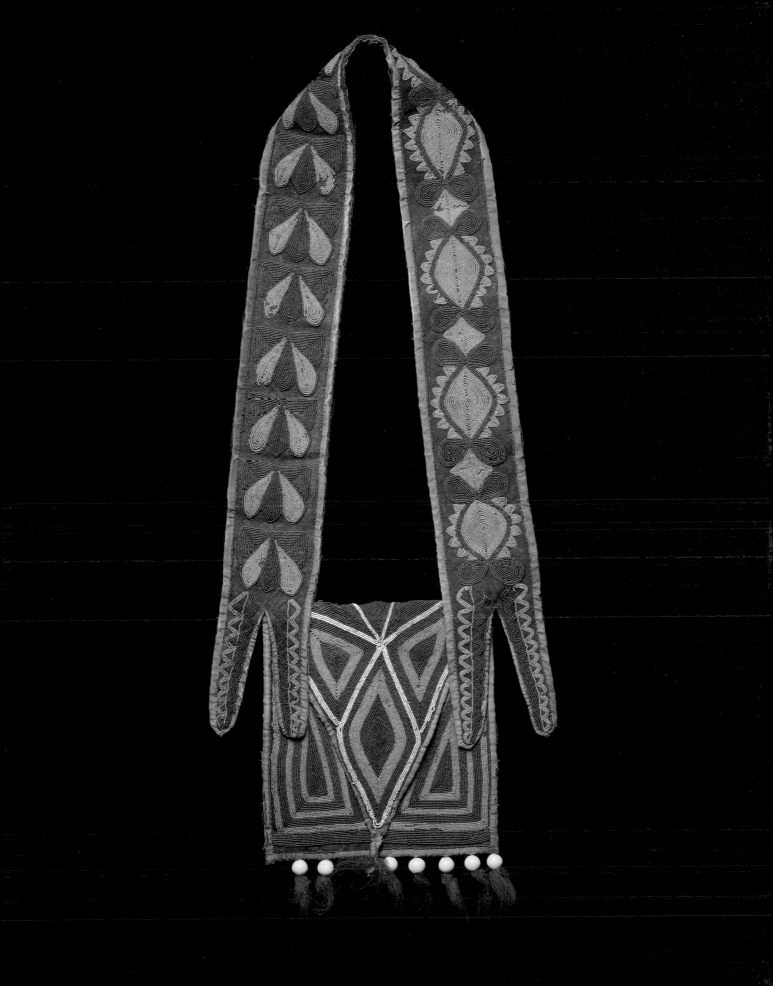

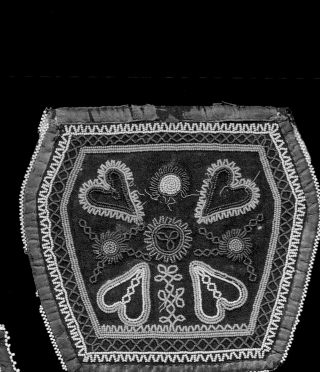

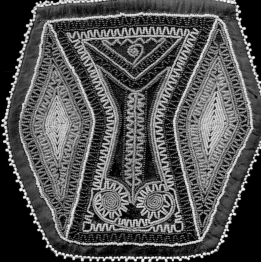

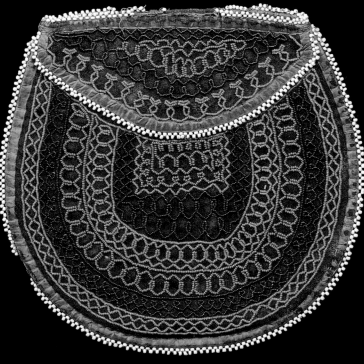

Plate 2
Bags, Northeast, 19th c. Wool, glass beads, silk ribbon, cotton. Right bag W 20 cm. L to R: 57-759; purchase, Temple 1929, 60-4513, 60-4515

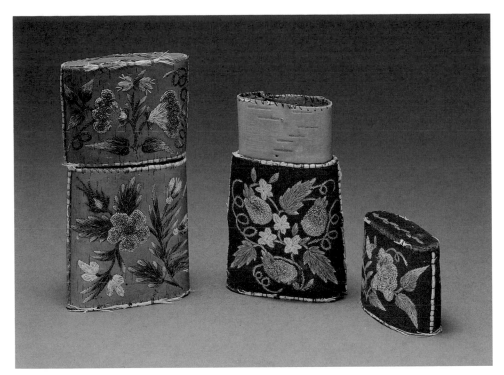

Plate 3
Cigar cases, Huron, ca. 1825. Birch bark, wool, dyed moose
hair. Left case H 15.5. Purchase, Temple 1929. L to R: 59-172,
83-410

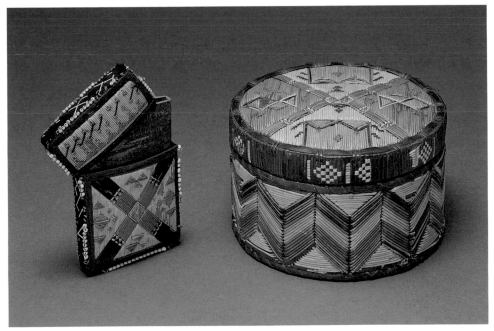

Plate 4
Calling card case and box, Micmac, ca. 1875. Birch bark,
porcupine quills, glass beads, spruce root, silk ribbon. Box D
14 cm. Purchase, Colcleugh 1930. L to R: 60-4653, B-72

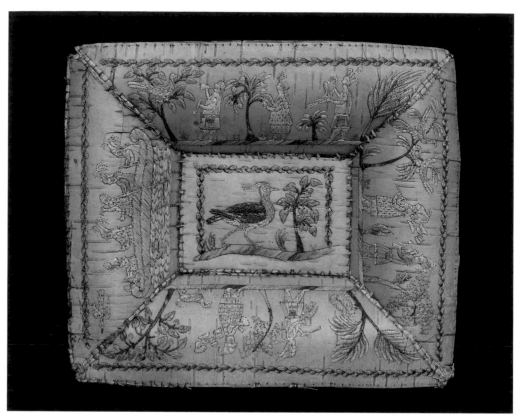

Plate 5
Calling card tray, Huron, ca. 1825. Birch bark, dyed moose
hair. L 23.5 cm. Source unknown. 83-403

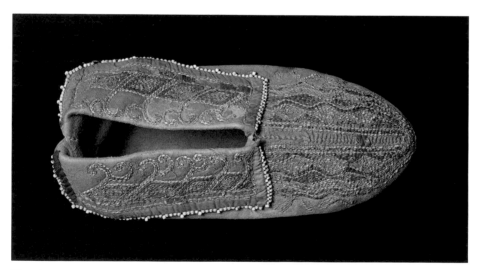

Plate 6
Moccasin, Iroquois, late 18th, early 19th c. Hide, porcupine
quills, silk, glass beads. L 23 cm. Purchase 1928. 60-4546

Plate 7
Cradleboard, Iroquois, late 19th c. Wood, paint, screws. L 71 cm.
Collected at St. Regis Reservation 1890; purchase, Rowell
1934. 57-210

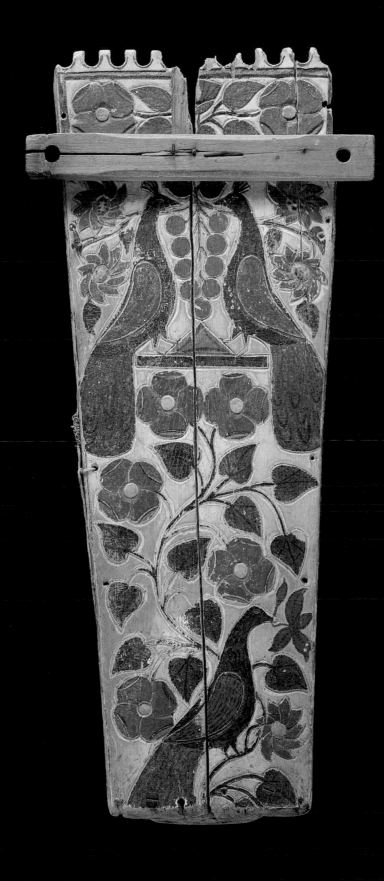

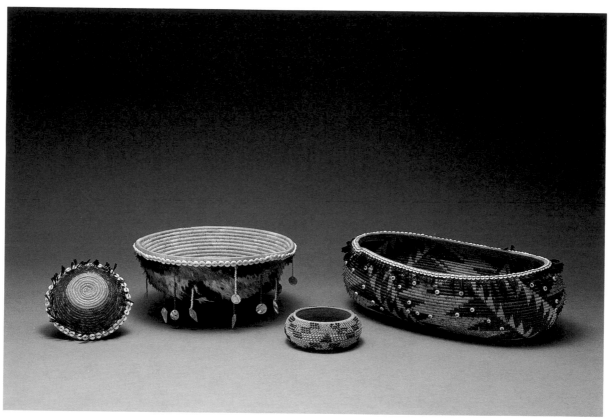

Plate 8
Gift baskets, Pomo, 19th c. Plant fibers, glass & shell beads,
feathers, shells. Right bowl H 10 cm. Purchase, Temple 1929
and Gribbel. L to R: B-56, B-55, 57-190, B-2

Plate 9
Headdresses, Yurok-Karok, 19th c. Hide, paint, feathers, fur.
Right headdress H 80 cm. L to R: purchase, Temple 1929,
57-386; purchase Gribbel, B-1171

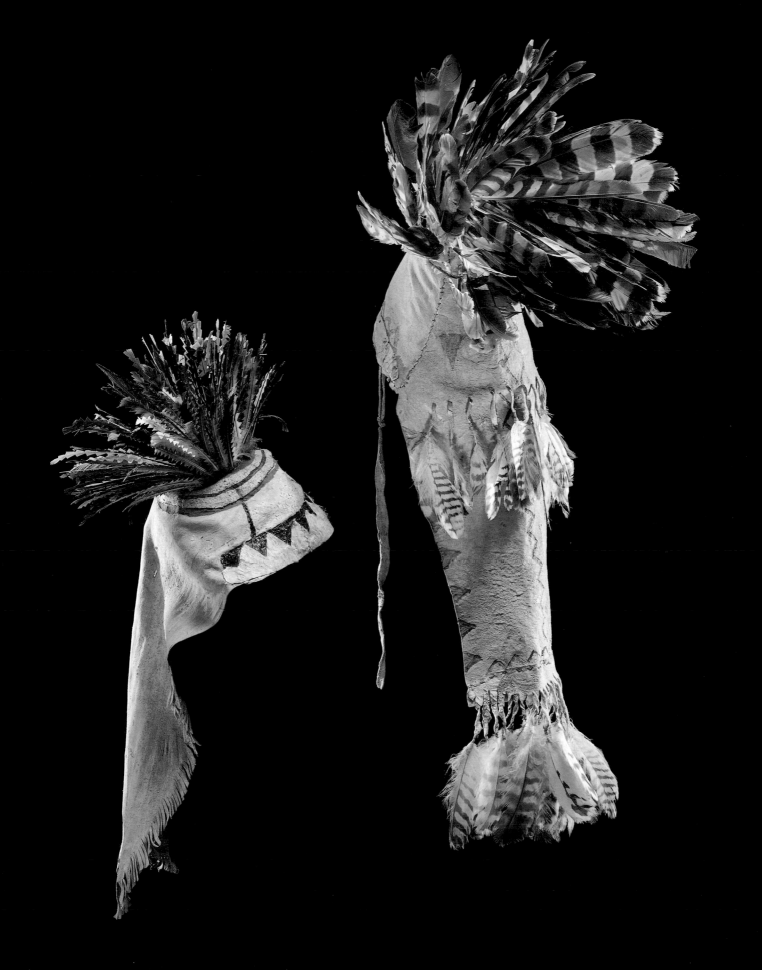

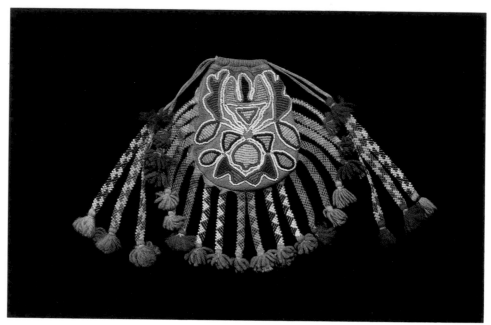

Plate 10
Tobacco pouch, Potawatomi, 19th c. Glass beads, smoked deer
hide, wool, sinew, thread. L 18 cm. Source unknown. 57-756

Plate 11
"Glengarry" cap and moccasins, Iroquois, 19th c. Glass beads,
velvet, silk ribbon, cotton tape, cloth, hide, military braid.
Cap, L 27 cm. L to R: purchase, Temple 1929, 57-466; 1/54

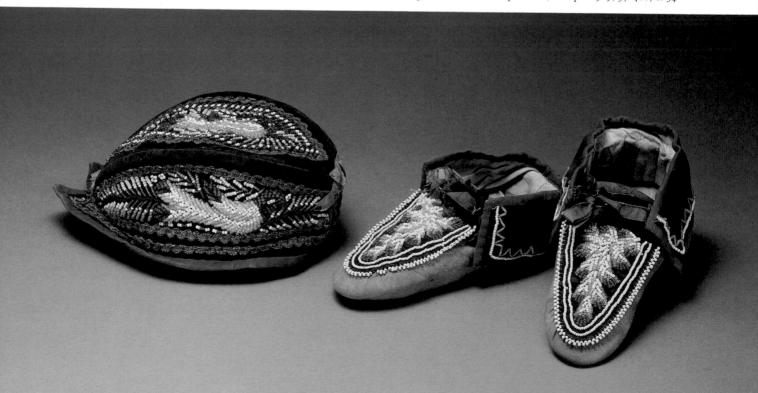

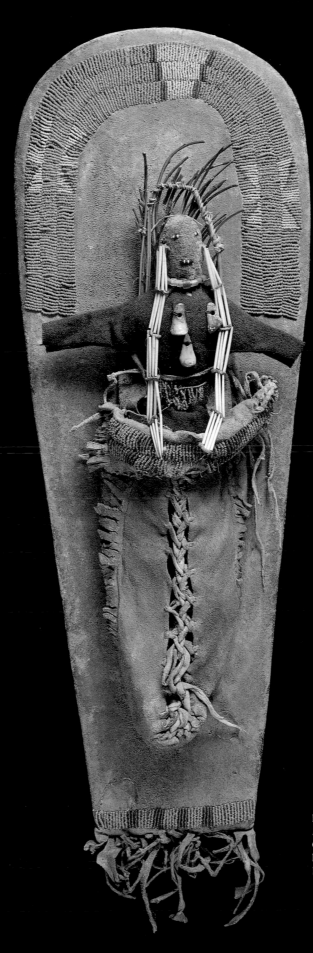

Plate 12
Doll in cradle, Northern Ute, 19th c.
Glass beads, porcupine quills, wood,
hide, wool, elk's teeth. L 58 cm.
Purchase, Temple 1929. 57-281

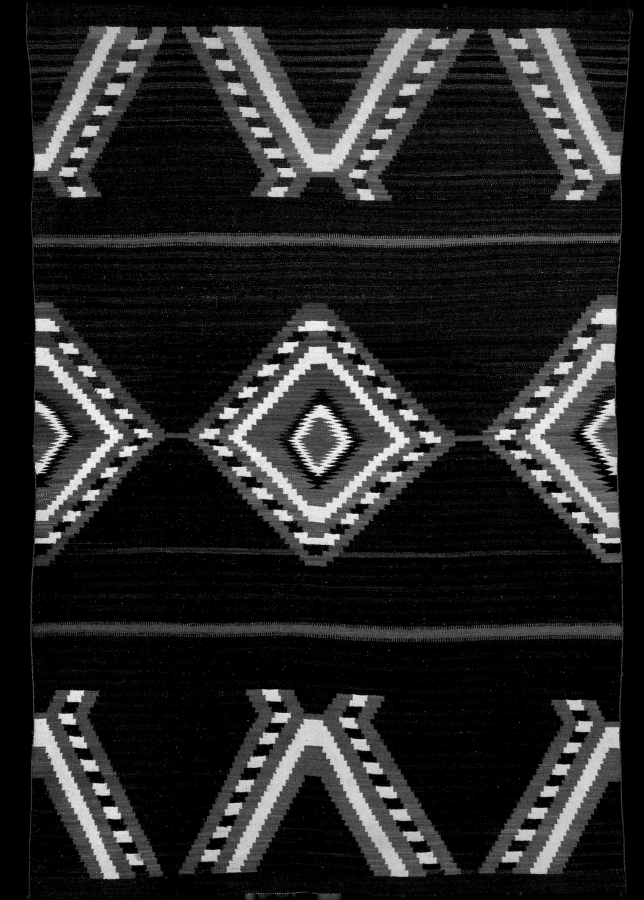

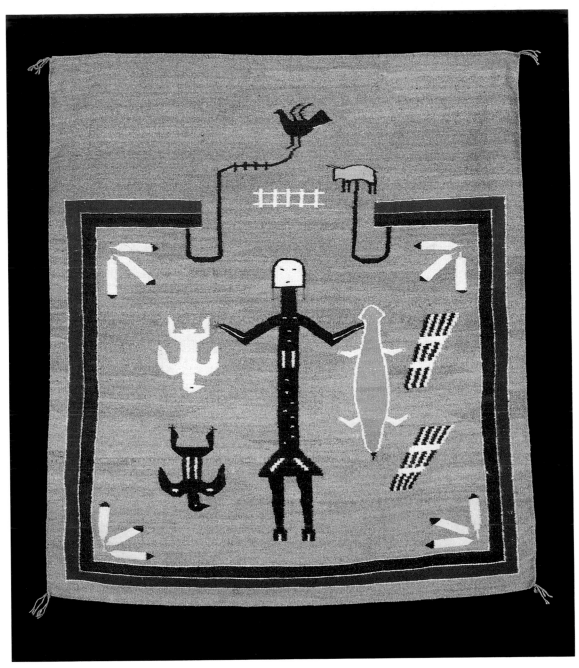

Plate 14
Sandpainting textile, Eagle Trap, Eagleway, Navajo, 1920s–
1930s. Commercial cotton warp, commercial wool weft.
L 126.5 cm. Purchase. 71-5070

Plate 13
Rug/blanket, Navajo, Moki-stripe Hubbell revival style,
Ganado, NM, 1890–1910. Wool. L 253.5 cm. Purchase. 74-162

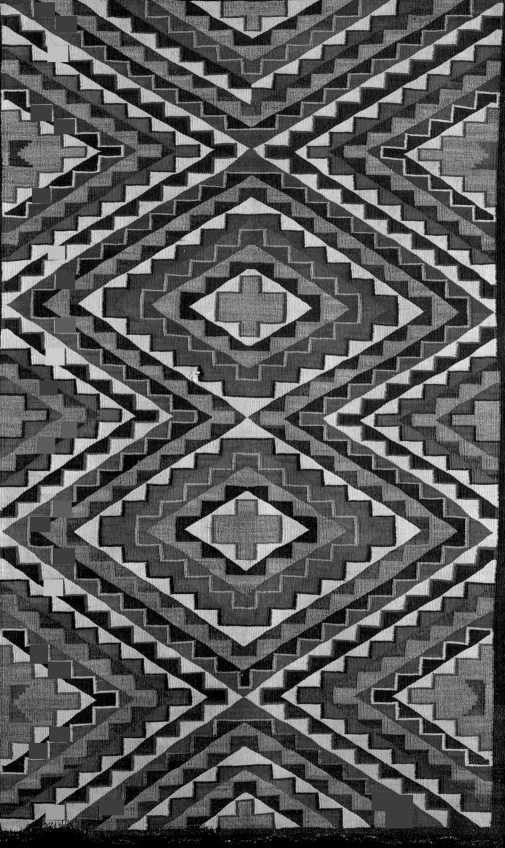

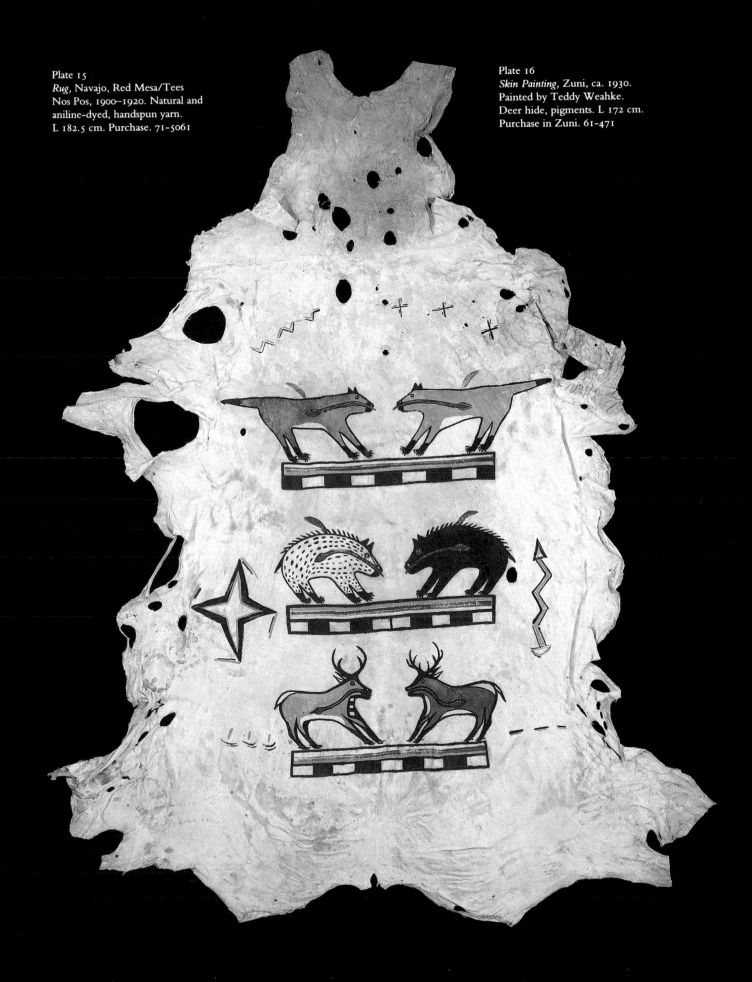

Plate 15
Rug, Navajo, Red Mesa/Tees
Nos Pos, 1900–1920. Natural and
aniline-dyed, handspun yarn.
L 182.5 cm. Purchase. 71-5061

Plate 16
Skin Painting, Zuni, ca. 1930.
Painted by Teddy Weahke.
Deer hide, pigments. L 172 cm.
Purchase in Zuni. 61-471

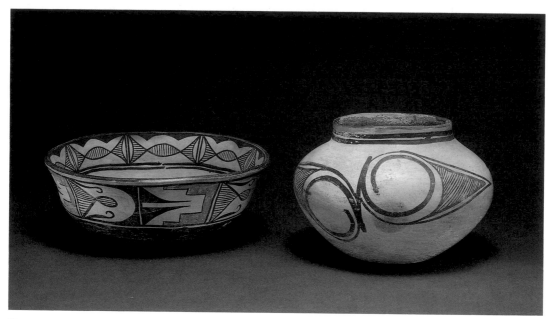

Plate 17
Bowl and jar, Hopi First Mesa, early- to mid-19th c. Clay, red
and black paint on cream (polacca polychrome). Jar D 21 cm.
Exchange, MAIHF 1945. L to R: 75-29, 75-28

Plate 18
Water jar, Sikyatki (Hopi prehistoric), AD 1375–1625.
Polychrome ceramic. D 40 cm. Purchase in Southwest.
75-91

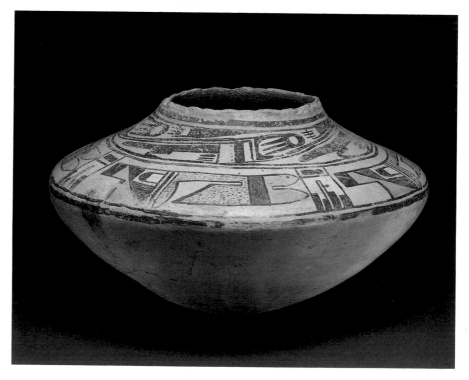

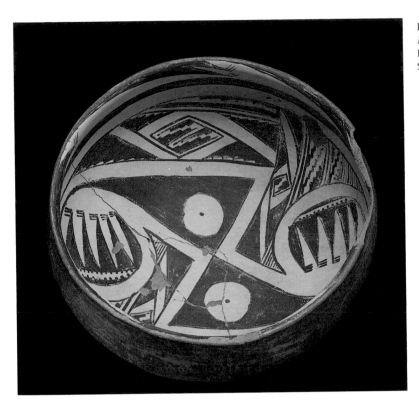

Plate 19
Bowl, Gila, Salado area, ca. AD 1700.
Polychrome ceramic. D 30 cm. Purchase in
Southwest. 61-262

Plate 20
Water jar and bowl, Zuni, ca. 1900. Clay, slip. Jar H 25 cm.
L to R: purchase in Southwest, 75-34; exchange, MAIHF 1945,
61-260

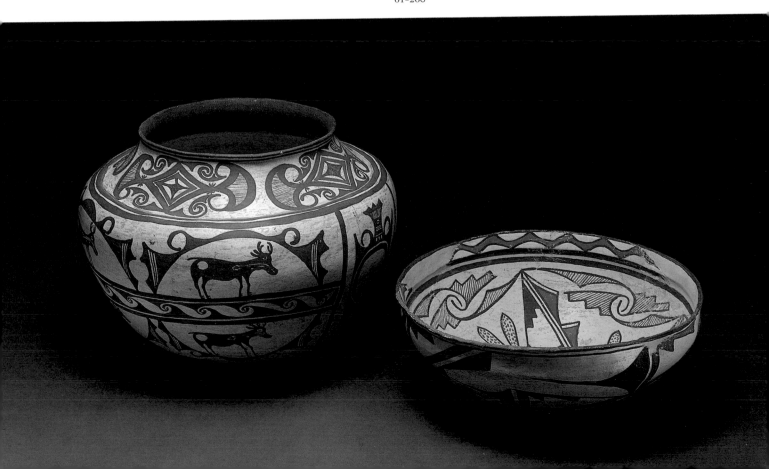

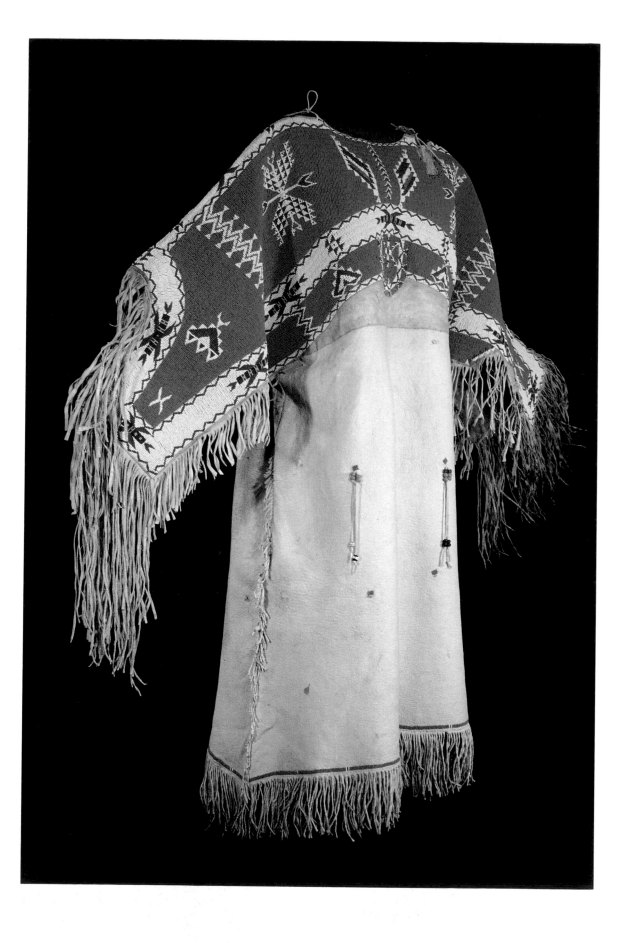

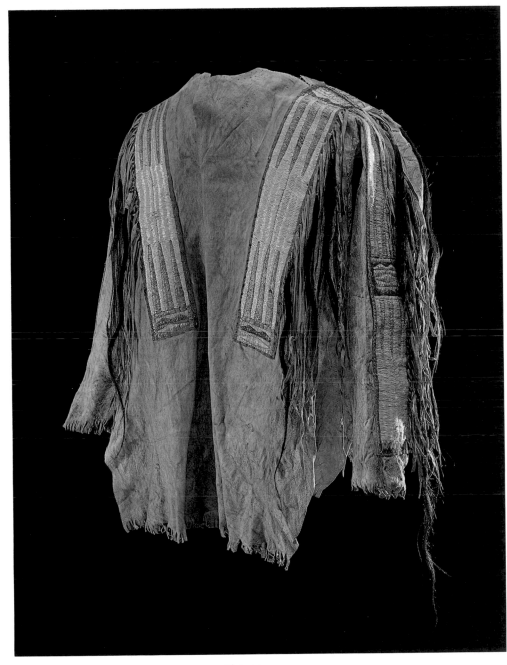

Plate 22
Shirt, Hidatsa/Mandan type, ca. 1870. Hide, sinew, dyed por-
cupine quills, human hair, cotton thread. L 71 cm. Purchase,
Temple 1929. 57-458

Plate 21
Dress, Oglala Sioux, early 20th c. Elk hide, glass beads, cotton
thread. L 122 cm. Collected Pine Ridge, SD 1929; exchange,
MAIHF 1943. 78-70

Plate 23
Water jar, Acoma, late 19th c. Clay, slip. D 28 cm. Exchange,
MAIHF 1945. 75-93

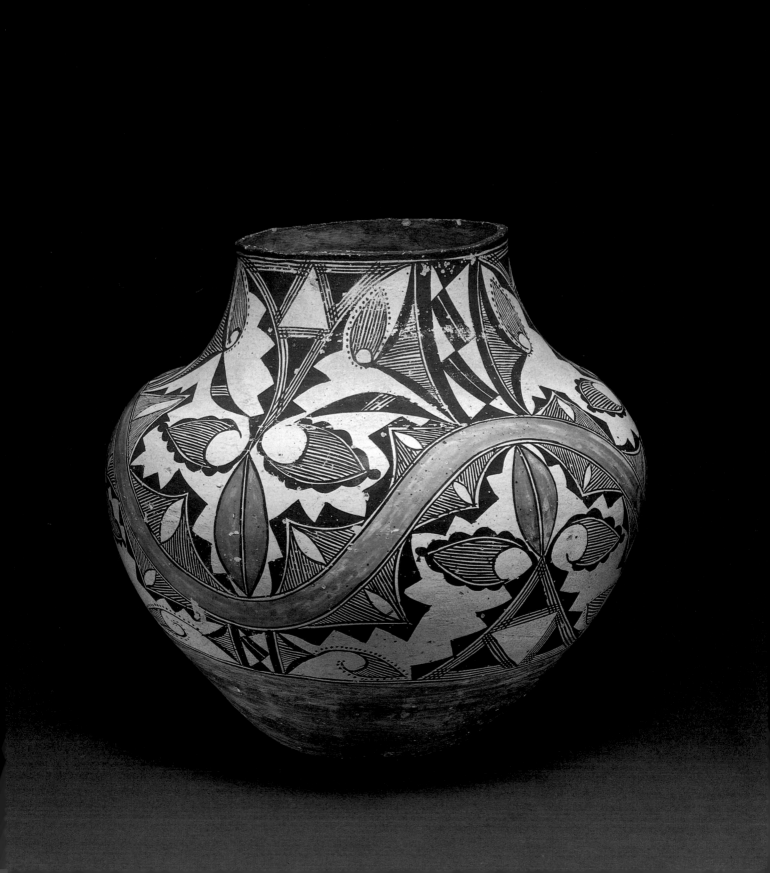

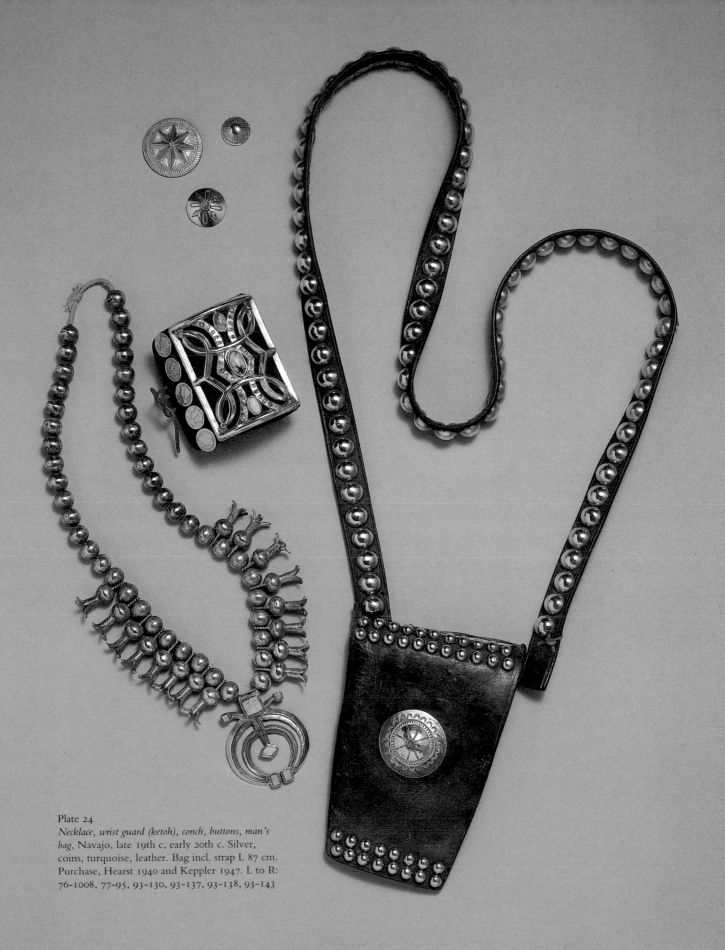

Plate 24
Necklace, wrist guard (ketoh), conch, buttons, man's bag, Navajo, late 19th c, early 20th c. Silver, coins, turquoise, leather. Bag incl. strap L 87 cm. Purchase, Hearst 1940 and Keppler 1947. L to R: 76-1008, 77-95, 93-130, 93-137, 93-138, 93-143

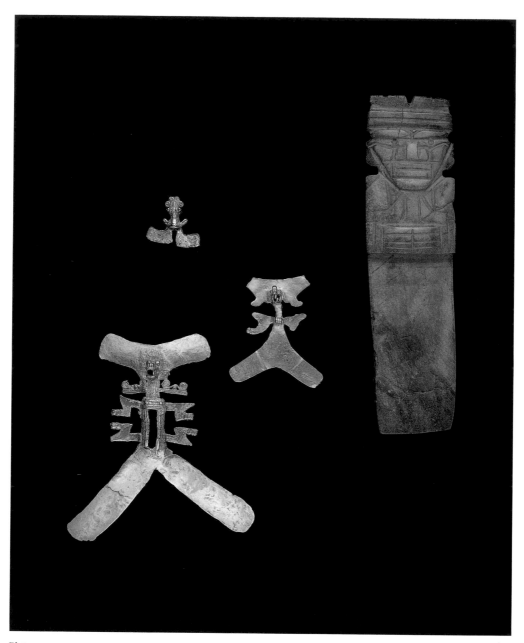

Plate 25
Gold and jade ornaments, Costa Rica. L to R: General Valley;
Puerto Jimenez; Atlantic zone; San Jose. Jade L 14 cm. Gold,
purchase, Gonzalez 1937. Jade, gift, Bryant 1928. CR-1,
CR-5, CR-2, CR-11

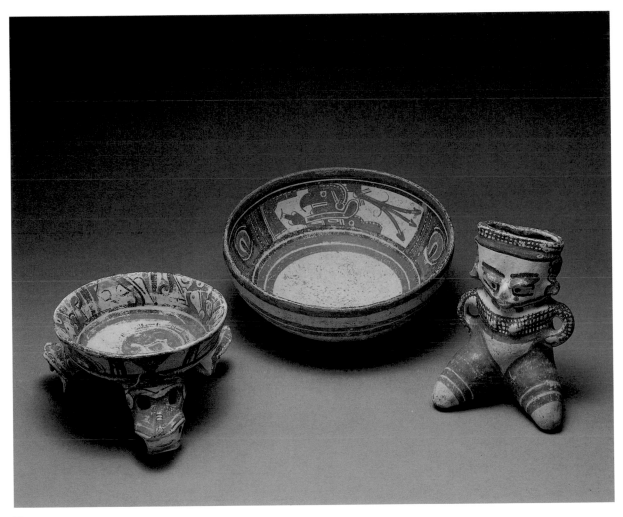

Plate 26
Ceramics, Nicoya area, Costa Rica, Post-Classic period,
AD 1000–1350. Papagayo Polychrome. Tripod bowl D 16 cm.
Purchase, Gonzalez 1937. L to R: CR-27, CR-30, CR-23

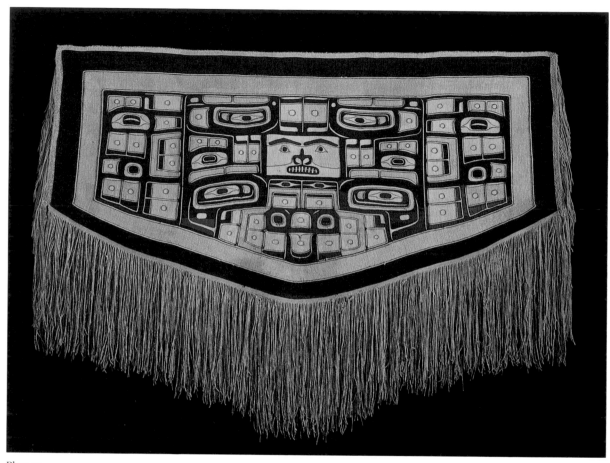

Plate 27
Dancing blanket, Chilkat, Tlingit, ca. 1880–1910. Mountain
goat wool, cedar bark. Top width 177 cm. Gift, Adams 1928.
81-20

Plate 28
Moccasins and belt, Tlingit, Inside Passage, ca. 1880–1920.
Caribou or deer hide, glass beads, cotton, fur. Moccasin L 24
cm. Gift, Adams estate (via Twaddle) 1958. L to R: 58-44,
60-4598

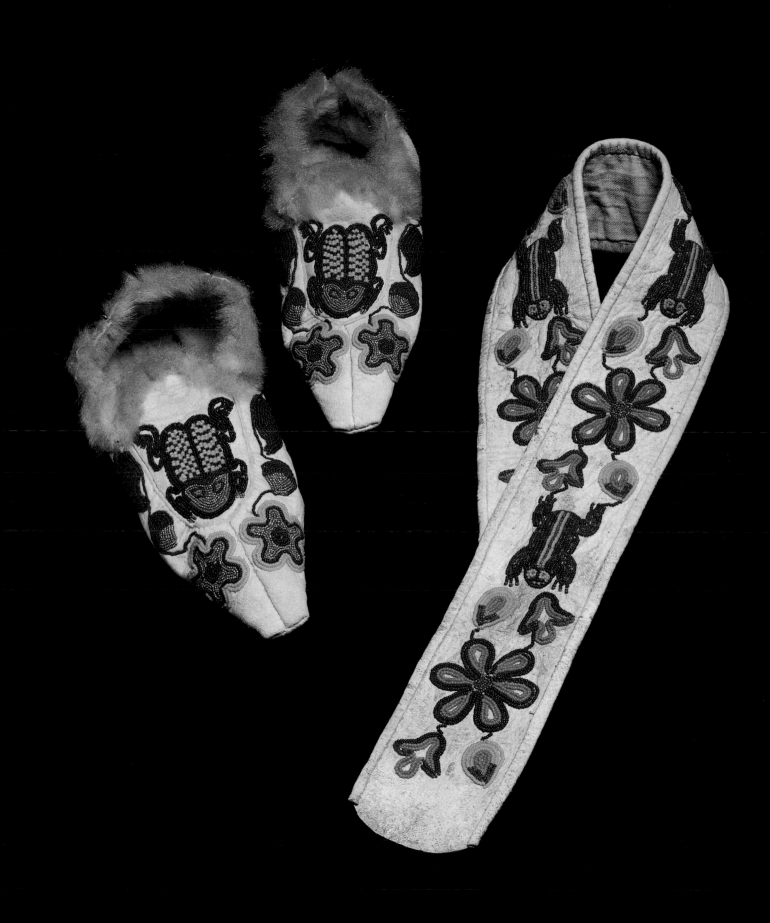

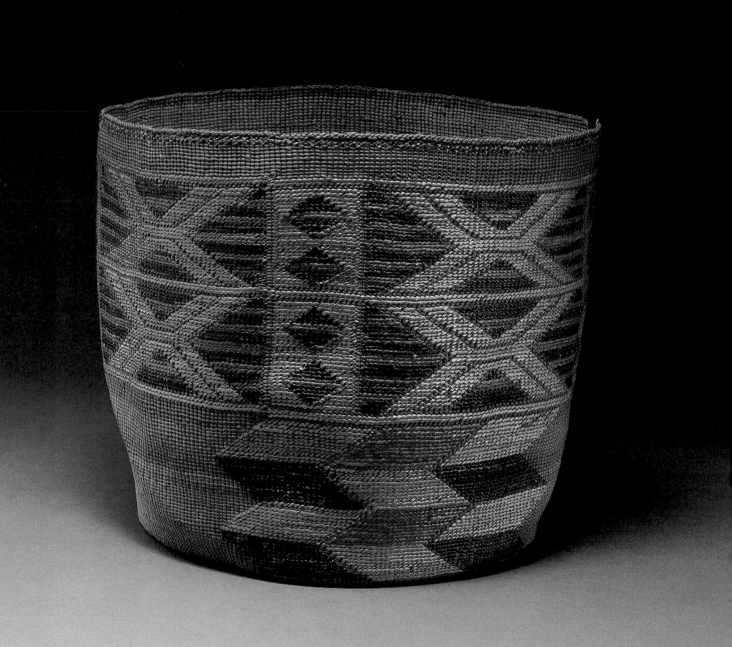

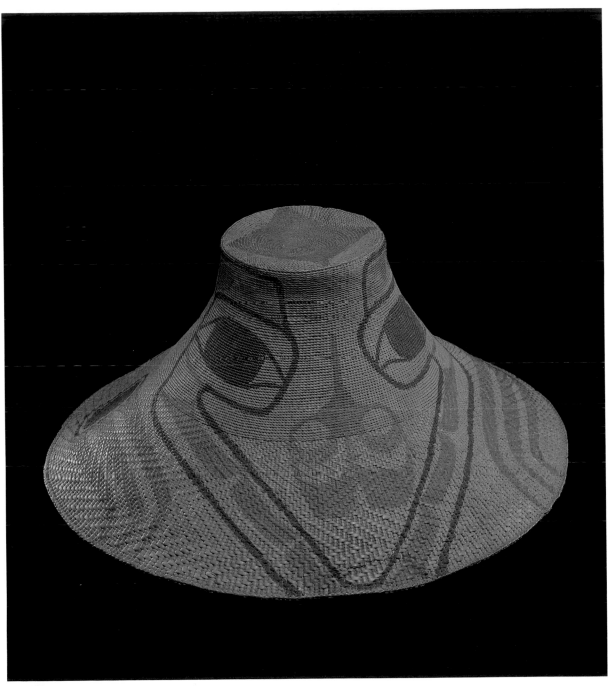

Plate 30
Hat, Haida, 1880s. Spruce root, pigments. D 38 cm. Collected at Masset, Queen Charlotte Island, 1888; purchase, Colcleugh 1930. 61-87

Plate 29
Basket, Tlingit, 19th c. Spruce root, beargrass, maidenhair fern. D 27 cm. Collected 1884–88; purchase, Colcleugh 1930. B-46

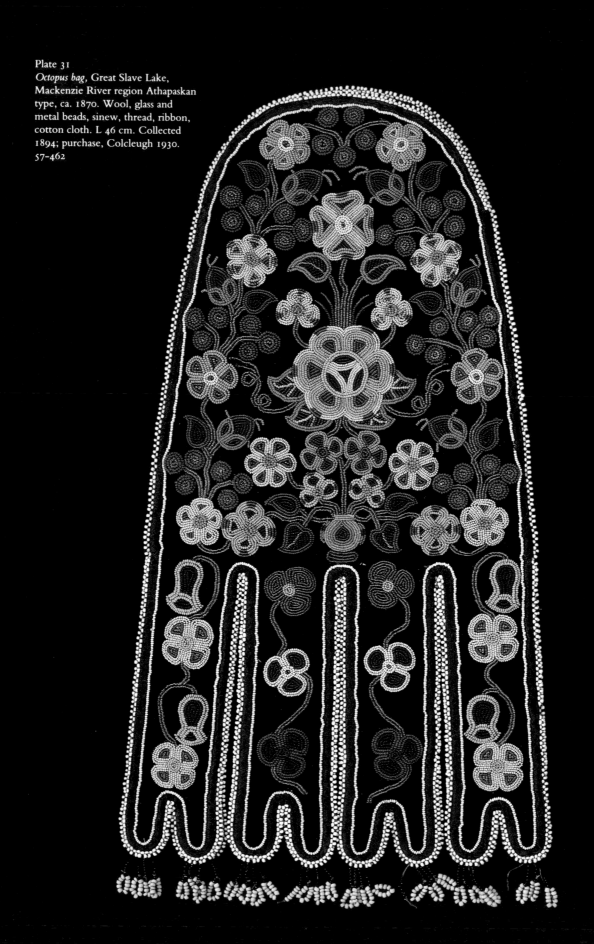

Plate 31
Octopus bag, Great Slave Lake, Mackenzie River region Athapaskan type, ca. 1870. Wool, glass and metal beads, sinew, thread, ribbon, cotton cloth. L 46 cm. Collected 1894; purchase, Colcleugh 1930. 57-462

Plate 32
Vest, Ojibwa/Chippewa, 19th c. Velvet, glass beads, cotton, grosgrain ribbon. L 42 cm. Purchase, Temple 1929. 79-61

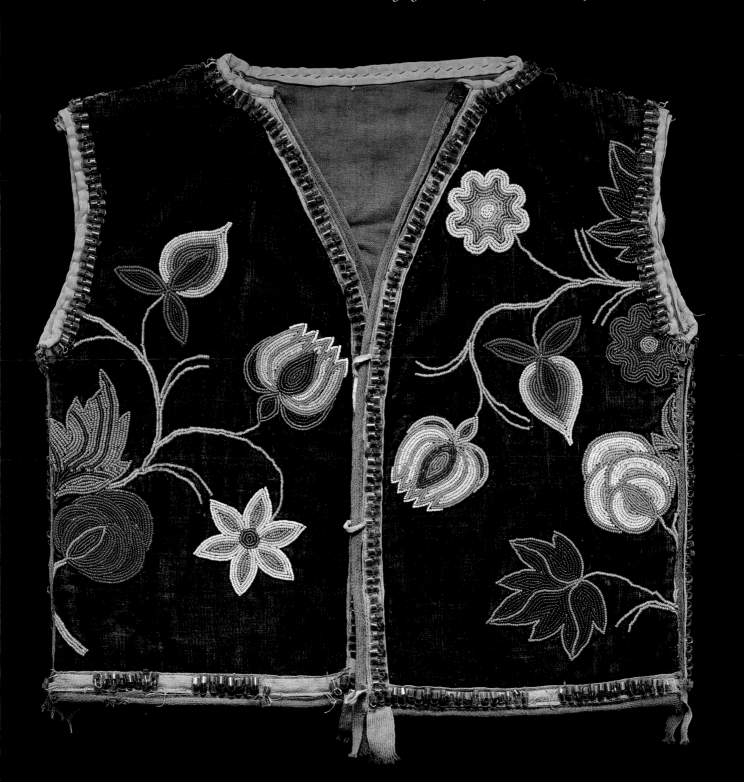

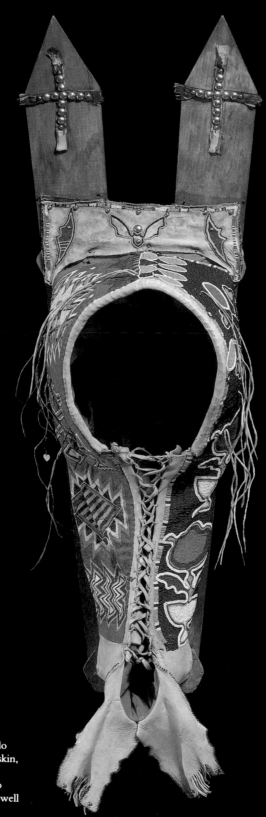

Plate 33
Lattice cradle, Kiowa, made by Tah'do
[Tah-o-te]. Wood, glass beads, deerskin,
sinew, cotton cloth, linoleum, metal.
L 106 cm. Gift, Guy Qui-ah-tone to
E. E. Rowell ca. 1910; purchase, Rowell
1934. 61-339

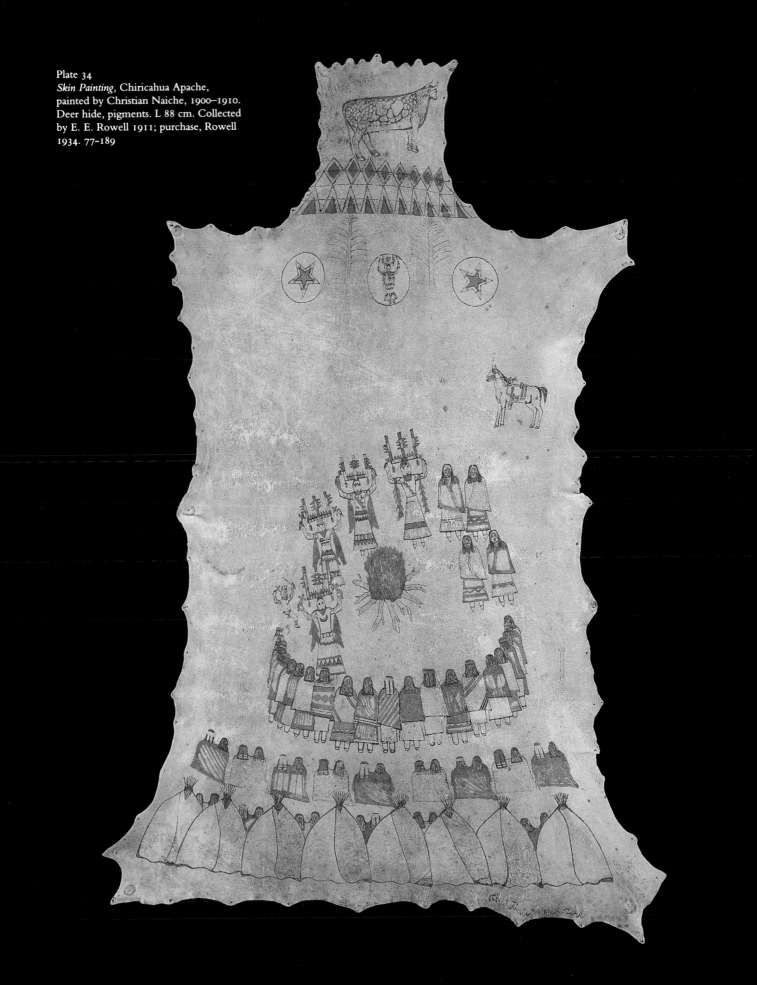

Plate 34
Skin Painting, Chiricahua Apache,
painted by Christian Naiche, 1900–1910.
Deer hide, pigments. L 88 cm. Collected
by E. E. Rowell 1911; purchase, Rowell
1934. 77-189

Plate 36
Projectile points, Columbia River area, various periods. L 2-6 cm.
Uncatalogued purchase.

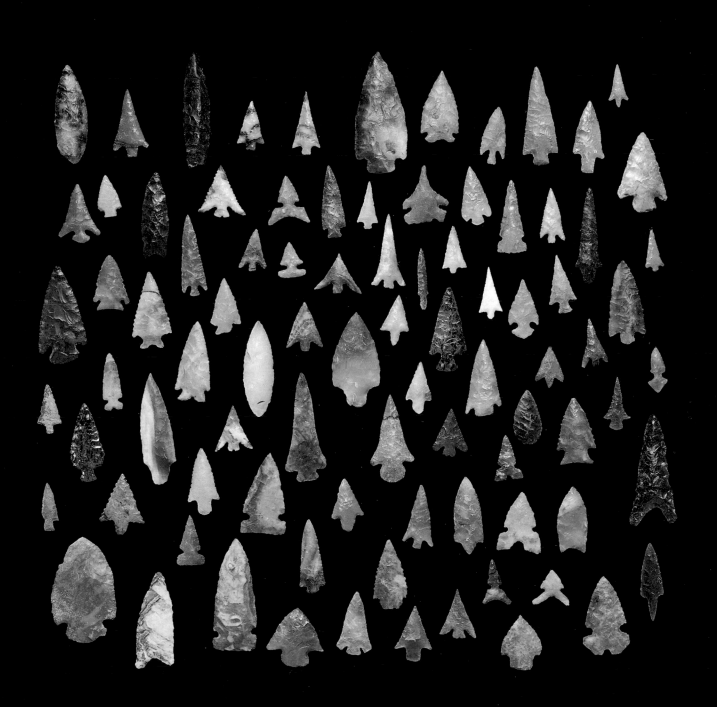

Haffenreffer Sanctuary for New England Indian Relics at Mt. Hope to Be Opened for Inspection Today

Collection, Considered One of the Finest in the Country, to be Available to Students of Archaeology and Indian Lore. Housed in Fireproof Building, the Collection is Now the Largest in New England and Will Soon be the Largest in the World if the Owner's Plans Are Carried Out. The Building Containing the Relics is on the Estate of R. F. Haffenreffer, Jr., Mt. Hope, Long the Hunting Grounds and Home of King Phillip and His Tribe. Pictured Below Are the Following: No. 1—F. H. Saville, Archaeologist, Holding an Indian Effigy Pastel; No. 2—R. F. Haffenreffer, Jr.; No. 3—An Ancient Wooden Mortar and Pestle of the Mashpee Indians Found at Middleboro, Mass.; No. 4—Bowl Made by the Nipmuck Indians From a Maple Knot, With Turtle Handles, Found at Southwick, Mass.; No. 5—Indian Bottle Found in 1879-80 on the Indian Burial Ground at the Babbitt Farm, North Kingstown; No. 6—Iron Tripod Kettle Traded to the Indians by the Whites, Which Was Found at Burr's Hill, Warren, in 1913. The Pot Was Lined by the Indian Owner, Part of Which Clings to the Side of the Iron Vessel; No. 7—A Section of the Display of Indian Relics For Friendly Missions; No. 8—Copper Necklace Found at Burr's Hill, Warren, in 1913. It is Believed to be the Same Necklace Which Historians Say Was Presented to Massasoit by Governor Winslow. It Was Later Used by the Indian Chieftain to Identify Delegates He Sent to the White Man; No. 9—Cache of 42 Stemmed Spear-Heads and Knives Found Near the Ice House on Willett Avenue, Riverside; No. 10—Dug-out Canoe, 13 Feet Long, Made of Hard Pine, Discovered by Henry J. Thayer, Sept. 7, 1896, at Gunners' Exchange Pond, Cape Cod; No. 11—A Fire-proof Building Erected at Mount Hope by R. F. Haffenreffer, Jr., For the Housing of Indian Objects of Historical Value

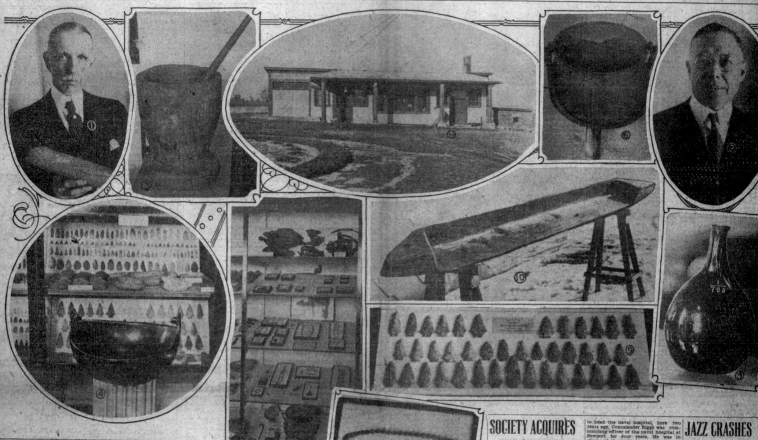

Haffenreffer Builds Shrine For King Philip at Bristol

SANCTUARY FOR INDIAN HISTORY ERECTED BY FALL RIVER MAN IS NEAR CHIEF'S GRAVE

Collection of Red Men's Relics, Now Largest in New England, Expected to Be Greatest in World.—Scientists and Archaeologists Coming to Mount Hope

As a fitting memorial to King Philip, the Indian patriot, who in 1675 tried to rally the aborigines against the flood of white immigration and save America to his people, R. F. Haffenreffer, Jr., of Fall River has built a shrine and archaeological sanctuary for the Indian history of New England at Mount Hope, Bristol. Within the shadow of the stone throne of the dead chieftain, Mr. Haffenreffer has erected a modern fireproof building for the housing of objects of Indian historic value.

The collection of Indian relics at Mount Hope, which is now the largest in New England and will soon be the greatest in the world, will be open to students of archaeology and Indian lore. Among the visitors expected to stay are several groups of scientists and archaeologists and the trustees of the George Hails Free Library at Warren.

The work of Mr. Haffenreffer, in investigating and preserving the history of King Philip, is considered of great importance and value by historians. Supplementing his New England collection, Mr. Haffenreffer has many fine Zuni and Navajo blankets and some prehistoric artifacts gathered in visits to the Southwest.

The private reservation of Mount Hope, or Montop, as it was called by the savages, includes the Cold spring and swamp where King Philip was slain by Capt. Benjamin Church's Indian benefactor. Four miles away is Burr's Hill, in Warren, where Philip's father, Massasoit, was buried.

[remaining columns of dense body text continue]

JAZZ CRASHES INTO METROPOLI
Continued from Page 1,

SOCIETY ACQUIRES LEE'S BIRTHPLACE

Daughters of Confederacy to Preserve Stratford Hall as National Shrine.

FOUNDATION TO BE FORMED

Will Direct Restoration of Estate in Virginia.—Memorial Scholarship Planned

TWO BOYS TELL DAWES OF ESCAPE FROM FIRE

Vice President's Adopted Son and Other Lad in Lawrenceville Blaze.

LUDENDORFF REPORTED "DUPED" BY ALCHEMISTS

Said to Have Aided Couple to Raise Funds to "Manufacture Gold."

DR. ROY CHAPMAN ANDREWS TO GET ELISHA KANE MEDAL

Will Be Honored by Geographical Society of Philadelphia.

SENATE CONFIRMS RIGGS AS SURGEON GENERAL

Appointee in Charge of Newport Hospital at Time of Mackinac Disaster.

POLICEMAN WHO EVADED TRAINING TO FACE BOARD

Patrolman Charged with Insubordination By Superintendent.

LICK OBSERVATORY SCIENTIST WINS JANSSEN GOLD MEDAL

William H. Wright, Astronomer, Honored By Paris Academy.

FOOT AND MOUTH DISEAS

Rudolf F. Haffenreffer and the King Philip Museum

by SHEPARD KRECH III

BEFORE 1929, a private museum in Rhode Island attracted little public notice beyond an occasional mention in the press in a story on statewide archaeology collections or some local matter, but that January it suddenly catapulted into regional consciousness. Featured prominently in Massachusetts and Rhode Island newspapers, it acquired a name, the King Philip Museum, and was depicted as a "shrine" or "sanctuary" for Philip, the great Pokanoket leader who died virtually within sight of where the Museum stood. The name of the Museum and of its founder, Rudolf F. Haffenreffer, subsequently became widely known. Reporters reached for superlatives to describe the Museum. "Collection of Red Men's Relics, Now Largest in New England, Expected to Be Greatest in World," one headline shouted (fig. 1-1); it would become "a mecca for students," another predicted.[1]

A local, partisan newspaper might be forgiven for hyperbole or stating expectations impossible to fulfill, but in time thousands of people did come through the museum's door, and many clearly liked what they saw. One was a Wampanoag

Indian, born LeRoy Perry, in Fall River, Massachusetts. In a register at the Museum he addressed Haffenreffer as "Quai Nun Memaeu Netomp," which can be translated as "Hello my loving friend," and wrote, on June 21, 1929, the following: "In appreciation of the Heart interest, of one who perpetuate that which we are unable to, whose work speaks its worth, and whose spirit will never die: proud as a descendant of this People to know him who has wrought so well – I subscribe in appreciation and heart felt satisfaction to all that he has so wonderfully done." He signed the register, "Chief Sachem, Ousa Mekin, Yellow Feather, Wampanoag," and left his mark, a feather superimposed on a turtle.[2] Two years later, George Gustav Heye, the unrelenting collector whose Museum of the American Indian in New York was an unparalleled repository of American Indian artifacts, recorded more prosaic thoughts on his first visit to the King Philip Museum. Heye wrote that this was "the best" of many private collections he had seen, and that Rhode Islanders were "forever indebted" to Haffenreffer for "a shrine that for all time will mean much to the lover of the American Indian. What he has done to perpetuate the history of our aboriginals is great and wonderful."[3]

Unlike Heye, whose eyes never wandered very far from his museum collections, Haffenreffer was primarily a successful businessman who made his

Fig. 1-1
"Haffenreffer Sanctuary for New England Indian Relics at Mt. Hope to Be Opened for Inspection Today," *Providence Sunday Journal,* January 20, 1929. Rudolf Haffenreffer is at right and Foster Saville at left. Haffenreffer Museum of Anthropology.

RUDOLF F. HAFFENREFFER
AND THE KING PHILIP MUSEUM
A Chronology

1868–71 Rudolf F. Haffenreffer (Sr.), a maltster and barrel-maker, arrives in Boston from Germany, marries Katherine Burkhardt and founds Boylston Lager Beer Company

JUNE 22, 1874 Rudolf F. Haffenreffer, Jr. born

1883–88 Attends Chauncy-Hall School

1888–90 Lives in Stuttgart and attends Institut Rauscher

1890–95 Attends United States Brewers' Academy and Massachusetts Institute of Technology

1895 Moves to Fall River, Massachusetts, and establishes Old Colony Brewing Company

JANUARY 29, 1902 Marries L. Maude Monroe

1902, 1906 Sons Rudolf F. Haffenreffer 3rd and Carl W. Haffenreffer born

1903 Purchases amusement park adjacent to Mount Hope in Bristol, Rhode Island

1912 Purchases Mount Hope and the Bradford House and consolidates his two properties at Mount Hope

1914–15 Boy Scouts establish Camp King Philip at Mount Hope

1915 Issues "Some Legends of Mount Hope," by W. Munro

1916 Rhode Island Field Naturalists visit Haffenreffer's "museum"

1917 Becomes president and managing director of Utah-Apex and Montezuma-Apex, mines in Utah and California, and begins annual trips West

1921 Fire destroys barns and other buildings at Mount Hope

1923 Moves collections to fireproof, cement building and gives speech to the Fall River Historical Society

1924 Purchases Herreshoff Manufacturing Company

1928–29 Hires Foster H. Saville to locate, purchase, and catalogue collections

1929 Uses the name, King Philip Museum, for the first time

1931 Constructs wing onto the King Philip Museum and dedicates it upon a visit of Rhode Island Historical Society

1931 Becomes president of Narragansett Brewing Company

1931 Appointed receiver of the Mount Hope Bridge Corporation

1933 Moves winter residence from Fall River to Providence

1936 Five hundred scouts come to Mount Hope as part of statewide campaign of "friendship" for Wampanoag Indians, and visit King Philip Museum

1936 Announces Rudolf Frederick Haffenreffer Awards for best essays on Wampanoags written by scouts

1939 Camp King Philip dedicated north of Mount Hope

1941, 46, 47 Three-day powwows or camporees bring thousands of Boy Scouts to Mount Hope

1946 Providence College awards Haffenreffer honorary doctorate of business administration

1949–53 Member of the Corporation, MIT

OCTOBER 9, 1954 Dies at age 80

1955 Rudolf F. Haffenreffer's heirs, and the R. F. Haffenreffer Family Foundation, donate Mount Hope lands and the King Philip Museum collections to Brown University.

mark as a brewer and industrialist. For years he headed one of the largest brewing operations in the United States. When his Museum first came into the public eye he was in his forties and had been collecting for some years. To convincingly grasp what drove Haffenreffer to collect and establish a museum for American Indian artifacts, we need to know something about his childhood influences, his adolescent experiences, and the communities in which he lived. To make the story complete, we must then identify the main catalysts of his interest in Indian America, comprehend how he used the Museum and the land surrounding it, especially to encourage Boy Scouts, and reveal his attitudes about the indigenous people of North America and their history.

FROM GERMANY TO
BOSTON, MASSACHUSETTS

Rudolf Frederick Haffenreffer, Jr. was born in Boston, Massachusetts, the first son of German immigrants. His father, Rudolf Friedrich Haffenreffer, came to America from Württemberg at age 21, six years before his son was born; he arrived with the skills of a cooper, a brewer, and a maltster that he had already put to use in Germany and France. His mother, Katharine Burkhardt Haffenreffer, was born in Baden where her father was a lumber dealer. Baden and Württemberg are adjacent regions in southwestern Germany, and Rudolf's mother's and father's birthplaces were both near Stuttgart. In Württemberg, the Haffenreffer line can be traced back through pastors, lawyers, seminarians, and professors to the sixteenth century.[4]

When they left Germany, Rudolf Haffenreffer, Katharine Burkhardt, and others were swept up in an emigrant tide that affected most social and economic classes and all of the various German states, Baden and Württemberg in particular. They were pushed from Germany by economic dislocation and famine, among other adversities. Hundreds of thousands chose America as their destination, pulled there by the prospect of greater opportunity and freedom: freedom from aristocracy, as a popular mid-century guidebook providing advice for German immigrants emphasized; freedom to travel and settle where one desired; and the opportunity perhaps – if one learned English – to do what one wished. Some Germans were genuine political refugees like the "forty-eighters," who fled the absolutist German states following the failed uprisings of 1848 against autocratic authority. Among them were men who were later both celebrated for the strength of their intellectual contribution to American life and notorious for the conviction of their political beliefs. As more Germans settled in America during the nineteenth century, it became an increasingly attractive destination.[5]

Rudolf Haffenreffer, pushed from Europe by declining economic opportunity, came to Boston in 1868. In choosing New England he was unlike most other mid- and late-nineteenth century German immigrants, who flooded urban and rural areas of the Mid-Atlantic and Midwest regions. There, thirty percent of the population was German-born. In New England, only two percent was, and Boston's German-born population never exceeded 10,000 in the nineteenth century.[6] The immigrants tended to concentrate in the southwestern section of the city, especially in Roxbury – known as Boston's "German district" – and neighboring Jamaica Plain, where Rudolf and Katharine Haffenreffer lived.[7] In contrast to cities where large, compact German residential neighborhoods acquired names like "Little Germany," German-language publications thrived, and German culture persisted tenaciously, Roxbury and Jamaica Plain were far more ethnically mixed areas where expressions of German ethnicity were never as visible or pervasive. In Boston, German immigrants and their German-American offspring more quickly became American than they did elsewhere. However, the process was by no means automatic, and the results were not the same for everyone.[8]

In nineteenth-century Boston, German immigrants adapted to a social landscape that included the Irish, the Italians, and other new arrivals from Europe as well as old-stock Yankees, who included the "Brahmin caste," as Oliver Wendell Holmes called his own Anglo-Saxon Protestant gentry who greeted the newcomers cautiously at best.[9] Brahmin ambivalence toward all immigrants ran deep.

In their estimation, Germans fared better than Italians and others because they were Teutonic, Protestant (in part), and admired for their educational, musical and intellectual achievements. Germans were also fewer in number and dispersed, hence less visible, in contrast to other immigrants whose large, bounded neighborhoods proclaimed a vibrant ethnic distinctiveness. In the turn-of-the-twentieth-century urban development and sociological literature, Germans received remarks such as "the best type" of immigrant, "industrious folk" who make "good citizens," and people "conspicuous for their industry, thrift and frugality."[10] Nevertheless, like other immigrants and their children, Germans remained less upwardly mobile in occupation than native-born Yankees.[11] Over time, economic and political realities forced Boston's Brahmins to temper their culturally determined attitudes concerning their new neighbors, and in any event Boston was an immigrant city at the end of the nineteenth century in which the economic position of one's family was crucial in determining one's own.[12]

After 1850, German-owned breweries were built in Roxbury and Jamaica Plain. Boston was a land of opportunity for brewers, in part (and ironically) because it was one of the first hotbeds of temperance, causing many drinkers to switch from hard liquor to ale early in the nineteenth century. In 1860, twenty-two brewers vied for a brisk trade, with German brewers in the thick of the competition. German-Americans rapidly came to dominate lager brewing in America. They started with a ready-made ethnic-based market for their beer and, in the second half of the nineteenth century, steadily attracted many other Americans who preferred the lighter, sparkling taste of German-brewed lager to darker, flat ales. In Boston, the German lager industry was prosperous.[13]

It is therefore easy to understand why this city was an attractive prospect for a maltster, a brewer, and a cooper like Rudolf Haffenreffer. He went to work for George F. Burkhardt, a forty-eighter and, like Haffenreffer, an experienced brewer in the Old World. Burkhardt, one of the pioneer Roxbury-based brewers of lager, founded Burkhardt Brewing Company in 1850 and rose quickly to prominence. Haffenreffer was seemingly skilled not only in brewing but as a manager, his capacity for work was unlimited, and his faith in God boundless. Burkhardt quickly gave him responsibility and Haffenreffer's rise in the firm was rapid. In 1871, Haffenreffer formed his own brewing operation, Boylston Lager Beer Brewery, which became Haffenreffer and Company and was located in Jamaica Plain with other German-American breweries. That same year he and Katharine Burkhardt, who was a cousin of George Burkhardt, were married. He was twenty-four and she eighteen.[14]

EARLY YEARS IN BOSTON AND STUTTGART

Between 1872 and 1885, Katharine Haffenreffer gave birth to ten children, five of whom survived infancy: Rudolf, Alice, Theodore, Adolf, and Catherine. Rudolf, born on June 22, 1874, was the oldest surviving child.[15] Like many other German-Americans, Rudolf grew up in a bilingual, Lutheran, patriarchal household in which the values of hard work and strong faith were taught; unlike others, the house was located on brewery property and contained domestic servants. In their secure economic means and select education Rudolf and his brothers and sisters were separated from many other German immigrants. In language they were as well: the older generation and the domestic help favored the use of German, but Rudolf and his siblings used English; for them, being American meant being anglophone.[16]

Chauncy-Hall School

Searching for the roots of Rudolf Haffenreffer's collecting interests in his family and childhood experiences is a speculative exercise. The firmest conclusions can be drawn from the records of the school he attended, which allow one to trace the influence of literature and museums. Rudolf's father privileged education, and he sent Rudolf and his siblings to a private school called Chauncy Hall. Located west of Boston Common on Boylston Street, it started as a school for boys in the 1820s and soon had a solid reputation for rigor and inclusiveness. Its principal wrote that the school

wished to avoid appealing to specific class, sect, or nationality and to make "fairly good character… the only absolute requisition" for consideration for admittance. Determining character, however, often involved calculations on social position, skills, and economic standing; it could exclude, in other words. So could fees, which were $175 for Rudolf in his last year but could be "modified" for those unable to pay. German surnames like Arnim, Bienenstock, Clausen, Haffenreffer, and Stahl and other immigrant names as Aguero, Abbé, Aynela, Chevalier, Rosello, Rua, and Toricelli give the appearance of student ethnic diversity at Chauncy Hall, but Yankees easily overwhelm them: Abbot, Adams, Aldrich, Bacon, Bent, Bigelow, Blake, Brooks, Chapin, Coolidge, Davis, Endicott, Lawrence, Pratt, Putnam, Sargent, Shepard, Thayer, Walker, Whitney, Whipple, Winslow, etc.[17]

At the time Rudolf matriculated Chauncy Hall was regarded as the "most notable" or among the "best known" of Boston's private schools and advertised itself as offering "unusual advantage" to students heading for Massachusetts Institute of Technology or other colleges and as stressing the "punctuality and exactness" required for success in business. Indeed, its graduates did go on to MIT and Harvard and were successful in the business world.[18]

Rudolf entered Chauncy-Hall School in the fall of 1883 at age nine and left at age fifteen. In six years, he progressed steadily through the equivalent of tenth grade today, taking a rigorous course of study in mathematics, geography, grammar, literature, natural science, and other subjects. In natural science and natural history as well as in literature, there was an opportunity to learn something about American Indians. For natural science, Rudolf took zoology one year, botany and mineralogy the next, and physiology and physics in his last year.[19] Zoology classes were held at the Boston Society of Natural History, whose galleries and collections contained hundreds of thousands of natural history specimens, including objects collected by Meriwether Lewis and William Clark on their epic trip west in 1804–06.[20]

In his grammar and literature classes, Rudolf and other students read selections from the *Iliad* and *Odyssey,* Hawthorne's *Tanglewood Tales,* Thomas Hughes's *School Days at Rugby,* and from Scott, Dickens, and Washington Irving's *Sketch Book.* Optional readings included one of James Fenimore Cooper's works and Prescott's *Conquest of Mexico* or *Conquest of Peru.* If Rudolf read one of Cooper's Leatherstocking Tales or Prescott's narratives he was at the very least exposed to their ideas about American Indian culture and history. By the same token, he would have absorbed the excitement of one of the Wild West shows touring the east during this era or been interested in other area museums to which his parents might have taken him. With the latter we are on speculative ground, but for Chauncy Hall's curriculum we are far less so, and the works mentioned above were part of a rigorous course of study through which the school instilled in its students a curiosity about the world at large. Furthermore, it would not have been unusual for Chauncy Hall to remind students of the accomplishments of illustrious graduates, among whom were Horatio Hale and Francis Parkman, whose works were excellent examples, respectively, of the period's North American Indian ethnology and linguistics, and the history of Indian-White relations.[21]

Germany, 1888–90

In the fall of 1888, Rudolf's mother died; she was only 38, and Rudolf was fourteen. Three weeks later he and his father went to Stuttgart where Rudolf enrolled at the Institut Rauscher, a residential school for polytechnic instruction in chemistry and other subjects. He remained in Germany through the summer of 1890, during which time his father arranged a second marriage and Rudolf acquired a stepmother: Christine Marie Soldner, who came to America from Bavaria; she subsequently bore two children, August and Martha, Rudolf's half-siblings.[22]

Rudolf's father probably organized the details of his stay in Germany. Perhaps Rudolf did not graduate from Chauncy Hall because his path had been set to follow his father into brewing, and in Stuttgart one could combine polytechnic instruc-

Fig. 1-2
Rudolf Haffenreffer and a secretary in Old Colony Brewery, Fall River, mid-1890s. Mount Hope Farm.

countryside developed at that time.[23]

Rudolf's interest in collecting probably also began during this phase of his life, and so may have his curiosity about American Indian imagery. One of his Institut Rauscher friends mentioned obtaining and perhaps sending to him, as if in response to a stated desire, an American stamp with an Indian on it. In 1889–90, there were only two possibilities, both newspaper and periodical bulk shipment stamps: one, a 2-cent stamp, showed Thomas Crawford's *Freedom* (which draws on American Indian imagery and is atop the Capitol Dome); the other, a $60 stamp, depicts an "Indian Maiden" in a typical nineteenth-century genre pose and wooded setting.[24]

THE BREWERY IN FALL RIVER, MASSACHUSETTS

After he returned to America, Haffenreffer continued his technical education and may also have worked for his father in the brewery. In summers, Haffenreffer went to the United States Brewers' Academy in New York and in 1894 enrolled, as a member of the class of 1895, at Massachusetts Institute of Technology for course work in fermentation.[25] In 1895 Haffenreffer left Boston, perhaps in order to establish his independence from his father.[26] He was twenty-one years old. His father remained in Boston, moving eventually from Jamaica Plain to Roxbury, and died on March 9, 1929 at the age of 82.[27] Haffenreffer

tion with other reasons many German-Americans gave for their trips back to the Fatherland: to renew ties with relatives, and to re-absorb (or firmly instill) German culture, language, and *weltanschauung* (world view). Rudolf found himself immediately embedded in a network of maternal and paternal – and, after January 1890, stepmaternal – kin eager to celebrate holidays, mark birthdays, and have him visit during vacations from Institut Rauscher. Some of Rudolf's most pleasurable moments in Germany were hunting deer and rabbits and trout fishing with his mother's relatives in Unterreichenbach, his mother's natal village in the Schwarzwald (Black Forest) west of Stuttgart. It may well be that his life-long interest in the

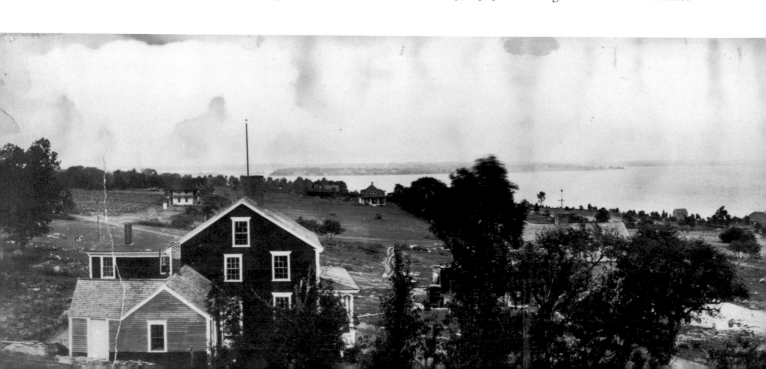

moved south of Boston to the city of Fall River, Massachusetts. In 1900, over 100,000 people, a mixture of Irish-American, French-Canadian, and other immigrants lived in Fall River and often worked in its cotton textile mills. The industry was in decline when Haffenreffer arrived, but Fall River's population represented a waiting market for German-brewed beer.[28] With financial backing from suppliers of brewing equipment and ingredients, Haffenreffer established Old Colony Brewing Company, which opened in 1896 and began producing lager, ale, porter, and malt extract in competition with four other breweries (fig. 1-2). For several years Haffenreffer lived on the premises of the brewery. Seven years later, Fall River's five breweries had become three, one of which was Old Colony, and by 1912, Haffenreffer and his partners controlled three Fall River breweries: Old Colony, King Philip, and Enterprise.[29]

After he moved to Fall River, Haffenreffer met L. Maude Monroe, a Bostonian of Scottish descent and five years his junior, who was marketing office supplies in the city. They married in January 1902 when Haffenreffer was twenty-six, and immediately began a family of their own: Rudolf Frederick 3rd, who was known as Pete, was born in the autumn of 1902 and Carl Wilhelm, known as Carl, in 1906.[30] The Haffenreffers quickly gained a reputation as "one of the best known and most important factors in the business parts" of Fall River.[31] Haffenreffer became active

in a number of arenas including efforts to improve the Fall River water system in which, as a brewer, he held natural interests. From 1914 to 1923, Haffenreffer was chairman of the Wattupa Water Board which extended water reservation properties in North Wattupa Pond to prevent pollution of Fall River's water supplies.[32] This involvement probably heightened his awareness of the existence of local Native people, since under the guise of assuring water quality, a number of measures had been taken several years before Haffenreffer became chairman. These included relocating Mrs. William Perry, the last Wampanoag Indian resident on the Fall River Indian Reservation, from the watershed.[33] It is conceivable that Haffenreffer first heard of the Perrys at this time; LeRoy Perry, whose words were quoted at the beginning of this essay and who later was employed by Haffenreffer, was born in Fall River.

THE RHODE ISLAND YEARS

In 1903 and 1912, Haffenreffer purchased contiguous properties in the small town of Bristol, Rhode Island, west and across Mount Hope Bay from Fall River. Bristol, a small town whose history was intimately linked with ships and the sea, was a homogeneous Yankee seaport in the seventeenth-

Fig. 1-3
Panorama from Mount Hope looking northward, with amusement park carousel on right and original building used to house artifacts in center foreground, and Mount Hope Bay beyond, 1903–06. Haffenreffer Museum of Anthropology.

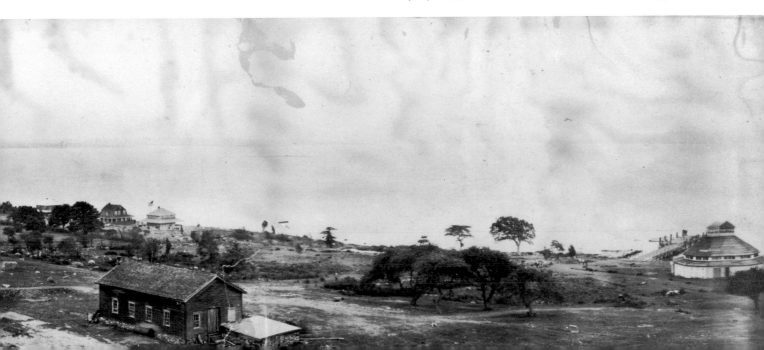

eighteenth centuries, and it remained predominantly a small ship-manufacturing Yankee village through the mid-nineteenth. At that point the town underwent an industrial transformation with textile and rubber goods manufacturing plants as well as a change in ethnic composition, since the new workers and residents were immigrant Portuguese and Italians. By 1900, one-half of Bristol's population was foreign-born, and many of its residents looked toward Providence for political, economic and social connections.[34]

After 1912, Haffenreffer's new lands (approximately five hundred acres in total) increasingly became the geographical and social focus of his life and of utmost significance in the development of the King Philip Museum. The property took its name from its most preeminent physical feature: Mount Hope, a granite gneiss and quartz outcrop that towered three hundred feet above sea level, providing a panoramic and unsurpassed view of Mount Hope Bay as well as the farmlands and woods surrounding it. Mount Hope also embraced sites where important seventeenth-century events relating to King Philip's War took place, and as a result was of central historic significance to the town of Bristol. In 1876, on the bicentenary of King Philip's death, the Rhode Island Historical Society erected two monuments in his memory. One was a boulder atop Mount Hope itself, the other a granite block near the spring where he died. Mount Hope was so pivotal to Bristol's identity that its image – a green mount beside the blue waters of Mount Hope Bay – was represented centrally on the town's coat of arms.[35]

This was now Haffenreffer's property. Its most distinguished residential structure from an architectural standpoint was usually linked with its most famous former owner: William Bradford, Deputy Governor of Rhode Island, United States Senator, and one-time host for George Washington. Bradford had purchased the property in 1783 from the State of Rhode Island, which had confiscated it from Isaac Royall, a Tory who fled to Nova Scotia.[36]

From the 1870s until after the turn-of-the-century, the northernmost 69 acres – the first of Haffenreffer's purchases – was an amusement park and summer resort and contained many houses and other buildings when Haffenreffer purchased it (fig. 1-3). Amusement parks flourished across America at that time, and in Rhode Island several coastal parks enticed urban-dwellers fleeing summer heat. In an era when people traveled regularly by water, Mount Hope Park attracted the public on excursions by steamboat, from Fall River, Bristol harbor, and elsewhere. Steamers disgorged passengers who then amused themselves on a carousel or baseball field or in a dance hall or bar. They took walks on trails and were offered clambakes in a dining hall seating one thousand and lodgings in cottages with fireplaces of white quartz. Mount Hope Park had been a failure before Haffenreffer purchased it in 1903, perhaps because of competition from other coastal parks, but he reopened it with clear intention to turn a profit.[37]

Haffenreffer's 1903 purchase of the Park was a business venture, but after he acquired the larger adjacent property in 1912, he consolidated the two tracts and immediately changed the location of his summer home from an island off Portsmouth to what was called the "King Philip House," located on the east slope of Mount Hope. This became the family's summer residence until Haffenreffer could restore the Bradford House which needed extensive renovations.[38] Winters were spent in Fall River until 1933, when the Haffenreffers – by then he was involved with Narragansett Brewing which was based in Cranston, Rhode Island – moved to Providence.[39] This seasonal movement to and fro was typical of other well-to-do residents of east coast cities, who wintered in their city residences and summered in inland rural, or seaside, communities.

Almost immediately following Haffenreffer's 1912 purchase, regrets were publically expressed that the State of Rhode Island had not bought the land when it was on the market. Over the next several years, various citizens organizations called for the State to appropriate the land. These were no doubt prompted by strong public sentiment about the beauty and historic value of Mount Hope. The head of a citizens' historical association named Mount Hope one of the "two points in

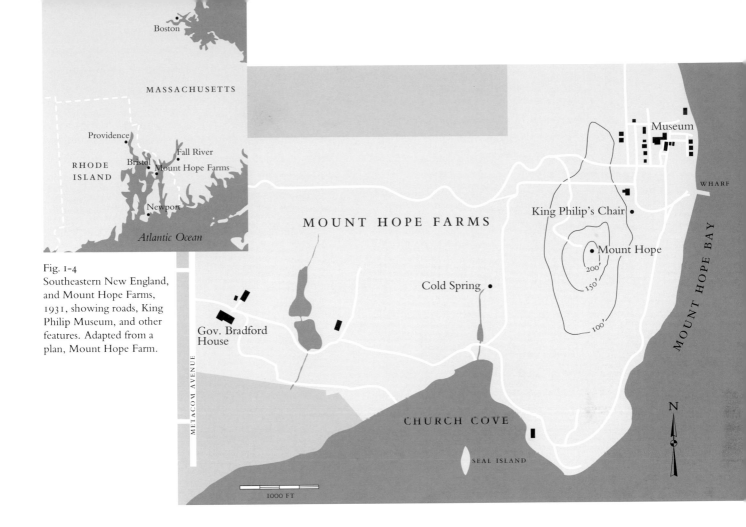

Fig. 1-4
Southeastern New England, and Mount Hope Farms, 1931, showing roads, King Philip Museum, and other features. Adapted from a plan, Mount Hope Farm.

Rhode Island that really have historic value," seeing in it "the only point of value in Indian history in New England." When he spoke of Mount Hope his imagery was Arcadian and sublime: "It is one of the most beautiful spots imaginable, having mountain scenery, uplands, crags, and cliffs, charming forests and all that go to make up an ideal spot for a public park. Here also are King Philip's Spring, and chair, and the swamp in which the wiley chief was killed Aug. 12, 1676." As a public park with two miles of shore front, this property would become, it was argued, a "great athletic field" for all New England and would enhance real estate values in Bristol.[40]

The effort to make Mount Hope Park public expanded. Somewhat surprisingly – he had just purchased the property – Haffenreffer was reported to be open to the idea of giving the State an option for a "reservation." Twice in the next three years, bond issues were attempted but failed for various reasons. One problem was that the value of Mount Hope Park had increased almost fourfold in four years.[41]

This surge in the property's value was due partly to improvements. The amusement park had been abandoned, and Mount Hope Park became the working core of "King Philip Farm," which was soon incorporated as Mount Hope Farms (figs. 1-4, 1-5). Cottages and other buildings, including the first structure that would house Haffenreffer's growing collection of artifacts, were put to use. Haffenreffer drilled an artesian well, built new roads, painted buildings, installed electricity, and changed a baseball field into three tennis courts. By 1921, a

two and one-half mile macadam road connected the Bradford house with the farm complex to the north and other parts of the property. In a setback that same year, a cow barn, a granary, and a creamery (in which the farm's mahogany-paneled business offices were located) burned to the ground. Nineteen cottages nearby were saved, as was a herd of fifty Guernsey cows, and new farm buildings were quickly built.[42]

The farm became an important setting for Haffenreffer's life. Called upon to list "Amusements" in his MIT 25th Reunion Class Book, he mentioned "farming and raising pure bred Guernsey cattle and horses." Another farm near Fall River was also important to him, as were New Hampshire and Massachusetts farms for his father. According to Carl Haffenreffer, both his father and grandfather were "ardent horsemen," and in Fall River his father "rode at a small farm he had outside of the city almost every day with Pete and me in tow often on Shetland and Welsh ponies;" unfortunately, in 1917 a horse reared and pinned Haffenreffer against a telephone pole, seriously injuring one leg which affected him the rest of his life (fig. 1-6).[43]

In Haffenreffer's day the rural life of the country gentleman held wide appeal, and country life and imagery were important to Haffenreffer's self-perception. He was attached to romantic and sublime images of landscape and painted small watercolors of German castles and landscapes. In purchasing a farm, Haffenreffer imitated his father but also recreated, wittingly or not, an American setting for experiences similar to the Schwarzwald

Fig. 1-5
Mount Hope Farms, ca. 1918. Mount Hope Farm.

Fig. 1-6
Rudolf Haffenreffer ca. 1915. Mount
Hope Farm.

ones he relished during his youth.

Haffenreffer lost no time integrating himself into his new community. Indeed, it seems that he was rapidly held in comfortable esteem, for in 1916 he was appointed Chief Marshall of the Fourth of July parade, Bristol's single most important annual event and one for which it gained renown far beyond the boundaries of the village. Haffenreffer's was a privileged position gained, perhaps, by his support of the Boy Scouts (as detailed below) as well as by his economic standing.[44]

His rapid ascendency to prominence occurred at the very moment when anti-German hysteria was on the rise across the nation. During World War I, the "bonds of loyalty" of Americans of German descent were tested throughout America. Anti-German sentiment was rife, especially where there were very recent German immigrants whose investments in German culture, language, and polity were considered potentially at odds with those of native born Americans.[45] Rhode Island was no exception to this; the editor of the *Providence Journal* was the source of what others have called the most outlandish, "pure and [unadulterated] fabrications" of German espionage, but nevertheless his words were reprinted widely. Bristol

reflected in microcosm the tensions across America: at least one German-American resident anglicized his name and another was arrested for prowling about Herreshoff Manufacturing Company, which was building boats under contract for the government.[46]

Haffenreffer was no stranger to personal expressions of anti-German-American sentiment but was not seriously affected by them in Bristol.[47] Like most German-Americans, he followed the War intently and with concern. In 1916 and 1917, Haffenreffer clipped from the *New Yorker Staats-Zeitung,* the leading German-American newspaper publishing in both German and English during the War years, columns written by Bernhard Ridder on neutrality and America's interests and on combating "foreign influence" in political life.[48]

While Haffenreffer kept a close eye on the War, he also attended to the business of business. In 1917, he expanded his holdings and simultaneously fulfilled a curiosity that may have developed as early as in geology and minerals classes at Chauncy Hall. That year he became president and managing director of the Utah-Apex Mining Company in Bingham Canyon, Utah and the Montezuma-Apex Mining Company in Placerville, California,

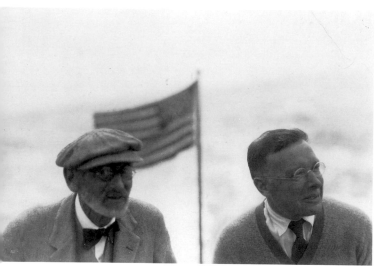

Fig. 1-7
Rudolf Haffenreffer and Nathanael Herreshoff watching cup race at Newport, 1925. Mount Hope Farm.

two tunnel mines producing lead and some silver.[49]

This was a significant step for his developing interest in American Indian artifacts, since for the next several decades Haffenreffer, often with his wife, traveled annually, usually in March and April, to inspect his mines in the far West where he remained for several weeks. En route, he stopped at Santa Fe, Tucson, Phoenix, and other places and sent "boxes, if not trunk loads, of his acquisitions back to Bristol." He even once visited Mexico.[50] These journeys west may have affected Haffenreffer's understanding of American Indian life, since in the West lived Indians whose entire appearance differed from what he knew in the East. It was not just that physiognomy differed; rather, in the West, the Indians made, carried in their hands or balanced on their heads, displayed on the ground around them, and dressed in what Haffenreffer and others wanted to collect. In the West, Indians more nearly corresponded to White expectations of "authenticity." Wild West shows, fairs, and pan-Indian organizations helped frame these expectations, but so did literature and visual print media. Haffenreffer no doubt encountered a variety of Indians on his trips West, but given his interests, Indians who were adept at taking advantage of the market he represented could not fail to impress him.[51]

Haffenreffer's other new business ventures were Rhode Island-based and increasingly expanded his circle of acquaintances and friends and brought him closer to the state's business and political leaders. The first of these ventures was the 1924 purchase at auction of Herreshoff Manufacturing Company, the famous designer and builder of yachts.[52] Herreshoff was synonymous with the America's Cup: from 1893 to 1920, their yachts beat British contenders consistently, never losing a match race. These Bristol-built boats brought that town cachet in the international yachting world, but in the mid-1920s, Herreshoff was in liquidation. Haffenreffer stepped in, and with his capital and management skills, he rescued Herreshoff, which quickly recovered its former luster and kept alive its streak of producing every Cup defender since 1893. Eventually it built the last of the syndicate-financed America's Cup defenders, but after producing minesweepers and other craft for the armed forces during World War II, Herreshoff closed its doors for good.[53]

Haffenreffer ensured that Herreshoff would keep Bristol at the center of the America's Cup for another two decades, but in public he never failed to downplay his own role. Previously, he had used his capital, drive, and business acumen to monopolize Fall River brewing and purchase mines. Now his circle expanded to include co-investors who moved in a New York-Newport axis, and he entered the yachting world at its most prestigious point – the America's Cup – at the instant when the races were shifted to the waters near Newport (fig. 1-7).[54]

It mattered little that Haffenreffer was not a sailor himself – he was rather "a power boat enthusiast (particularly fast ones)." What was important was his business acumen, which ensured that Herreshoff (and therefore Bristol) would continue to shine. In a short time, Haffenreffer was entertaining expansively in Bristol, especially during the 1930 Cup races, and though widely lauded, he demurred (so it was reported), saying simply that he was seeking to "carry on the work of that old master," Captain Nat Herreshoff, co-founder of the company and an MIT graduate.[55]

A second enterprise enhancing Haffenreffer's local visibility was running the Mount Hope

Bridge, which linked Bristol and Portsmouth and ended Bristol's isolated position at the bottom of Mount Hope Neck. Built in the late 1920s, the bridge opened for traffic four days before the Crash of October 1929 and the company that owned it defaulted within two years. The Superior Court appointed Haffenreffer receiver, and in 1932 he acquired the bridge at auction and ran the Mount Hope Bridge Corporation for over twenty years after Rhode Island voters defeated a proposal to buy it.[56]

Most of Haffenreffer's important real estate and business transactions in Bristol related in some way to how the town's residents conducted their lives and thought of their community. In purchasing Mount Hope, Haffenreffer acquired the very land that gave the Bristol region its identity, which accounts for community sentiment that emerged to obtain it for public domain. In buying Herreshoff and preserving its name, Haffenreffer enabled Bristol to continue its domination of the most prestigious race in the yachting world, which is not to be underestimated among people who drew historical associations from the sea. And in acquiring and making profitable the Mount Hope Bridge, Haffenreffer affected every resident of Bristol who wanted to drive south toward Portsmouth and Newport. Whether or not these moves were universally popular, one cannot deny that each took him into the thick of local politics. Rhode Island voters twice refused the opportunity to reverse Haffenreffer purchases – of Mount Hope and the Mount Hope Bridge. On its masthead, the *Bristol Phoenix* pictured three images: in the center was Mount Hope at the center of the town seal; on one side was a yacht under full sail (Herreshoff was the most noted boat builder); and on the other a factory which stood for "manufacturing," of which the town's two rubber companies were best known. Inasmuch as Bristolians derived their identity from these three icons, it is interesting to note that Haffenreffer owned two.

Haffenreffer remained a brewer to the end of his life. Near prohibition's end, Narragansett Brewing Company approached him to finance modernization of and manage its Cranston plant. Founded in 1890 by German-Americans, Narragansett was the largest brewery in New England by 1909 and maintained this position for decades. But profits lagged considerably following ratification of the eighteenth amendment in 1921, and Narragansett was in precarious financial condition by the end of prohibition twelve years later. Many other breweries, unable to adapt to near-beer and nonalcoholic products, failed. For decades Haffenreffer served as chairman of the board of Narragansett, the beer of Red Sox baseball and consumers across the nation, and ensured its position for a time in the top dozen breweries nationally.[57]

Rudolf Haffenreffer is remembered by some as a hard-working man with great drive and organizational ability who went to work with three brief cases: one for the brewery, one for the mines, and one for Herreshoff.[58] In politics his reputation was for independence, and indeed he described himself as a "mugwump" or fence-straddling independent.[59] People whose positions differed greatly relative to his, for whom he was father, grandfather, uncle, great-uncle, Mr. Haffenreffer, Mr. Haff, or Father Haff, remember him today in contrasting terms: stern, kind, hard-driving, warm and cordial, imposing, generous, controlling, quietly austere, entrepreneurial, and so on.[60] Haffenreffer's business accomplishments were obvious, especially at the helm of Narragansett. During his lifetime he also gained a reputation for devoting time and resources not only to various pursuits like the King Philip Museum but to the communities where he lived – for example, opening the Mount Hope beach when sewage forced a closing of the Bristol beach, and donating milk to needy Bristol families during the height of the Depression, an island he owned in the Sakonnet River to the Fall River Children's Home, and his Fall River residence to Union Hospital.[61] Throughout his life he contributed to community and philanthropic interests as an individual and through his Family Foundation, and many knew or suspected that he was behind anonymous donations.

During the last decade of his life, Haffenreffer was honored in a number of ways for his various contributions. He served as a member of the Cor-

poration of Massachusetts Institute of Technology. He was a director of charitable organizations, the head of a governor's commission on water quality and a member of other commissions, and he received the honorary degree of doctor of business administration from Providence College. Finally, his active involvement with the Boy Scouts for four decades culminated in the visits of thousands of Scouts to Mount Hope and the King Philip Museum. Rudolf Haffenreffer died in October 1954, several months after his 80th birthday.[62]

MOUNT HOPE: THE CATALYST

In considering the various immediate influences on the genesis of Rudolf Haffenreffer's interest in the American Indian, Mount Hope looms as very important. Shortly after he consolidated the two contiguous properties he had purchased in 1903 and 1912, Haffenreffer issued privately "Some Legends of Mount Hope," a booklet written by Wilfred Harold Munro, emeritus professor of European history at Brown University and long-time president of the Rhode Island Historical Society. Bound with beaded leather thongs and a cover depicting an Indian with a feather in his hair sitting before a Plains tepee on a wooded shore, this 61-page booklet contained chapters on the Norse, Massasoit and Edward Winslow, King Philip and Benjamin Church, and William Bradford and George Washington. It was illustrated with small engravings of Indians bonneted, feathered, armed, paddling a canoe, blanketed, or dancing. Any doubt about the centrality of Mount Hope and its owners to New England history was surely dispelled by this short book, which situated on that property significant events (and non-events) and important individuals over a 900-year period.[63]

The publication of this booklet reflected Haffenreffer's intellectual curiosity about New England history, especially the seventeenth-century wars and the region's indigenous inhabitants, and not necessarily a desire to associate himself with the former owners of that historic property. This was in contrast to how the public knew Haffenreffer at that time; for them, he was mainly "the Fall River brewer," who had made his mark at Old Colony,

King Philip, and Enterprise, and who had taken over the former amusement park. On the surface he was a hard-working businessman who knew how to attract capital and compete successfully.

By the time he published "Some Legends of Mount Hope," Haffenreffer had owned land in Bristol for over a decade, but the Mount for only several years. The purchase of the historic Mount seems to have been the catalyst for articulating an interest in history and American Indians, although history may have piqued Haffenreffer's curiosity long ago at Chauncy-Hall School. But once Mount Hope was his and he rode or drove around it, he could scarcely avoid either history or Indian America, since the Historical Society had canonized both with its monuments.[64]

This connection with seventeenth-century New England was of greatest importance. In the 1670s, King Philip, also known as Metacom, made his summer home at a Pokanoket village near Mount Hope (the Pokanoket, also known as the Wampanoag, lived south of the Massachusett and east of the Narragansett).[65] Mount Hope was one of several central locations for the Pokanoket and, because land heights were accorded symbolic value, a deeply meaningful site. It was also the location of King Philip's death in 1676. The events which preceded his demise near the close of King Philip's War were unleashed in the mid-1670s, but their roots lay deeper in the history of the colonial relationship between English settlers on the one hand and the Pokanoket, Narragansett, and other native people of southeastern Massachusetts and Rhode Island on the other. At the beginning of the century Indians had died in droves from introduced epidemic diseases, and as the century progressed, colonial-Indian relations were marked by mounting imbalance and frustration. Those Indians who remained steadily lost access to their traditional lands, because some among them signed away rights which in some instances were legitimately theirs and in other instances were not; because they relinquished lands in transactions whose implications for land-use they misunderstood; or because colonists and land speculators illegally appropriated their lands. They became

Fig. 1-8
Mount Hope Farms, ca. 1948. The King Philip Museum is
adjacent to barn at center, and Bristol is in the background.
Mount Hope Farm.

politically disempowered, and their societies were
internally riven. Their relations with Whites were
marked by frequent misunderstandings, and griev-
ances abounded. King Philip, a proud leader who
deeply resented how the English were treating
him and his people, rebelled. The frustration
among his people and their allies must have been
very widespread, for Philip almost succeeded. But
he was eventually caught and killed at Mount
Hope after months on the run, and in the manner
of the day his body was quartered, and his head
piked and displayed. His wife and children were
sold into slavery in the West Indies. King Philip's
War started near Mount Hope, and it ended at
Mount Hope.[66]

In Mount Hope, then, Haffenreffer acquired
ground recognized by all New Englanders as the site
of one of the most significant events of the seven-
teenth century. The land was especially hallowed
by the descendants of the seventeenth-century
Pokanoket (and Native people today consider the
Mount itself, a hollowed incline in its face known
as King Philip's Chair, and the spring where King
Philip died as symbolically charged, even sacred,
places).

The publication of "Some Legends of Mount
Hope" signaled Haffenreffer's awareness that these
important events unfolded on his property. The
publication also coincided with the early stages of
the formation of his collection of antiquities, folk
art, and other artifacts. No matter how altered by
human hand Mount Hope was, this site embodied
an essential history of Indian–White relations, and

its natural historical state, one might argue, represented Arcadia. Mount Hope had already been memorialized by the Rhode Island Historical Society, and as American Indians were increasingly seen as a part of history, as well as quintessentially in Nature, in a long intellectual tradition finding expression in text and imagery, a museum dedicated to the Native American might well have occurred to Haffenreffer as he spent greater amounts of time on this ground.

THE KING PHILIP MUSEUM

There is, in fact, evidence that Haffenreffer's interest in archaeological "relics" developed around the time he bought Mount Hope – that is to say, sometime between 1903 and 1912. After 1912, Mount Hope's status as farm and summer residence, analogous to an Arcadian estate or Adirondacks lodge, evolved quickly (fig. 1-8). Workmen undertaking renovations and construction were said to have "uncovered…curios" that interested Haffenreffer, and he "soon thereafter" purchased other objects to make "a representative collection," perhaps because he was "always interested in the American Indian." There were also many buildings on the site of the former amusement park, one of which might have been dedicated to collections and may have inspired Haffenreffer to become more systematic about collecting and housing the artifacts that became more numerous from the yearly trips west after 1917.[67]

According to his son, Rudolf Haffenreffer was an "accumulator," not a collector, who sometimes "sent his emissary" to purchase objects or tended himself to "buy the whole thing" believing that it was "less expensive to buy a collection at one fell swoop instead of item by item." The idea was to "accumulate to collect with the idea he would winnow out good from bad, wheat from chaff," but he "never really got around to it."[68] In 1931 – a good fifteen or twenty years after Haffenreffer first began to collect – one local reporter remarked that Haffenreffer was "inspired by a desire to learn more of the Indian's religious, tribal and other habits" and so "began the collection of objects which would interpret these things truthfully – for

he found the white man's history of the Indian scarcely unprejudiced." He continued, in words which ennobled a powerful man: "It has been with the purpose of inquisitiveness, rather than one of acquisitiveness," he wrote, that "the Rhode Islander has built up his collection. He is more interested in the interpretation that may be obtained from his relics than in their mere possession." It may have been for this reason that Haffenreffer was said to "[dislike] the term museum as not fitting his purpose in collecting the relics."[69]

These two ways of looking at Haffenreffer are not necessarily incompatible. There is truth in both: he did sometimes buy by lot, and he was indeed inspired to speak about American Indian culture and history. Throughout his adult life, Haffenreffer collected not just ethnographic and archaeological artifacts, but stamps, rare autographs, maps, rare books, antiques, carousel figures, and cigar-store Indians. He purchased in bulk – the furnishings of a church, cobblestones from a street, lamp posts from Newport – and some items he recycled in use at Mount Hope Farm.[70]

The first reference to the existence of a collection large enough to be housed in a separate building came in 1916, when the Rhode Island Field Naturalists visited Mount Hope where they "inspect[ed] the many objects of interest contained" in Haffenreffer's "museum."[71] That building was a modest single-story rectangular wooden and shingle-roofed building, and seems to have been as much a storage shed as a museum as it contained both archaeological artifacts and amusement-park carousel horses.[72] By 1923 – only two years after the destructive fire – the growing and "valuable collection of Indian relics," which included "10,000 arrowheads, stone axes, mortar and pestles, weapons and blankets…antique firearms and buffalo robes" had been moved to a "stone" building said to be fireproof. The new building is part of the Museum today, and from 1925–31, a porch was attached to its south-facing entrance (fig. 1-9). Haffenreffer marked this occasion with a talk to the Fall River Historical Society. It was his most significant speech on American Indians and is discussed below.[73]

Fig. 1-9
Rudolf Haffenreffer's museum, ca. 1923. Haffenreffer
Museum of Anthropology.

In 1925, the Museum, still nameless but linked
with Haffenreffer, received top billing in a news-
paper story on Rhode Island archaeological collec-
tions. It was said to have "many thousand speci-
mens from all parts of North America," including
"perhaps the largest collection of Indian imple-
ments in Rhode Island." No single account of the
Museum before this date contained such detail:
"The collection is in a separate fireproof building
which has become a museum of Indian imple-
ments and ornithological specimens. The walls are
literally covered with countless specimens on dis-
play boards, while larger objects, such as blankets,
pottery, moccasins and the like are piled upon
chairs and tables. A very beautiful bead jacket,
remarkably heavy, hangs on one of the chairs and
immediately attracts the attention of the visitor.
Rugs, books on Indians and various objects of

earthenware, leather and basketry make up the vast
collection." With archaeological, ethnographic,
and ornithological specimens, and tables and chairs,
the Museum resembled a private natural history
museum.[74]

The three years beginning in 1928 represented a
watershed period for the Museum (Gregg, Hail,
this volume). In 1928, Haffenreffer signaled a more
intense interest in acquisitions and in systematic
collections documentation, display, and use by hir-
ing Foster H. Saville, an archaeologist and long-
time member of the staff of the Museum of the
American Indian, Heye Foundation.[75] One imme-
diate result was a spurt in acquisitions, especially
archaeological objects from the Northeast; Haffen-
reffer may have purchased most objects in his col-
lections in these two years.

In 1929, Haffenreffer and others began calling
his Museum the King Philip Museum.[76] Its treat-
ment in local newspapers shifted perceptibly – that
was the year the prediction was made that it

would become a "mecca for students" – and the similarities between the accounts indicates either that reporters were drawing on each other or that the museum released photographs and information to different newspapers simultaneously. One report linked "the importance of preserving relics" with inevitable American Indian assimilation, and it seems clear that the Museum was undergoing construction as a musum of Indian history.[77] What was descriptively the "Haffenreffer Museum at Mount Hope" four years earlier had become a "Shrine of Indian Relics," a "Sanctuary for New England Indian Relics," a "Sanctuary for Indian History," a "Memorial to King Philip," and a "Shrine to King Philip." The King Philip Museum was born (fig. 1-10).

In 1929, the Museum contained archaeological and ethnographic materials from throughout North America (Gregg, Hail, this volume).[78] Haffenreffer showed a concern for documentation, research, and education, all of which may be attributed to Saville's perspective and advice. Artifacts were displayed densely, with stone tools on one shelf, baskets on another, and pots on a third, and the shelves were inclined forward "so a visitor a few feet away can see all without stooping." Some objects were in self-contained cases which could be picked up and moved and, presumably,

Fig. 1-10
"Mount Hope Shrine of Indian Relics," *Bristol Phoenix,* January 22, 1929. Haffenreffer Museum of Anthropology.

Has Finest Private Indian Museum

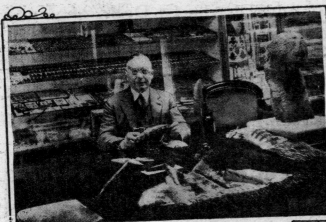

R. F. Haffenreffer in His New Museum

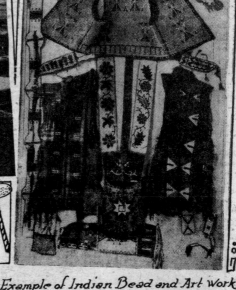

An Example of Indian Bead and Art Work

Bristol Collector Dedicates Memorial, Housing Relics of North and South America, to King Philip This Week

WITHIN an arrow's flight of the great stone seat on the face of Mount Hope where King Philip had his throne, there has been erected a memorial to the Wampanoag chieftain who in 1675 led his people against the whites in a vain effort to save America for his race. R. F. Haffenreffer of Bristol on Saturday will entertain the Rhode Island Historical Society in the newly completed wing of his museum, a massive, fireproof addition which dwarfs the original building, fine as it was. And within this wing he will show a collection now described by authorities as being the finest private accumulation of its kind in America. Devoted primarily to Rhode Island and its Indian tribes, the collection, built up through the past quarter century, contains many of the finest known examples of Indian civilization of North America and many parts of South America.

But transcending even this magnificent collection in human interest is the life story of King Philip—and of his red brethren throughout the country—as revealed by Mr. Haffenreffer.

The years of study, and the small fortune this Bristol man has devoted to the amassing of his unrivalled collection were not inspired by a love of accumulation.

Relics discovered many years ago while chairman of the Fall River water supply commission, stories heard while pursuing inquiries concerning them, and

creed by his father, but who found no justice for himself or his people among the white and, in desperation, without hope of real victory, turned against the white invaders and in one of the worst Indian wars of the East, led his allies to preordained defeat; was himself massacred, his wife and children sent into slavery and his people scattered.

Thus did the white man make return to Philip for corn which the father, Massasoit, had in kindness collected from his hungry people that the starving Pilgrims might survive a terrible winter.

It has been with the purpose of inquisitiveness, rather than one of acquisitiveness, that the Rhode Islander has built up his collection. He is more interested in the interpretation that may be obtained from his relics than in their mere possession.

No less an authority than George G. Heye of the North American Indian Museum of New York, who is considered the leader in Indian research, wrote into the visitors' book at Mount Hope:

"Of many private collections I have seen, this is by far the best. The people of Rhode Island are forever indebted to Mr. Haffenreffer for a shrine that for all time will mean much to the lover of the American Indian. What he has done to perpetuate the history of our aboriginals is great and wonderful."

Similar sentiments are inscribed in the register by scores of others.

◆ ◆ ◆

Attempting to describe the contents

Other photographs of the new Haffenreffer Museum are reproduced in today's Artgravure Section.

The building housing the collection—Mr. Haffenreffer dislikes the term museum as not fitting his purpose in collecting the relics—is a single-storied structure of steel, concrete and stucco, fire and burglar proof. Its treasures are arrayed on inclined trays within tightly sealed glass cases which surround the main room of the museum, which is 50x100 feet in dimensions.

A colorful, tiled floor, great mahogany tables and leather-covered chairs and divans supply a note of comfort.

One entire room is given over to a part of the collection of invaluable Indian ceremonial rugs and blankets. Another houses hundreds of exquisitely bound volumes, most of them relating to Indian lore.

Some of the most perfect examples of Indian bead work in existence are to be found in the cases in the main room.

The building itself has been constructed on a ledge of the hill from which the estate of Mount Hope, or Montop, as the Indians called it, takes its name. The reservation includes the historic "Cold Spring" and swamp which figured so tragically in King Philip's life and death, and contains over 500

On the estate is the Colonial home of William Bradford, first deputy governor of Rhode Island, and friend of Washington, and the old DeWolf homestead, both carefully preserved.

◆ ◆ ◆

Of the thousands of pieces in the museum, greatest local interest attaches, perhaps, to the historical material excavated from Burr's Hill in Warren, the last resting place of Massasoit. Here is provided a definite link with the days when the Pilgrims, struggling with the wilderness, were laying the foundations of New England.

In this collection is a large tripod kettle that was traded with the Indians. Apparently the aboriginal owner did not like the taste of food cooked in an iron vessel for he had lined it with pottery, much of which has now disappeared. There is also a copper necklace which early writers say Governor Winslow gave to Massasoit so the chief might have a token to send with his messengers to prove they came from him.

Mr. Haffenreffer's early collection included artifacts found at Fall River and at Mount Hope, added to by purchasing numerous local collections. This made a representative collection of historic stone implements. Of special interest among these is a steatite or soapstone vessel with annular base, shaped like a goblet, fine ceremonials, gouges, pestles, axes and celts, mostly from around Mount Hope.

Visits to the Southwest by Mr. Haffenreffer resulted in gathering fine Zuni

Fig. 1-11
"Has Finest Private Indian Museum," *Providence Journal Magazine*, October 11, 1931. Mount Hope Farm.

closely examined without damage to them. There was a new interest in organized and accessible information: objects were "numbered so that the student by referring to a card index in the same room can immediately get the history of each subject." Under Saville, Haffenreffer expanded his appreciation for legal possession of collections with affidavits "subscribed and sworn to by the original collectors" for each acquisition. Affidavits displayed next to artifacts provided context for collecting history and lent authenticity to the artifacts.[79]

From one standpoint, the King Philip Museum's typological exhibits reduced American Indians to taxonomy and artifacts – there were none of the "life groups" here that could be found at major anthropological museums. From another, they relegated Native people to an archaeological and ethnographic past. In this the Museum may have resembled other smaller and regional museums, but the American Indian past at the King Philip Museum was not exclusively pre-European; it was also the history of Indian-White relations in New England. As one account reported, American Indian artifacts were to be seen alongside maps, manuscripts, and other documents: "A large collection of historic documents, Indian deeds, sermons in Gay Head language, manuscripts in Indian tongues, yellow with age and closely connected with the pioneers of New England's old white families, is shown in special cases."[80] One reporter remarked on the didactic nature of the King Philip Museum: "Generations of white people have risen to give Philip the credit due him, and throughout the years to come thousands more will come here to Mount Hope, his last refuge, to pay him tribute and to study all that is left of his race, the crude stone implements and weapons they pathetically pitted against the powder and shot of the conquering whites."[81]

In 1931, a new fireproof wing that dwarfed the original building was completed. The dedication of this building, "a single-storied structure of steel, concrete and stucco, fire and burglar proof," was witnessed by the Rhode Island Historical Society, and was an apogean moment in the history of the Museum (fig. I-11). The descriptions of the interior on this occasion were almost lyrical. Inside this modern, secure building one's eyes were immediately drawn to a "colorful, tiled floor" and to "great mahogany tables and leather-covered chairs and divans." The Museum contained "several rooms...filled with thousands of catalogued exhibits, many of them priceless." In one room was "part of the collection of invaluable Indian ceremonial rugs and blankets...headdresses, saddle blankets, footwear and jewelry...[and] some of the most perfect examples of bead work in existence." These artifacts were "[skillfully and appropriately] displayed to relieve the expanses of dull gray stone," some arrayed as "treasures...on inclined trays within tightly sealed glass cases" that lined the walls of the main room. In another room were "hundreds of exquisitely bound volumes, most of them relating to Indian lore." A reporter concluded: "The place, despite the predominant note sounded by the stone utensils and weapons so common to the red man, is beautiful."[82]

After this the pace slowed. Saville no longer worked for Haffenreffer. Haffenreffer continued to add to the collection, and several people who worked for him in different capacities prepared labels for objects and typed correspondence,[83] but Haffenreffer's attentions were soon deflected by Narragansett Brewing, which presented important new challenges.

Significantly, Haffenreffer's interests in Native America also shifted away from Indian artifacts toward Indian imagery and he started to collect cigar-store Indians (fig. I-12). In one way this returned him to the "Indianer" stamp obtained in Stuttgart and was also reflected in his acquisition of E. S. Curtis orotones and a Cyrus E. Dallin sculpture, *Appeal to the Great Spirit*. Of all the objects he collected, the cigar-store Indians gained him the most national attention. Haffenreffer possessed other wood-sculpted figures, including Black Forest bears and coatracks, and carousel figures and ship figureheads. This wood-sculpting craft had deep roots in Germany and traveled across the Atlantic to America, where German-Americans were active carvers.[84]

However these ethnic considerations resonated

Fig. 1-12
Cigar-store Indian, unidentified sculptor,
19th century, wood, H 217 cm.
Haffenreffer Museum of Anthropology.

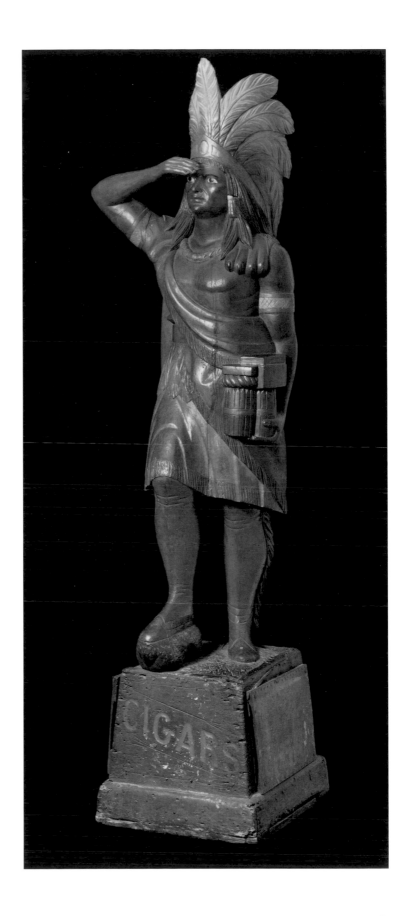

with Haffenreffer, there was a very practical side to his interest in cigar-store Indians: they were directly related to an opportunity to promote Narragansett, and a cartoon designed by Theodore Geisel (Dr. Seuss), a Dartmouth College acquaintance of his sons, soon appeared showing "Chief Gansett," an angular wooden Indian on a base with wheels, offering a frothy glass of "Gansett" beer (fig. I-13).[85] Haffenreffer sent agents to locate and purchase cigar-store Indians and trade signs and collected himself, bidding at auctions in Detroit and elsewhere. For him, collecting wooden Indians became one more "passionate hobby," and he eventually owned more than two hundred cigar-store Indians and trade signs.[86] He kept them in various places, including his office at Narragansett. In the King Philip Museum they came to dominate exhibition space in one room, and many who today remember the interior of the Museum in the 1940s recall cigar-store Indians most of all: rows of them, standing like they were "in bleachers, facing inwards" between whom one walked; "you felt," as one man remarked, "like you were in the middle of a tribe."[87]

The King Philip Museum was above all Haffenreffer's private space, where he might pursue a consuming avocation without distraction, or where he and his guests might retreat for cigars and wine. Haffenreffer spent a great deal of his time there on weekends, whether or not others joined him.[88] Native American artifacts, Indian images, Black Forest wooden bears to remind him of the Schwarzwald: all were there. The tile floor was utilitarian, and the large fireplace in one room was intended to be used. There were hundreds of books to be perused in comfortable sofas or at tables. This was not just a museum but a setting containing books, comfortable reading chairs, and ready access to a wine cellar and a humidor. It was men's space, fully analogous to the Victorian smoking room, and not a temple for art.

THE MUSEUM AND THE PUBLIC

Visitors could also arrange to come to the King Philip Museum, and Haffenreffer enjoyed showing the collection to his guests. The Museum was private, geographically isolated, and largely out of sight. It was located at the heart of the farm complex and reached by driving from the property's main entrance north along a winding two and one-half mile long road that skirted Mount Hope Bay; or by one of the more direct entrances to the farm buildings.

Like other private museums, access was determined by the owner. Members of the Haffenreffer family and their personal friends and guests gained entrance most often, but any individual or group could try to arrange in advance to see the collection. From 1929 to 1955, over six thousand visitors signed their names in a register kept at the Museum. They came an average of once or twice each month. The names of Haffenreffers of three generations appear often: Rudolf Haffenreffer himself; his wife; brothers and sisters and their spouses

Fig. I-13
"Your Gansett, Sir." Chief Gansett, by Dr. Seuss (Theodore Seuss Geisel), *Bristol Phoenix*, February 21, 1941. Roger Williams University.

and relatives; sons, daughters-in-law and other in-laws; nephews and nieces; and grandchildren and great-nephews and great-nieces. Members of the family remember today visiting the Museum as well as family gatherings or "roundups," which often included a visit to the Museum. Grandchildren recollect being with their grandfather when he went to the Museum on Sunday after lunch and remember helping to arrange artifacts.[89]

Many who came to the King Philip Museum were connected personally in some way with Rudolf Haffenreffer, his wife, their sons, or other members of the family: friends from Fall River, headmasters of boys' schools, sons' college roommates, Dartmouth administrators. Other visitors were linked in some fashion to Haffenreffer's business, philanthropic, or community concerns: a mine president, yachtsmen and boat designers, a church group, the trustees of the Museum of the American Indian, Heye Foundation.

More than one-third of visitors came to the Museum in a few large organized groups: Boy Scouts several times in numbers of over two hundred; Garden Club members several times in numbers over one hundred strong. Other groups were smaller and a Haffenreffer was often involved: a class from Moses Brown School in Providence or a scout troop, for example.

Three times, significant changes in the Museum's status were marked. The first was in 1923, when Haffenreffer spoke to the Fall River Historical Society after they had toured the Museum, which replaced the farm offices destroyed in the fire. The second occasion took place in January 1929, after Saville had been working for several months. Several "groups of scientists and archaeologists" and a local library's trustees visited and at that affair, Haffenreffer may have determined to make collections more "open to students of archaeology and Indian lore" than they had been.[90] The final event was in October 1931, when 125 members and guests of the Rhode Island Historical Society gathered to celebrate the new wing of the Museum "erected…as a memorial to King Philip."[91]

Other special events drew people to the King Philip Museum. In 1936, the year of Rhode Island's Tercentenary, hundreds of visitors toured Mount Hope's historic sites and came to the Museum, where a special exhibition of Governor Bradford memorabilia had been assembled: his family Bible, gold watch, medicine cabinet, a Queen Anne lowboy and other furniture, his ivory seal.[92] In 1946, the Yankee Network broadcast at the Museum a drama about Mary Rowlandson's capture by King Philip, and the host narrator concluded – perhaps mindful of Haffenreffer's attitudes – that contrary to the day's orthodoxy, King Philip should not be painted as a savage or assigned full responsibility for the events which led to the war that bore his name.[93]

THE BOY SCOUTS

Within a year of purchasing Mount Hope itself, Haffenreffer discovered that the newly organized Boy Scouts were interested in using the property for a summer camp. From that moment on his interests and those of the Scouts were often mutually supportive and in years ahead, scouts gained access to Mount Hope and the King Philip Museum more than any other public organization. One can readily comprehend why the Scouts were interested in Mount Hope Farm's wooded and bayside setting and the cleared spaces and buildings formerly used at the amusement park. As for why Haffenreffer would open Mount Hope to the public, the northernmost part had of course been open in its days as an amusement park and some arrangement may have been made at the time for patrons to tour the Rhode Island Historical Society monuments. Moreover, public desire for access to this historic property was strong, and his sons were active scouts. In making Mount Hope available, Haffenreffer immediately became a constructive member of his new community and, by linking himself with an organization whose goals were so openly patriotic, simultaneously underlined his identity as an American.[94]

Scouting began to take shape in America in 1910. The movement received ringing endorsements in Rhode Island, where troops quickly formed, and a summer camp was held the next year.[95] The first Bristol Troop formed in 1912 and

soon joined the Rhode Island Boy Scouts (RIBS). For the first several years, Rhode Island camps were located at sites where the facilities and water were both somewhat problematic. One was Mount Hope, in which the Scouts were interested as early as January 1913 when the Bristol Troop hiked to Mount Hope where they "cooked their dinner in real Indian style," using forked green branches for frying pans for meat and bread toasters, and eating in front of two roaring wood fires. That summer, Haffenreffer offered Mount Hope to scouts for their summer encampments, and in June, Haffenreffer and George Flynn showed twenty-five Scoutmasters and their assistants around the grounds and offered another "real Indian style" dinner. The Scoutmasters liked what they discovered, and after Haffenreffer drilled an artesian well and a wireless was erected on Mount Hope, King Philip Camp was ready. For ten weeks that summer, troops from Providence, East Providence, and Bristol visited in succession, and the site was called "the best location that could be found in the state."[96]

In 1914, several troops came simultaneously for week-long summer camps at Mount Hope, overseen by a Chief Scout identified in name with King Philip.[97] The next year, King Philip Camp was designated as the official RIBS camp, and over one thousand scouts were expected over a seven-week period. In July, scouts came to Haffenreffer's summer residence where his sons, who were thirteen and nine at the time, presented prizes to contest winners.[98]

Some years later, the *Bristol Phoenix* – hardly an unbiased source – called Bristol's own King Philip Camp "the State's outstanding camp." Yet in 1916, the Scouts left Mount Hope. Two apparent problems with Mount Hope and other early sites were "limited water-supply and facilities." Moreover, as RIBS became better organized, with a firmer sense of its own identity as a formal organization, it sought its own assets including campsites. In 1916, after investigating various sites fronting on lakes, the Scouts settled on Yawgoog Pond, located in southwestern Rhode Island. This 130-acre site had better woods and safer waters for a variety of scouting activities and offered long-term

control and financial security. To this day it has remained the RIBS summer headquarters.[99]

In 1920, the Bristol troops started Camp Takarest on Mount Hope Bay north of Haffenreffer's property, and formed an honorary society called the "Braves of King Philip." Midway through the decade, Bristol's troops used Camp Takarest for weekend outings, sharing the site with Camp Fire Girls and Girl Scouts. The use of Mount Hope was limited to events like a hike to the Mount hosted by Haffenreffer during Boy Scout Week in February 1924, followed by a ceremony at one of the Rhode Island Historical Society monuments to King Philip.[100]

Scouting in Rhode Island during these initial decades stressed military drill and competitive activities like life-saving and other swimming events, and to a lesser degree woodcraft and tracking. Discipline, attendance, competitiveness, and responsibility were constant reminders of how to build character. Haffenreffer and other visitors to King Philip Camp watched dress parade, relay races, baseball, and a drum and bugle corps. Scouts marched about in formation and engaged in competitive events like gymnastics, building a bridge of birch poles, flag signaling, tent pitching, human pyramids, and Indian club swinging. In summer camp, tracking and woodcraft were offered. Occasionally, troops set off to hike Mount Washington in New Hampshire. In 1924, awards were given for development of morale, physical activity, and scoutcraft; one award included membership in the "Wincheek Indians."[101]

These early years witnessed an emergent though uneven coincidence of American Indian imagery and woodcraft with scouting, which made Haffenreffer's collection of American Indian artifacts at Mount Hope timely. Two men were principally responsible for the presence of Indian imagery and activities in scouting when it got underway in America: Ernest Thompson Seton and Charles A. Eastman. Seton, Chief Scout in 1910, played the larger role, but the impact of Eastman, also known as Ohiyesa, should not be underestimated.[102] Seton's main contribution was to promote "Woodcraft, the oldest of all sciences and one of the

best," in a series of articles published in 1902–03 in the *Ladies Home Journal,* which had a vast circulation. Then he incorporated his ideas in the *Official Handbook for Boys* (the first Boy Scouts of America scout manual), which contained sections he wrote on woodlore, animals, trees, mushrooms, tracking and signalling, and games.[103] Seton's progressive-era version of the practical and skilled Indian and Eastman's idealized stories of his youth and Indian customs complemented each other well, and both were in great popularity in the teens and twenties. Both Eastman and Seton came to Rhode Island or southeastern Massachusetts – in 1911, Eastman spoke to a large audience in Fall River – and scout leaders in Rhode Island knew Seton's work well.[104] Rhode Island scouts knew not only of Eastman but of other Indians on tour like Chief Rain-in-the-Face, an Oklahoma Sioux who came to Bristol for the 1916 Fourth of July parade and spoke about Indians to local scouts; and Chief Bluesky, a Cherokee, who performed several years later in full regalia for Bristol-area and other scouts "in various imitations of the birds and animals and the dances and ancient customs of the real American Indian."[105]

The impact on Rhode Island scouting of these books and national tours developed gradually in the teens and twenties. In 1927, the interest in Indian America picked up as Providence-area scouts "'Turn[ed] Indian' for Winter Camping" (a headline stated) and lived for four days in January in two canvas-covered tepees. Their goal was evidently to convince people "that they could take care of themselves in the open at any season after the manner and customs of the original Americans."[106] Three years later, Plains Indians continued to come to Rhode Island on educational tours, "the study of the customs, dances and ceremonials and handicraft of the American Indian" had surged in popularity, and any RIBS troop which could not "boast of at least one member...trained in Indian lore" was regarded as "unfortunate." At the time, RIBS was sponsoring an "Indiancraft Leaders' Club" to train scout leaders.[107]

Given the new prominence of the King Philip Museum, these trends played to Haffenreffer's

strengths, for he also was interested in promoting American Indian customs in scouting. He was clearly not alone and although like others he advocated the image and the material culture of Indians from the Plains, he was unusual in also pushing an agenda that focused on the history of local American Indians.

Haffenreffer's impact was dependent on scouts' use of the Museum and Mount Hope, a healthy Camp Takarest, and the extent to which he was willing to commit resources. He always seemed to make Mount Hope and the King Philip Museum available to scouts. In October 1936, five hundred scouts assembled at Mount Hope and visited the Museum. That month, all members of RIBS "were mobilized...in a unique campaign of friendship for the Wampanoag Indians," a powerful expression of symbolic association between RIBS and local Native people. Haffenreffer took advantage of this occasion by announcing that he would sponsor a contest and award prizes – which became known as the Rudolf Frederick Haffenreffer Awards – for the three best essays on the Wampanoag written by scouts. First prize was "a solid gold medal" and "a selection from Mr. Haffenreffer's collection of Indian relics which it is hoped, will be the start of a collection of [a scout's] own, if not a prized addition to one already started" (fig. 1-14). Rhode

Fig. 1-14
Rudolf Frederick Haffenreffer Award. Designed by Cyrus E. Dallin. In the 1937 contest for the best Boy Scout essays on the Wampanoag, Keith Wilbur won this second prize. Courtesy of Keith Wilbur.

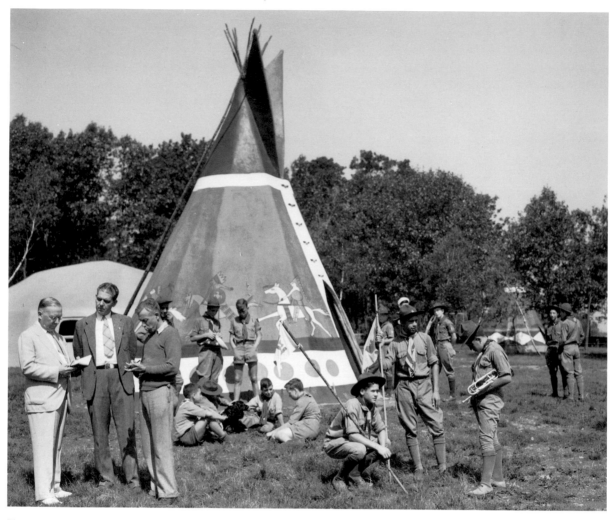

Fig. 1-15
Rudolf Haffenreffer and John Haley, far left, and scouts
in front of Camp King Philip's cement tepees, ca. 1940.
Haffenreffer Museum of Anthropology.

Island's scouts received a rule book on essay length and thirteen permissible subjects, all on Wampanoag culture and history, including "the origin of the tribe; the principal sachems of the Wampanoags – Massasoit, Alexander, and King Philip; the relationship of the Wampanoags with the New England tribes; their weapons, utensils, and systems of warfare; the military history of King Philip's War; and the origin of the name, 'Mount Hope' and its close relationship with the history of the Wampanoags." The following September, seventy-five people gathered in the Museum where the awards were presented and Cyrus Dallin spoke on his experiences with American Indians.[108]

Camp Takarest was also important to Haffenreffer's success, but by 1936 this Camp was beset by financial problems, unsafe buildings, and obsolete equipment, and would have closed had Haffenreffer not intervened. He decided not merely to fund it through the season but to help transform its modest facilities – two large "long-houses," a reroofed and refurbished recreation building that had fallen into disrepair, and a large fly tent serving as kitchen and dining hall – "into an Indian Village." Evidently both he and the Scouts were interested in that transformation. The *Bristol Phoenix* editorialized that Haffenreffer's actions were as "fine an example of public spirit at its best" as could be had, and that this was merely the latest of

"many" instances when Haffenreffer "has answered the call of 'Help,' " although few of those instances, it was remarked, "[had come] before the public eye."[109]

With the support of Haffenreffer, who paid for all materials, and the Works Project Administration, Camp Takarest was reconstructed. It also changed its name, first to Camp Wampanoag and then to Camp King Philip. Haffenreffer sent Federal Art Project artists to the American Museum of Natural History in New York in order to copy Arapahoe tepee designs which they subsequently painted on cement tepees, which were constructed in addition to a concrete roundhouse and other structures (fig. 1-15). In 1939, one thousand people attended the dedication of Camp King Philip. When he spoke, Haffenreffer, who was presented with an inscribed deerskin and extolled for having done much to make the camp become "so closely identified with the Indian history of this section of New England," emphasized that "when I began collecting Indian relics it was my hope that I might pass on to others the many interesting facts about a powerful and honorable race."[110]

In addition to sponsoring essays and encouraging boys to start their own collections, Haffenreffer urged scouts to undertake archaeological investigations, and he provided funds for Indian costume-making.[111] The Museum was a means to both ends. Haffenreffer gave away artifacts, wanting the recipients "to get to know the first owners" of Mount Hope and thinking that they "will find a fascinating hobby in making collections of their own of the traces which the Indians have left of their life in this country." His sponsorship of "Indiancraft," especially the making of clothing, also furthered his aims; in the mid-1940s he gave prizes for the best Indian clothing and underwrote the cost of courses to "[perpetuate the] knowledge of Indian lore, customs, and costumes" in which students were expected to make their own garments.[112]

Haffenreffer's educational intentions were clear when he spoke to medal winners in the 1937 essay contest: "The strange customs and ceremonies [of American Indians] and their inner meanings [are] largely hidden from the observer. I wanted to clothe this collection with flesh and blood. The American Indian had perfect equilibrium and absolute poise in body, mind and spirit. The simplicity and the uprightness of the Indian should appeal to the American of today." But Haffenreffer had also embraced the larger goals of scouting, for just months later he spoke of Boy Scouts becoming "America's greatest hope, her greatest safeguard against radicalism, disloyalty, immorality, un-Americanism, crime, and all vicious and undermining disbeliefs in God, man, and country."[113]

In the 1940s, scouts continued to come to Mount Hope. Haffenreffer sponsored three three-day powwows or camporees at Mount Hope. The first was in 1941, when one thousand scouts assembled, and the last two were in 1946 and 1947 (none was held during the War), when twenty-five hundred to three thousand boys from Rhode Island and nearby Massachusetts registered for each three-day powwow, camped on Mount Hope, visited the historic sites, and were shown the King Philip Museum. In 1946, torrential rains, which are remembered to this day, drowned out a planned "Indian pageant" and mired everything. But the next year, scouts gathered in "an amphitheater for Indian dances and other shenanigans" and witnessed "an Indian pageant" at which one hundred costumed scouts danced under the direction of "Chief Trailmaker," Charles Harrington. Newport-area scouts presented Haffenreffer with a totem pole they had made, and he gave all scouts souvenirs: the first year, a metal neckerchief slide; and the second, a pocket medallion on which appeared two Indians and the legend, "Narragansett Pow Wow, Bristol, R.I., 1947."[114]

But the strain on resources at Mount Hope was too great, and in the 1950s, the Scouts went to Quonset and other parts of the State for powwows. Haffenreffer was nearing the end of active involvement with an organization that had meant a great deal to him. He had been singled out for his contributions on a number of occasions since 1912 and had served as a member of the Board of Directors of the Narragansett Council, Boy Scouts of America. By the end of his life he had dedicated over forty years to the Scouts.[115]

Fig. 1-16
Untitled painting, T. H. Matteson, 1850s, oil on canvas, 75 x 62 cm. Haffenreffer Museum of Anthropology.

RUDOLF HAFFENREFFER'S THOUGHTS ABOUT THE AMERICAN INDIAN

One of the most important questions to ask of a museum founder like Rudolf Haffenreffer, and often one of the most difficult to answer, is what he or she thought about the indigenous people whose artifacts were in the collections. Insight comes from the collections themselves and their records, as well as from Native people today, and is discussed by others at length (Gregg, Hail, McMullen, this volume).

There are other, hidden sources of insight, including museum architecture and interior space, literary works, the company a founder kept, and writings he or she may have left behind. The King Philip Museum had evolved through several stages into a low concrete building whose exterior was unimposing, blocklike, and rather bland in appear-ance with the exception of four Doric columns that supported the roof of the front porch that existed in the twenties and set the Museum apart architecturally from surrounding barns and other buildings. Inside, the Museum was gradually transformed by built-in mahogany cases made at the Herreshoff Boat Yard, a commanding stone fireplace in one room, and furnishings which included a sofa and various bookcases and tables. The furniture was heavy, American-made and contemporary in a variety of styles, with accessories like carved wooden bears and a coatrack in the German and Swiss rustic Black Forest style. Sculptures and paintings were romantic visions of a lost past: an oil painting of a young Indian man and woman in a sylvan setting by T. K. Matteson (fig. 1-16); Dallin's *Appeal to the Great Spirit* (fig. 1-17); a number of Edward Sherriff Curtis's orotones; and vari-

ous small sculptures. As described above, artifacts were displayed densely, points on boards and, with other lithics, behind glass on shelves where they joined ethnographic objects of various kinds. In the 1940s, cigar-store Indians and other smoke-shop signs dominated free-standing space in at least one of the Museum's rooms, and in the minds of some visitors overwhelmed archaeological and ethnographic artifacts.

The bookcases and book cabinets located in both main rooms of the Museum eventually contained over six hundred books, journals, and pamphlets.[116] The overwhelming number were concerned with North American Indian ethnology, archaeology, material culture, and history. In literally dozens of works published by the Smithsonian Institution's Bureau of American Ethnology, the American Museum of Natural History, the Museum of the American Indian, and Canadian federal departments, Haffenreffer had at his disposal the fundamental writings by anthropologists of his generation. Archaeology was a general interest, and the archaeology (and geology) of New England was a specific strength. Another focus was research directly related to the collection: works on Navajo blankets, Iroquois masks, pottery from Santo Domingo and other Pueblos, Northwest Coast totem poles, and dozens of works on shell mounds and archaeology. Complementing these were treatises of a historical nature: exploration and frontier narratives, reports on United States and Mexican boundary surveys and railroad surveys. The library had great depth in the history of New England, especially of seventeenth-century Indian-White relations. Haffenreffer collected many of the primary sources published from the seventeenth through the nineteenth century for the historiography of Indian-White relations in New England, and they were all here.

Haffenreffer possessed, in addition, principal texts by many whose sympathies clearly lay with Indians in the tortured history of Indian-White relations. These include Thomas L. McKenney and James Hall's *History of the Indian Tribes of North America* and works by Helen Hunt Jackson, Hamlin Garland, and Warren K. Moorehead, among others,

which defined the reform movement. He also possessed more poetic, but nevertheless deeply influential, works in scouting and other areas, like Charles Eastman's *The Soul of the Indian* and Ernest Thompson Seton's *The Gospel of the Red Man.*

Haffenreffer's contacts with collectors, academics, and artists whose lives revolved around Native America were limited. During the course of his life, he met men and women who left their salutations in books they had written, including Mary E. Laing and William Brooks Cabot, or who, like Dallin, sculpted or painted Indians. He exchanged extensive correspondence with Warren Moorehead, the archaeologist and reformer, but their relationship was vexed by Haffenreffer's attempted purchase of the coveted King Philip's Club (Hail, this volume). Mary Wheelright, who wintered in Santa Fe and summered in Maine, visited the King Philip Museum once. In the museum world, Haffenreffer's closest relationship was with George Heye; they were eventually on a familiar first name basis

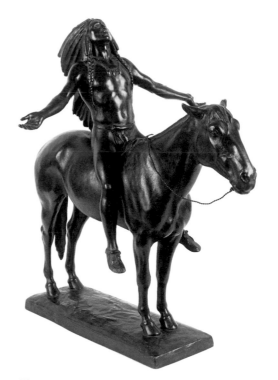

Fig. 1-17
Appeal to the Great Spirit, Cyrus E. Dallin, 1913, bronze, H 55 cm. Haffenreffer Museum of Anthropology.

and saw each other socially with their wives at least once.

The inferences concerning Haffenreffer's attitudes about Native people that can be drawn from these relationships, books, and Museum architecture are unhappily limited and conjectural. Haffenreffer spent little time with Native people despite his involvement in the National Algonquin Indian Council, which reached its peak of influence in the 1920s (McMullen, this volume). His participation in that local pan-Indian organization and other evidence suggests that he developed his own thoughts concerning Native people independent of Heye and Moorehead.[117]

If there were not additional information, any further conclusions would probably be very unsatisfactory. Fortunately, there is more. In 1931, Haffenreffer made remarks to the Rhode Island Historical Society when the new wing of the Museum was dedicated, and newspapers duly summarized his comments, which appear to have emphasized that Indians "were nearer God-like than the civilized people before 'they were contaminated by the white man's ways,'" that Indians "were not savages but were reduced to savagery by the white men," and that "lessons learned from the Indians will be of much value to present civilization."[118]

These thoughts are intriguing, but they are largely a reporter's paraphrasing of Haffenreffer's words – and woefully brief. Nevertheless, the remarks suggest that Haffenreffer held sentiments concerning Indians and Indian-White history which were romantic, revisionist, and in part reformist. Although there is no reason to suspect that the reporter was writing something other than what he thought he heard, Haffenreffer's remarks delivered in 1931 are in fact clearly related to his most revealing, and only fully recorded, talk about New England Native people and history: a speech to the Fall River Historical Society (joined by members of the Providence and Bristol societies) in 1923. This event was reported in Providence, Bristol, and Fall River newspapers. The speech was published fully in the *Fall River Evening Herald* as well as the *Proceedings of the Fall River Historical*

Society (fig. 1-18).[119]

The speech traced the seventeenth-century history of relations between the Indians and the English in Massachusetts and Rhode Island. Beginning with the Pokanoket or Wampanoag and their sachems – Massasoit and his son, Metacom or King Philip – Haffenreffer mentioned in his remarks the devastating impact of disease, the political aggression of the Narragansett, and the alliances sought by the Pokanoket in a rapidly changing landscape. Some of Haffenreffer's comments constituted a Pokanoket-centered version of history in which, in the changing relations between the Narragansett and Pokanoket during the seventeenth century, Massasoit was "humbled" in a "galling" ceremony by hegemonic Narragansett leaders who had looked "covetously" on Pokanoket lands. Though weaker in arms and men than the Narragansett, Massasoit possessed "far-sighted vision" while his enemies, in contrast, were pictured as aggressive imperialists.

Shifting to Pokanoket-English relations, Haffenreffer depicted Massasoit as faithful in upholding his end of a treaty of alliance and as "justified" when he thought ill of the whites. Haffenreffer reserved his most pointed irony for the English, who came off poorly. The displayed head of a decapitated Massachusett sachem was "testimony of the Christianity, civilization and humanity of the Pilgrims." The execution by the English of a captive Narragansett, a former ally, was "the reward he received for assisting the English" in earlier days. "Inhumanity charged against the Indians," Haffenreffer emphasized, "was practiced by their white associates." In fact, in commenting on the Pequot War of 1637, Haffenreffer found it "scarcely...possible to picture a more disgraceful and wanton act of destruction, a slaughter of innocents," than an incident in which English were reported to kill defenseless, unarmed women and children.

Haffenreffer built up to the war led by King Philip against the English and his death at Mount Hope. It is clear that Haffenreffer's sympathies lay with Philip and his people. "No independent sovereign with any self-respect," Haffenreffer said,

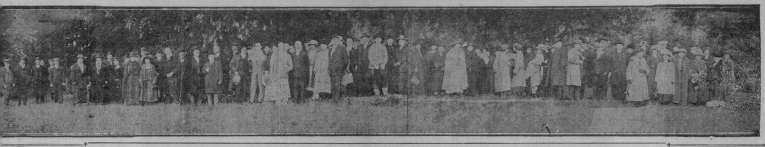

Fig. 1-18
"Story of the Indians Who Lived Here," *Fall River Evening Herald,* September 17, 1923. Mount Hope Farm.

"could be expected to submit" to what Philip's older brother, Alexander, had been asked to by the Plymouth authorities. As for Philip himself, who "grieved to make war on his personal friends," conflict – his eponymous War – was inevitable. There was no other way to "check this vast stream of white men" which flooded and isolated the "ethnological islands" which were his and other Indians' communities.

Haffenreffer also argued that the Indian was born "where everything in nature was dignified and sublime." His speech ended with the "unburied Philip," who "gave his life, his wife, his son, all he had to give, to save his native land – his fellow countrymen. He lost, and now Mount Hope, lifting its lofty head, stands in beautiful solitary loneliness, eternally his mausoleum."[120]

This speech placed Haffenreffer squarely in sympathy with romantic readings of the past which thrived in particular genres like poetry and appeared occasionally in the writings of scholars looking at the distant events of two centuries ago in New England. The sentiments were even reminiscent of Washington Irving's "Philip of Pokanoket." Munro had excerpted this particular essay in "Some Legends of Mount Hope," published by Haffenreffer several years before, and it appeared in Irving's *Sketch-Book,* which was a key text at Chauncy Hall when Haffenreffer was a student. The speech also allied Haffenreffer with reformers of the day. At one point he invoked Helen Hunt Jackson's *Century of Dishonor,* published some decades earlier, which was a critical text for many

who sought a corrective to Manifest Destiny versions of history that painted the Indian as a savage without discernible rights who impeded the progress of civilized people with law, reason, and ethics on their side. Haffenreffer's remarks separated him from those local historians who continued to extol the English as conquerers of King Philip.[121]

When he spoke, Haffenreffer cautioned his audience that he stood before them with "trepidation," because "I realize that, in the comparisons that I am to draw, the English settlers, the ancestors of many of you, will stand in a rather unfavorable light as regards their treatment of the Indians, and will present a rather sorry picture when contrasted with the savage red man." Those words never made it into print, which is just one of the ways that Haffenreffer's published speech departed from its spoken version. Another passage which was excised (by whom we do not know) remarked on the breaches of faith Haffenreffer thought marked Puritan actions. He called the English "opportunists, with a warped sense of humor, unbound by their obligations" and as presenting "a foul picture of hypocritical morality."[122]

From phrases like these, which were undoubtedly his voice, one gets the sense that this speech may above all have been about ethnic intolerance, and it may not be coincidental that Haffenreffer spoke as he did during an era when the German ancestry of German-Americans was periodically called to question. Compared with Yankees who were his neighbors and whom he pointedly addressed in his audience, Haffenreffer was far more likely to have been aware of the problems faced in America by what were then widely known as "hyphenated" Americans (like Irish-Americans and German-Americans), which they shared with minorities like Native Americans, and he was also far more likely to have been sensitive to different readings of history (fig. 1-19).

Rudolf Haffenreffer's speech to the Fall River Historical Society, the King Philip Museum and its collections, and his work with the Boy Scouts constitute part of his legacy. That Haffenreffer was interested in the fate of the thoughts he expressed in that address can be inferred from his later decision to dedicate a museum to King Philip and his sponsorship of essays on Wampanoag history among the Boy Scouts. He was also concerned about how local American Indians would react to his remarks. In 1925, he read a feature article in the *Boston Sunday Post* about Emma Safford, an elderly descendant of the Pokanoket sachem, Massasoit, and sister of Melinda and Charlotte Mitchell whom he had met over a decade earlier. In his address to the Fall River Historical Society, Haffenreffer remembered that meeting with the Mitchells. Their perception of their own past, he said, as well as the "unjust" words he had read about that past, led to a "combative yearning...to defend the Indian cause." Haffenreffer invited Emma Safford or "any of your descendents" to visit Mount Hope at any time, and he sent her a copy of the address, hoping, as his final thought, "that you will approve of my remarks."[123]

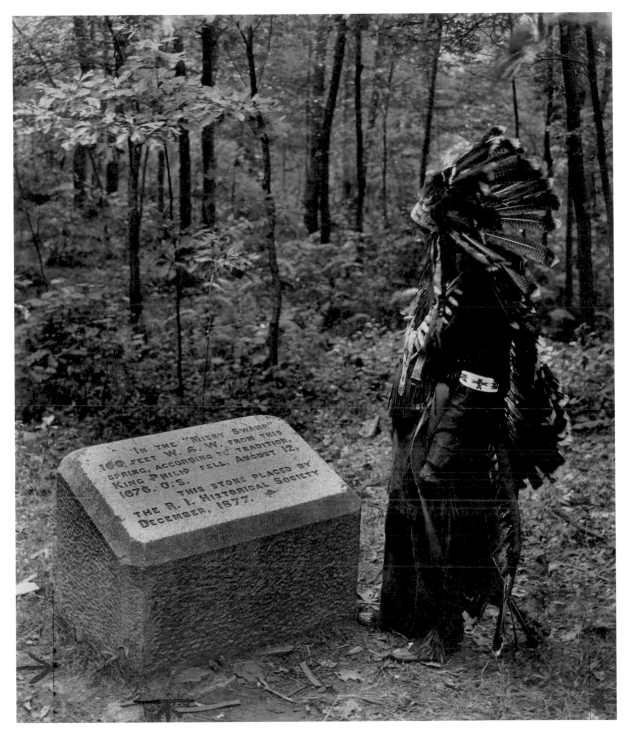

Fig. 1-19
LeRoy Perry (Ousa Mekin) examining Rhode Island Historical
Society monument at Cold Spring, Mount Hope, near site of
King Philip's death, ca. 1931. Mount Hope Farm.

ACKNOWLEDGEMENTS

This essay could not have been written without the support of many individuals and institutions. I wish first to acknowledge the warm encouragement and full cooperation received from many members of the Haffenreffer family, especially Carl W. Haffenreffer, Rudolf F. Haffenreffer IV, David Haffenreffer, Theodore C. Haffenreffer, Jr., and Harriet Haffenreffer Shields, to whom collectively I turned often for advice; their many specific contributions are recognized throughout the notes.

Several historians, anthropologists, and writers generously shared their insights on nineteenth-century American intellectual, social, and cultural history, Americans of German descent, immigration and ethnicity, Native people of New England, brewing in America, and the Providence community (or they pointed me toward the people who did), among them Will Anderson, Kathleen Bragdon, Charles Cheape, Kathleen Conzen, John Cumbler, Marion Deshkmuth, Perry Duis, Christian Feest, Richard Fox, Gary Gerstle, Hartmut Keil, Frederick Luebke, Rebecca More, Nanepashemet, Stephen Nissenbaum, Nancy Pope, La Vern J. Rippley, Roy Rosenzweig, David Harris Sacks, Philip Silvia, Kathryn Kish Sklar, Reed Ueda, and Elizabeth Warren. Interviews were conducted both over the telephone and in person with several people who knew Rudolf Haffenreffer, were involved with the Boy Scouts, Narragansett Brewing, or other aspects of his life, or who remember the King Philip Museum, including H. Cushman Anthony, Roswell Bosworth, John C. Ewers, William Fenton, Ray Gruener, and Nancy Haley Lyle.

I wish also to thank others who answered inquiries made to institutions and organizations: Helen Tessler, Curator and Librarian, Bristol Historical and Preservation Society; Judy Badessa, Boy Scouts of America, Rhode Island Office; Deborah Collins and Dennis Binette, Fall River Historical Society; Barbara Dailey, Baker Library, Harvard University; Elaine Deguzis, St. Paul's Evangelical Lutheran Church, Providence; Peter Drummey, Massachusetts Historical Society; the staff of the Library, German Historical Institute; Bonny Kellerman, Associate Registrar, Massachusetts Institute of Technology; Dan Lelievre, Fall River Public Library; Jan Malcheski, Boston Athenaeum; Randall Mason, State House Library (Massachusetts); Helen W. Samuels, Institute Archivist, Massachusetts Institute of Technology; Warren Seamans, Massachusetts Institute of Technology Museum, Massachusetts Institute of Technology; and Kara Schneiderman, Massachusetts Institute of Technology. For research assistance I am grateful to Julie Fuchs, Peter Ammirati, Melanie Guy, Mary McCutcheon Kell, Scott McWilliam, and Katherine Woodhouse-Beyer; and to the librarians of the Woodrow Wilson International Center and National Humanities Center, especially George Wagner, Alan Tuttle, Rebecca Vargha, and Jean Houston.

I also gratefully acknowledge the support of the Haffenreffer Family Fund; and the Woodrow Wilson International Center for Scholars and the National Humanities Center, where I was resident from September 1992 through May 1994. Finally, I am indebted to my co-workers, David Gregg, Barbara Hail, and Ann McMullen, with whom I have discussed this entire project at great length; to Rebecca and Tim More for lodgings and relief; and to Sheila ffolliott for her patience and advice.

NOTES

1. There had been one prominent mention of the Museum in 1925 (see text below), but it was nothing compared to the blitz of publicity in 1929. *Providence Journal,* March 8, 1925; *ibid.,* January 20, 1929; *Bristol Phoenix,* January 22, 1929; *Boston Sunday Post,* January 20, 1929, *The New Bedford Sunday Standard,* January 20, 1929, *The Boston Herald,* July 21, 1929.

2. I am grateful to Nanepashemet (fax to author, August 30, 1993) and Kathleen Bragdon (telephone conversation with author, December 3, 1993) for examining LeRoy Perry's entry in the Visitor's Book and for suggesting how this phrase might be translated and what Perry meant.

3. Haffenreffer Museum of Anthropology Archives [H M A A] Visitor's Book, 1929–1954.

4. Rudolf Friedrich Haffenreffer came from Heidenheim in Württemberg, and Katharine Burkhardt Haffenreffer from Unterreichenbach in Baden. On the name Rudolf F. Haffenreffer: after the birth of his son in 1874, Rudolf Friedrich Haffenreffer (1847–1929) used Sr. following his name. For the son, Friedrich was anglicized to Frederick (and in Chauncy-Hall School records is spelled Frederic). Following the death of his father in 1929, Rudolf Frederick Haffenreffer, Jr. (1874–1954) – the founder of the King Philip Museum – ceased using Jr. The following convention is adopted here for him: in his youth, sometimes Rudolf; as an adult, sometimes Jr. but (following his own usage) not after 1929; often, simply Haffenreffer. The context should make clear which of the two Rudolf Haffenreffers is meant. Information on the Haffenreffers is from the Genealogy of the Haffenreffer Family, Mount Hope Farm Papers; *Rudolf F. Haffenreffer, Letters to Home 1864–1879* (privately printed, no date); Carl W.

Haffenreffer, conversation with author, April 20, 1993; Theodore C. Haffenreffer, telephone conversation with author, December 6, 1993.

5. Each year from 1850 to 1900, more immigrants arrived in America from Germany than anywhere else. On migration from Germany to America, see Kathleen Neils Conzen, "Germans," in *Harvard Encyclopedia of American Ethnic Groups,* ed. Stephan Thernstrom (Cambridge, Mass.: Harvard University Press, 1980), 405–25; Günter Moltmann, "The Pattern of German Emigration to the United States in the Nineteenth Century," in *America and the Germans: An Assessment of a Three-Hundred-Year History, Vol. 1: Immigration, Language, Ethnicity,* eds. Frank Trommler and Joseph McVeigh (Philadelphia: University of Pennsylvania Press, 1985), 14–24; Don Heinrich Tolzmann, ed., *The German Immigrant in America: F.W. Bogen's Guidebook* (Bowie, Md.: Heritage Books, 1992 [orig. 1851]); also Oscar Handlin, *Immigration as a Factor in American History* (Englewood Cliffs, N.J.: Prentice-Hall, 1959), 24–26. On the forty-eighters, see especially Adolf E. Zucker, ed., *The Forty-Eighters: Political Refugees of the German Revolution of 1848* (New York: Columbia University Press, 1950); Carl Frederick Wittke, *Refugees of Revolution: The German Forty-Eighters in America* (Westport, Conn.: Greenwood Press, 1970 [orig. 1952]; Ernest Bruncken, *German Political Refugees In the United States during the Period From 1815–1860* (San Francisco, 1970); Marcus L. Hansen, "The Revolutions of 1848 and German Emigration," *Journal of Economic and Business History* 2 (1930): 630–58. On the history of the Haffenreffers, see Genealogy of the Haffenreffer Family, Mount Hope Farm Papers; Carl W. Haffenreffer, letter to author, March 26, 1992; *ibid.,* conversation with author, April 20, 1993; Theodore C. Haffenreffer, telephone conversation with author, December 6, 1993; Harriet Haffenreffer Shields, telephone conversation with author March 23, 1993.

6. Ten thousand represented two percent of Boston's population near the end of the century. In contrast to Boston, as many as fifty thousand German-born immigrants lived in Cincinnati, Saint Louis, Philadelphia, and Chicago, respectively, and 150,000 in New York City. See especially Conzen, "Germans." On the arrival of Haffenreffer in the United States, see Genealogy of the Haffenreffer Family, Mount Hope Farm Papers; Carl W. Haffenreffer, letter to author, March 26, 1992; ibid., conversation with author, April 20, 1993; Theodore C. Haffenreffer, telephone conversation with author, December 6, 1993.

7. On Boston's neighborhoods, see Robert A. Woods, *The City Wilderness: A Settlement Study* (Cambridge, Mass.: The Riverside Press, 1898), 51; Frederick Bushee, *Ethnic Factors in the Population of Boston,* Publications of the American Economic Association 4, no. 2 (New York: Macmillan, 1903), 25–31; Peter R. Knights, *The Plain People of Boston, 1830–1860: A Study in City Growth* (New York: Oxford University Press, 1971); Leo F. Schnore and Peter R. Knights, "Residence and Social Structure: Boston in the Ante-Bellum Period," in *Nineteenth-Century Cities: Essays in the New Urban History,* eds. Stephan Thernstrom and Richard Sennett (New Haven, Conn.: Yale University Press, 1969), 247–57; Oscar Handlin, *Boston's Immigrants: A Study in Acculturation* (Cambridge, Mass.: Harvard University Press, 1959). Information on Haffenreffer's Boston residences is from various Chauncy-Hall School publications (see note 19) and city directories.

8. The process whereby immigrants and their offspring, including Germans and German-Americans – all of whom at the time were commonly referred to as "hyphenated" Americans – has been explored by many including Handlin, *Immigration as a Factor,* Leonard Dinnerstein and David Reimers, *Ethnic Americans: A History of Immigration and Assimilation* (New York: Dodd, Mead & Company, 1975), Milton M. Gordon, *Assimilation in American Life: The Role of Race, Religion, and National Origins* (New York: Oxford University Press, 1964), Oscar Handlin, ed., *Children of the Uprooted* (New York: George Braziller, 1966), Charles Anderson, *White Protestant Americans: From National Origins to Religious Group* (Englewood Cliffs, N.J.: Prentice-Hall, 1970). For Germans, see Stanley Nadel, *Little Germany: Ethnicity, Religion, and Class in New York City, 1845–80* (Chicago: University of Illinois Press, 1990), Jay P. Dolan, *The Immigrant Church: New York's Irish and German Catholics, 1815–1865* (Notre Dame, Ind.: University of Notre Dame Press, 1975), 27–44, Carl Wittke, *Against the Current: The Life of Karl Heinzen, 1809–80* (Chicago: University of Chicago Press, 1945), La Vern J. Rippley, *The German-Americans* (Boston: Twayne, 1976).

9. On the deeply conflicted and ambivalent attitudes toward immigrants see Barbara Miller Solomon, *Ancestors and Immigrants: A Changing New England Tradition* (Boston: Northeastern University Press, 1989 [orig 1956]), who explores to great effect the cultural worlds of old and new peoples in Boston. I use Yankee here for New England residents who were descendants of seventeenth-century Puritan settlers (see Oscar Hamlin, "Yankees," in *Harvard Encyclopedia of American Ethnic Groups,* ed. Stephan Thernstrom (Cambridge, Mass.: Harvard University Press, 1980), 1028–30.

10. See Bushee, *Ethnic Factors in the Population of Boston,* 154; Robert A. Woods, *The City Wilderness,* 51; Edwin M. Bacon, *King's Dictionary of Boston* (Cambridge, Mass.: Moses King, 1883), 197. For a comprehensive work exploring the German contribution to American life, see Albert Bernhardt Faust, *The German Element in the United States,* 2 vols. (New York: The Steuben Society of America, 1927); see also Henry Pochmann, *German Culture in America: Philosophical and Literary Influences, 1600–1900* (Madison: University of Wisconsin Press, 1955).

11. Stephan Thernstrom, "Immigrants and Wasps: Ethnic Differences in Occupational Mobility in Boston, 1890–1940," in *Nineteenth-Century Cities: Essays in the New Urban History,* eds. Stephan Thernstrom and Richard Sennett (New Haven, Conn.: Yale University Press, 1969), 125–64; Stephan Thernstrom, *The Other Bostonians: Poverty and Progress in the American Metropolis, 1880–1970* (Cambridge, Mass.: Harvard University Press, 1973), 111–44 and *passim.*

12. On Brahmin attitudes, see Solomon, *Ancestors and Immigrants*; and on mobility in Boston, Thernstrom, *The Other Bostonians.*

13. In Boston, the German lager industry was dominated at first by Michael Ludwig, then John Roessle, who brewed the first lager beer in New England. See Bacon, *King's Dictionary,* 54–55; *One Hundred Years of Brewing. A Complete History of the Progress Made in the Art, Science and Industry of Brewing in the World, Particularly during the Nineteenth Century. A Supplement to The Western Brewer, 1903* (Chicago and New York: H. S. Rich & Co., 1903), 229; Perry R. Duis, *The Saloon: Public Drinking in Chicago and Boston, 1880–1920* (Urbana: University of Illinois Press, 1983), 16. During this era, other German-Americans whose names resonate today started brewing lager

or inherited or bought out existing brewing companies: Eberhard Anheuser and Adolphus Busch, Adolph Coors, Theodor Hamm, Frederick Miller, Frederick Pabst, Frederick and Maximilian Schaefer, and Joseph Schlitz were among them. Stanley Baron, *Brewed In America: A History of Beer and Ale in the United States* (Boston: Little, Brown, 1962).

14. On Haffenreffer's business during this period: Dun & Bradstreet Credit Reports, Baker Library, Harvard Business School, R.G. Dun/MA 85/ p. 71, 349; R.G. Dun/MA 79/ p. a-4, 18, R.G. Dun/MA 87/ p. 314; *Rudolf F. Haffenreffer, Letters to Home 1864–1879*; Theodore C. Haffenreffer, telephone conversation with author, December 6, 1993. Burkhardt captured the German immigrant taste as well as a growing market among Bostonians at large for lager and soon ranked seventh in sales of the city's fifteen brewers of ale, stout, and lager. The market was dominated by Rueter & Alley, a German-Irish partnership that produced prize-winning Highland Spring Ale, and by Boston Brewing, a Yankee firm incorporated in the 1820s. But Rueter & Alley and Boston brewed ale; Burkhardt, in contrast (and Roessle), brewed lager, so their markets were different. *One Hundred Years of Brewing*, 197, 229–30, 288, 403, 467, 468, 567, 612; Bacon, *King's Dictionary*, 40–41, 54; see also William D. Ross, *An Index to American Brewers and Breweries in One Hundred Years of Brewing* (Knoxville, Tenn., 1975); Will Anderson, *Beer New England* (Portland, Maine: Will Anderson, 1988), 77.

15. Ten years separated Rudolf from Catherine, his youngest full sibling. Genealogy of the Haffenreffer Family.

16. The Haffenreffers were Missouri Synod Lutherans. On Haffenreffer's household, *Rudolf F. Haffenreffer, Letters to Home 1864–1879*; Theodore C. Haffenreffer, telephone conversation with author, December 6, 1993. For language use in German-American families, see Marion L. Huffines, "Language-Maintenance Efforts among German Immigrants and Their Descendants in the United States," in *America and the Germans: An Assessment of a Three-Hundred-Year History, Vol. 1: Immigration, Language, Ethnicity*, eds. Frank Trommler and Joseph McVeigh (Philadelphia: University of Pennsylvania Press, 1985), 241–50.

17. Thomas Cushing, *Historical Sketch of Chauncy-Hall School* (Boston, 1895), 40–41 and *passim*.

18. George W. Engelhardt, *Boston Massachusetts* (Boston, 1897), 65; Bacon, *King's Dictionary*, 378–9; Bacon, *Bacon's Dictionary of Boston* (Boston, 1886), advertisement.

19. Several Burkhardts – cousins? – preceded Rudolf at Chauncy Hall and his siblings Alice, Theodore, and Adolf followed. He progressed from the Primary Department through the third or second class of the Upper Department. For his progress and for the curriculum, see *Fifty-Fifth Annual Catalogue of Chauncy-Hall School, 1882–1883* (Boston, 1883), *Fifty-Sixth Annual Catalogue...* (Boston, 1884), *Fifty-Eighth Annual Catalogue...* (Boston, 1886), *Fifty-Ninth Annual Catalogue...* (Boston, 1887), *Sixtieth Annual Catalogue...* (Boston, 1888), *Sixty-First Annual Catalogue...* (Boston, 1889), *Sixty-Second Annual Catalogue...* (Boston, 1890). The only report on Rudolf that still exists is for November 1883, when he received an Excellent in Lessons and "Tiptop" in Deportment. Chauncy-Hall School, Primary Department, Report, November 1883, Mount Hope Farm Papers. On student enrollment, see Cushing, *Historical Sketch*.

20. For the Boston Society of Natural History and other Boston-area museums, see Valentine Ball, "Report on a Visit to the Museums of America and Canada," *Report of the Science and Art Museum for the Year 1884* (Dublin, 1884), 310–42; Frederick J. H. Merrill, "Natural History Museums of the United States and Canada," *New York State Museum Bulletin 62*, Miscellaneous 1 (Albany, 1903), 67–80; Bacon, *King's Dictionary*, 221, 300–303, 309.

21. Perhaps Rudolf witnessed one or more of the Wild West shows – Buffalo Bill was the best known – which toured the East in the 1880s. In 1885 (when Rudolf was eleven), Buffalo Bill Cody and his entourage including Annie Oakley and Sitting Bull and other Indians came east, and over one million people saw the show. It was immensely popular in Boston, where the troop held widely publicized performances night and day. Buffalo Bill brought his show to Boston in 1885 and toured New England in 1895–97. For his schedule, see William F. Cody, *Story of the Wild West and Camp-Fire Chats* (H. S. Smith, 1888), 694–98; Frank Winch, *Thrilling Lives of Buffalo Bill...and Pawnee Bill* (New York: S. L. Parsons and Co., 1911), 177–83; Walter Havighurst, *Annie Oakley of the Wild West* (New York, 1954), 55–59, 189–92; Donald B. Russell, *The Lives and Legends of Buffalo Bill* (Norman, 1960), 295–310; Nellie Snyder Yost, *Buffalo Bill: His Family, Friends, Fame, Failures, and Fortunes* (Chicago, 1979), 145–74; Joseph G. Rosa and Robin May, *Buffalo Bill and His Wild West* (Lawrence, 1989), 66–99; also Sarah J. Blackstone, *Buckskins, Bullets, and Business: A History of Buffalo Bill's Wild West* (New York, 1986), C. R. Cooper, *Annie Oakley: Woman at Arms* (New York: Duffield and Co., 1927).

Rudolf's family, not an obvious source of his interest in Native America, may nevertheless have made it possible for him to visit area museums such as Harvard University's Peabody Museum of Archaeology and Ethnology, whose galleries contained American Indian artifacts and were open for public tours each week. For museums see Ball, "Report on a Visit;" Merrill, "Natural History Museums;" Bacon, *King's Dictionary*, 221, 300–303, 309. For Horatio Hale and Francis Parkman, see A. Johnson and D. Malone, eds., *Dictionary of American Biography*, vol. 4 (New York: C. Scribner's Sons, 1960), 104–105, and D. Malone, ed., *Dictionary of American Biography*, vol. 7 (New York: C. Scribner's Sons, 1962), 247–50.

22. Rudolf's stepmother was from Augsburg, east of Stuttgart. August was sixteen years younger than Rudolf, and Martha was nineteen. On Rudolf's family and his travels in 1888–89, see Genealogy of the Haffenreffer Family, Cabin Passenger List, *Lahn*, New York to Bremen, November 28, 1888, Cajüts-Passagiere, *Aller*, Bremen to New York, February 6, 1889 and other papers and letters in Mount Hope Farm Papers.

23. But Haffenreffer never returned to Germany. Letters between Rudolf Haffenreffer and various family members and friends during his stay in Germany, 1889–90, Mount Hope Farm Papers.

24. Letters from and to Rudolf Haffenreffer in Germany, 1889–90, Mount Hope Farm Papers. After 1875, revenue stamps were evidently usually retained by the post office, but could have come into collectors' hands. For information on stamps, I am grateful to Nancy Pope, National Postal Museum, telephone conversation with author August 2, 1993; see also *Scott's Specialized Catalogue of United States Stamps*, 69th edition (Sidney, Ohio, 1990), 193–95. These inferences fit other evidence that Haffenreffer's earliest collection was of stamps (Carl W. Haffenreffer, conversation with author, April 20, 1993).

Whether or not Rudolf "discovered" Native America in other ways in Germany is even more speculative. Mention should nevertheless be made of Karl May and other writers, and Buffalo Bill. May's many novels on the American frontier were then appearing – the first in 1870 – as was fiction of other German writers and translations of Cooper's Leatherstocking Tales, which were wildly popular at the time. See Preston A. Barba, "The American Indian in German Fiction," *German-American Annals* 15 (1913), 143–74; Ray Allen Billington, *Land of Savagery Land of Promise: The European Image of the American Frontier* (New York: Norton, 1981), Klaus Mann, "Karl May: Hitler's Literary Mentor," *Kenyon Review* 2 (1940), 391–400; Ernst Stadler, "Karl May: The Wild West Under the German Umlaut," *Missouri Historical Bulletin* 21 (1965), 299–307; Joseph Wechsberg, "Winnetou of der Wild West," *American West* 1 (summer 1964), 32–39; Ralph S. Walker, "The Wonderful World of Karl May," *American West* 10, no. 6 (1973), 28–33; Richard Cracroft, "The American West of Karl May," *American Quarterly* 19 (1967), 249–58. Buffalo Bill toured Stuttgart and other European cities in the spring and summer of 1890 (Winch, *Thrilling Lives,* 177–83 passim; Russell, *Lives and Legends,* 353–71 passim). Finally – to eliminate a non-possibility – Stuttgart's Linden Museum did not then exist, and Prince Maximilian de Wied's collections of Plains artifacts were at Neuwied and not on display (Christian Feest, letter to author, December 9, 1993).

25. In 1890, New England Brewing Company, an English syndicate, acquired Haffenreffer & Company and three other breweries – English syndicates were investing widely in America at that time – but Haffenreffer remained manager until he retired in 1905. In 1893, Rudolf may have gone to the American Brewing Academy in Chicago, which offered four-month long courses in their model brewery and laboratories (Letter from Wahl and Henius, Directors of the Scientific Station for Brewing of Chicago, American Brewing Academy, to Rudolf Haffenreffer [Sr.], November 9, 1892, Mount Hope Farm Papers). On MIT: Haffenreffer was a special student at MIT in the fall of 1894 at which time he studied Fermentation, and in MIT records is listed as a member of the class of 1895 (Bonny Kellermann, Associate Registrar, MIT, letter to author, March 31, 1993).

26. Carl W. Haffenreffer, conversation with author, April 20, 1993.

27. *One Hundred Years,* 469.

28. On Fall River, see John T. Cumbler, *Working-Class Community in Industrial America: Work, Leisure, and Struggle in Two Industrial Cities, 1880–1930* (Westport, Conn.: Greenwood Press, 1979), Judith A. Boss, *Fall River: A Pictorial History* (Norfolk, Va.: Donning Company, 1982); *Fall River Massachusetts,* Fall River Trade and Industry Association (Fall River: H. H. Acornley & Company, 1911); Stephen Nissenbaum, "The Lizzie Borden Murders," in *The Pursuit of Liberty,* second ed., R. Jackson Wilson et al, (Belmont, Cal.: Wadsworth, 1990), 696–735; Philip Silvia, *Victorian Vistas: Fall River, 1901–1911, As Viewed through Its Newspaper Accounts* (Fall River: R. E. Smith, 1992).

29. The account of Fall River business ventures has been pieced together from a variety of sources. Haffenreffer seems always to have been general manager and treasurer, while others – presumably financiers – served as president and vice-president. Enterprise Brewery was established in 1894 and King Philip Brewery in 1898. By 1912, when Haffenreffer controlled the management of them and Old Colony, George D. Flynn was president of all three. In 1910, Haffenreffer's brother, Adolf, became a resident in his house and soon became superintendent of Old Colony. Haffenreffer also started Yale Brewery in New London, Connecticut and contemplated expansion to Taunton, Massachusetts. See *One Hundred Years,* 469, 470; *History of Fall River; Fall River Directories, 1896–1922* (Fall River, 1896–1922); Carl W. Haffenreffer, letter to author, March 26, 1992; *Providence Journal,* October 9, 1954. Haffenreffer's relations with the Brewery Workers' Union were not always smooth, which must be put in the context of industry-wide labor relations as well as in the Fall River industrial scene as a whole (*Brauer-Zeitung,* May 25, 1901).

30. Carl W. Haffenreffer, conversation with author, April 20, 1993. In 1903 (following his marriage), Haffenreffer's residence is listed at 575 Prospect Street, not at the brewery on Davol Street where he had lived before that year (Fall River Directory, 1903).

31. Henry M. Fenner, *History of Fall River* (New York: F. T. Smiley, 1906), 238–39.

32. *Fall River Herald News,* October 9, 1954. Among his other activities, Haffenreffer was president of Fall River Automatic Telephone Company.

33. Silvia, *Victorian Vistas,* 178–79, 318–20, 353–54, 427–28, 497, 506–508, 549–52, 912–13, 919 and passim; Hugo A. Dubuque, *Fall River Indian Reservation* (Fall River, 1907).

34. Elizabeth Warren and Pamela Kennedy, *Historic and Architectural Resources of Bristol, Rhode Island* (Providence: Rhode Island Historical Preservation Commission, 1990), 18–22.

35. Thomas W. Bicknell, "Historic Mount Hope," *Bristol Phoenix,* October 21, 1913; Warren and Kennedy, *Historic and Architectural Resources of Bristol,* 1; *Rhode Island Tercentenary 1636–1936* (State of Rhode Island and Providence Plantations: Rhode Island Tercentenary Commission, 1937), 85.

36. Royall started construction on what is usually known as the Bradford house. Warren and Kennedy, *Historic and Architectural Resources,* 99.

37. On the history of the lands immediately surrounding and including Mount Hope, see Charles O. F. Thompson, *Sketches of Old Bristol* (Providence: Roger Williams Press, 1942), 357–59, Wilfred H. Munro, *The History of Bristol, R. I.: The Story of the Mount Hope Lands, From the Visit of the Northmen to the Present Time* (Providence: J. A. & R. A. Reid, 1880), 195 (illus), 243–44, 253–57. According to George Howe, William B. deWolf was Mount Hope's developer (George Howe, *Mount Hope: A New England Chronicle* [New York: Viking Press, 1959], 62). For Mount Hope Park, see "Mount Hope, The Home of King Philip," [advertisement], *Bristol Phoenix,* June 19, 1880; *ibid.,* June 7, 1898; *ibid.,* July 18, 1900; *ibid.,* August 7, 1900; *ibid.,* August 13, 1901; *ibid.,* May 20, 1904; *Providence Journal,* October 23, 1903; *The Midway: An Illustrated Magazine of Amusement Resorts and Attractions,* vol. 1, 1905, passim; William G. McLoughlin, *Rhode Island: A History* (New York: Norton, 1986); Gary Kyriazi, *The Great American Amusement Parks: A Pictorial History* (Secaucus, N.J.: Citadel Press, 1976).

38. In 1903, Haffenreffer acquired Mount Hope Park with John Coughlin, ex-Mayor of Fall River. In 1912, Haffenreffer bought the Church property adjacent to the Park with George D. Flynn, president of Old Colony Brewery, and maybe one of Haffenreffer's younger brothers. By 1916, Haffenreffer

was the sole owner of the entire property. The next year, Haffenreffer leased a house and several acres north of his property from Miss Ethel Mason for several years; and in 1920, Mrs. Helena Goff transferred land and a cottage at Mount Hope to him. See *Providence Journal*, October 23, 1903; Carl W. Haffenreffer, letter to author, March 26, 1992; *Fall River Directory*, 1914; *Bristol Phoenix*, March 20, 1914; *ibid.*, 4 December 1917; *ibid.*, April 23, 1920.

39. In 1933, the Haffenreffers donated their Fall River home at 575 Prospect Avenue to Union Hospital, which used it as a convalescent home, and moved to 231 Arlington Avenue in Providence (*Fall River Directory*, 1933; *Providence Directory*, 1933; *Fall River Herald News*, October 9, 1954; Carl W. Haffenreffer, conversation with author, April 20, 1993). By 1933, both sons, the beneficiaries of private education after early school in Fall River, had graduated from Dartmouth College.

40. Thomas Bicknell was being paraphrased here (*Bristol Phoenix*, March 25, 1913).

41. In four years, the Mount Hope Park assessment rose from $39,800 to $88,000, and the purchase price to $150,000. On this and other events, see *Bristol Phoenix*, April 19, 1912; *ibid.*, March 21, 25, 1913; *ibid.*, March 20, 1914; *ibid.*, April 21, 28, 1914; *ibid.*, May 19, 1914; *ibid.*, March 3, 24, 28, 1916.

42. *Bristol Phoenix*, July 28, 1914; *ibid.*, May 7, 1915; *ibid.*, May 17, 1918; *ibid.*, February 22, 1921; *Providence Journal*, October 2, 1914; *ibid.*, February 19, 1921; *Fall River Evening Herald*, February 19, 1921; *Fall River Globe*, February 19, 1921. Haffenreffer, according to his son, Carl, "had an outstanding herd of certified Guernsey milk cows, later augmented by beef cattle." Carl W. Haffenreffer, letter to author, March 26, 1992.

43. Haffenreffer wore a brace on one leg for the rest of his life, and the injury affected his stride. Carl W. Haffenreffer, letter to author, March 26, 1992; conversation with author, December 17, 1993; Rudolf F. Haffenreffer IV, conversation with author, July 12, 1993; *Bristol Phoenix*, May 8, 1917; *Class Book, 25th Anniversary, MIT 95* (Boston, 1920), 62.

44. At the 1916 parade, Adolf was his brother's aide, and one son, Pete, was Chief Marshall of the Boy Scouts division, and the other, Carl, was his aide. On Bristol events, see *Bristol Phoenix*, August 6, 1915; *ibid.*, October 26, 1915; *ibid.*, July 7, 1916; *ibid.*, January 24, 1918; *ibid.*, February 19, 1918; *ibid.*, March 8, 1918.

45. Gustavus Ohlinger, *Their True Faith and Allegiance* (New York: The Macmillan Company, 1916); Owen Wister, "Foreword," in *Ibid*. On German-Americans during the War years, see Carl Wittke, *German-Americans and the World War* (Columbus: Ohio State Archaeological and Historical Society, 1936), Frederick C. Luebke, *Bonds of Loyalty: German-Americans and World War I* (DeKalb: Northern Illinois University Press, 1974). See also John Higham, *Strangers in the Land: Patterns of American Nativism, 1860–1925* (New Brunswick, N.J.: Rutgers University Press, 1955) and Edward George Hartmann, *The Movement to Americanize the Immigrant* (New York: Columbia University Press, 1948) for pressures on recent immigrants prior to and including World War I.

46. Luebke, *Bonds of Loyalty*, 243; Wittke, *German-Americans and the World War*; *Bristol Phoenix*, August 6, 1915; *ibid.*, July 20, 1917; *ibid.*, November 2, 1917; *ibid.*, February 19, 1918.

47. In one incident dating from this time, Haffenreffer was walking his dogs (dachshunds) in Fall River when stones were thrown at them, presumably because they (and he) were of German extraction (Rudolf F. Haffenreffer IV, conversation with author, July 12, 1993).

48. HMAA, Newspaper clippings of Bernhard Hermann Ritter's columns. On German print, see Wittke, *German-Americans and the World War*, passim; Luebke, *Bonds of Loyalty*, 122ff, 142ff, passim.

49. Haffenreffer's interest in mineral mining developed at Chauncy-Hall or MIT, and he was a heavy investor in both mines and remained president and managing director of both until they were sold to Anaconda Copper Co. some years later (Carl W. Haffenreffer, conversation with author, April 20, 1993).

50. The quotation is from Carl W. Haffenreffer, letter to author, February 21, 1991; see also *Bristol Phoenix*, April 15, 1930; HMAA, Rudolf Haffenreffer Collection Files.

51. See e.g. Barbara Babcock, "'A New Mexican Rebecca': Imaging Pueblo Women," *Journal of the Southwest* (1990), 400–37; Marvin Cahodas, "Louisa Keyser and the Cohns: Mythmaking and Basket Making in the American West," in *The Early Years of Native American Art History*, ed. Janet Berlo (Seattle : University of Washington Press, 1992), 88–133; Ann T. Walton, "The Louis W. Hill, Sr., Collection of American Indian Art," in *After the Buffalo Were Gone: The Louis Warren Hill, Sr. Collection of Indian Art* (St. Paul, Minn.: Northwest Area Foundation, 1985), 10–35.

52. Haffenreffer became president of Herreshoff. This company took its name from Nathanael Greene Herreshoff, an MIT graduate, and other descendents of Charles F. Herreshoff, a late-eighteenth-century German immigrant, and his wife Sarah, a daughter of John Brown of Providence.

53. *Bristol Phoenix*, July 29, 1924; *ibid.*, August 19, 22, 26, 1924; *ibid.*, November 18, 1924; *Providence Journal*, September 5, 1924; *ibid.*, November 16, 1924; *ibid.*, December 5, 1941; *ibid.*, June 23, 1942; *ibid.*, November 24, 1944; McLoughlin, *Rhode Island*, 175.

54. Haffenreffer's associates in Herreshoff were all prominent yachtsmen: George Nichols, Junius Morgan, Harold S. Vanderbilt, Arthur Curtis James, E. W. Clark, Thomas Slocum, and Harry Tiffany (*Providence Journal*, October 9, 1954).

55. On "power boat enthusiast," Carl W. Haffenreffer, letter to author, March 26, 1992, who also said that his father occasionally commuted by boat to the brewery in Fall River. For Haffenreffer and Herreshoff in 1930, see *Bristol Phoenix*, March 4, 7, 1930; *ibid.*, April 29, 1930; *ibid.*, August 29, 1930; *ibid.*, September 12, 1930; *Providence Journal*, September 11, 1930; *ibid.*, October 1954; *Yachts by Herreshoff* (Herreshoff Manufacturing Company, Bristol, R.I., n.d.).

56. Mount Hope Bridge's soaring structure won recognition from the American Institute of Steel Construction for design. *Bristol Phoenix*, February 1, 1924; *ibid.*, June 24, 1930; January 26, 1940; Warren and Kennedy, *Historic and Architectural Resources*, 64.

57. Narragansett's share of the market plunged in the 1960s and 1970s after it was purchased by Falstaff, which advertised its own brand, and years of high-cost production in an outmoded brewery. Anderson, *Beer New England*, 46–49. On early 1950s production figures (C. W. Haffenreffer, treas.): *Providence Journal*, June 8, 1952; also Carl W. Haffenreffer, conversation with author, April 19, 1993.

58. On "three brief cases," Carl W. Haffenreffer, conversation with author, April 20, 1993. Rudolf Haffenreffer was also

a trustee of R. F. Haffenreffer Family Foundation and Narragansett Brewing Co. Foundation, a member of American Mining Congress, United States Conservation Commission, and Chamber of Commerce.

59. Mugwump was an Algonquian loan form (it came to denote "big chief"). Its use in American politics derives from the fence-sitting image of a mug (face) on one side and wump (rump) on the other. The mugwumps included Theodore Roosevelt, Henry Cabot Lodge, and other descendents of reform-minded Republicans who broke with James Blaine and the Republican Party to vote for Grover Cleveland in 1884. One cannot assume anything further about Haffenreffer's views on these reformists, but the link with Lodge is interesting. As United States Senator, this old-stock Yankee was a key participant in the 1890s national debates on immigration and a political force behind the Immigration Restriction League, but he also embraced Teutonic virtue and "heralded a new attitude toward the German American" that was decidedly favorable (Barbara Solomon, *Ancestors and Immigrants*, 111–21, 158, and passim). It may not be coincidental that Haffenreffer purchased Henry Cabot Lodge's desk and used it in the King Philip Museum. For mugwump, see *Providence Journal*, October 9, 1954; R. Jackson Wilson et al, *The Pursuit of Liberty*, second ed., (Belmont, Cal.: Wadsworth Publishing Co., 1990), 581.

60. Rudolf F. Haffenreffer IV, conversation with author, July 12, 1993; Carl Haffenreffer, conversation with author, December 10, 1993; Hatsy Shields, telephone conversation with author, March 23, 1993; H. Cushman Anthony, conversation with author, 19 May 1993; Ray Gruenwald, telephone conversation with author, June 21, 1993, conversation with author, July 12, 1993; Keith Wilbur, telephone conversation with author, June 9, 1993; Roswell Bosworth, telephone conversation with author, June 18, 1993; Nancy Haley Lyle, telephone conversation with author, June 18, 1993.

61. *Bristol Phoenix*, April 24, 1931; *ibid.*, July 1, 1932; *ibid.*, November 28, 1941; *Providence Journal*, January 7, 1936.

62. Haffenreffer was a director of charitable organizations including the Rhode Island Infantile Paralysis Foundation, American Heart Association, Children's Heart Association, Rhode Island Heart Association, and Bristol District Nursing Association. He was president of the Fall River MIT Club and a member of the MIT Corporation from 1949–54. In the 1940s, Brown University founded a chair in internal medicine which he funded, and in 1946 Providence College awarded him his honorary degree. He was also called upon to serve as head of the Rhode Island Water Commission and on other commissions. Federal Hill House gave him its first annual award for meritorious public service. *Providence Journal*, October 9, 1954, *Fall River Herald News*, October 9, 1954.

63. Haffenreffer issued this booklet with George Flynn, his business partner in Fall River breweries and Mount Hope lands (*Bristol Phoenix*, April 27, 1915). In 1880, Munro published *The Story of the Mount Hope Lands* (Providence, 1880), a several-hundred page history of Bristol, and his briefer booklet is an adaptation of parts of this earlier work.

64. Haffenreffer was barely settled before a Thayer Street Grammar School group came from Providence to see the historic sites associated with King Philip's War, as had undoubtedly happened many times before (*Bristol Phoenix*, May 19, 1914).

65. Bert Salwen, "Indians of Southern New England and Long Island: Early Period," in *Handbook of North American Indians, vol 15: Northeast*, ed. Bruce G. Trigger (Washington, D.C.: Smithsonian Institution Press, 1978), 160–76.

66. On seventeenth-century events, see Douglas E. Leach, *Flintlock and Tomahawk: New England in King Philip's War* (New York: Macmillan, 1958); Francis Jennings, *Invasion of America: Indians, Colonialism, and the Cant of Conquest* (Chapel Hill: University of North Carolina Press, 1975); Wilcomb Washburn, "Seventeenth-Century Indian Wars," in *Handbook of North American Indians. Vol 15: Northeast*, 89–100; Douglas E. Leach, "Colonial Indian Wars," in *Handbook of North American Indians. Vol 4: History of Indian-White Relations*, ed. Wilcomb Washburn (Washington, D.C.: Smithsonian Institution, 1988), 128–43.

67. This is pieced together from dates of Haffenreffer's land purchases and three newspaper accounts: *Bristol Phoenix*, January 22, 1929; *Providence Journal*, January 20, 1929; *ibid.*, October 11, 1931.

68. Carl Haffenreffer used the phrase, "part squirrel blood," to refer to what he saw as his father's accumulating habits. Carl W. Haffenreffer, conversation with author, April 20, 1993.

69. *Providence Journal*, October 11, 1931.

70. Carl W. Haffenreffer, letter to author, February 21, 1991.

71. Carl W. Haffenreffer, letter to author, February 21, 1991; quote from *Bristol Phoenix*, November 3, 1916.

72. Carl W. Haffenreffer, conversation with author, April 20, 1993.

73. *Bristol Phoenix*, September 18, 1923.

74. *Providence Journal*, March 8, 1925.

75. Before 1925, Haffenreffer's methods have to be pieced together from oral history and newspaper accounts; from the late 1920s on there is a Museum record. On Saville's work for Haffenreffer, see HMAA, RHC. On Saville's importance, see *Providence Journal*, January 20, 1929, *Bristol Phoenix*, January 22, 1929.

76. HMAA, RHC, Correspondence. There was a surge of interest in the Museum in late January 1929, when identical photographs were published in several newspapers, suggesting that Haffenreffer had materials sent to the press or alerted them simultaneously to his Museum. See *Boston Sunday Post*, January 20, 1929; *Providence Journal*, January 20, 1929; *New Bedford Sunday Standard*, January 20, 1929; *Bristol Phoenix*, January 22, 1929; see also *Boston Herald*, July 21, 1929.

77. *Providence Journal*, January 20, 1929; *Bristol Phoenix*, January 22, 1929. A typescript dated 1930 in Museum archives was either drawn from, or it was a later version of one which preceded, the 1929 newspaper articles.

78. *Providence Journal*, January 20, 1929; *Bristol Phoenix*, January 22, 1929.

79. *Providence Journal*, January 20, 1929; *New Bedford Sunday Standard*, January 20, 1929; cf. *Bristol Phoenix*, January 22, 1929.

80. *Providence Journal*, January 20, 1929; cf. *Bristol Phoenix*, January 22, 1929.

81. *Bristol Phoenix*, January 22, 1929.

82. *Providence Journal*, October 11, 1931.

83. John Haley, who worked in public relations for Narragansett and hosted for two decades a weekly radio program on history in Rhode Island, catalogued objects and did other work for the Museum during the 1930s (Nancy Haley Lyle, telephone conversation with author, June 18, 1993).

84. The carousel figures at Mount Hope Park may have been carved by Charles Looff, a German-American whose base was Rhode Island. For German-Americans and wood carving, see Frederick Fried, *A Pictorial History of the Carousel* (New York: A. S. Barnes and Company, 1964), Frederick Fried, *Artists in Wood: American Carvers of Cigar-Store Indians, Show Figures, and Circus Wagons* (New York: Clarkson N. Potter, 1970), Jean Lipman, *American Folk Art in Wood, Metal and Stone* (New York: Pantheon, 1948), Erwin O. Christensen, *Early American Wood Carving* (New York: Dover, 1952), Anthony Pendergast and W. Porter Ware, *Cigar Store Figures in American Folk Art* (Chicago: Lightner Publishing Corporation, 1953), *The Haffenreffer Collection of Cigar Store Indians and Other American Trade Signs, Parts One and Two* (New York: Parke-Bernet Galleries Inc., 1956).

85. *Bristol Phoenix,* February 21, 1941.

86. "The Vanishing American," *Time Magazine,* May 12, 1952. The Haffenreffer Collection.

87. For "tribe," H. Cushman Anthony, conversation with author, 19 May 1993; on "bleachers," John Ewers, conversation with author, June 10, 1993; Ray Gruenwald (telephone conversation with author, June 21, 1993, conversation with author, July 12, 1993) who was purchasing agent and general manager for Narragansett, said that he worked without pay at the Museum "many days" during the late 1940s and early 1950s on "inventory" and arranging arrowheads in cases; "all I remember," he said, "are the wooden Indians." In 1956, cigar-store Indians were all arranged in rows in one of the museum's rooms (William Fenton, conversation with author, November 6, 1993).

88. Carl W. Haffenreffer, conversation with author, April 20, 1993.

89. HMAA, Visitors' Book. On "roundups," Carl Haffenreffer, conversation with author, Rudolf F. Haffenreffer IV, conversation with author

90. *Providence Journal,* January 20, 1929.

91. Haffenreffer was also a member of the Bristol Historical Society and the Fall River Historical Society. *Providence Journal,* October 18, 1931.

92. *Bristol Phoenix,* June 12, 30, 1936; *ibid.,* July 3, 7, 1936; HMAA, Visitors' Book.

93. *Bristol Phoenix,* February 15, 1946.

94. *Providence Journal,* October 9, 1954. At one point, Pete and Carl were members of a troop associated with the First Congregational Church in Fall River.

95. At first, the RIBS formed as a non-sectarian, separate state-chartered body distinct from the national Scouting movement, which consisted of two feuding bodies from which Rhode Island leaders wished to distance themselves; but by the end of the war, they were part of the national movement. See *Providence Journal,* October 7, 24, 1910; *ibid.,* March 13, 1910; *ibid.,* April 15, 1911; *ibid.,* May 21, 1919; *Bristol Phoenix,* January 2, 1912; J. Harold Williams, *The Yawgoog Story. Volume I: 1916–1965;* and H. Cushman Anthony *The Yawgoog Story. Vol II: 1965–1985* (Providence: The Yawgoog Alumni Assn., Narragansett Council, Boy Scouts of America, 1985).

96. *Bristol Phoenix,* January 28, 1913; *ibid.,* March 21, 1913; *ibid.,* June 5, 12, 1914; *ibid.,* July 14, 17 1914; *ibid.,* January 2, 1923.

97. In 1914, Jerome Barrus, a local poet, dedicated a poem, "King Philip's Chair," to the Boy Scouts, eliciting the comment that "An ancient chronicler quaintly declares it would melt the heart of a stone to witness the ruthless slaughter of the Indians" (*Bristol Phoenix,* June 30, 1914).

98. Carl Haffenreffer remembers today camping out with the Scouts at Mount Hope even before he was a scout, sleeping in the infirmary tent. One time, he said, two black bear cubs that his father kept in cages escaped and ended up in a tub of cocoa. Carl W. Haffenreffer, conversation with author, April 20, 1993. See also *Bristol Phoenix,* July 14, 17, 1914; *ibid.,* June 15, 1915; *ibid.,* July 2, 30, 1915; *Providence Journal,* 26 June 1915; *ibid.,* September 26, 1920.

99. Camp King Philip was abandoned when questions arose over whether Mount Hope Park should be privately held or purchased by the state through a bond, and when anti-German sentiment was on the rise, but there is no evidence whatsoever that either affected the Scouts' decision to move. *Providence Journal,* April 15, 1911; *ibid.,* March 6, 1917; *ibid.,* July 8, 1917; *ibid.,* August 12, 1917; *ibid.,* June 28, 1918; *ibid.,* August 17, 1919; *ibid.,* September 26, 1920; *ibid.,* September 8, 1923; *Bristol Phoenix,* March 18, 1913; *ibid.,* August 25, 1936; Williams, *The Yawgoog Story,* 3–4.

100. Unlike Yawgoog, Camp Takarest was a short-term camp. *Bristol Phoenix,* October 13, 1914; *ibid.,* January 2, 1923; *ibid.,* June 26, 1923; *ibid.,* February 5, 8, 1924; *ibid.,* April 22, 1924; *ibid.,* July 22, 1924; *ibid.,* August 15, 1924; *ibid.,* March 3, 10, 1925.

101. *Bristol Phoenix,* July 17, 1914; *Providence Journal,* October 24, 1910; *ibid.,* January 8, 1913; *ibid.,* June 19, 1921; *ibid.,* February 25, 1923; *ibid.,* June 21, 1924; *ibid.,* October 11, 1925.

102. For Seton, see John Henry Wadland, *Ernest Thompson Seton: Man in Nature and the Progressive Era, 1880–1915* (New York: Arno Press, 1978), H. Allen Anderson, *The Chief: Ernest Thompson Seton and the Changing West* (College Station: Texas A&M University Press, 1986).

103. Ernest Thompson Seton, "Ernest Thompson Seton's Boys," *Ladies Home Journal,* May 1902, 15, 41, June 1902, 15, July 1902, 17, August 1902, 16, September 1902, 15, October 1902, 14, November 1902, 15; *Boy Scouts of America, The Official Manual for Boys,* 1911.

104. H. Cushman Anthony, conversation with author, May 19, 1993; *Fall River Daily Globe,* February 27, 1911. For Eastman, see Raymond Wilson, *Ohiyesa: Charles Eastman, Santee Sioux* (Urbana: University of Illinois Press, 1983); David Reed Miller, "Charles Alexander Eastman, Santee Sioux, 1858–1939," in *American Indian Intellectuals,* ed. Margot Liberty (St. Paul: West, 1978), 60–73; and Charles A. Eastman (Ohiyesa), *Indian Boyhood* (New York: Dover, 1971 [orig. 1902]), *The Soul of the Indian: An Interpretation* (New York: Johnson Reprint, 1971 [orig. 1911]), and *Indian Scout Talks: A Guide for Boy Scouts and Camp Fire Girls* (Boston: Little, Brown, 1914).

105. *Bristol Phoenix,* July 11, 1916; *ibid.,* January 3, 1919.

106. *Providence Journal,* January 2, 1927.

107. *Providence Journal,* December 28, 1930.

108. *Providence Journal,* October 25, 1936; *Bristol Phoenix,* October 27, 1936; *ibid.,* February 5, 1937; *ibid.,* September 24, 28, 1937. In 1952, the Narragansett Indians Council Powwow, also called the "R. F. Haffenreffer Powwow," was held in Providence and the Haffenreffer Foundation gave prizes in the Indian Essay Contest (*Bristol Phoenix,* February 12, 19, 1952).

109. *Bristol Phoenix,* August 14, 25, 1936; *ibid.,* September 1, 1936.

110. *Bristol Phoenix,* August 26, 1938; *ibid.,* June 30, 1939; *ibid.,* September 12, 1939; *Providence Journal,* September 11, 1939. In 1940, a lease from the Rhode Island Soldiers Home to Camp King Philip was assured by the legislature (*Bristol Phoenix,* April 16, 1940). In the period from 1935–40, Scouting in Rhode Island grew greatly from its endorsement by the Catholic Church; see J. Harold Williams, *Scout Trail, 1910–1962* (Providence: Rhode Island Boy Scouts and Narragansett Council, Boy Scouts of America, 1964), 31.

111. On Haffenreffer's monetary support, H. Cushman Anthony, conversation with author, May 19, 1993.

112. *Providence Journal,* October 25, 1936; *ibid.,* June 9, 1946; *ibid.,* November 17, 1946; *Bristol Phoenix,* October 9, 27, 1936; HMAA, RH Collections Files, RH: Arnold, letter from Rudolf Haffenreffer to James Arnold, April 12, 1942.

113. *Bristol Phoenix,* September 28, 1937; *ibid.,* January 11, 1938.

114. H. Cushman Anthony, conversation with author, May 19, 1993; *Providence Journal,* March 9, 1941; *ibid.,* May 27, 1941; *ibid.,* November 18, 1945; *ibid.,* June 1, 2, 1946; *ibid.,* June 14 (two articles), 15, 1947. *Bristol Phoenix,* June 4, 1946; *ibid.,* June 10, 1947.

115. J. Harold Williams, *Scout Trail, 1910–1962,* 52–53, 59; Bristol Phoenix, December 31, 1937.

116. HMAA, *Inventory of Book Cases,* ca 1955.

117. Unfortunately, very little has come to light that yields insight on any thoughts Haffenreffer and Heye may have shared with each other about Native people, and it is all about Heye, not Haffenreffer.

118. *Providence Journal,* October 18, 1931.

119. *Providence Journal,* September 16, 1923, *Fall River Evening Herald,* September 17, 1923, *Fall River Evening News,* September 17, 1923; R. F. Haffenreffer, Jr., "Indian History of Mount Hope and Vicinity," *Fall River Historical Society. Proceedings of the Society from its Organization in 1921 to August 1926* (Fall River: Fall River Historical Society, 1927), 34-62. The possibility always exists that Haffenreffer, who never hesitated to employ others to fulfill various tasks for him, had help drafting this speech. After 1924, Haffenreffer employed John Haley at Herreshoff and later at Narragansett in advertising and publicity. Haley wrote for Haffenreffer in the 1930s and 1940s. Even if Haley or someone else had a hand in this speech – the rhetoric seems not to resemble Haley's, and there is no evidence that he or anyone else played any role – it does contain indisputable signs of being Haffenreffer's, especially in the spoken version, a typescript of which is in Haffenreffer Museum archives.

120. All quotations, unless otherwise indicated, are from Haffenreffer, "Indian History of Mount Hope and Vicinity."

121. Haffenreffer was certainly not a lone voice in either romantic or revisionist readings of New England's past, but his forceful words separated him from many others of his day and were no doubt especially unusual among those with whom he associated in the business world. For a variety of texts see *Bristol Phoenix,* July 29, 1927; *Providence Journal,* August 8, 1926; Fenner, *History of Fall River,* William J. Miller, *Celebration of the Two-Hundredth Anniversary of the Settlement of the Town of Bristol, Rhode Island, September 24th, A. D. 1880;* Munro, *The Story of the Mount Hope Lands.*

122. HMAA, Untitled typescript of "Indian History of Mount Hope and Vicinity."

123. *Boston Sunday Post,* November 22, 1925. Mount Hope Farm Papers, letter from Rudolf Haffenreffer to Mrs. Emma Safford, November 24, 1925.

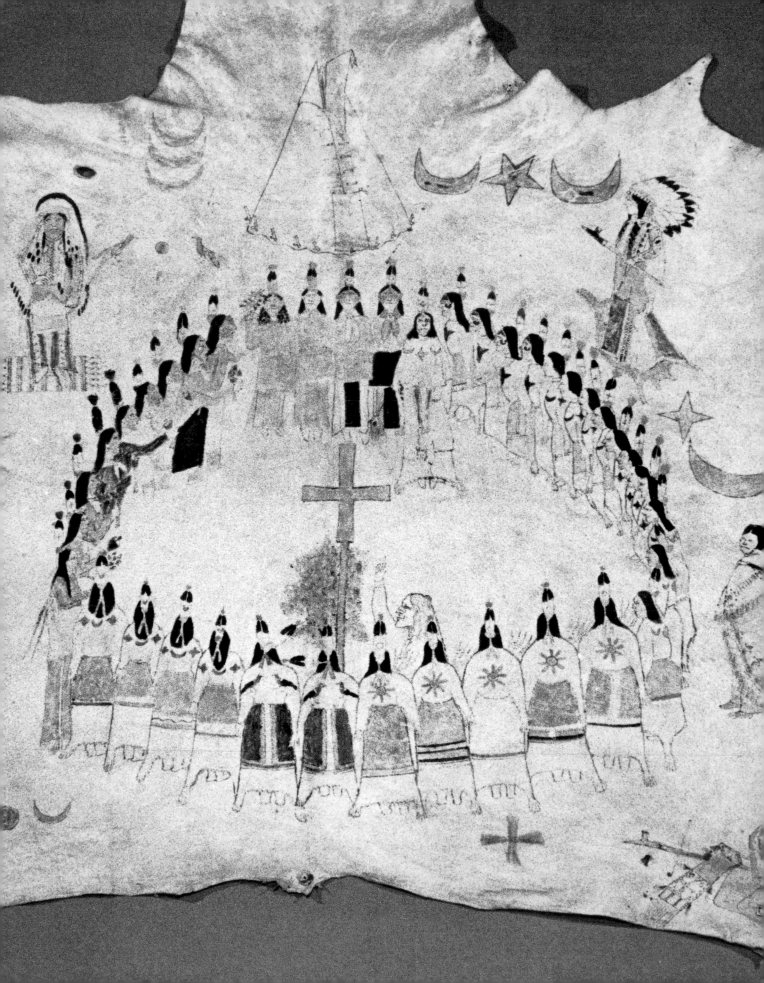

The Ethnographic Collection

by BARBARA A. HAIL

RUDOLF HAFFENREFFER'S inspirations for collecting Native American ethnographic objects grew naturally from the activities and interests of his life. They began with a local New England focus and widened to include all of the Americas, reflecting his own experiences. Important among these were his purchase of historic Indian lands and his desire to clarify the misconceptions perpetuated through time about Native people. They broadened as his business interests in Utah and California took him west every year into the heart of Indian country, and found a focus at home through his strong involvement in the Scouting movement which was based partly on Native American ethics and woodlore. Through his participation on the board of the Museum of the American Indian, Heye Foundation, he met major figures in the world of institutional and private collection. Throughout, his enthusiasm was constantly reinforced by the response of local friends and collectors, and the press, which followed his activities with interest. Anthropologist Edward Malin, growing up in Providence in the early 1930s, recalled, "as a little boy, I was always excited about what Rudolf Haffenreffer was doing."[1]

This essay will examine the manner in which Rudolf Haffenreffer put his ethnographic collection together, exploring what, when, and from whom he purchased, and how he selected from available materials.[2] To understand his collection it is also necessary to know what he coveted but could not obtain, as well as those things that he was offered but declined. Was there an overall plan for the collection? Was he attempting a comprehensive inventory of a vanishing world on the model established by the great ethnographic museum collections of the late nineteenth century? Was his collecting part of the "salvage paradigm," like turn-of-the-century photographer Edward S. Curtis, whose goal was to visually document every Indian tribe before it disappeared?[3] Or, was he quite simply carrying on his philosophical interest in Native American history, taking pleasure in learning, through collecting, about its material expressions?

The evidence points to the last, and also to a rather eclectic collecting approach. Some things – such as local seventeenth century Wampanoag materials – he actively sought; others, such as a Navajo and Zuni silver collection, came his way by chance. Like his friend George Heye, Rudolf Haffenreffer could be said to have a "boxcar" approach to collecting, taking advantages of opportunities to buy in quantity when they occurred

Fig. II-1
Skin Painting (detail) of Ghost Dance, Kiowa, painted by Silverhorn (Hauunguah), ca. 1910. Deer hide, water-base paints. L 110 cm. Purchase, Rowell 1934 (see p. 122). 77–188

rather than making individual selections for specific aesthetic, cultural, or regional reasons.[4] A newspaper of the time said that his purpose in collecting was inquisitive rather than acquisitive, to learn about Native people rather than to showcase objects.[5] Indeed it seems that he was not concerned with the formal aesthetic values that other non–Native people might assign to objects, and that his interest in his collection was an extension of his interest in the culture and history of Native people.

Rudolf Haffenreffer's ethnographic collection is broad in scope, unlike his archaeological collection which focuses heavily on southeastern New England. Although it is difficult to distinguish between collections of archaeology and ethnography, the latter, in general, represent cultural materials obtained directly or indirectly from the people who made and used them. Haffenreffer's ethnographic materials were acquired in a variety of ways: through personal collecting trips to the Southwest and California, where he purchased from both Native and non–Native individuals and from trading posts and retail outlets; through major purchases made in the East by a professional curator, Foster Saville; through auctions in Newport, Rhode Island and New York City; through dealers; through exchanges with the Museum of the American Indian, Heye Foundation; and through gifts and purchases of family treasures from fellow New Englanders, some of whom had personally acquired the objects from Native people. These private collectors sought out the King Philip Museum as a safe repository for their treasures, perhaps because it so frequently appeared in the press as "the most valuable collection in New England" and as "a sanctuary" for Indian materials.[6]

Even if not purposefully put together as a universally representative collection, by 1955 the King Philip Museum had come to include some 2300 ethnographic objects, most of which were from the major culture areas of the Americas. The North American collections represent, in descending order by number of objects, the Native cultures of the Southwest, Plains, Northeast, Arctic, Subarctic, California, Northwest Coast, Great Lakes, Southeast, Basin, and Plateau. From the Southwest

there are examples of prehistoric and historic pottery, basketry, silver ornament and horse gear, stone and shell jewelry, painted skins, weavings, and embroideries. From the Plains come quilled and beaded hide clothing and containers, painted skins, weapons and utensils, eagle feather bonnets, dance and ritual paraphernalia, and carved catlinite pipes. People of the Northeast are represented by stone effigy pipes, containers of bark, splint and sweetgrass, carved burl bowls and ladles, beaded and quilled bags and wearing apparel, wooden cradleboards, masks, and clubs. There are carved ivories from the Arctic and basketry and feather headdresses from California. The Subarctic collection contains caribou-hide clothing embroidered with silk thread, velvet and woolen bags decorated in floral beadwork, woven porcupine quillwork, bark and babiche containers, and stone pipes. A Chilkat dancing blanket of mountain goat hair, twined basketry, gaming sticks, horn dippers, carved wooden feast dishes, and a halibut hook represent the Northwest Coast people. There are ball-game sticks, pottery, and an early beaded bandolier bag from the Southeast, later beaded bandolier bags and hair ornaments from the Great Lakes, and basketry and beadwork from the Basin and Plateau.

The collections from Mesoamerica and South America are archaeological, with the exception of a dozen baskets and some colonial silverwork from Peru. Some of the archaeological materials have consistently been stored, exhibited, and interpreted with the ethnographic collection and are discussed here. These include pre-Columbian ceramics and stone carvings, and ornaments of stone and precious metals. Although he did not actively seek materials outside of the Americas, Haffenreffer obtained some 490 African objects (mostly arrows), twenty-five objects from the Pacific and two from Asia – all parts of larger collections of primarily American materials purchased as a unit (see Appendix).

THE BEGINNING

The first date recorded in the museum archives for the acquisition of ethnographic materials is 1923, but it is clear that Haffenreffer was collecting much earlier. In 1916, the *Bristol Phoenix* spoke of

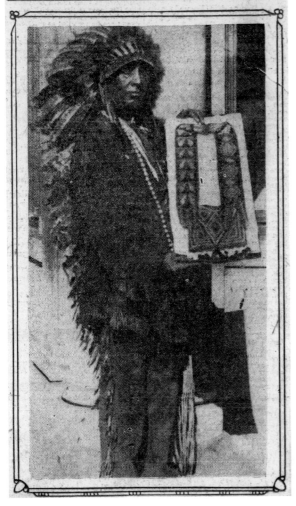

KING PHILIP'S TOBACCO POUCH

Fig. 11-2
Chief Sachem Ousa Mekin (LeRoy Perry) holding the purported "King Philip's Tobacco Pouch." *Providence Journal,* September 7, 1930.

"the many objects of interest contained in his museum."[7] And a *Providence Journal* article in 1931 stated that his collection "had been built up through the past quarter century."[8]

Haffenreffer's purchase in 1912 of the historic Mount Hope property with its eighteenth century homestead may have first stimulated his interest in ethnographic objects. Formerly in the family of William Bradford, first Deputy Governor of Rhode Island, the property contained, according to newspaper sources, "King Philip's powder pouch and horn" in addition to furniture that had belonged

to the Bradford family and historic manuscripts.[9] Haffenreffer was already interested in local archaeology for what it might reveal about the Native past, and these ethnographic pieces must only have increased his interest.

In 1930 Ousa Mekin (LeRoy Perry), a Wampanoag leader whom Haffenreffer employed to interpret the Mount Hope site to visitors, was pictured by the *Providence Journal* holding the powder pouch, with the caption, "King Philip's Tobacco Pouch" (fig. 11-2).[10] The pouch (an early nineteenth century Southeastern bandolier bag, plate 1) and painted powder horn (probably Southern Plains) are featured in most of the early photo compositions of favorite materials in the collection.[11] As was typical of the times, when claims were made that dozens of hide warshirts decorated with hair locks had been "worn by Crazy Horse at the Battle of the Little Big Horn," an object gained authority if it could be associated with a widely-known culture hero. In Rhode Island that hero was King Philip. Neither bag nor horn was given a provenience by Rudolf Haffenreffer in the collection information prepared for the card catalogue. This is curious and might suggest that at some point he became aware that they were not seventeenth-century Wampanoag pieces.[12] Regardless, their romantic association with the Wampanoag past, which Haffenreffer was extremely interested in reinterpreting positively, may have been early agents of inspiration for his ethnographic collecting.

BUILDING THE COLLECTION

The 1920s were years of intensive collection building. Facilities were expanded, and Haffenreffer's collections were exhibited in a permanent, fireproof structure which received press coverage as a "museum." In May 1928 he hired Foster Saville, formerly with the Museum of the American Indian, as a professional curator, and encouraged him to seek additions to the collection from the area he knew best, the Northeast (Gregg, this volume). Saville stayed less than a year, but during this time he created a registration system and regularized Haffenreffer's collections record-keeping. So while the years of 1928 and 1929 seem to have

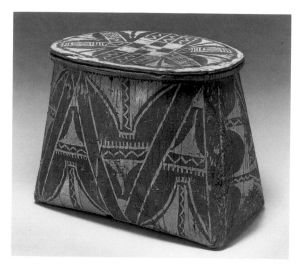

Fig. 11-3
Container, Penobscot, 19th c. Birch bark, spruce root, wood splint. H 30 cm. Purchase, Colonial Shop, New Bedford, Mass. 1928. B-70

been the time of Haffenreffer's most intensive acquisitions, they may only be the first well-documented period of his collecting.

Saville obtained significant Northeastern collections for Haffenreffer, both archaeological and ethnographic. Some locally made Native materials came through his contacts with Horace Grant, a Providence antique, coin, and hobby shop owner who served as middle man for primary collectors. Others were obtained from W. W. Bennett, proprietor of the Colonial Shop in New Bedford, Massachusetts, not far from the Wampanoag community of Mashpee. Here Saville purchased historic Mashpee-made objects, including an eighteenth-century wooden mortar and nineteenth-century splint baskets, as well as incised bark containers from the Penobscot and Passamaquoddy (figs. 11-3, 11-4). Other Northeastern materials – early Algonquian burl bowls (fig. 111-8), Algonquian and Iroquois effigy pipes (fig. 111-9), and many pairs of moccasins, beaded bags and headgear came into the collection at this time (plate 6). With these acquisitions, Haffenreffer established himself as a serious collector of Northeastern materials, scarce even at that time, due to the early disruption of Native life in this area. Haffenreffer's interest in local ethnographic material followed natu-

rally from his interest in local Native history and fulfilled his desire to memorialize the historic leader, King Philip.

In 1929 Foster Saville purchased for Haffenreffer, via Ada Cheyney of West Chester, Pennsylvania, the ethnographic and archaeological collection of her late husband, Jacob Paxson Temple, a decorative arts dealer (Gregg, this volume). The collection includes 250 ethnographic objects. Of these, 129 are from the Plains, forty from the Southwest, ten from the Northwest Coast, and the rest widely distributed throughout North and South America. Among the significant pieces are mid-nineteenth-century Northeast beaded bags, a Pomo pipe and bag, Huron moosehair-embroidered bark cases, northern California feathered baskets, a Yurok/Karok headdress of clipped owl feathers and painted hide, a nineteenth-century Ojibwa beaded vest and Iroquois beaded "Glengarry" cap, and a

Fig. 11-4
Picnic basket, Passamaquoddy, ca. 1900. Made by Tomah Joseph. Birch bark, wood, spruce root. H 37 cm. Purchase, 1928. 61-94

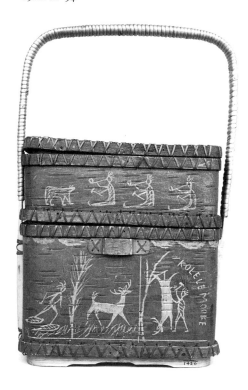

Northern Ute doll on an inverted u-shape cradle (fig. 11-5 and plates 2, 3, 8, 9, 11, 12, 32).

The Temple collection contains several excellent examples of Great Lakes beadwork, including bandolier bags, garters, and a woman's beaded hair tie. There are four Iroquois wooden masks from the Society of Faces and a cornhusk mask. One of the wooden masks is Seneca and may have been made for ceremonial use; the other three were made for sale. Also included is a small Seneca doll made of cornhusk and dressed in eighteenth century woman's clothing (fig. 11-6). The collection contains thirty-nine ceramics from the prehistoric Midwest, prehistoric Peru, and the historic Southwest. Among the more interesting of the latter group are several Zuni and Cochiti pieces, including a canteen, pitcher, and water bottles.

Mrs. Cheyney had retained the photograph album documenting the Temple collection, and Haffenreffer sent her a telegram following the purchase insisting that it be sent to him. In this, as in many other negotiations, Haffenreffer made repeated attempts to establish the origins of his acquisitions. He utilized a system of affidavits, that is, certificates that donors wrote and signed to attest to the authenticity of objects, noting object history, function, and when and where they were obtained. These records, somewhat unusual for a museum, probably stemmed from his sound business instincts requiring "truth in advertising," but they also show his awareness of the importance of collection history.

Many other collectors did not share this awareness. With donors of all types, Haffenreffer constantly had to repeat his requests for documentation. In 1935, after an exchange of seventeenth-century Wampanoag material from the Museum of the American Indian, Haffenreffer wrote to George Heye, "Upon cataloguing the specimens you so kindly sent me, I find that I have no information relative to the origin or history concerning same. Would you be so kind as to send me as soon as possible, all available information pertinent to these beautiful specimens whose numbers appear on attached sheet?"[13] Haffenreffer even requested documentation from the president of the Rhode Island Historical Society, a donor, who replied

Fig. 11-5
Pipe and bag, Pomo, 19th c. Hide, pigment, wood. Pipe, L 11.5 cm. Purchase, Temple 1929. L to R: 61-92, 57-199

Fig. 11-6
Doll, Seneca, 19th c. Corn husk, lace, cotton cloth & string, glass beads. L 26 cm. Purchase, Temple 1929. 57-253.

with embarrassment: "I know perfectly well that a museum specimen is of slight value without data and I am chagrined that I omitted the little I know about the Alaskan articles from the package."[14] Even with his understanding of the importance of collection history, Haffenreffer found it difficult to maintain sustained internal record-keeping with no professional curator except during the brief Saville era. In this, his was like other small private museums rather than the larger regional museums of the time.

THE WEST DISCOVERED

In 1917 Rudolf Haffenreffer purchased lead and silver mines in Utah and California. As a result, he began taking regular business trips to the Southwest which continued through the 1940s, long after he had sold his mines. On these trips he developed a growing awareness of and collecting interest in the Native arts of the Southwest and the Plains, and indeed in all of the Americas.

To collectors of Native American material culture who lived in the East, the Southwest and the West were quite possibly synonymous, each standing for the other and both in some way for the frontier. The towns of Santa Fe, Albuquerque, and Gallup had long been centers of trading post activity and of the exchange of Indian arts and crafts from a wide area. A number of factors combined to create this phenomenon.

Trade between Native people of the Southwest and Mexico had been active since pre-Columbian times and continued to flourish when non-Indians became consumers. In the 1880s the newly-laid rail lines of the Atchison, Topeka and Santa Fe, along with other railroads, began to bring Easterners from Chicago to the Southwest and then on to California. They came on business, as new settlers, and soon as sightseers, especially after the Fred Harvey Company was franchised by the railroad in 1889 to provide restaurants and hotels at key stopovers, such as the Alvarado Hotel in Albuquerque. This made travel by train a pleasant excursion rather than an uncomfortable ordeal (fig. 11-7).[15]

By the early twentieth century, a large tourist community created a steady market for Native-made objects. Materials from the more isolated Plains reservations also began to filter to the Southwest where they found ready buyers. At the same time, Santa Fe and surrounding areas were becoming a mecca for artists and writers, who were attracted by the natural beauty of the landscape and the ambiance of the Native and Hispanic communities. The White artistic community, and individuals with philanthropic and business interests, joined anthropologists at the Museum of New Mexico in encouraging a series of fairs, events, and markets for the advancement of local Native arts.[16]

It was thus to an area charged with excitement about Native arts that Haffenreffer came in 1917, and he responded enthusiastically. In later years he was often accompanied by his wife Maude and frequently made Phoenix his first destination, staying there for three or four days before going to his mine in Bingham Canyon, Utah.[17] This relaxed, vacation-like stopover may explain a rather substantial purchase at Vaughn's Indian Store in Phoenix on April 9, 1928, of five Navajo rugs, a "mastodon" bone, three metates, 134 prehistoric lithics and sixty-seven obsidian, red, and jasper points.[18]

The diverse nature of Rudolf Haffenreffer's collecting habits in the West seems to indicate his excitement at the many opportunities for collecting along the lines of his personal interests – opportunities that were not as readily available in the East. Perhaps this was a fairly typical reaction of an Easterner newly arrived in the West. It was certainly typical of the eclectic collections of the late-nineteenth-century cabinets of curiosity and natural history museums, to which Haffenreffer had undoubtedly been exposed in his youth. In 1929 Haffenreffer purchased dinosaur prints from the Babbitt Ranch in Flagstaff, Arizona, and in 1931, a forty pound fragment of a meteorite which had recently been discovered in nearby Canyon Diablo.[19] The local newspaper coverage of these additions to the Haffenreffer collection was extensive, indicative of the intense interest of the time in "scientific" finds that might help explain the origins of the natural world and, particularly, the wonders of evolution.

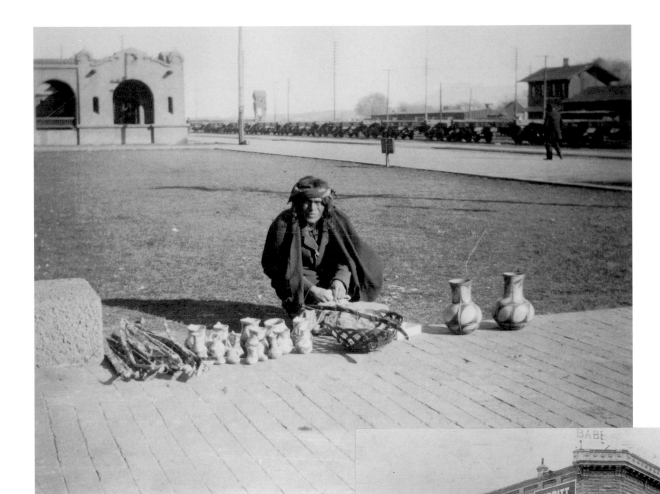

Fig. 11-7
Man selling Santo Domingo pottery and bows and arrows
to tourists and other travelers at train station, Albuquerque,
N.M.; Alvarado Hotel in background. Churchill Collection
1907, National Museum of the American Indian, Smithsonian
Institution.

Fig. 11-8
Babbitt Brothers, General Merchandise, Flagstaff, Ariz.
ca. 1915. Arizona Historical Society.

Haffenreffer purchased Indian objects at a num-
ber of old and well known trading companies –
among them Babbitt Brothers of Flagstaff, Arizona
(fig. 11-8); Ilfeld's of Zuni, New Mexico; and the
C. N. Cotton Co. of Gallup, New Mexico.[20]
These three giants of the Indian trading world
each maintained large central warehouses, from
which they stocked their smaller trading posts
located in the more isolated areas of the Navajo
and various Pueblo reservations. Haffenreffer also
visited some small rural posts. In 1937, in Teestoh,
Arizona, on the Navajo Reservation along the

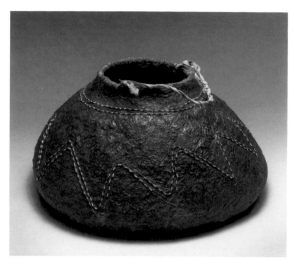

Fig. 11-9
Water jar, Apache, ca. 1900. Sumac, resin, glass beads, cotton cloth. H 25 cm. Purchase, Vaughn's Indian Store, Phoenix, Ariz. 1929. 71-5030

border of Hopi, he obtained a curious miniature stone representation of a Veracruz ball player's yoke, dating from A D 300 to 900, with recarved faces of a type common in Central Mexico, dating to the mid-nineteenth century. Other objects acquired on the same 1937 trip – which might be from Teestoh although not specified as such – include prehistoric Anasazi, Hohokam, and Sikyatki pottery, Apache resin-covered basketry water jars, Plains and Southwestern drums, and "Aztec" figurines. Aztec was a term very generally applied at the time to most pre-Columbian objects, or reproductions of them.[21]

A "buying spree," from April 25th through May 15th, 1929, reveals the way in which Haffenreffer collected large numbers of objects in a short time, fitting his Indian interests into his principal purpose for going West – to oversee his silver and lead mines. Haffenreffer usually made these trips in late spring. Sometimes he purchased personally; at other times company officials acted on his behalf. On April 25th, Vaughn's Indian Store in Phoenix invoiced the Utah-Apex Mining Company fifty-eight dollars for prehistoric pottery, Hopi "boomerangs" (rabbit-hunting sticks), Hopi and Tewa drums, and an Apache resin-covered basketry water jar imbedded with glass beads (fig. 11-9). On April

27th, C. N. Cotton in Gallup sent nine Navajo rugs valued at $450 express collect to Haffenreffer's Fall River, Massachusetts home.[22] One day later Haffenreffer was at the Ilfeld Indian Trading Company in Zuni, New Mexico buying pottery; and on April 29th at La Fonda Indian Shop located in the La Fonda Hotel, in Santa Fe, part of the Fred Harvey chain, he selected prehistoric lithics for the King Philip Museum.[23] On May 1st, the Spanish & Indian Trading Company of Santa Fe invoiced the King Philip Museum forty dollars for sixteen "stone idols" and a "fetish."[24] Finally, on May 15th, Mr. Hilton, Secretary of the Utah-Apex Mining Company in Fall River, who frequently accompanied Haffenreffer on his Western trips, purchased a group of arrows at Vaughn's which were sent east care of the company.[25]

In his travels about the Southwest in the 1920s and 1930s, Haffenreffer experienced the Indian trading posts during their most successful period. Through them he had the opportunity for direct contact with both traders and Native people, and he had a wide variety of exceptionally finely crafted Native arts from which to choose. At that time trading posts were still the most important exchange link for Native people. To them they brought their handmade arts, particularly rugs, as well as raw wool, and live sheep and calves, in exchange for commercial products such as canned foods, syrup, coffee, seed, hardware, tools, and cloth.[26]

Fig. 11-10. *Tag,* United Indian Traders Association. H M A Archives.

In order to inspire confidence in the art market, the Indian Arts and Crafts Board of the Department of Interior attempted in 1931 to monitor the quality and verify the authenticity of Indian-made objects through the formation of the United Indian Traders Association (U.I.T.A.). The Board provided tags which were to be attached to approved Native-made goods. Many of the pieces purchased by Haffenreffer bear the UITA tag (fig. 11-10).[27]

In 1931 Haffenreffer enjoyed several trips through the Utah countryside with Heber J. Grant, President of the Mormon Church, and "was interested to find that the Mormon creed is somewhat based upon the Indian beliefs."[28] Grant and his wife later visited the King Philip Museum. In 1937 and 1938 Haffenreffer visited Hopi country, and in 1938 he stopped at Juan Lorenzo Hubbell's trading post at Ganado, Arizona. On this and many other occasions through 1947, Haffenreffer bought objects in the West that appealed to him, probably without attempting to make type collections or to balance regional representation.[29] Nevertheless, the Western trips – taken over a period of some thirty years – represent a sustained interest in and continuing additions to his collections of Navajo rugs and silverwork, Pueblo textiles, painted skins, pottery, and jewelry, and Plains beadwork and drums.

Navajo Rugs

In the 1920s Rudolf Haffenreffer purchased numerous Navajo rugs, both for his own personal use and for the Museum. The twenty rugs in the Museum collection in 1955 represent a period of transformation in Navajo economic production, as the blanket – an article of Native clothing – became the rug, an article of home furnishing for non-Indians.[30] Since first learning to weave from the Pueblo people in protohistoric times, the Navajos had long bartered their woven wool wearing-blankets with other tribes and with Mexicans. But it was not until after their return from a four year imprisonment in Ft. Sumner, New Mexico to a newly created Agency at Fort Defiance, Arizona in 1868, that the manufacture of Navajo weavings for an outside market began. By the first quarter of the twentieth century rugs had become

a major part of the Navajo/trader economic complex, with the market for them exploding in a forty-fold increase in earnings between 1890 and 1931.[31]

This expansion was due largely to the influence of White traders who began to move into and near the newly formed Navajo Reservation in the 1870s. Juan Lorenzo Hubbell and Clinton N. Cotton, partners through the 1880s, particularly sought to increase the output of weavings and to find new eastern markets for them. Larger pieces were encouraged, in order to create room-size rugs, and borders began to appear. Smaller sizes, suitable for chair coverings, table runners, and pillow throws were developed.

Haffenreffer's first recorded acquisitions, in 1923, of Navajo weavings were actually made in California, not in the Southwest. There, within two days, he purchased fourteen Navajo rugs and some Navajo camp furnishings. The "bale of Indian rugs" was mailed to Haffenreffer by American Express. Several were described as "yeibichai" and "sand painting" rugs.[32]

Some of the Haffenreffer rugs reflect changes in design, as traders imposed ideas of their own, or those taken from Caucasian rugs, onto the stripes, blocks, crosses, stepped triangles, and zigzags of the earlier Navajo repertoire which was based on their own basketry tradition and a variety of earlier Pueblo prototypes.[33] Trading post styles soon became recognizable, and the Crystal, New Mexico trading post published a catalogue of its designs in 1911.[34] Several rugs in the Haffenreffer collection can be attributed to weavers from the Crystal area, who incorporated oriental rug motifs such as hooks into their designs (figs. 11-11, 11-12).

J. L. Hubbell hung painted pictures of favorite old blanket designs on the walls of his Ganado trading post, and encouraged weavers to follow them. A large Moki-stripe, hand-spun rug or blanket, probably from 1890–1910, represents a revival style favored by Hubbell (plate 13). A similar example is pictured in a 1905 catalogue and price list distributed by Hubbell and could be ordered in a number of sizes. Advertised as "fine grade old style weaves and patterns," this rug/blanket, with

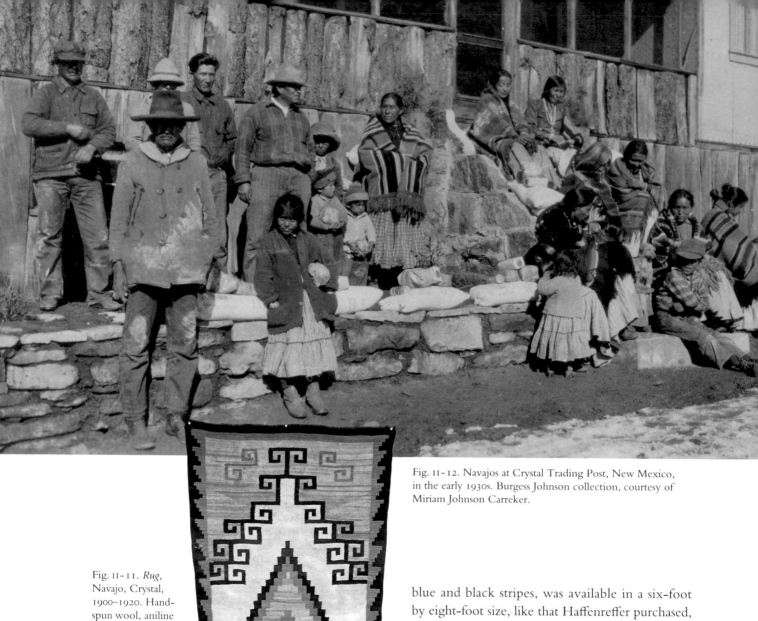

Fig. 11-12. Navajos at Crystal Trading Post, New Mexico, in the early 1930s. Burgess Johnson collection, courtesy of Miriam Johnson Carreker.

Fig. 11-11. *Rug,* Navajo, Crystal, 1900–1920. Hand-spun wool, aniline dyes. L 193 cm. Purchase. 71-5062

blue and black stripes, was available in a six-foot by eight-foot size, like that Haffenreffer purchased, for fifty to seventy-five dollars. Such revival weavings were part of Hubbell's endeavor to elevate the quality of Navajo weaving from its turn-of-the-century slump. They were produced by the several hundred weavers who sold to Hubbell, and he then marketed them wholesale to C. N. Cotton, Fred Harvey, and other outlets, or sold them directly from his Ganado post.[35]

Pictorial rugs, sometimes showing *ye'ii* (a holy person) or *ye'ii bicheii* (*ye'ii* dancer), became increasingly popular after the turn of the century. In the traders' invoices, those with religious subject matter are sometimes called "sandpainting" rugs, named for the medium in which they were originally executed. Rudolf Haffenreffer purchased sev-

eral of these, among them one depicting Eagle Trap, Eagleway (plate 14). Based on its similarity to an earlier (1904) rug in the Huckel Collection of the Taylor Museum, the central figure is probably Monster Slayer, hero of the myth of the Eagle Chant, here depicted trapping eagles using a yellow prairie dog for bait.[36]

The Haffenreffer collection contains three rug/blankets from the late Transitional Period (ca. 1880–1920) woven in a zigzag outline style, apparently derived from earlier weavings that are called "eye-dazzlers" because of their small, serrate triangle and diamond patterns in intense, contrasting colors (plate 15).[37] Other interesting weavings in the Haffenreffer collection are a child's wearing blanket woven in a serape pattern, and a diamond twill saddle blanket.

Pueblo Textiles

The nine pueblo textiles in the collection lack specific history but were likely purchased in the Southwest by Rudolf Haffenreffer between 1917 and 1947. Included are a Hopi kilt, a Hopi wedding sash and four other sashes of cotton with wool brocades, and two woven belts. There is also a Jemez Pueblo shirt of handwoven cotton with wool embroidery, made in three pieces, with commercial cotton twine tool-twisted warp, and brocade of Germantown wool (fig. 11-13).

Pueblo textile artists were skilled in spinning and weaving a species of cotton, *gossypium hopi,* that has been grown from Peru to the Southwest United States since pre-Columbian times.[38] Until recent years the Hopis continued to grow cotton in small patches at the foot of their mesas, holding on to this traditional industry longer than other pueblo groups, who gradually turned their cotton fields to other crops after the railroads brought inexpensive manufactured cotton cloth to the Southwest. A 1905 brochure from Hubbell's Trading Post advertised hand-woven Hopi apparel.[39] Haffenreffer visited Hubbell's and the Hopi Reservation in 1937 and 1938 and may have purchased the pieces at either place (fig. 11-14).

Fig. 11-13.
Shirt, Jemez Pueblo, ca. 1900.
Handwoven cotton, wool embroidery. L 60 cm.
Purchase in southwest.
60-4578

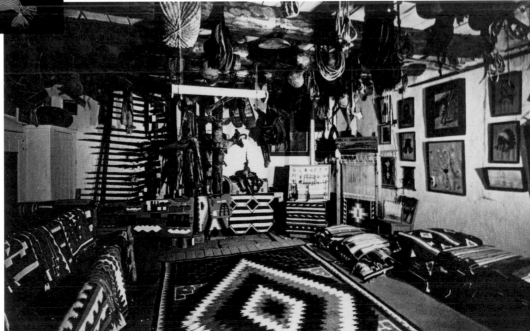

Fig. 11-14
Hubbell Trading Post, rug room. Arizona Historical Society 60035.

Painted Skins and Jewelry

Haffenreffer purchased silver, turquoise and shell jewelry, and painted skins, as well as historic and prehistoric pottery at Zuni, at least some of which is from Ilfeld Indian Trading Company (fig. 11-15). Haffenreffer made many of his purchases from Dick Senaha (Tsinnahe), known to outsiders as "Zuni Dick," an interpreter, artisan, storyteller, and prankster, who had been a tribal governor in 1888 (fig. 11-16). Tsinnahe was well known to anthropologists who worked with the Zuni — among them Frank Cushing, Matilda Coxe Stevenson, Stewart Culin, and Ruth Bunzel — as a facilitator between outsiders and the Zuni commu-

nity.[40] Haffenreffer wrote of a meeting with Tsinnahe in 1929, "I had a very interesting visit with Zuni Dick and several of the other tribes' Governors...." Apparently they met several times thereafter, Haffenreffer enjoying his acquaintance and often sharing his stories with his sons.[41] A stone and shell necklace in the collection, with birds and other animals and a cross inlaid with turquoise, is attributed to Zuni Dick's daughter.

Two skin paintings purchased in Zuni were favorite pieces of Haffenreffer's, judging by their frequent inclusion in newspaper photographs of his collection. Both skins are spiritual in subject matter but were made for decorative rather than

Fig. 11-15
Ilfeld Indian Trading
Company, Zuni, N.M., 1923.
In foreground are bread
ovens and bridge over Zuni
River. Victor Schindler,
National Museum of the
American Indian, Smithsonian
Institution. On left, a bill of
sale from Ilfeld to Haffenreffer
dated April 28, 1929.

Fig. 11-16
Zuni Dick (on right) using
drill to make beads, 1897,
Zuni, New Mexico. National
Museum of the American
Indian, Smithsonian Institution.

religious purposes. One depicts three pairs of animals (mountain lion, bear or badger, and deer), with spirit lines. The animals are symbols used on the altars of curing societies (plate 16). The other skin depicts the spirit *Achiya: latapa* (Knife Wing), which was used as a symbol of power by the *Lhe we: kwe* (Sword Swallowing Society), no longer in existence, and *Halo: kwe* (Ant Society) (fig. 11-17). Both skins were almost certainly painted by Teddy Weahkee, a Zuni artist who worked for C. G. Wallace, a trader at Zuni, from the mid-1920s through the 1930s. Commercially available during this period, such painted skins had no part in Zuni ritual. *Achiya: latapa* has also frequently been represented in Zuni silver and lapidary art.[42]

Pottery

Rudolf Haffenreffer created a pottery collection quite broad in scope and from a variety of sources. In 1955, it contained 351 examples, of which he personally collected 162 in the southwest, obtained thirty-nine from the Temple collection, and received seventeen in exchanges with the Museum of the American Indian, Heye Foundation. From the Northeast region there is a seventeenth-century pot that was unearthed in New Jersey and a late-nineteenth-century wheel-thrown water jar from the Gay Head Wampanoag. Six pots of the Atlantic Late Woodland period are from Georgia and Florida and three prehistoric ceramics are from California. From an independent trader, Dr.

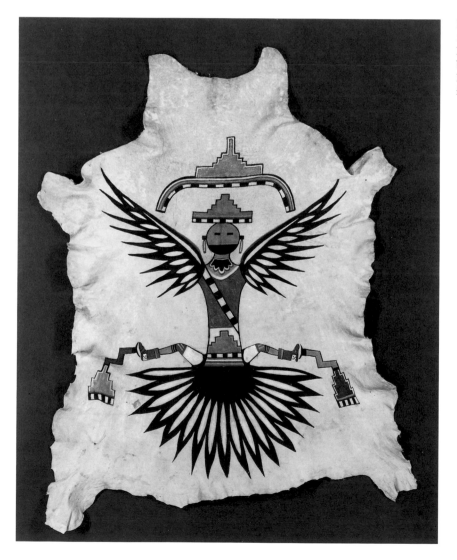

Fig. 11-17
Skin Painting of the spirit Achiya: latapa (Knife-Wing), Zuni. Painted by Teddy Weahke, ca. 1930. Deer hide, pigments. L 200 cm. Purchase in Zuni. 75-92

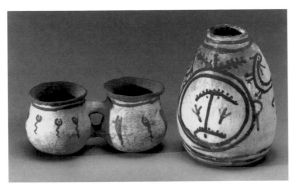

Fig. II-18
Double paint cup and jar, Zuni, ca. 1850. Clay, slip. Jar H 17 cm.
L to R: 61-229, purchase in Southwest; 75-17, purchase
Temple 1929.

José Gonzalez, Haffenreffer purchased twenty examples of Costa Rican prehistoric pottery. The remaining ceramics are from the Southwest, where Haffenreffer obtained both historic and prehistoric pottery at trading posts and retail outlets during his Western trips beginning in 1917. Some of the pots are badly worn, discolored, or not particularly significant in form or design. They may represent the "lots" which Haffenreffer sometimes purchased,

containing a few excellent pieces, and many mediocre ones, which he intended to "weed out" at some point (Krech, this volume).

Included are examples from the Anasazi (figs. III-18, III-19), Hohokam, and Mogollon, Hopi, San Ildefonso, Santa Clara, Maricopa, Zuni, Acoma, Laguna, and Cochiti. Among the historically and artistically important pieces purchased by Haffenreffer are a Sikyatki water jar, ca. AD 1500, of which only about fifty same-size vessels exist in good condition elsewhere (plate 18).[43] There is an early historic Gila bowl from the Salado area (plate 19), a classic Zuni water jar (plate 20), and two probable Zuni altar pieces, namely, a double paint cup with tadpoles painted on the outside, used for body painting in ritual dancing. and a jar possibly molded around a gourd, painted with four-legged birds (fig. II-18).[44] Also important are Cochiti animal effigies (fig. II-19), a San Ildefonso blackware vase made by Maria Martinez, painted by her husband Julian, and signed "Marie," a Santa Clara blackware jar with bear paws, and several Maricopa effigy pieces signed "Mary Juan" and "Luke Young" (fig. II-20). The practice of signing pottery began in the 1920s, encouraged by anthropologists at the Museum of New Mexico who felt that such signatures would increase the market value of a known potter's work.

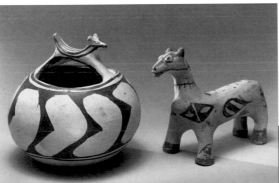

Fig. II-19
Effigy ceramics, Cochiti, early 20th c.
Clay, slip. Bowl D 17 cm.
Purchase in Southwest.
L to R: 75-27, 75-24

Fig. II-20
Ceramics, Maricopa, signed
"Mary Juan" and "Luke Young,"
ca. 1930. Clay, slip, glass beads,
paint. Right bowl H 17 cm.
Purchase in Southwest.
L to R: 61-226, 61-283, 61-282

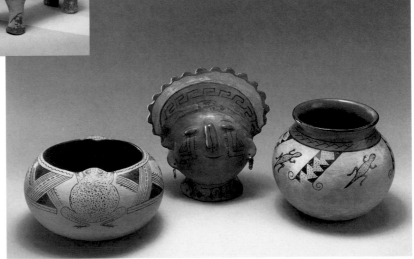

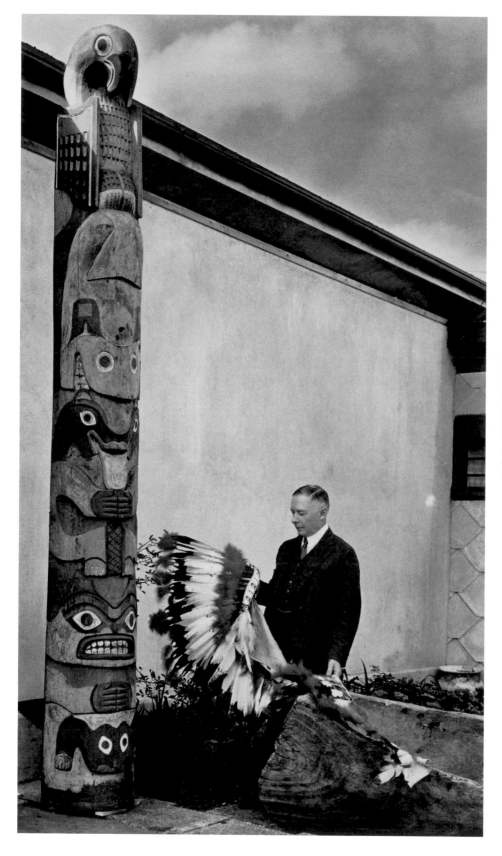

Fig. 11-21
Rudolf Haffenreffer
outside the King Philip
Museum with totem
pole purchased in 1931,
dugout canoe, and
headdress commissioned
in 1929 to signify his
rank as Honorary Chief
Sachem of the National
Algonquin Indian Coun-
cil. Haffenreffer Museum
of Anthropology.

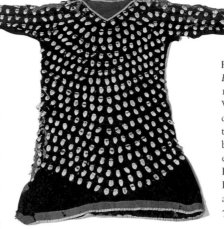

Fig. 11-22
Dress, Crow, late 19th, early 20th c. Wool, glass beads, cotton string and tape, hide, elk teeth, bone, elk antler, earth paint.
L 105 cm. Purchase, Plume Trading and Sales, N.Y., 1936. 74-44

THE PLAINS COLLECTION
AND THE INFLUENCE OF SCOUTING

The Plains collection was Rudolf Haffenreffer's favorite.[45] The degree to which he surrounded himself with objects from the Plains may indicate that he identified the Plains with "Indianness" in his mind. In the course of thirty years he collected some 450 examples of nineteenth- and twentieth-century Plains material culture.[46] No record exists of personal buying trips to the central and northern Plains, but Haffenreffer and others acting for him purchased Plains materials in Utah, New Mexico, and Arizona, and some objects were ordered from suppliers in Nebraska. The Lyon Curio Store in Clinton, Nebraska provided him with three eagle feather headdresses in 1929. One of these was newly made and, according to newspaper accounts, was worn by him to signify his rank of Honorary Chief Sachem of the National Algonquin Indian Council (fig. 11-21. McMullen, this volume).[47]

Haffenreffer's close involvement with the Scouting movement may have stimulated his interest in Plains materials (Krech, this volume). Several books important to Scouting and possessed by Haffenreffer were written with a Plains orientation, among them *My Life as an Indian* by James Willard Schultz, an Easterner married to a Blackfeet woman. Through such literature, Scouts became familiar with the words and deeds of Plains historic figures. In 1937, the year following the large gathering of five hundred Rhode Island Boy Scouts at Mount Hope, Haffenreffer purchased ten drums, of both frame and box type, during his trip West, perhaps to fill Scouting needs.

Certain trading supply companies catered to the Scouts as much as to Indian customers, supplying beads, leather, feathers, and other items for the preparation of traditional dance paraphernalia. An important supplier in the East was James R. Luongo, owner of Plume Trading and Sales, in New York

City, and through the years, from 1936 to 1943, Haffenreffer was a steady customer.

Originally a hatmaker, Luongo came into the Indian trade by chance. In the 1920s, Mohawks from the St. Regis Reservation in upper New York State who were construction workers in New York City began coming to his milliner's shop at 155 Lexington Avenue to buy feathers for dance regalia. Soon Luongo stocked not only feathers but other materials such as beads, leather, and hawk bells that Indians would buy. Before long, he gave up making hats, and devoted his store and a mail order business to items appealing to Native people, hobbyists, and the large Scouting market. He named his enterprise the Plume Trading Company (later Plume Trading and Sales) in honor of the feathers which had started it, and he became the premier distributor of Indian goods in the East, from 1927 when the company was founded until 1986 when the last of the merchandise was sold.[48]

Through Luongo, Haffenreffer purchased the remaining ethnographic objects in the inventory of Adrian Carter, who had operated a trading post at Crow Agency, Montana in the first quarter of the twentieth century. Carter's stock included three interesting examples of the use of wealth as ornamentation by Plains women: the first was a dress belonging to Julia K. Selwyn, a Yankton Sioux, who in 1900 had covered the bodice of her cloth wedding dress with 358 aluminum tokens,

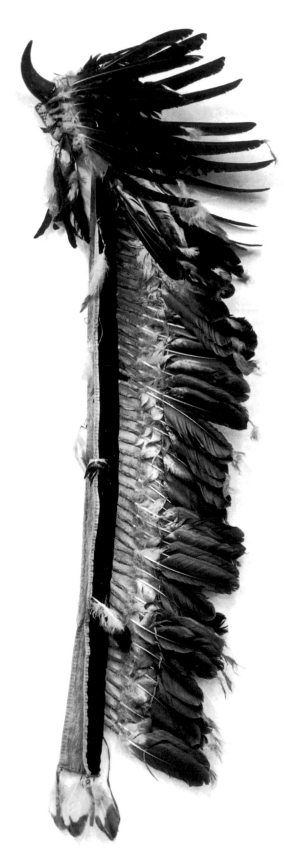

Fig. 11-23
Eagle feather horned headdress, Northern Cheyenne or Teton
Sioux type, 1870–1910. Golden eagle and black-billed magpie
feathers, bison horn, wool, cotton, dyed horse
hair, glass beads, felt, hide, sinew, wire. L 203 cm. Purchase,
Temple 1929. 77-195

applied in curved lateral rows, each token stamped with her name on it; the second was a Crow woman's woolen dress with 872 elk's teeth and imitations of same (fig. 11-22); and the third was a Cheyenne child's dress of velour embroidered with 245 cowrie shells, also applied in curved lateral rows.

Other sources of Haffenreffer's Plains material were private collections (Remington 1928, Temple 1929, Colcleugh 1930, Rowell 1934) and auctions such as that held in 1938 by Gustave J. S. White of Newport. The Temple collection alone contained 129 Plains objects (fig. 11-23 and plate 22). Finally, in a 1943 cash exchange with the Museum of the American Indian, discussed elsewhere, Haffenreffer acquired thirty-seven Plains objects.

BOARD MEMBER OF THE MUSEUM OF THE AMERICAN INDIAN

In 1930 Rudolf Haffenreffer was invited to join the Board of Trustees of the Museum of the American Indian, Heye Foundation in New York City, which held the largest collection of Indian materials in the world. His membership on the Board continued for twenty-two years, from 1930 to 1952, and his friendship with George Gustav Heye, its founder and director, lasted the rest of his lifetime. The influence of this personal relationship must be considered a factor in his development as a collector. George Heye served as a kind of mentor, advising and encouraging Haffenreffer as he built his collection, while Rudolf in turn served as a financial advisor to Heye's increasingly debt-ridden museum. Like Haffenreffer, Heye was of German-American descent. Both men were born in 1874, and they died within three years of one another. Both men built museum collections, but for George Heye, the Museum was the focus of his life, while for

Haffenreffer, it remained a "passionate hobby," secondary to his many business interests. While Haffenreffer had acquired about twenty-three hundred ethnographic and forty-two thousand archaeological specimens by the time of his death in 1954, Heye, starting at about the same time, had acquired close to three million specimens when he died in 1957.[49]

Haffenreffer's fellow trustees included major figures of the New York business, social, and intellectual world. Archer Huntington had provided the site for the building complex that housed the Museum. William Shirley Fulton, an avocational archaeologist, founded the Amerind Foundation, and together with Henry Lee Ferguson, a business man and naturalist, wrote a monograph on the archaeology of Fisher's Island, N. Y.[50] Joseph Keppler was a cartoonist and noted collector, whose collections eventually came to Heye's Museum. The Board relationship thus put Haffenreffer in touch with other major collectors and gave him access to private sales and auctions as he gained information by word of mouth about dealers, trades, and available objects. Through these contacts, and a series of exchanges with the Museum of the American Indian, Haffenreffer continued to build his collection through the 1940s.

Haffenreffer and Heye enjoyed a cordial relationship from the start. Trustees' meetings were held six times a year, and Maude and Rudolf Haffenreffer and George and Thea Heye also met socially. In a 1931 letter, Heye wrote, "Mrs. Heye and I often speak of the very pleasant time we had with you and Mrs. Haffenreffer and hope you have not forgotten your promise to let us know when you reach New York so that you can try some of that real German beer."[51] Occasionally in the 1930s a summer meeting of the Trustees would be held in Bristol, hosted by Haffenreffer. Sometimes also the members met on Fisher's Island, with Henry Ferguson as host. In December 1936 Frederick K. Seward, secretary of the Heye Foundation Board of Trustees, wrote to Haffenreffer: "We missed you a lot at our recent Trustees' meeting. The members of the Fisher's Island, Squantum, Bristol Expedition were all there, with the exception of your good self. We had a lot of fun at the meeting and at the dinner afterwards, talking over the big party."[52] In this relaxed and congenial atmosphere of shared enthusiasms, Haffenreffer undoubtedly learned much that was to help him build his collection. Sometimes the help was direct. In 1937 the president of the American Art Association sent a catalogue to Seward announcing the sale of the Baisley collection of American Indian art, collected over a period of fifty years, and wrote: "It is very seldom that material of this kind is dispersed at public sale."[53] Seward shared the information with Haffenreffer, and thirty-four excellent examples of basketry from the Northwest Coast, California, Plateau, Basin, and the Southwest came to the King Philip Museum from the Baisley collection (fig. 11-24).

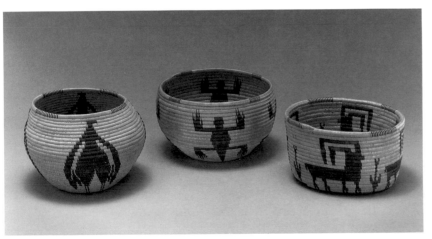

Fig. 11-24
Baskets, Washo, late 19th, early 20th c. Willow, bracken fern root. Left basket H 9.5 cm. Left & right, purchase, Baisley 1937. Center, purchase, Little Colorado Trading Post.
L to R: B-141a, 71-5198, B-141b

In March 1931 Haffenreffer sought advice from Heye about a totem pole offered for sale at Leonard Galleries of Boston. He eventually purchased it and immediately sent a photo of it, with himself standing by, to George Heye, and wrote: "I secured the totem pole, and it appears to me to be a fairly old one. Can you decipher the figures?"[54] Heye responded with an analysis of the carvings and added: "I am delighted that you got the totem pole and to know that you feel it is a fairly old one. Undoubtedly it is of extreme age compared with the living totem standing by it..." (fig. 11-21).[55] In the same letter Heye thanked Haffenreffer for his contribution of one hundred dollars toward the purchase of a buffalo tepee for the Museum of the American Indian. On numerous occasions Haffenreffer made similar donations for acquisitions requested by Heye for his museum.

During 1931 and 1932 the two men discussed the possibility of each purchasing one of the old seventy-foot high poles still standing in the Nass Valley of British Columbia. "It certainly would be a magnificent thing to put near the shore in front of your Museum and I really believe it is the last opportunity to get any poles out from British Columbia at least for many years to come....there are several museums in the country that will take it in case you do not want it," Heye wrote.[56] The cost of the pole, landed in Bristol, would have been $2500. Haffenreffer declined: "I doubt very much that I would be enough interested to the extent of $2500 just at this time."[57]

Exchanges

In 1932, Haffenreffer asked Heye for advice on the best way to "round out" his collection, stating "you are so much the better judge of what I need, that I would suggest that if it is agreeable, you prepare a list of the items, together with their cost, which I may have for study.... The Burr's Hill items have, of course, particular interest, because of their close proximity."[58] Heye responded with a list of types of objects from different culture areas and estimated prices. Haffenreffer did not actively follow up this advice, possibly because he felt he already owned sufficient objects in the various cat-

egories to suit him. He had been steadily acquiring artifacts in the Southwest, the Northeast, and, with the purchase of the Temple collection in 1929 and the Colcleugh collection in 1930, the Plains, Northwest Coast and Subarctic as well. The next letter from Heye discussed a collection of twenty pipes which had been offered him for three hundred dollars. "The Trustees are subscribing sums of $25 and $50 each toward their purchase, and I am writing to see if you feel that you could contribute toward this fund."[59] In November 1934, Heye sent Haffenreffer a box containing a representative collection from Burr's Hill, Rhode Island, a seventeenth-century Wampanoag burial ground. In what was called an "exchange" Haffenreffer received the ninety-one specimens, with a value of one-hundred dollars, in return for "pipes." Since the pipes are not described in the exchange, nor is there any record of pipes having left the Haffenreffer Museum, one assumes that Haffenreffer received this exchange material in return for a one-hundred dollar contribution toward Heye's earlier request for help in purchasing the pipe collection. Through this process Haffenreffer and other Board members acted as patrons to Heye.

The term "exchange" needs clarification. Exchanges of museum materials were a common practice of the period, especially among private museums, many of whose founders felt they had a right to trade, sell, buy, or give away their collections as they saw fit. Some institutions had strict guidelines. Warren K. Moorehead, director of the Department of American Archaeology at Phillips Academy, Andover, sent a selection of archaeological materials from the Archaic "red paint" complex in Maine to Haffenreffer in 1929, and explained: "It has been our policy to assist the new museums in the way of collections. That is, of course, following the general custom we never sell specimens, but it is legitimate for a museum to

Fig. 11-25
Jacket, Teton Sioux, ca. 1890. Deer hide, glass beads, sinew, yellow ochre. L 79 cm. Collected 1921; exchange, MAIHF 1943. 73-27

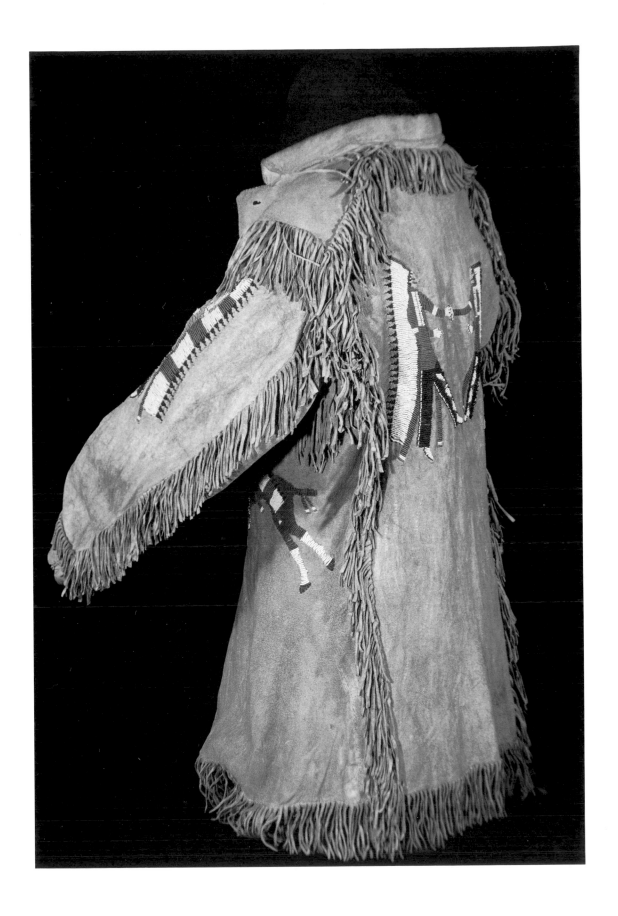

send some of its material to another institution of like character. That institution may, or may not, send an honorarium toward field work. You having already done so, we return the favor."[60]

The Foundation Deed of the Museum of the American Indian allowed the trustees to make "loans to or exchanges with other scientific institutions of...duplicate or surplus material..."[61] Accordingly, the Museum of the American Indian kept a Book of Exchanges. In 1933, for example, this book records an exchange with the Field Museum in Chicago of H. R. Voth's 1870s collection of Hopi ceremonial material in return for some duplicate textiles from the Southwest, Northwest Coast, and Mesoamerica from the Museum of American Indian's collections.[62] And in 1934, among many other exchanges, there is recorded the exchange of Burr's Hill materials with the King Philip Museum.

In 1943, the desperate state of finances of the Museum of the American Indian called for a change in the nature of these exchanges. On May 5, 1942, George Heye, as Chairman of the Board of Trustees, submitted a letter to his Board recommending that "In view of the fact that the Museum's income was less than the $28,000 called for by the budget...I recommend that you authorize the sale or disposition of...duplicate and surplus specimens..."[63] The Trustees adopted this resolution.

Shortly thereafter, Heye negotiated the exchange of thirty-seven Plains ethnographic objects and seventy-four California archaeological specimens in return for $1580 from Haffenreffer. The Plains objects acquired at this time included some outstanding examples of nineteenth- and twentieth-

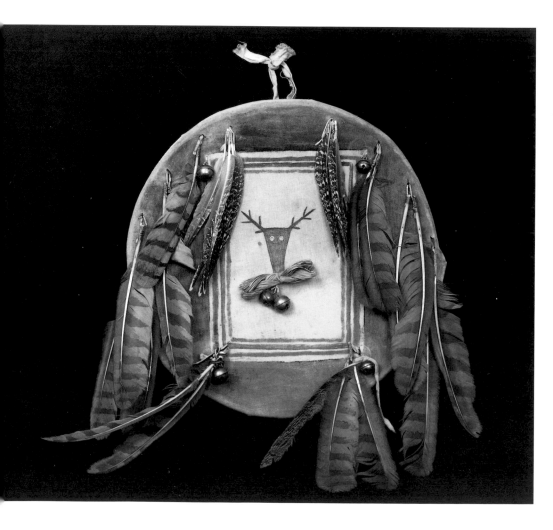

Fig. 11-26
Dance shield, Elk Dreamer's Society, Teton Sioux, before 1888. Muslin, willow, paint, hawk bells, sweet grass, owl and grouse feathers. D 48 cm. Exchange, MAIHF 1943. 78-107

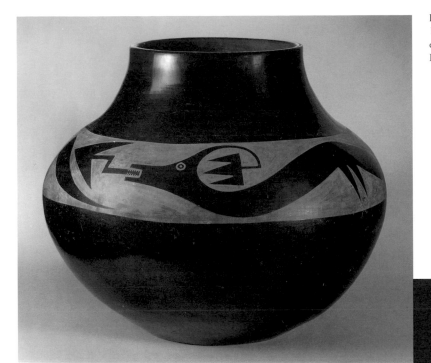

Fig. 11-27
Water jar, San Ildefonso, signed "Tonita,"
early 1920s. Clay, slip. D 35 cm.
Exchange, MAIHF 1945. 75-11

Fig. 11-28
Jar, Santo Domingo, late 19th c.
Ceramic, slip. H: 20 cm.
Exchange, MAIHF 1945. 61-255

century beaded and quilled clothing, lattice cradles, musical instruments and dance paraphernalia (figs. 11-25, 11-26 and plate 21). Many objects had been collected directly from Native people by reliable collectors; among these are a Cree stone maul collected by Donald A. Cadzow, and a Wichita gourd rattle and Kiowa parfleche collected by Mark R. Harrington. From the Crow people there was a medicine bundle collected by William Wildschut, a pack saddle collected by Joseph K. Dixon, and a woman's beaded leather belt collected by Milford G. Chandler.

Heye expressed his gratitude to Haffenreffer in a letter, "My dear Rudy: The shipment of four pieces goes forward today. I have added other specimens to the lot and I figured the amount equals $1,580.00. I really hope that you are satisfied with the deal, and I want to thank you most heartily for your liberality. You certainly are a friend in need."[64] Haffenreffer acted as a good board member in coming to the financial rescue of Heye at this time and was also an astute collector in adding such significant objects to his own collection.

Again in 1945 Haffenreffer and Heye completed a "cash exchange" of fourteen pieces of southwestern pottery in return for $250. The pottery includes bowls from Santo Domingo, Hopi and Zuni; and ollas, one a Hopi 1850 polacca polychrome with stylized rainbow motif, the other a San Ildefonso blackware signed "Tonita;" and two classic Acoma and Santo Domingo jars (figs. 11-27, 11-28 and plates 17, 23). George Heye's letter read: "I have finally picked out the collection of South-

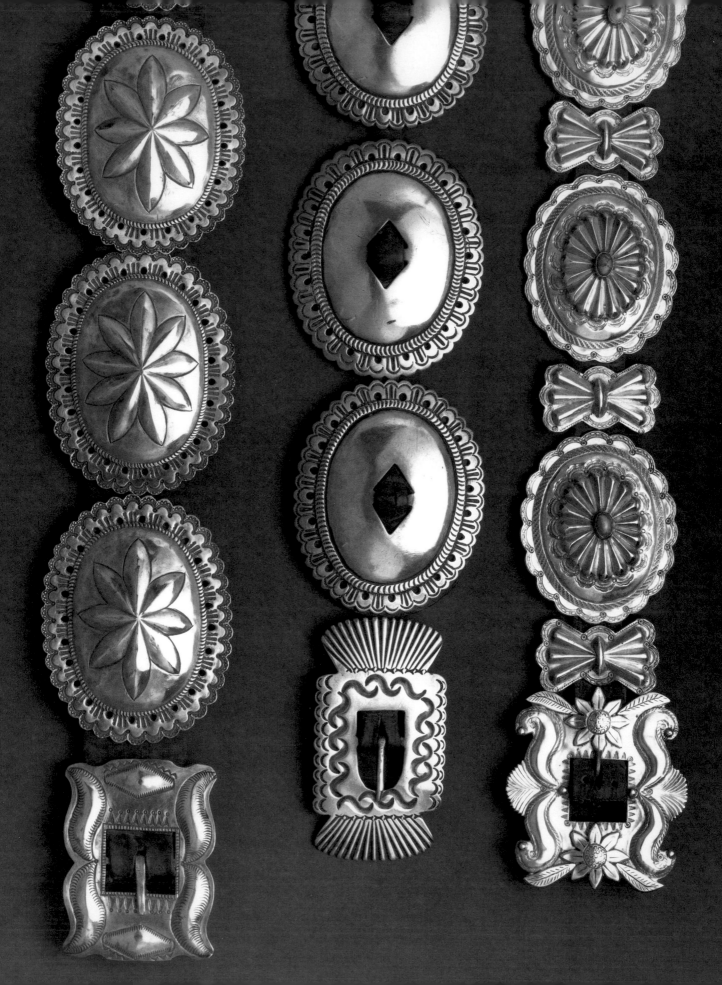

west pottery…I have tried to give you a good example from seven of the Pueblos and two specimens from the Hopi. I have taken the value of these at $316 so you see you are getting a fairly good discount."[65]

In 1947, an exchange of six pieces of Native-made silver from New Mexico, valued by Heye at $110, was not for cash, but for an equivalent value of six Ecuadorean figures. Through 1950, and undoubtedly longer, the Museum of the American Indian continued to make cash exchanges with numerous museums.

Southwest Silver

Nearly half of the 125 pieces in Rudolf Haffenreffer's collection of Southwest silver were acquired through his friendship with George Heye. Heye put him in touch with two major collectors who were selling: William Randolph Hearst and Joseph Keppler. In 1940 Hearst was experiencing financial difficulties and placed some objects from his Indian collection for sale through *Antiques & Objects of Art,* a New York City gallery.[66] The gallery contacted George Heye, who made some purchases and urged Rudolf Haffenreffer to do the same: "In my opinion, these articles are really old, genuine pieces, not made for the tourist trade, as most of them are today. The bridles are now extremely rare… However, you are the Captain!"[67] Haffenreffer asked Heye to make selections for him, and Heye chose ten pieces, eight Navajo and two Zuni: namely, a Navajo man's silver studded leather pouch with strap (sometimes called a medicine pouch), two bridles, two bracelets, a ring, two necklaces, and two conch belts (fig. 11-29 and plate 24).

In 1947 the ailing Joseph Keppler offered to sell his Indian collection – then on loan to Heye's Museum of the American Indian – on favorable terms. Part of it, named the Gyantwaka Collection, was to be resold by the Museum in order to raise funds to purchase the remainder of the Keppler Collection.[68] Heye sent a list of the Keppler

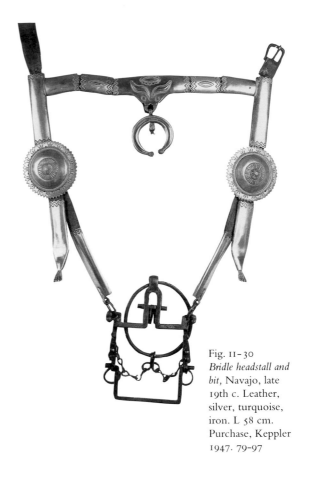

Fig. 11-30
Bridle headstall and bit, Navajo, late 19th c. Leather, silver, turquoise, iron. L 58 cm. Purchase, Keppler 1947. 79-97

Fig. 11-29
Conch Belts (detail), Navajo, late 19th-early 20th c. Silver, turquoise, metal, leather. Left belt L 108.3 cm. Purchase, Hearst 1940 and Keppler 1947. L to R: 93-149, 93-145, 72-2363

silver (and Iroquois ethnographic material) to Haffenreffer, indicating with an "M" the pieces that he wanted to keep for his own museum, and offering any of the rest to Haffenreffer for purchase.[69] Haffenreffer selected forty-six items, among them a bridle with incised face over the *naja* on the headpiece, a Navajo man's leather pouch with silver conches, belts, necklaces, rings, and bracelets. Among the distinctive pieces are a Navajo squash blossom necklace with double banded *naja* pendant and single turquoise inlay and a Santo Domingo necklace, ca. 1880, with thirty-seven solid silver crosses, forty-six hollow beads, and a *naja* pendant (figs. 11-30, 11-31).

Heye undoubtedly circulated the list to other members of his Board of Trustees and other friends who were collectors, but it seems that he gave Haffenreffer the first purchase opportunity after himself. By 1947, Haffenreffer was not aggressively adding to his collection, but he still made a selec-

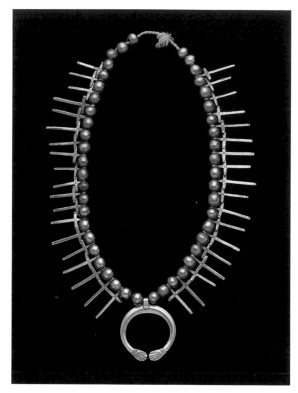

Fig. II-31
Necklace, Santo Domingo, ca. 1880. Silver. L 36 cm.
Purchase, Keppler 1947. 56-2

tion of the silver, seemingly out of a sense of
obligation as a board member.

Costa Rican Pottery

In 1937, Haffenreffer sought advice from Heye
about a purchase of Costa Rican pottery from Jose
B. Gonzalez, referred to him through James Luongo
of the Plume Trading Company. Haffenreffer was
uncertain about the wisdom of branching out in a
new collection area: "As I am entirely unac-
quainted with [Costa Rican pottery] I thought it
was best to have him see you to find out if you
cared for any of it, and if not, to give me an idea
as to what I should pay for it. I believe the whole
Collection can be bought for somewhere in the
neighborhood of $1000."[70] Heye responded that
he felt eight hundred dollars would be a fair price,
and added: "After thinking what you said over, I
believe you are right to confine your collecting
more or less to the eastern part of our own coun-

try, for if you start collecting from Central and
South America you will have a pretty large job
ahead of you."[71] Both Heye and Haffenreffer
became impatient at the amount of bargaining
required to establish a price. Haffenreffer wrote:
"You must have the patience of Job to talk and
dicker with the type of Dr. Gonzalez! He took a
whole day of my time and every moment changed
his mind. It was simply a case of 'Off-again-on-
again-gone again-Finnegan' and when we got all
through, it was nothing but disappointment! He
started out with a price of $20,000, and then came
down to $5000, $3000, and then $1200...."[72]
Despite his frustrations, Haffenreffer did purchase
twenty pieces of Costa Rican polychrome and
plainware ceramics and seven examples of Costa
Rican stone carvings from the Guanacaste-Nicoyan
archaeological zone, Period IV to VI, and six
Costa Rican postclassic gold ornaments made in
the lost wax process, all for around one thousand
dollars, and they were, as Gonzalez had attested, of
excellent quality and an important addition to the
collection (fig. III-15, plates 25, 26). As an astute
business man who knew how to drive a hard bar-
gain, Haffenreffer probably enjoyed the encounter
more than he admitted to Heye.

THE KING PHILIP MUSEUM AS SANCTUARY
FOR PERSONAL TREASURES

As Haffenreffer added to his private collection he
developed a reputation among local collectors and
scholars for his deep interest in, and knowledge
and care of, Indian materials. This resulted in
major gifts and offers to purchase collections from
local primary and secondary collectors. In 1923
Haffenreffer had delivered a stirring speech to the
historical societies of Providence, Bristol, and Fall
River on the need for reinterpreting the place of
the Northeast American Indian in history. Perhaps
it was not surprising that one of the early major
donations to the new King Philip Museum – a
Chilkat dancing blanket, from Klukwan (plate 27;
see also plate 28) – was from Edward Stowe
Adams, who was a founder of the Fall River His-
torical Society in 1920, and a book store owner
and amateur historian.[73] Many of the gifts that fol-

lowed were from Fall River residents, perhaps inspired by one of their own who had stated the case for Native people so strongly that day at Mount Hope. With building improvements, and enthusiastic press coverage depicting the King Philip Museum as a "shrine" for New England relics, the general public began to look to it as a safe repository for treasured family possessions, a kind of "sanctuary" for American Indian cultural objects, just as the Mount Hope site itself was proclaimed in the press as a sanctuary or shrine for the memory of the Wampanoag leader, King Philip.[74]

Friends began exploring attics and bringing forth possessions which they thought would be better preserved in a museum setting. In 1928 a Bristol

neighbor, Henry Remington, sent over a woven horsehair bridle and a rare, mid-nineteenth-century Plains saddle blanket of bison hide embroidered with large glass beads (fig. 11-32). His accompanying letter read:

> The saddle blanket was a part of an outfit, the property of an Indian Chief who was captured (shot) by our (Col.) John Galligan, an old Indian fighter and a very close friend of my father's…. The outfit was given to me when a small boy some 60 years ago (I am now 72) and consisted of a blanket, a saddle (the shape of a cushion or pillow with beadwork and made of skin same as blanket), rawhide stirrups, and straps. There was also an elaborate horsehair bridle in several colors and an old shotgun. I can remember the Col. telling my father that the encounter took place in a growth of timber at night and that it was him or the Indian.[75]

Fig. 11-32
Interior of King Philip Museum, ca. 1929, with saddle blanket and horse-hair bridle, Central Plains, mid-19th c. Blanket L 132 cm. Gift, Remington 1928. 76-1122a,b. Haffenreffer Museum of Anthropology

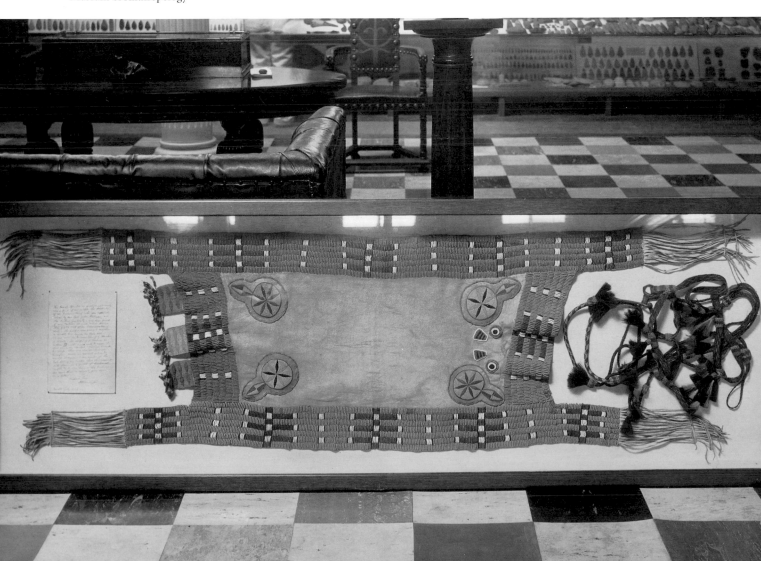

War Department records show a Lt. Col. J. Galligan, Fourth Regiment Iowa Infantry, born in 1819. Haffenreffer ordered construction of a mahogany and glass case to house the blanket, and this display, with its handwritten letter, added immediacy and drama to his exhibits. Displays of war spoils – including scalp locks, tomahawks, and even human remains – were in keeping with the attitudes of the times toward Indians, in which an exhibit evoking fear of the recently subdued "savage" might easily adjoin one containing a romanticized tribute to his nobility. Attitudes of the 1920s were a confused heritage of those expressed by James Fenimore Cooper, Charles Eastman, and General George Armstrong Custer, and emotions of admiration, horror, excitement, guilt, and sympathy often prevailed over straightforward analyses.

Another donor of family treasures was Albert E. Lownes, a Providence industrialist, naturalist, and scholar of the history of science, who had interests which overlapped Haffenreffer's along a number of lines. A collector of books on natural history, he was also an ardent Scouting enthusiast, and president of the Narragansett Council, Boy Scouts of America, to whom he eventually donated his 250 acre estate. Lownes was at various times president of the Rhode Island Historical Society, the South County Museum, and the Providence Art Club Museum. In 1937 he donated a collection of sixty-five Alaskan ivories to the King Philip Museum (figs. 11-33, 11-34). In response to a letter from Haffenreffer asking for more information about the gift, he replied:

These were all brought back by a great-uncle who went to Alaska early in the gold-rush (about 1897) and who stayed there three or four years.... Most of the articles are toys, game-counters, or one or two of them may be talismans or ceremonial articles.... many of them are models of larger things, – sledges, kayaks, fish traps, etc. The numbers were put on the articles when I was a small boy and had a "museum." The catalog to which they refer has long since disappeared. When I came across the little collection a couple of years ago, I packed it up for you and it has been laid away since then...[76]

Fig. 11-33
Pipe, toys, counters, Alaskan Eskimo, 19th c. Ivory, bone, wood, sinew, pigment. Pipe L 17.5 cm. Collected 1897; gift, Lownes 1937.

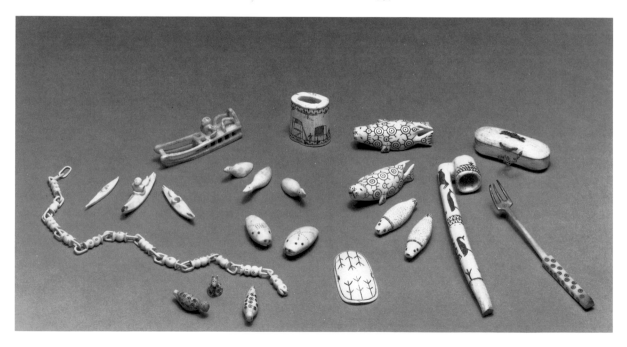

Fig. 11-34
Bowdrill handle (detail), North Alaskan Eskimo, 19th c. Ivory, pigment. L 63 cm. Collected 1897; gift, Lownes 1937. 57-86

A personal friendship between Haffenreffer and William L. Bryant, director of the Roger Williams Park Museum in Rhode Island from 1925 to 1947, resulted in two interesting gifts from Bryant's private collection: in 1928, a jade pendant which had been presented to him by the president of Costa Rica; and in 1937, an eighteenth-century Seneca effigy wooden ladle, collected by Bryant – formerly an attorney for the Cayuga Nation – on the Cattaraugus Reservation in western New York (plate 25 and fig. 11-35). In his gift letter for the ladle, Bryant wrote: "It is an old one as shown by the wear and by the fact that it is probably one hundred and fifty years since the Senecas gave up eating from the kettles. These ladles were made to hang over the edge of the kettle.... The pot was kept simmering over the fire and the Indian

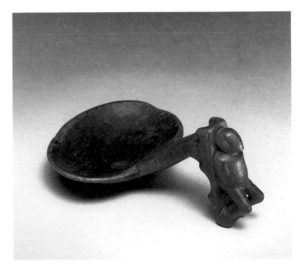

Fig. 11-35
Ladle, effigy, Seneca, ca. 1800. Wood. L 14 cm. Gift, Bryant 1940. 83-46

Fig. 11-36
Gambling sticks and bag, Tlingit, 1880s. Caribou hide, wood, pigment, bone. L average stick 12.5 cm. Collected in Alaska 1884–89; purchase, Colcleugh 1930. 57-368

helped himself to a ladle full of food whenever he was hungry."[77]

Some of the donors to the King Philip Museum had personally collected in the field and only in old age did they regretfully give up their items for needed cash and to assure their continued safe-keeping. One such primary collector was Emma Shaw Colcleugh, a Rhode Island newspaperwoman who had traveled extensively on assignment between 1875 and 1910 in the Arctic, Subarctic, Plains, Pacific, and East Africa.[78] Colcleugh contacted Rudolf Haffenreffer in 1930, when she was 84 years old, and asked if he was interested in purchasing her collection of 220 objects. To his credit, Haffenreffer understood the value of such a primary collection and purchased it in total, along with the notebook in which she had, through the years, recorded her acquisitions, often with anecdotes about the circumstances of their purchase. A collections record such as this notebook is extremely rare, providing a history of specific pieces not obtainable in other ways (figs. 11-36–39

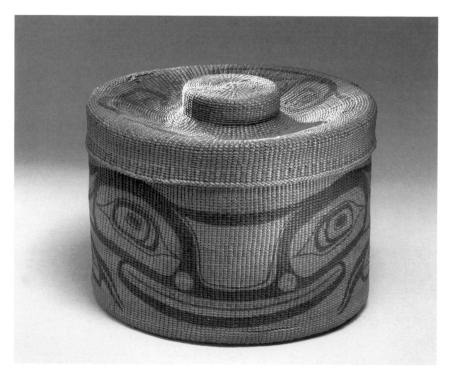

Fig. 11-37
Basket with rattle lid, painted by Charles Edenshaw, Haida, ca. 1880s. Spruce root, pigment. D 18 cm. Collected 1884–89; purchase, Colcleugh 1930. B-47

and plates 29, 30, 31).[79]

Another such personal collection was that of Elizabeth Nicholson White of Providence. A northeastern birchbark basket decorated with sweet grass and porcupine quills, containing an apple full of cloves, had been made the day Mrs. White was born, on September 28, 1877, and had always been in her possession. Upon her death, the family considered the museum a suitable place for this sentimental treasure.[80]

Fig. 11-39
Feast ladle, Haida, 1880s. Mountain sheep horn. L 57 cm. Collected 1884–89 in Masset, Queen Charlotte Island; purchase, Colcleugh 1930. 61-83

Fig. 11-38
Feast dish, effigy halibut hook (Haida or Tlingit), *soapberry spoons,* Haida, 1880s. Cedar wood and spruce root, opercula, iron. Spoons L 38.5 cm. Collected in Alaska, 1884–89; purchase, Colcleugh 1930. L to R: 61-86, 61-89, 57-225, 57-224

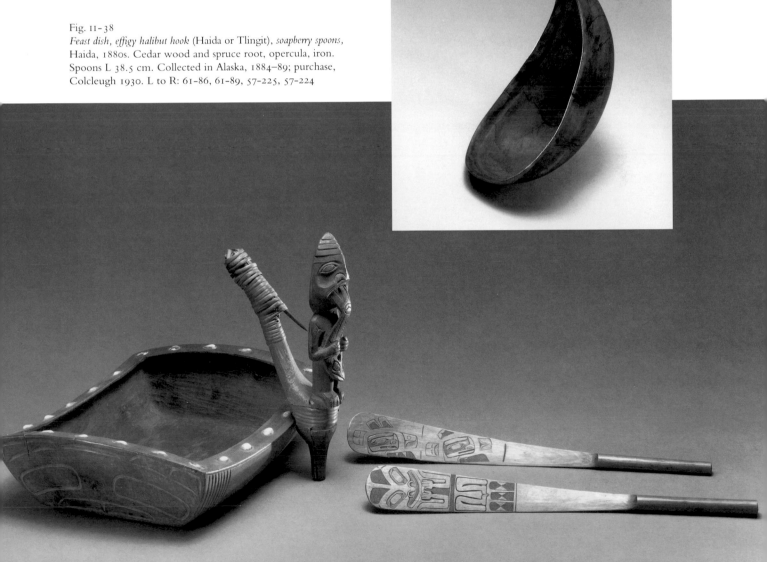

Sometimes friendships, as well as gifts, resulted from the shared enthusiasm of collectors and scholars whose interest was the American Indian. In March 1928, William B. Cabot, who had carried out ethnographic studies among the Naskapi Indians of Labrador, visited Mount Hope and viewed the King Philip Museum collection. In October of that year he made Haffenreffer a handsome present of a Naskapi painted caribou hide coat personally obtained in the field sometime between 1904 and 1909. He accompanied the coat with his book, *In Northern Labrador,* and later sent an Indian manuscript.[81] Haffenreffer was duly impressed: "I do not know just how to start to thank you for the princely gift which you have given me. It is a wonderful specimen and certainly will be the finest addition to my collection in a long time."[82] Throughout the next six years, the two corresponded in a friendly and informative fashion. They exchanged ideas about books they admired, such as Charles Bird Grinnell's *Blackfeet Tales,* and shared mutual friends, among them the sculptor, Cyrus Dallin, their comradery stemming from their common interest in the American Indian.

One collector expressed in writing his clear choice of Haffenreffer's museum as a repository. George Rowell, who sold his collection to Haffenreffer in 1934, after spurning a 1925 offer from Heye, wrote: "I am quite sincere in saying (and I trust you will believe this) I would prefer for you to have my collection than anyone who has evidenced an interest in acquiring it."[83] One of the most diverse and significant collections purchased by Haffenreffer, Rowell's contained objects of personal significance to Native families, of a kind seldom parted with except for economic reasons or because of a personal relationship with the recipient. It had belonged to three brothers, George P., E. Everett, and James F. Rowell, originally of Stamford, Connecticut, and included historic objects from the Kiowa, Comanche, Iroquois, and Pequot, prehistoric ceramics from the Southeast, and Mexican and Peruvian ceramics, lithics, and silverwork. All of the ethnographic objects were personally collected (plate 7).

Two of the Rowell brothers were doctors, and one had married a member of the Kiowa tribe. Through family ties, and sometimes in exchange for medical services through the years, the Rowells received three Kiowa beaded lattice cradles (plate 33), numerous articles of clothing, and an elk-horn saddle. In his affidavit for Haffenreffer George Rowell states: "My brother, Dr. James F. Rowell, of Oklahoma, married a Kiowa girl who was related to 'Qui-ah-tone,' (owner of the saddle). It was only because of this fact, and the affection which many of the elder and more prominent Kiowas had for my brother, who had gratuitously rendered professional service to them for years and who was legally adopted by them as a member of the Kiowa tribe," that the saddle came to Rowell.[84] Another example of such a gift exchange was a very well-worn but beautifully constructed pair of leg moccasins, given to Dr. E. Everett Rowell by an elderly Kiowa woman from whom he had successfully removed a fibroid tumor.[85]

Sometimes pieces were commissioned. E. Everett Rowell asked the well-known Kiowa artist Hauunguah (Silverhorn), another relation of James Rowell's wife, to paint two skins for him. One is a narrative, incorporating scenes of his brother "Maba" and of the Kiowa sun dance already documented by Silverhorn in skins painted for James Mooney and now in the Smithsonian.[86] The other is a unique depiction of a Kiowa ghost dance (fig. 11-1 and see *Hau, Kola!* cats. 289, 290).

E. E. Rowell's attempts to purchase a skin painting depicting *gaan* dancers, by the Chiricahua Apache war chief, Christian Naiche, met with resistance, but he succeeded (plate 34). Like Geronimo, the former warrior had settled near Fort Sill, Oklahoma, the site of his last imprisonment. There, in the early years of this century, he earned needed cash income as an artist, portraying scenes of traditional life for non-Natives. In his affidavit George Rowell explains the circumstances of purchase:

> The late A. D. Lawrence of Lawton, for a long time a friend of our family, had for many years kept a trader's store near Fort Sill, Oklahoma.[87] This store, somewhat of an ancient landmark, was

known as 'The Red Store,' and its principal business was with the Kiowa, Comanche and Apache Indians in that vicinity. My brother happened to show [Hauunguah's] painting to Mr. Lawrence who thereupon remarked that Naiche had one which it might be possible to obtain. Thereafter Mr. Lawrence got in touch with Naiche who brought his painting in question to the store, where, after some negotiation, it was bought by my brother for twenty-five dollars. Naiche was reluctant to part with it. He said he had only painted about twenty, and that this was the last one and that on account of his age and increasing infirmities he would not be able to paint another.[88]

George Rowell was obviously sensitive to the meaning that objects held for their original owners and thought it appropriate to convey this information to Rudolf Haffenreffer through the affidavit.

Many New Englanders possessed Indian objects not personally collected but for which they felt a sense of responsibility. Two Rhode Island women passed on Chippewa bandolier bags which they had received from an official of the United States Indian Service in Wisconsin. His gift letters to them in 1935 told of his high regard for the bags – one of them "given me by an old Indian Chippewa Chief in gratitude for timely assistance I was able to render when he was in great trouble."[89] The other was "a Medicine Bag once owned by the head chief of the Minnesota Chippewas. This old Warrior passed to the 'Happy Hunting Grounds' many years ago. I have owned the bag some 40 years and it came into my possession under circumstances which cause me to prize it greatly in addition to its beauty and value.... they no longer make such work, so that the bags are rarely to be found at the present day. I am very pleased for you to have it for I know you will appreciate it..." (plate 35).[90]

Six years later, in 1941, Jessie Tripp, a recipient of one of the bags, offered it to Rudolf Haffenreffer: "I understand you have a museum of Indian Relics. I have in my possession a beautiful and in a perfect condition Indian Medicine Bag, which was sent to me from Wisconsin, and was owned by the head chief of the Minnesota Chippewas. I...will be glad to show it to you if you care to see it." In a follow-up letter to Haffenreffer a month later, after he had acquired the bag, Tripp was concerned about retaining her original gift letter from Rodman, and wrote: "During your busy season perhaps you may have overlooked taking a copy of Mr. Rodman's letter which was put in the box with the bag. Will you please return it when convenient, as I would like to preserve it. We read with much interest of the success of the Scout celebration from which you must have taken much pleasure, besides giving it to many others."[91] Clearly donors were reassured in their confidence in Haffenreffer when they learned of his other philanthropic activities.

Another way that potential donors learned of the King Philip Museum was by word of mouth from other collectors. In 1940 Mrs. Edmond Abbott of West Kingstown contacted Haffenreffer: "I wrote you in regard to my Indian things and received a very courteous letter from you...Since the above date I have been in the R. I. Hospital but am home now in a wheel chair and still wish to sell *my Indian treasures*. Mr. Harry M. Wheeler has been here from Wickford, knows you and your collection, says you have not an Indian Club like mine..." (Gregg, this volume).[92]

Rudolf Haffenreffer responded personally and warmly to donors, especially to young ones whom he encouraged to become collectors like himself. To a youth who brought a stone axe to the Museum he wrote: "When you come to Bristol again, I would like to give you a few Indian artifacts we have, so that you might start a collection, as I like to see young boys start out with an interest in the Indians."[93]

OBJECTS DESIRED BUT NOT OBTAINED

The single object that Rudolf Haffenreffer wanted most for his collection was King Philip's war club. This club, made of highly polished maple wood, was ball-headed and inlaid with 104 purple and white shell "wampum" beads along the top. According to the owner, a Mrs. Daniels of Union,

Maine, it had been taken as a war spoil by an ancestor who was a member of Colonel Benjamin Church's militia, which had ambushed and killed King Philip in 1676. The club had remained in the family ever since. If it was not actually King Philip's, it was certainly of the period. Haffenreffer felt that it belonged at Mount Hope, the site of King Philip's council seat, his death, and the museum named for him.

In September 1929, Warren K. Moorehead, director of the Department of American Archaeology at Phillips Academy, Andover, had advised Haffenreffer that the club might be available. Negotiations were constant until May 1930, when Moorehead successfully purchased the club – using Phillips Academy expedition funds – not for Haffenreffer but for Miss Clara Endicott Sears's Fruitlands Museums in Harvard, Massachusetts. The intensity of Haffenreffer's feelings about the club was evident as in no other potential acquisition.[94] It symbolized for Haffenreffer the purpose of his museum as a place in which to reinterpret Native New England history. Museum archives indicate that Moorehead suggested the club could be purchased for $250, if the owner was willing to let it go at all. Moorehead had offered $200 five years earlier and had been turned down, but he thought it was not price, but rather a secure, long-term home for the club which most concerned the owner. He asked Haffenreffer if he would be willing to pay as much as $350 if necessary, but Haffenreffer replied by telegram: "If the implement you refer to is in good condition and thoroughly authenticated I think two hundred fifty dollars would be an adequate price to pay."[95] A series of letters followed which included assurances that Moorehead was proceeding with the King Philip club matter on behalf of Haffenreffer. The Fruitlands Museums' Archives show that Moorehead was negotiating with Sears at the same time and that she was willing to pay $500, plus $51 for Moorehead's traveling expenses, while Haffenreffer's top bid in 1929 was $300, and that Sears eventually prevailed.[96]

It is unclear whether or not Haffenreffer was aware of her offer and had been given the opportunity to match or better it, as he was traveling in the West through March. The war club's purchase was announced in the Boston and Fall River newspapers on June 13, which stated that it was "now a part of the remarkable collection of relics in the Archaeology building [Phillips Academy]," but a letter from Haffenreffer to Moorehead on June 17th indicates that he still thought the club was his: "I am very anxious to get War Club down here."[97] Thus, Haffenreffer was understandably upset to learn otherwise. He had helped fund Moorehead's 1929 collecting trip in Maine (Gregg, this volume), and it was implicit in the correspondence that the *quid pro quo* would be Moorehead's efforts to obtain the club for Haffenreffer, although it was always clear that the cost of the club was separate from the funding for the expedition. When Moorehead asked him the following winter for financial help for an expedition to southern states, Haffenreffer replied, with some restraint, "I would much prefer to compensate anyone for the specimens available for my collection, rather than make advances for possibilities, as these sometimes turn out in an unexpected manner – such as King Philip's Club – the loss of which I so keenly deplore."[98]

OBJECTS OFFERED BUT REJECTED

Haffenreffer often turned down collections, especially in later years. In 1949, Edward Malin, a Providence native, and student at the University of Colorado, offered his collection of forty-one objects, composed mainly of nineteenth-century bead and quillwork from the Plains and some Northwest Coast wood carvings to the King Philip Museum for a total of $475. Malin was selling in order to support his graduate studies in anthropology. Haffenreffer declined, saying "many of the items are ethnological, and we have little or no room to add to that type. Archaeological specimens are of more interest." Malin offered to collect materials in the Northwest Coast, where he would be continuing field research for the next several years: "I could be of service to you in securing some excellent carvings in the form of

ceremonial masks, head pieces, dishes and bowls, totem poles; materials that are fast disappearing from the northwest coast scene." But the offer to collect was not acted upon, nor was the collection purchased.[99] Fortunately, other Northwest Coast materials – twined basketry, horn ladles, and feast dishes – had been purchased from Emma Shaw Colcleugh in 1930. These, along with the Adams gift of the Chilkat blanket and Tlingit beadwork and additional baskets from a number of sources, form a small but highly interesting collection from that area.

Another collection that Haffenreffer turned down as early as 1937 was comprised of three hundred and fifty examples of Maricopa pottery, most collected prior to 1900. Although provided with illustrations and documentation for the exceptional group of pieces, and despite the fact that the purchase was highly recommended by A. L. Flagg, vice president of the Arizona Museum in Phoenix, Haffenreffer refused it. The price of five hundred dollars was reasonable for the large collection which the owner insisted on selling as a whole. Since Haffenreffer was not averse to "lot" buying, he may have lacked interest because he had just returned from a buying trip in the Southwest, did not foresee another one for a year, and was unwilling to purchase the pottery without examining it, and the owner was unwilling to ship it to him on approval.[100]

Haffenreffer also turned down "the King Philip Chair," offered for two thousand dollars by Duncan Hazard of Newport in 1930. A turned wooden chair, dating to about 1625, it was said to have been the property of Preserved Abell of Seekonk, who always brought it out of the house for King Philip to sit on when he visited the family. Howard Chapin, Librarian of the Rhode Island Historical Society, recommended the purchase, saying that "there are very few objects actually connected with King Philip that have as great a claim to authenticity as this one..."[101] But Haffenreffer declined the offer, perhaps because the chair was not of Native manufacture and thus did not increase the understanding of Native people as their own cultural artifacts did.

CONCLUSION

Museums have been compared to Noah's Ark: their objects representative of cultures, yet cut off from their original contexts, so that they take their meaning not only from their cultural origins but from the selectivity of their collectors and the new museum contexts in which they have been placed.[102] If the objects in the King Philip Museum were cut off from their origins, from where does their meaning come? In order to identify this meaning to Rudolf Haffenreffer, and to others of his time, both Native and non-Native, we have traced the processes through which Rudolf Haffenreffer built his collection of ethnographic objects. In this way, we seek to understand its legacy.

By 1955 Rudolf Haffenreffer had acquired ethnographic objects from most of the historic Native culture areas of North America, and from all

Fig. 11-40
Wooden doll in cradleboard, Iroquois, prob. 19th c. Wood, pigment, wool, cotton, twine, glass beads, screws. L 55 cm. Source unknown. 61-340

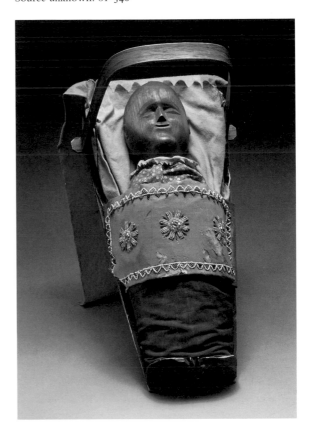

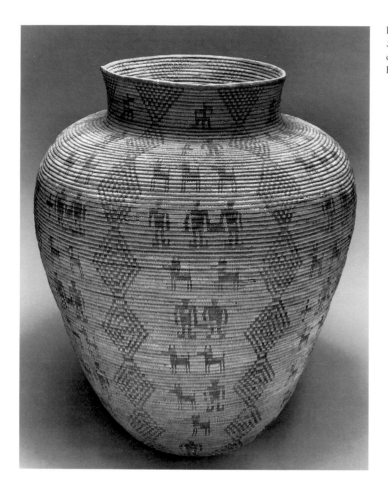

Fig. 11-41
Storage basket, Western Apache,
ca. 1900. Willow, devil's claw.
H 68 cm. Purchase. 71-5035

major categories of material culture. He actively sought certain materials that would fit the historically inquisitive nature of his collecting interests, particularly objects associated with King Philip and early New England. Foster Saville's astute selections added many Northeastern materials. Other objects came his way through a random process of purchasing, often in quantity, from individual collectors and from dealers. Sometimes objects of historic importance and aesthetic excellence were among those with no attributable source. These include a moosehair-embroidered birchbark tray in a style developed by Huron girls under the direction of Ursuline nuns in Lorette, Quebec; a Potawatomi beaded tobacco pouch of unusual design; and a delicately featured carved wooden doll in a cradleboard (Iroquois) (plates 5, 10, and fig. 11-40). Haffenreffer acquired large collections from the Southwest, through direct purchases, and

through auctions, word-of-mouth private sales, and exchanges with the Museum of the American Indian. The result is an excellent selection of pottery, basketry (fig. 11-41), weavings, embroideries, silverwork, and stone and shell jewelry that well-represents the area and the period of collection, and also includes some earlier historic and prehistoric materials. Haffenreffer also acquired Plains, Northeast, and California materials through exchanges with the Museum of the American Indian, Heye Foundation. In these, George Heye aided him in broadening his collection by recommending the acquisition of particular pieces. Of great importance, Haffenreffer acquired several collections that were personally obtained in the field by other collectors. These were often well-documented, if not systematic. For instance, journalist and teacher Emma Shaw Colcleugh traveled widely in the Plains, Northwest Coast, Subarctic

and Arctic regions in the late-nineteenth century and returned with objects that were utilized by northern Native communities until the time of purchase. James Rowell married into and was adopted by the Kiowa people of Oklahoma, and, with his two brothers, was able to collect from his Native relatives possessions that would not have been available to outsiders. Finally, Haffenreffer received as gifts Native-made objects that had been the personal family possessions of friends and acquaintances. Many of these objects were collected directly from Native people, among these a mid-nineteenth-century beaded hide saddle blanket from the Plains, one of very few that exists from the period (see fig. 11-32).

Starting as an interest in reinterpreting local New England Indian history, especially in the "truths" that local archaeology would tell about the lives of the original inhabitants of the area, Haffenreffer's collection grew to encompass the rest of Native North America. Throughout, archaeology was always mentioned as his greater interest, possibly because it represented a time relatively untainted by European contact, and therefore more likely to reveal the previously unknown facets of early Native life. But ethnography was important, too, and came to be appreciated by Haffenreffer as his knowledge and interests grew.

Although concerned with building a broad collection, it is doubtful that Haffenreffer related this to the idea of salvaging "vanishing" cultures, since he had confidence in living Native people. When invited to become Honorary Chief Sachem of the National Algonquin Indian Council he stated his strong belief that such an organization, composed of both Native and non-Native members, should be built up.[103] He cordially welcomed local Native people to the Museum, exchanged collection ideas with Pequot Chief Silver Star, and provided a base on the grounds and employment as an interpreter for Wampanoag LeRoy Perry (Ousa Mekin).[104] Through the years, local Native people held generally positive feelings about his museum, but even more so about Haffenreffer's stewardship of the historic site. The site was their own immediate history; the objects in the museum, for the most part,

were someone else's (McMullen, this volume).

Museum records, beginning in 1923, show the period of greatest financial investment in the ethnographic collection as the 1920s, followed by the 1940s and then the 1930s. More objects were actually collected in the 1930s than in the '40s, but prices in immediate post-depression years were much lower. Given Haffenreffer's reluctance to purchase even field collected and documented objects from Malin in 1949, it seems clear that by the end of this decade he felt he had completed his collection.[105] Unlike Heye, Haffenreffer did not believe he had to acquire everything, especially if it meant exposing himself financially, or asking others to help fund a purchase. The collection was his pleasure, not his burden, his familiarity with Heye's monetary woes perhaps serving as a cautionary lesson.

Comparing more broadly, while there were many collectors of Indian artifacts, few actually made these collections the nucleus of a permanent museum. One who did was Rowland Gibson Hazard II, of Peace Dale, Rhode Island, who began his private archaeological collection with documented surface finds from local nineteenth-century collectors. With his friends, geologist William Phipps Blake and William Seward Webb, a railroad magnate, Hazard added ethnographic materials from western North America. The collection was institutionalized in 1891 as the Museum of Primitive Art.[106] On a much smaller scale than the Haffenreffer collection, it represents a similar type of personal and selective collecting, unlike the more planned institutional collecting of the larger public and university museums.

Another local museum founder was Clara Endicott Sears of Harvard, Massachusetts who laid the foundation stone for her Indian museum in 1930, approximately the same time as Rudolf Haffenreffer enlarged his building. Sears actually created four museum collections which she united as the Fruitlands Museums: they include Bronson Alcott's Fruitlands, site of an experiment in communal living organized by Bronson Alcott and Charles Lane; the Shaker House; the American Indian Museum; and the Picture Gallery, containing

Fig. II-42
Carrying bag (kiaha), Pima/Papago, late
19th c. Saguaro wood, agave fiber, horse
hair, pigment. H 87 cm. Purchase. 57-774

Fig. II-43
Apron, Hupa/Yurok, 19th c.
Bear grass, hide. L 46 cm.
Purchase. 57-257

Hudson River School and primitive paintings. The unifying theme was her belief in alternate cultural approaches to those of the twentieth-century Western world, especially those providing fulfillment in human personal development and spiritual growth. Her interpretation of Native American materials was based on her own spiritual orientation.

Although Haffenreffer was aware of these other local museum founders, they seemed to have very little influence on his own collection or collecting. Sears and Haffenreffer sometimes used the same professional sources for collecting and advising, most notably Warren K. Moorehead, but there is no evidence that they ever visited each other's museums. They did share, however, a common interest in local history and especially in King Philip.[107]

Ironically, although Haffenreffer's interests were initially in the early history of New England and the interpretation of Native cultures through archaeology, what he eventually succeeded best in doing was to document, through his ethnographic collection, a period of rapid change for Native people throughout North America in the late nineteenth and early twentieth centuries. As a legacy, Rudolf Haffenreffer's ethnographic collection has proven extremely useful in a university teaching museum such as the Haffenreffer Museum has become, providing a realistic picture of what was being produced during a historic period of cultural stress and transition for Native people as they gradually developed economic skills for survival in a non-Indian environment. As is true with all collections of this era, most objects show the impact of European materials in their design and structure, and many were made for sale in an expanding market. This market developed as travelers and tourists admired decorated Native-made

and worn accoutrements and asked to purchase them. Native artisans responded, and soon made similar objects solely for sale. These objects include, among others, certain twentieth-century Navajo rugs and Pueblo pottery, and some Northeastern beadwork, moosehair embroidery, and bark and basketry containers. Other objects collected by Haffenreffer, such as a Pima/Papago carrying bag of netted agave fiber and a Hupa/Yurok apron of leather and bear grass (figs. 11-42, 11-43), were still made specifically for use within Native communities, as were cradleboards, toys and gaming sticks, pipes, ladles, warshirts, horse gear, tobacco pouches, beaded and silver ornaments, and many other objects.

The Plains collection represents the Reservation period of the last third of the nineteenth and first third of the twentieth centuries, during which there appeared an intense concentration of decoration on a wide variety of materials, transforming hide and cloth wearing apparel, horse furnishings, and utilitarian objects into items of brilliance through the application of glass trade beads, porcupine quills, and paint. Yet most of these heavily ornamented objects were a product of their makers' reservation confinement rather than of earlier nomadic lifestyles, and thus reflected the cultural upheaval following the Plains wars. The Northwest Coast collection is from the late nineteenth century when sight-seers were beginning to tour that unusually beautiful area; it includes both Native-used and made-for-sale articles in the traditional materials of wood, horn, shell, and plant and animal fibers, and in trade materials such as glass beads. Similarly, the California collection contains both nineteenth-century gift baskets, featherwork, clothing and prehistoric shell ornament made for Native use, and baskets made for the market. In the Arctic collection are Native-used tools, weapons and ivory-carved bow-drills and wrist guards, and also small ivory toys intended for the sailor's trade.[108]

Haffenreffer did not introduce these evidences of acculturation and change into his collections purposefully, but rather because they were the available objects at the time he was purchasing. He lived during the great age of tourist collecting, made possible by the evolution in travel by railroad and steamship, when people from varied economic classes were able to go to previously inaccessible areas and collect representations of the other's culture. Although much of his collecting was of a secondary nature, from others who had direct contact with makers, he recognized the value of primary collections and sought them out. Rudolf Haffenreffer demonstrated through his collection, and ultimately through its institutionalization as a museum, his belief in the importance of understanding Native culture and history and its material manifestations. Through his efforts thousands of ethnographic objects from Native America have been preserved and are available for all to study. This may be today the primary meaning of his collection, and is certainly his legacy.

ACKNOWLEDGEMENTS

I would like to thank those individuals who generously contributed their expertise to various portions of this chapter: Jacob Ahtone, James Babbitt, John Barbry, Bruce Bernstein, Nancy Blomberg, Ros Bosworth, Florence Brigham, Paul Bullock, Miriam Carreker, Michael Coe, Deborah Collins, W. Randall Dixon, Frederick Dockstader, Kate Duncan, Diana Fane, Linda Foss, Thierry Gentis, Rodney Gerry, David Gregg, Ray Gruenwald, Carl Haffenreffer, Carol Hagglund, Sharron Ahtone Harjo, Russell Hartman, Kristine Hastreiter, Marion Fergusen Hawkins, Marnie Hawkins, Joe Hays, Ann Hedlund, Bill Holm, Alan Hoover, Albert Klyberg, Shepard Krech III, Edmund J. Ladd, Dan Lelievra, Tricia Loescher, Vera Lindgren, Nancy Haley Lyle, Edward Malin, Marilyn Massaro, Susan McGreevy, James McJunkin, Ann McMullen, Triloki N. Pandey, Nancy Parezo, Russell Peters, Carolyn Riccardelli, Laura Roberts, Marion Rodee, Robert Sandvick, Cheryl Samuel, Philip T. Silvia Jr., Deborah Slaney, William Sturtevant, Joan Twaddle, Anthony Waring, Bonnie Warren, and Laila Williamson. These institutions provided valuable information: Arizona Historical Society, Brown University Archives, Church of Jesus Christ of Latter-Day Saints, Fall River Historical Society, Historical Society of New Mexico, Huntington Free Library & Reading Room, Museum of the Great Plains, National

Museum of the American Indian, Rhode Island Histori-
cal Society, Rhode Island Preservation Society, Rhode
Island School of Design Museum, Roger Williams
Park Museum of Natural History, and Utah Historical
Society.

NOTES

1. Edward Malin, conversation with author, October 20,
1993.

2. Ethnographic, as used here, encompasses all non-archae-
ological objects, that is, objects collected from a specific peo-
ple, and made for use within their society or for sale outside of
it. Primary collections are obtained directly from the people of
the society. Secondary collections are made through an inter-
mediary, without direct contact with the object's society of
origin.

3. See Richard Handler, "On Having a Culture," in *Objects
and Others*, ed., George W. Stocking Jr. (Madison: University
of Wisconsin Press, 1985), 193.

4. Kevin Wallace, "Slim-Shin's Monument," *New Yorker*,
November 19, 1960, 109.

5. *Providence Journal*, October 11, 1931

6. *Bristol Phoenix*, January 22, 1929; *Providence Sunday Jour-
nal*, January 20, 1929.

7. "A Visit to Mt. Hope," *Bristol Phoenix*, November 3,
1916.

8. "Has Finest Private Indian Museum," *Providence Sunday
Journal Magazine*, October 11, 1931, 4.

9. "Mt. Hope Museum Immortalizes Indian," *Sunday Stan-
dard*, New Bedford, Mass., January 20, 1929.

10. Illustration in *Providence Sunday Journal*, September 7,
1930.

11. Howard M. Chapin, Librarian, Rhode Island Historical
Society, "Rhode Island Abounds with Relics of Red Man's
Deeds," in *Providence Journal*, March 25, 1925.

12. In an article on Mount Hope prepared by John W.
Haley for publication in the national magazine of the Daugh-
ters of the American Revolution, the pouch and horn are still
attributed to King Philip in 1936. Haffenreffer Museum of
Anthropology Archives [HMAA] Collections Files, Rudolf
Haffenreffer [RH]:Haley.

13. HMAA Collections Files, RH:Heye. Letter from Rudolf
Haffenreffer to George Heye, June 19, 1935.

14. HMAA Collections Files, RH:Lownes. Albert E.
Lownes to Rudolf Haffenreffer, September 30, 1937.

15. The "Harvey Girls," waitresses hired through selective
screening for intelligence, attractiveness and character, were
trained by Fred Harvey to serve a complete 3 course dinner
in a 30 minute train stop and to do it graciously. See Lesley
Poling-Kempes, *The Harvey Girls: Women Who Opened the West*
(New York: Paragon House, 1989) 21–42.

16. For example, in 1922 Edgar Lee Hewett, first director
of the School of American Research and the Museum of New
Mexico, spearheaded the expansion of a yearly Santa Fe fiesta
into today's Indian Market, an annual exhibition and sale of
Indian arts attracting thousands of visitors. Curator Kenneth
Chapman organized the first juried exhibition of traditional
Indian arts as part of the 1922 fair. See Bruce Bernstein, "From

Indian Fair to Indian Market," *El Palacio* (Summer 1993),
14–19, 47–54. Bernstein is working on a study of Indian mar-
ket and how Santa Fe establishments and museums worked
together for its success.

17. Carl Haffenreffer, conversation with the author, August
25, 1993.

18. HMAA Collections Files, RH:Vaughn's. Invoice for
$1145, Vaughn's Indian Store, April 9, 1928.

19. Jim Babbitt, of Babbitt Brothers in Flagstaff, Arizona,
remembers when Haffenreffer purchased the dinosaur prints
and meteorite and says the store did a thriving business in
those two things (telephone conversation with author, Octo-
ber 10, 1993). For Babbitt history, see Dean Smith, *Brothers
Five: The Babbitts of Arizona* (Tempe: Arizona Historical Foun-
dation, 1989).

20. For an overview of trading post history, see Frank
McNitt, *The Indian Traders* (Norman: University of Oklahoma
Press, 1962); Robert M. Utley,"The Reservation Trader in
Navajo History," *El Palacio* 68/1 (Spring 1961), 5–27; William
J. Parish, *The Charles Ilfeld Company: A Study of the Rise and
Decline of Mercantile Capitalism in New Mexico* (Cambridge:
Harvard University Press, 1961); L. L. Williams, M. D., *C. N.
Cotton and his Navajo Blankets* (Albuquerque N. M.: Avanyu,
1989). Williams has accompanied a biography of C. N. Cotton
with reprintings of 3 mail order catalogs of Navajo blankets
and rugs originally printed between 1896 and 1919.

21. For "Aztec" terminology, Michael Coe, conversation
with author, December 12, 1993. For Teestoh, James McJunkin,
whose parents owned Teestoh, recalled that in the 1930s Indi-
ans brought in prehistoric pottery finds from the surrounding
area for trade. One year, a man (perhaps Haffenreffer?) drove
up and bought all the pottery, lifting McJunkin's family out of
their post-depression debt. Teestoh Trading Post was razed
about 1980, and a park was created on the site by the Navajo
in memory of Mabel and James McJunkin, traders from 1932
to 1980 (telephone conversation with author, October 18,
1993).

22. Clinton N. Cotton was for many years in partnership
with Juan Lorenzo Hubbell at the trading post in Ganado, Ari-
zona. Cotton was the trader who first introduced Arbuckle's
Coffee – "the coffee that won the West!" – and Pendleton
Indian Robes to the Southwest in the 1890s. *Smoke Signals*
(Summer 1993), brochure of Dewey Trading Co., Santa Fe,
N. M.

23. For Fred Harvey Company, see Patrick Houlihan, *The
Fred Harvey Fine Arts Collection* (Phoenix: The Heard Museum,
1972); Byron Harvey III, "The Fred Harvey Collection, 1899-
1963," *Plateau* 36 (1):33-63, 1963. Diana Pardue is working on
a history of the Fred Harvey collection of the Heard Museum,
Phoenix.

24. The name on this invoice was William P. Sargent of
Barrington, R. I. The connection between Sargent and
Haffenreffer is unknown, but Sargent was an avid collector
himself. His Plains collection was donated in 1938 to the
Peabody Museum of Natural History, Yale University.

25. Reese Vaughn corresponded with Hilton the following
year about the purchase of rare Zuni stone "fetishes." There
are no further records on the subject, and it is not known
whether Hilton was interested for himself or for Haffenreffer.

26. Because Indians had little ready cash, traders developed
seco, or trade tokens, stamped from thin pieces of tin or alu-
minum, usually with the name of the trader and sometimes a

value. These were exchanged for goods but were only redeemable at the particular trading post which had issued them. In 1934 these tokens were abolished after pressure by the Bureau of Indian Affairs, because the practice seemed to encourage permanent Native indebtedness to traders. See Robert M. Utley, "The Reservation Trader in Navajo History," *El Palacio* 68/1 (Spring 1961), 18.

27. By the mid-1950s circumstances were changing in the Southwest, marking the beginning of the end of the trading post period. Today, some true trading activities continue – at Shiprock on the Navajo Reservation, where Bill Foutz at Foutz's trading post supplies boards to Navajos for their sand paintings, which he then sells at his stores. (Bruce Bernstein, Laboratory of Anthropology, Museum of New Mexico, conversation with author, September 9, 1993.) Also see Nancy Parezo, *Navajo Sandpainting: From Religious Act to Commercial Art* (Tucson: University of Arizona Press, 1983).

28. HMAA Collections Files, RH:Cabot. Letter from Rudolf Haffenreffer to William B. Cabot, June 16, 1931.

29. Carl Haffenreffer, conversation with author, August 28, 1993.

30. Charles A. Amsden, *Navajo Weaving: Its Technic and Its History,* 2nd ed., (Albuquerque, 1940), 171.

31. Robert M. Utley "The Reservation Trader in Navajo History," *El Palacio* 68/1 (Spring 1961), 14, 15.

32. On February 26 he paid $350 to James P. Hayes of San Diego for six rugs which were shipped to his Fall River home, the invoice signed by a William Perley in California; on February 27 he paid $535 to Fred A. Wedler of Hollywood for eight rugs and the camp furnishings, which included six mats, four pillow slips, and a couch cover. Specific rugs in the collection cannot be matched with specific purchase records. The source of purchases was not recorded on catalogue cards for these years. Further, most invoices were written in a cryptic manner, without providing measurements or description of any kind, except for the adjectival "yei," "sand painting," "chief," "ceremonial," or "Spanish." Most of the invoices use the term "blankets," while all of the weavings presently in the collection are "rugs" or "rug/blankets." HMAA Collections Files, RH:Hayes, Wedler.

33. Ann Lane Hedlund, *Reflections of the Weaver's World,* (Denver: Denver Art Museum, 1992), 17.

34. J. B. Moore, U. S. Licensed Indian Trader, *The Navajo,* Crystal, Navajo Reservation, New Mexico, 1911. Reprint, (Avanyu, Albuquerque, 1986).

35. J. L. Hubbell, Indian Trader, *Navajo Blankets & Indian Curios: Catalogue and Price List.* Reprint of a folder used by J. L. Hubbell in 1905. For Hubbell's influence on weaving quality, see Joe Ben Wheat, "Two Centuries of Navajo Weaving," *Arizona Highways,* July 1974: 13ff.

36. See Leland C. Wyman, *Navajo Sand Painting: Huckel Collection,* Colorado Springs Fine Arts Center, The Taylor Museum, (Colorado Springs), 80, 81, #105-3267, 1960. See also Nancy Parezo, *Navajo Sandpainting: From Religious Act to Commercial Art.* For comments on HMA rugs by Nancy Blomberg, Russell Hartman, Susan McGreevy, and Marion Rodee see HMAA Collections Files, RH:Navajo Rugs.

37. Marion Rodee, *Old Navajo Rugs* (UNM Press, Albuquerque, 1981), 92.

38. Ruth Underhill, *Pueblo Crafts* (Washington D.C.: U. S. Department of the Interior, 1944), 33.

39. J. L. Hubbell, Indian Trader, *Navajo Blankets & Indian Curios: Catalogue and Price List,* 1905.

40. See *Zuni History: Victories in the 1990s* (Seattle: The Institute of the North American West, 1991), section I:17; Diana Fane, Ira Jacknis, and Lise M. Breen, *Objects of Myth and Memory,* (New York: Brooklyn Museum, 1991), 33, 57, 104; and Dr. Triloki N. Pandey, UC Santa Cruz, conversation with author, October 4, 1993.

41. HMAA Collections Files, RH:Young. Letter from Rudolf Haffenreffer to Provost Levi Edgar Young, University of Utah, Salt Lake City, May 17, 1929; and R. F. Haffenreffer 3rd, conversation with author, Fall 1987.

42. Edmund J. Ladd, Curator, Laboratory of Anthropology, Museum of New Mexico, telephone conversations with author, October 16, 1993 and January 7, 1994. For interpretation of use of similar symbols in Zuni altars, see M. C. Stevenson, *23rd Annual Report, Bureau of American Ethnology,* 1901–2. For history of C. G. Wallace, see Deborah Slaney, "The Role of C. G. Wallace in the Development of Twentieth-Century Zuni Silver and Lapidary Arts," (master's thesis, University of Oklahoma, 1992). The National Museum of the American Indian has a painted skin of Knife Wing (21/5132) that is similar to but not exactly like the HMA skin.

43. Edwin Wade, consultation with author on HMA pottery collection, April 1980.

44. Linda Foss, Curator of Native Arts, Museum of Fine Arts, Boston, has interpreted the iconography in an unpublished paper presented at the Native American Art Studies Association conference, Santa Fe, November 3–5, 1993. See HMAA Collections Files, RH:Temple.

45. Rudolf Haffenreffer 3rd, conversation with the author, August 10, 1980.

46. See Barbara A. Hail, *Hau, Kola! The Plains Indian Collection of the Haffenreffer Museum of Anthropology,* (Bristol, R. I.: Haffenreffer Museum of Anthropology, Brown University, 1993 [rev. ed.]).

47. *Providence Journal,* October 11, 1935.

48. The Plume stock was bought by Paul Bullock, proprietor of The Wandering Bull in Attleboro, Mass. and currently a major supplier of Native American paraphernalia to hobbyists, Scouts, and Native people in the New England area. Luongo's private collection, which had grown very large, was sold as a unit to a Japanese buyer in the early 1980s (Paul Bullock, conversation with author, October 10, 1993).

49. This figure was estimated by J. Alden Mason in his memorial to George Heye, who died January 20, 1957 (*George G. Heye, 1874–1957,* Leaflets of the Museum of the American Indian, Heye Foundation, Number 6, 1958.) The catalog entries, which included groups of objects under a single number, numbered 225,201 the year of Heye's death, according to the Annual Report for the period March 31, 1956–April 1, 1957, of Board of Trustees of Museum of American Indian, Heye Foundation, p. 18, National Museum of the American Indian Archives OC 180. According to John Barbry, NMAI Archivist, Heye personally applied each number (conversation with the author December 15, 1993).

50. *Indian Notes, Number 24,* Museum of the American Indian, Heye Foundation.

51. HMAA Collection files, RH:Heye. Letter from George Heye to Rudolf Haffenreffer, July 24, 1931.

52. National Museum of the American Indian, Archives: OC247 F4#2710. Letter from Frederick K. Seward to Rudolf Haffenreffer, December 11, 1936.

53. National Museum of the American Indian, Archives: OC247 F4. Letter from H. H. Parker to Frederick K. Seward, October 14, 1937.

54. HMAA Collections Files, RH:Heye. Letter from Rudolf Haffenreffer to George Heye, March 3, 1931.

55. HMAA Collections Files, RH:Heye. Letter from George Heye to Rudolf Haffenreffer, March 4, 1931.

56. HMAA Collections Files, RH:Heye. Letter from George Heye to Rudolf Haffenreffer, February 1, 1932.

57. HMAA Collections Files, RH:Heye. Letter from Rudolf Haffenreffer to George Heye, February 19, 1932.

58. HMAA Collections Files, RH:Heye. Letter from Rudolf Haffenreffer to George Heye, March 3, 1932.

59. HMAA Collections Files, RH:Heye. Letter from George Heye to Rudolf Haffenreffer, April 9, 1932.

60. HMAA Collections Files, RH:Moorehead. Warren K. Moorehead to Rudolf Haffenreffer, December 6, 1929.

61. Trustees of Museum of American Indian, Heye Foundation R/V/III/5, Annual Report May 5, 1942.

62. Heye notified his trustees that "the most important exchange, in your Director's opinion, ever undertaken by the Museum has been consummated with Mr. John L. Nelson. From the Field Museum in Chicago, Mr. Nelson obtained practically all the ceremonial material collected by H. R. Voth in 1890–1898, the first scientific collector to go among the Hopi Indians of Arizona. For this collection consisting of about 100 masks, headdresses and ceremonial objects, as well as 178 Kachina dolls, we have given him duplicate textiles from the Navajo, Hopi, Chilkat and from various tribes of Mexico, Guatemala and Panama (as well as a now obsolete Akeley moving picture outfit.) Now that the Federal Government has prohibited the purchase of any ceremonial material from the tribes of the Southwest, the collection we obtained is conservatively worth $7500." Trustees of Museum of American Indian, Heye Foundation, Annual Report 1933–34, p. 14.

63. Trustees of Museum of American Indian, Heye Foundation R/V/III/5, Annual Report May 5, 1942.

64. HMAA Collections Files, RH:Heye. Letter from George Heye to Rudolf Haffenreffer, February 16, 1943. We can not determine which four pieces were selected first, or whether the selection was made by Heye or by Haffenreffer.

65. HMAA Collections Files, RH:Heye. Letter from George Heye to Rudolf Haffenreffer, January 12, 1945.

66. Nancy Blomberg, telephone conversation with the author, September 20, 1993.

67. HMAA Collections Files, RH:Heye. Letter from George Heye to Rudolf Haffenreffer, June 26, 1940.

68. Trustees of Museum of the American Indian, Heye Foundation, Records, vol. IV:5, Minutes, February 4, 1947, p. 716.

69. HMAA Collections Files, RH:Exchange with MAI. Letter from George Heye to Rudolf Haffenreffer, February 11, 1947.

70. HMAA Collections Files, RH:Heye. Letter from Rudolf Haffenreffer to George Heye, January 4, 1937.

71. HMAA Collections Files, RH:Heye. Letter from George Heye to Rudolf Haffenreffer, January 5, 1937.

72. HMAA Collections Files, RH:Heye. Letter from Rudolf Haffenreffer to George Heye, January 6, 1937.

73. HMAA Collections Files, RH:Adams, Twaddle. To reinforce the "museum as sanctuary" model, in 1958 the estate of Mrs. E. S. Adams added other Alaskan materials to the original gift: two pairs of Tlingit beaded moccasins and two baskets from Metlakatla, probably collected at the same time as the Chilkat blanket in the early years of the century on one of the popular sightseeing excursions through the inland passage. The objects had remained together in the Adams house for many years, and the heirs saw fit to reunite them in what they considered a secure museum context.

74. "Mt. Hope Shrine of Indian Relics," *Bristol Phoenix,* January 22, 1929; "Haffenreffer Sanctuary for New England Indian Relics at Mt. Hope to Be Opened for Inspection Today," *Providence Sunday Journal,* January 20, 1929.

75. HMAA Collections Files, RH:Remington. Letter from Henry Remington to Rudolf Haffenreffer, July 24, 1928.

76. HMAA Collections Files, RH:Lownes. Letter from Albert E. Lownes to Rudolf Haffenreffer, September 30, 1937.

77. HMAA Collections Files, RH: Bryant. Letter from William L. Bryant to Rudolf Haffenreffer, October 4, 1937.

78. See Barbara A. Hail and Kate C. Duncan, *Out of the North: The Subarctic Collections of the Haffenreffer Museum of Anthropology* (Bristol, R. I.: Haffenreffer Museum of Anthropology, Brown University, 1989).

79. In 1988, as a result of publicity surrounding the exhibit and catalogue of Colcleugh's collections, her great-great-grand niece learned of the museum collection for the first time and donated to the Museum five scrapbooks of newspaper clippings compiled by and about her great-aunt, enhancing considerably the documentation of the collection and exemplifying a continuity of attitude about the museum as "sanctuary" through several generations.

80. HMAA Collections Files, RH:White.

81. William Brooks Cabot, *In Northern Labrador* (Boston: R.G. Badger, 1912) inscribed to "RFH" from author.

82. HMAA Collections Files, RH:Cabot, October 31, 1928. There was no record of the coat in the collections card catalogue in 1955, nor is it in the collections.

83. HMAA Collections Files, RH:Rowell. Letter to Rudolf Haffenreffer from George Rowell, December 23, 1931.

84. HMAA Collections Files, RH:Rowell. Affidavit for Kiowa saddle, May 21, 1934, George P. Rowell.

85. HMAA Collections Files, RH:Rowell. Affidavit for Buckskin Leggings, Dresses, Shirts, etc. May 21, 1934, George P. Rowell.

86. See United States National Museum of Natural History, Smithsonian Institution 233092, one of a series of skins commissioned from Silverhorn by James Mooney.

87. The collection of trader A. D. Lawrence is in the Museum of the Great Plains, Lawton, Oklahoma.

88. HMAA Collections Files, RH:Rowell. Affidavit for The Apache Pictograph. May 21, 1934, George P. Rowell.

89. HMAA Collections Files, RH:Austin. Letter from Rowland G. Rodman, Ashland, Wisconsin, to Emma Austin, New Bedford, Mass., December 6, 1935.

90. HMAA Collections Files, RH:Tripp. Letter from Rowland G. Rodman, Ashland, Wisconsin, to Jessie Tripp, Providence, Rhode Island, November 23, 1935.

91. HMAA Collections Files, RH:Tripp. Letters from Jessie Tripp, Providence, R. I. to Rudolf Haffenreffer, May 16, 1941 and June 18, 1941.

92. HMAA Collections Files, RH:Abbott. Letter from Mrs. Edmund Abbott, West Kingston, R. I. to Rudolf Haffenreffer, June 10, 1940.

93. HMAA Collections Files, RH:Arnold. Letter from

Rudolf Haffenreffer to James E. Arnold, Jr., Natick, Mass., April 12, 1943.

94. HMAA Collections Files, RH:Moorehead. Correspondence 1929, 1930.

95. HMAA Collections Files, RH:Moorehead. Telegram, Rudolf Haffenreffer to Warren K. Moorehead at Knox Hotel, Thomaston, Maine, September 16 , 1929.

96. Fruitlands Museums Archives, Letters Indian Museum Volume II, June 30, 1930.

97. *Fall River Herald News,* Friday, June 13, 1930; HMAA Collections Files, RH:Moorehead. Letter from Rudolf Haffenreffer to Warren K. Moorehead, June 17, 1929.

98. HMAA Collections Files, RH:Moorehead. Letter from Rudolf Haffenreffer to Warren K. Moorehead, December 20–25, 1930. In June 1970 the club (length 56 cm) was stolen from the Fruitlands Indian Museum. Its whereabouts are unknown.

99. HMAA Collections Files, King Philip Museum: Collections Offered for Sale: Malin. Correspondence between Edward Malin and Rudolf Haffenreffer in 1949. In 1993 Malin said, "I had the passion for Indian art then and I still have it now, at 70" (conversation with author, October 20, 1993). See Edward Malin, *A World of Faces: Masks of the Northwest Coast Indians,* (Forest Grove, Ore.: Timber Press, 1978).

100. HMAA Collections Files, King Philip Museum: Collections Offered for Sale: Smurthwaite.

101. HMAA Collections Files, King Philip Museum: Collections Offered for Sale. Letter from Howard Chapin to Rudolf Haffenreffer, September 18, 1930.

102. For Noah's Ark comparisons see Diana Fane. "New Questions for 'Old Things,' The Brooklyn Museum's Zuni Collection," in *The Early Years of Native American Art History,* ed. Janet Berlo, (Seattle: University of Washington Press, 1992), 62–64; and Susan Stewart, *On Longing: Narratives of the Miniature, the Gigantic, the Souvenir, the Collection,* (Baltimore: Johns Hopkins University Press, 1984), 152.

103. HMAA Collections Files, RH:Moorehead. Letter from Rudolf Haffenreffer to Moorehead, September 30, 1929.

104. Haffenreffer Family Collection, Mount Hope Farm, Bristol, R. I. Letter from Rudolf Haffenreffer to Emma Safford, November 25, 1925.

105. Yet he continued to expand his interests as a museum professional during the '40s, and in 1941 supported the newly formed New England Museum Association by hosting the history and natural science museum delegates to the annual conference in Newport for a tour of the King Philip Museum. *Program,* New England Museum Association, Newport Meetings, Fall 1941.

106. See Sarah P. Turnbaugh and William A. Turnbaugh, *The Nineteenth Century American Collector: a Rhode Island Perspective* (Peace Dale, R. I.: Museum of Primitive Art and Culture, 1991), 1–14. Webb's son and daughter-in-law carried on his interest in collecting and founded the Shelburne Museum in Vermont in 1947.

107. Clara Endicott Sears authored a book on the King Philip War entitled *The Great Powwow: The story of Nashaway Valley in the King Philip's War* (Boston: Houghton Mifflin Co., 1934). It was in Rudolf Haffenreffer's museum library.

108. Made-for-sale objects, strongly represented in most museum collections, have recently been receiving more serious attention by scholars. They serve as evidence of Native people's successful accommodation to the dominant society, while maintaining and reinforcing their cultural integrity through their arts. See Ruth Phillips, "Why Not Tourist Art? Significant Silences in Native American Museum Representations," in *After Colonialism: Imperialism and the Colonial Aftermath* (Provisional title). (Princeton, N. J.: Princeton University Press, in press); Joan Lester, *Tomah Joseph, Passamaquoddy Artist in Birchbark* (Bristol, R. I.: Haffenreffer Museum of Anthropology, 1993).

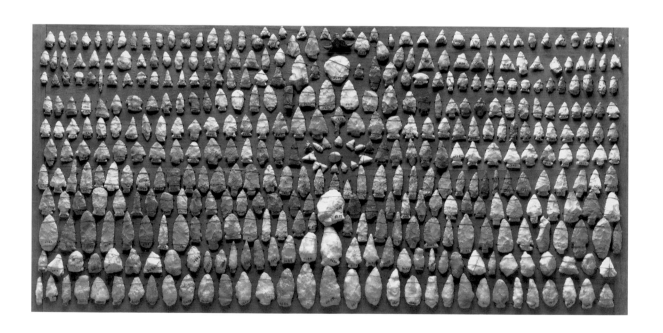

The Archaeological Collection

by DAVID W. GREGG

IN 1954 Rudolf Haffenreffer's archaeological collection contained approximately forty-two thousand artifacts. These included tools like stone axes, hammers, mortars and pestles, and net weights; ceremonial or decorative items such as gorgets, beads, and amulets of shell, jade, slate and bone; and everyday objects such as ceramic pipes, pots, and spindle-whorls. Also in the collection were "tomahawks," arrowheads presented by Buffalo Bill, and "Aztec idols." Most remarkable were the approximately thirty-five thousand stone arrowheads, spear tips, and other projectile points in the collection, including examples from forty-three U.S. states and six countries.

Throughout his life Haffenreffer collected many things including wood carvings, ethnographic artifacts, folk art, decorative art, stamps, even companies, as well as archaeological artifacts. Nevertheless, archaeology held a special place for him. It was a part of his general interest in Native Americans, and archaeology probably first piqued his curiosity about local Native history and culture (Krech, this volume). Additionally, the taxonomic nature and "collectibility" of archaeological artifacts suited them well to the interests of hobbyists and non-academic museum builders like Haffenreffer.

Haffenreffer's archaeological collection had a distinctive geographic and typological character.[1] Although most areas of the western hemisphere were represented, approximately eighty percent of the artifacts were from the northeastern United States. Most of the rest were from the Midwest and the Plateau, while the southwestern United States and Central and South America were represented by small but archaeologically significant collections. Although there were many types of artifacts, almost eighty percent of the collection consisted of stone arrowheads, spear tips, and other projectile points. Whole categories of artifacts highly desired by collectors for their aesthetic qualities, such as birdstones, platform pipes, and fancy bannerstones, were virtually absent.

The nature of the collection was a product of Haffenreffer's varied collecting activities. The local archaeological artifacts he purchased largely through agents such as Foster H. Saville, an archaeologist of long association with the Museum of the American Indian, Heye Foundation in New York, and Horace M. Grant, an antique and curio dealer in Providence. Haffenreffer also collected in the field, during his trips to the Southwest. Many of the artifacts from beyond New England were acquired through social, business, or museum contacts such as his friend George Heye. Sometimes his reputa-

Fig. III-1
Exhibit board, made before 1923. 123 x 60 cm.
Artifacts from Bigelow and Anthony collections.

tion as a collector brought strangers to his door offering artifacts for sale.

Although referred to here as Haffenreffer's "archaeological collection," the distinction between archaeological and ethnographic artifacts (between those excavated from the ground and those collected from the people who made and used them) may not have been as important to Haffenreffer as it is to museums today, where it has become reified for a variety of reasons.[2] To many people in Haffenreffer's time all Indian artifacts belonged to the past as did Indians generally.[3] Neither was the distinction important to Haffenreffer's desire that his collection memorialize King Philip and Native people; for this purpose he needed artifacts that were simply "Indian," whether ethnographic or archaeological. Finally, he exhibited archaeological and ethnographic artifacts together, often on the same shelf, and he frequently purchased lots that included both.[4]

This essay describes artifacts and collections that the King Philip Museum contained in 1954, and in doing so also sheds light on Haffenreffer himself. It brings together descriptions, photographs, and the collection histories of archaeological materials which, because of their curation history, have long been inaccessible to researchers.

THE EARLY YEARS

By 1916 Haffenreffer's Indian collection, including hundreds of arrowheads and other archaeological artifacts, filled a small building at Mount Hope.[5] A newspaper account suggested that by this time he had already been collecting for five or ten years.[6] The building was not just a place to store a burgeoning accumulation of stone tools and other "Indian relics," however; from early on it also contained stuffed birds, carousel horses, and other curios and was toured by more than thirty members of the Rhode Island Field Naturalists Club on a field trip to Mount Hope in 1916.[7] At first the points, axes, pestles, and other artifacts were stored in glass candy-store counters, and later on some of the points were wired in decorative patterns to boards that were hung from the walls.[8] Three such boards survive at the Museum (fig. III-1). The

points on the boards were not numbered before they were wired on and probably remained unlabeled until 1928 or 1929.

Today, it is difficult to identify which artifacts in the collection were owned by Haffenreffer before 1927. Two major collections from this period which can still be identified are the Bigelow and Anthony collections, although it is not known whether they were Haffenreffer's as early as 1916. The points wired to the boards, which were certainly made up before the mid-1920s, are from those two collections. The Bigelow collection contained approximately three thousand artifacts, mostly points from Massachusetts and Missouri, but also including some from Ohio and Mexico, and approximately one hundred axes, celts, and projectile points from Green County, Illinois. Nothing is known of the origin of this collection. The collection of Edward Anthony, of Fishhawk Farm, Bristol, belonged to Haffenreffer by 1923 since it was mentioned in a newspaper description of his collections written in that year.[9] It contained 291 artifacts, mostly points, and came from Rhode Island, Missouri, and Kentucky.

The Haffenreffer collection before 1928 also included some archaeological artifacts from the Southwest. From around 1917 Haffenreffer made trips west to conduct mining business (Krech, this volume), and in later periods, at least, these were occasions for massive purchases of ethnographic and archaeological artifacts (Hail, this volume). Although records do not allow definite identification of those Southwestern artifacts purchased before 1928, some of the earliest belong to a group of Arizona artifacts listed at the beginning of a catalogue of New England archaeological artifacts begun in that year.[10] These included a range of groundstone axes and hammers and "scoria" (cellular lava) mortars, pestles, rings, and balls. Of particular interest is a lot of sixty-nine three-quarter grooved axes and six hammers.

By the mid-1920s Haffenreffer, then in his fifties, had begun to perceive of his accumulated artifacts as a collection of interest to the public. The *Bristol Phoenix* described the visit of the Fall River Historical Society in 1923, when "the guests inspected

Mr. Haffenreffer's valuable collection of Indian relics, which includes ten thousand arrowheads, stone axes, mortar and pestles, weapons and blankets.... The relics also include antique firearms and buffalo-robes. The collection is exhibited in a stone building a short distance from Mount Hope Bay."[11] This "stone building" was a purpose-built "fireproof" structure thirty feet by forty feet which replaced the 1916 building and which held exhibits and also provided Haffenreffer with an office for Museum business and library space for personal study. Although later additions have dwarfed it, this space still serves as the Museum's office and houses some storage.

With the new building came an emphasis on professionalism and standards of museum practice. This new emphasis manifested itself in Haffenreffer's documentation of collections with affidavits from collectors and with a catalogue number system; commencement of a museum archive; and employment of a professional archaeologist, Foster Saville, to build the collection. Museum-building, historical and Indian contacts, and Scouting all appear to have contributed to a crescendo of activity that built from about 1925 and culminated after 1930 (Krech, Hail, McMullen, this volume).

A 1927 letter to Haffenreffer from D. A. Seamans, a Riverside, R.I. archaeological collector, provides insight into the impetus for these developments. It shows that Haffenreffer had already made contacts among collectors in the area, and his interest in local Native history had led him to pursue archaeological collections, searching in particular for relics from Burr's Hill, a large Contact-period Native cemetery in Warren, R.I. and reputedly the site of the graves of Massasoit's family.[12] Seamans wrote, "I will tell you the story of the finding of these relics [a pipe, beads, and other artifacts from Burr's Hill] and you can mark them as you see fit.... I was thinking since you were here that it might be a good idea to get John Richardson, Clarence's brother to go down with me. I think he could give you a lot of information as they travelled together since they were boys."[13] Haffenreffer's interest in local Native history probably led him to local archaeological collectors such as Seamans

(Krech, this volume).

One significant event in this early period which may have catalyzed the museum-building was Haffenreffer's purchase of the Richardson collection. Clarence E. Richardson, of Attleboro, Massachusetts, ran a small precious metals refining and scrap recovery business and had collected archaeological artifacts since the 1890s.[14] The collection included approximately five thousand artifacts, mostly projectile points and mostly from southeastern Massachusetts around Attleboro and northeastern Rhode Island around Riverside. In addition to projectile points, there were pestles, axes, steatite bowl fragments, and a very unusual carved stone figurine, probably from Rhode Island or Massachusetts (fig. III-2). There were also substantial numbers of points from Georgia, Missouri, New York, Ohio,

Fig. III-2
Figurine, southern New England, Woodland period. Stone. H 9 cm. Purchase, C. Richardson 1927. 81-37

and California. The California materials included shell beads. In most cases, particularly for the New England artifacts, the objects were provenienced by town.

Clarence Richardson died in October 1926 and his widow sold his collection to Haffenreffer the following February. A letter from Mrs. Richardson to Haffenreffer gives us some of our only direct information about Haffenreffer's collecting methods before 1928.[15]

> January 31st 1927
> Dear Sir:
>
> Some time ago a Mr. Haffenraffer wrote to my husband asking him if he had any Indian Implements to dispose of.
>
> My husband passed away in October and I have been trying to find the letter so I could get the correct address of the party who wrote him, so far I have not been successful.
>
> It was suggested to me that I write you regarding same, and should you not be the gentleman I was trying to locate, perhaps you might know him and be kind enough to send me his address. I enclose a stamped addressed envelope.
>
> Should you be the Mr. Haffenraffer I am in reference to, I would like to have the opportunity of showing you this collection. I think you might be interested in it as I feel sure it is one of the best private collections in this part of the country.
>
> Could you please let me hear from you within a reasonable amount of time, as I intend to write to several of the Museum's if I cannot get a private party to buy it.
>
> Thanking you in advance for a reply.
>
> I am yours very truly
>
> Helen C. Richardson[16]

How Haffenreffer heard of the Richardson collection and how Mrs. Richardson heard that Rudolf Haffenreffer might have been the interested party are tantalizing questions that remain unanswered, although the exchange bespeaks the existence of an information network among amateur and avocational archaeologists in the region. The Richardson collection contained a bone awl from Burr's Hill and that, taken together with Seamans's acquaintance with the Richardsons, suggests that Haffenreffer may have been led to Clarence Richardson

in his search for Burr's Hill artifacts. Foster Saville made use of this grapevine when he began building up the collection for Haffenreffer the following year.

As Seamans noted in his letter, Clarence Richardson's brother, John, was also interested in archaeology, and the two used to travel around the region by carriage, bicycle, and foot searching plowed fields, river banks, and other exposures for artifacts.[17] While Haffenreffer bought Clarence's collection in 1927, John Richardson continued to build his collection until it reached approximately fifty thousand pieces. In the late 1930s it was purchased by the Attleboro Museum Associates, a consortium of businessmen/philanthropists organized by Massachusetts Archaeological Society founder Maurice "Doc" Robbins to preserve the collection of the town.[18] Later the collection was taken over and added to by the Massachusetts Archaeological Society and is now the core of the collection of their Robbins Museum in Middleboro. The continuing curation of the John Richardson collection makes Haffenreffer's preservation of the Clarence Richardson collection especially valuable. Together the two collections provide archaeologists of southern New England with an enormous body of data.

The Richardson collection increased the size of Haffenreffer's archaeological holdings by about fifty percent at a stroke, and at a price of two thousand dollars was one of Haffenreffer's most expensive acquisitions, twice what he paid for the larger and more diverse Temple collection and more than he spent on all but the largest Southwestern purchases. It is difficult to say what brought him to make such a substantial outlay. It added no new artifact types to Haffenreffer's collection, and it did little to change the collection's geographic representation. It may have been important because the sheer number of artifacts added "mass" to the Museum as a monument to local Native people. The Richardson purchase seems best understood as the first step in the larger process through which Haffenreffer's hobby was maturing into a museum; a large, well-documented collection, whatever the immediate reason for its acquisition, may have

piqued his interest and inspired the florescence that followed.

THE GOLDEN AGE OF ARCHAEOLOGY AT THE KING PHILIP MUSEUM

In May 1928 Haffenreffer hired Foster H. Saville, an "expert on cataloguing and arranging collections,"[19] to expand the collection, develop a cataloguing system, and advise on organization and display. Saville's tenure represented a Golden Age at the King Philip Museum during which the archaeological collection grew from thirteen thousand to over thirty-five thousand artifacts as the Museum was tripled in size and dedicated to King Philip with much public notice and fanfare. During this time the card catalogues still used today were begun and excavations were carried out in Haffenreffer's name at nearby archaeological sites.

Foster Saville, the brother of better known Central American archaeologist Marshall H. Saville, was a free-lance archaeologist who, since its 1916 founding, had spent much of his time working for the Museum of the American Indian, Heye Foundation in New York. Saville's home was in Rockport, Mass., but he traveled extensively in southern New England and on Long Island. Around 1918 Saville, working for the Museum of the American Indian, was in southern New England gathering from relic collectors material from Burr's Hill. In the 1920s he conducted several excavations on eastern Long Island.[20] In 1924 he lectured at Roger Williams Park on the Wampanoags and published on the Burr's Hill material.[21] Saville's local collecting and publications must have attracted Haffenreffer's attention, given that they shared an interest in King Philip and the Indians of southern New England.

Throughout the early growth of his museum, it seems likely that Haffenreffer, with perhaps the help of a secretary, did all the work of finding, documenting, and organizing the collection. From 1928 through 1931, however, the demands on Haffenreffer's time were great — the acceleration of the Museum's collecting activities, its installation in a new, expanded gallery, and its heightened local profile coincided with a period of great activity in Haffenreffer's business life, which then included mines in the West, the Herreshoff Company, and the Mount Hope Bridge, in addition to brewing (Krech, this volume). Saville took up the same kinds of collections development and management tasks that Haffenreffer had previously done principally on his own, and made the Museum more formal and professional.

Saville worked for Haffenreffer most of the time between May 1928 and March 1929. In May he began working his way into the local archaeological scene by talking with Howard Chapin, librarian and director of the Rhode Island Historical Society since 1918. Saville wrote, "May 7th at Providence all day, saw Mr. Chapin of the Rhode Island Historical Society, he gave me quite a lot of information in regard to some local material, and told me that anything he could do to help out he would be much pleased to do."[22] They may have known each other from Saville's earlier collecting forays, but Chapin's several publications on archaeology would have eventually led Saville to him anyway. In a 1925 newspaper article, for instance, Chapin described the most important archaeological collections in the state and included Haffenreffer's.[23] Saville probably used this article as a "battle-plan" because in his first few weeks on the job he visited nearly every collector mentioned in the story to view their artifacts and see if they were for sale.

Saville also conducted excavations for Haffenreffer. During the summer of 1928, Saville excavated at several unspecified locations on Haffenreffer's Mount Hope property and at a site referred to in surviving Museum documentation as "the ancient village site" at Mount Hope Narrows.[24] The Saville/Mount Hope collection includes about one hundred stone and bone artifacts and about one hundred unworked bone and shell fragments. No diagnostic artifacts were found, but well-preserved bone and a shoreline location suggest the presence of a Woodland-period fishing camp or summer settlement.

The modest finds from Saville's dig imply a small-scale excavation using few diggers, and the degree to which Haffenreffer or Saville themselves participated is unknown. Museum records refer to the "Saville Collection dug for Mr. Haffenreffer" or to

"material from 'general diggings' @ the Wampanoag site on the Mount Hope grant, 1928, dug by R. F. Haffenreffer, Jr." or style the work as "the Haffenreffer Expedition," perhaps in imitation of contemporary sponsored expeditions from larger museums to Central America and elsewhere.

Although no field notes from the excavations survive, results must have been less than remarkable since Haffenreffer never followed through on his first intention to continue excavating the following summer. Saville and Haffenreffer apparently had planned to continue the previous year's excavations in the summer of 1929 as mentioned in a letter from Warren K. Moorehead, an archaeologist at Phillips Academy, Andover, Mass. to Haffenreffer in February of that year: "I shall be very glad indeed to see the collection and later when Professor Saville is carrying on excavations for you it will afford me pleasure to come down and see them and help in any way that I can."[25] There is no evidence that a second season of excavation ever took place.

In September and October, Saville again worked full-time touring the region to examine and purchase single artifacts and whole collections. During these collecting trips Saville had license to travel and purchase materials at his own discretion. Haffenreffer advanced Saville money, and they formally settled accounts about every month. From November until March 1929 a reduced correspondence between Saville and Haffenreffer concerned primarily the transfer of collections and settling of accounts.

For his first month on the job, Saville kept a journal in which he described his activities and listed his purchases, but for subsequent months he kept only an expense account. As part of his work he also maintained a file of the collections he had heard of or examined and recorded his impressions of their quality, the character of the owner, the asking price, and any counter-offers. Examples from among the thirty-five entries in this file reveal the way that Saville and Haffenreffer worked.[26] About Mrs. A. B. Bradshaw of Providence, Saville wrote, "has a small collection, but very fine [lists 9 pieces]. Made an offer of $100. for this collection. Mrs.

Bradshaw will call up and make an appointment for some Sunday to visit Mount Hope to see if she wants her collection to go there." John Drown of Warren, Rhode Island "has a small lot of Burr Hill material consisting of trade pipes, plated spoons, two glass bottles, beads, copper dish, aboriginal pipe. Made an offer of $125., which is a good high price, but to save time increased it to $200., with a limit of time to October 17, 1928." Oscar Tyler's collection was mentioned in Chapin's 1925 newspaper article and upon visiting the owner, Saville wrote, "Oscar Tyler, Washington, R.I. has a very large collection, approximately 3,000 specimens; a number of pipes, axes, celts, gouges, pestles, mortars. A very good collection, but he has an exorbitant idea as to its valuation." By using Saville's notes Haffenreffer was later able to acquire on his own some of the collections Saville had located, for example the Turner collection, mentioned in Chapin's article and Saville's notes but not purchased until after 1933.

In the only surviving correspondence between Haffenreffer and Saville after March 1929, their business relationship had reverted to that of acquaintances with shared interests. In March 1930 Haffenreffer wrote to "Professor Saville" thanking him for showing him a piece for sale but declining to purchase it because the price was too high. He also included a check for some Burr's Hill "wampum" Saville had located and signed himself "with kindest personal regards."[27] If Saville was still doing some reconnaissance for Haffenreffer he was no longer collecting at his own discretion.

Catalogues

Although there was a catalogue of some of Haffenreffer's archaeological specimens before 1928 the earliest catalogues that survive were begun by Saville. Beginning around 1928 two catalogue numbering systems were used simultaneously – a *numerical system* (1 through 10,156) and a *fractional system* (1/1 through 1/8033, 2/1 through 2/31, and an indeterminate number of pieces numbered with 8 as the numerator). At an uncertain but probably later date an *alphabetical system* which was organized by geographical areas (AL-x for artifacts

from Alabama, TX-x for those from Texas, etc.) and by typological categories (B-x for baskets or blankets, M-x for mortars, etc.) was added. The numerical system, starting with the first forty-six hundred or so pieces of the Richardson collection, predated Saville's arrival (fig. III-3), but it was probably Saville who had the existing catalogue cards for the Richardson collection typed. Even while he was adding to the numerical system, Saville also introduced the fractional system, patterned after the catalogue at the Museum of the American Indian. For either system Saville assigned ranges of numbers to incoming collections or groups of artifacts already in the collection and three-by-five index cards were typed by the Museum's secretary. The reasons for two, and ultimately three, numbering styles are uncertain. One possibility is that several large collections arrived already numbered, and in order to save time Saville solved the doubling of numbers by drawing numerators onto the artifacts above the old numbers. There are several examples of pieces where the numerator and denominator are written in a different hands. There are also examples of artifacts with four-digit numbers where the first, or thousands, digit is in a different hand than the rest.

Although Haffenreffer maintained a card catalogue and other collections records from Saville's time onward, a number of artifacts in the collection

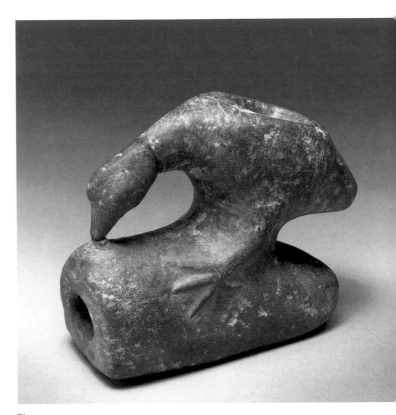

Fig. III-4
Pipe, Ohio (?), Late Woodland period, AD 600–900. Stone. H 12 cm. 61-457

do not have substantive provenience information. Many otherwise well-documented collections contained uncatalogued residual pieces of "lesser interest." In some cases, artifacts that were catalogued in lots were never individually labelled, and have since become disassociated from their numbers. In other cases, a small number of catalogue cards were either never completed or subsequently misplaced. The vast majority of unnumbered or uncatalogued artifacts are relatively undistinguished, such as fragmentary projectile points or other flaked stone artifacts.

There are a few archaeological objects which, although uncatalogued, are worthy of special consideration. One of these is a stone pipe carved in the shape of an ibis-like bird on a loaf-shaped block (fig. III-4). Although nothing is known about the origin of this piece, a similar example, from Ross County, Ohio is illustrated in Moorehead's *Prehistoric Relics.*[28] Another unusual object is a large

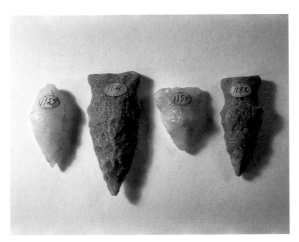

Fig. III-3
Projectile points with Clarence Richardson's original catalogue numbers. Right point L 5 cm.

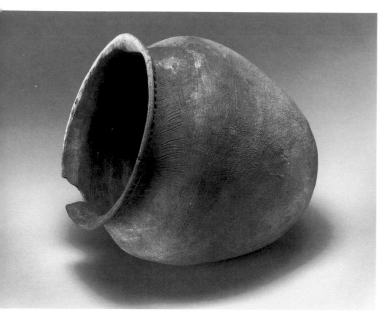

Fig. III-5
Jar, Lamar (Ft. Walton) culture, Florida, AD 1350–1500. Grit-tempered clay. H 30 cm. F-209

round-bottomed pot. The catalogue provides only "Florida" for its collection history. The body of the vessel is 30 cm high and 29 cm across at the widest point, while the everted rim is 25 cm in diameter. The body is brushed and the underside of the rim is decorated with a row of thumbnail impressions (fig. III-5).

Affidavits

Although Haffenreffer's formal cataloguing system did not even begin until 1928 and was changed several times after that, as early as 1927 and the purchase of the Richardson collection, most acquisitions were accompanied by affidavits that included a statement about who had collected the material and from where and that acknowledged the receipt of payment. In several cases there were two separate documents, a bill of sale and a testimonial affidavit. Haffenreffer's affidavits, some of them framed, were displayed with the collections and were unusual enough to draw the attention of the *Bristol Phoenix* which described them as "very important in the years to come."[29]

Haffenreffer was scrupulous about these documents, often writing back to sources who had not included satisfactory collection information. George Rowell, source of a large archaeological collection, responded to a request by Haffenreffer for information about artifacts that had already been purchased, regretting that "this is the first opportunity I have had of sending you the material I mentioned when I saw you last bearing upon the identity of the things in my archaeological collection."[30] At Haffenreffer's request James Moffitt, from whom Haffenreffer bought another collection of Mesoamerican artifacts, had to write back to his source to get satisfactory information.[31] Two contemporary collectors with whom Haffenreffer interacted, George Heye and Warren Moorehead, have been noted for their lack of attention to collecting records.[32] Much is known about the Saville period at the King Philip Museum, however, in part because of the affidavits which Haffenreffer required.

Many affidavits were formal, legal-looking documents, being typed, witnessed, and notarized. The affidavit accompanying the Theodore A. Russell cache was very formal.

North Hadley, Mass., May 15, 1928

This certifies that I, Theodore A. Russell of North Hadley, County of Hampshire and Commonwealth of Massachusetts, on April 26, 1928, while plowing on my farm in the town, county and commonwealth aforesaid, while plowing through a dead furrow to a depth of 14″ instead of the usual 7″, my attention was attracted to an unusual noise on the plowshare (my farm is unusually clear of stone), and on further examination soon found a cache of 319 spear heads or knives, varying in length from 3 to 6″, the majority of these spears being pointed in a northerly direction and buried not deeper than 20″.
 Theodore A. Russell
Witness: Arthur T. Conant
 Commonwealth of Massachusetts
 Hampshire, ss.
 Hadley, Mass., May 15, 1928

Then personally appeared the above named Theodore A. Russell and swore to the truth of the foregoing statement, before me,
 Frank H. Pelissier
 Justice of the Peace.[33]

Some affidavits were informal, handwritten on hotel stationery, index cards, or other convenient paper. Charles A. Luther wrote the following affidavit on stationery from the Narragansett Hotel in Providence. "I Charles A. Luther of Metacom Ave Warren, Rhode Island make affidavit and say that in April 1927 I found on ploughed land at the Whiteman farm in Warren an Indian pestle which I have sold and delivered to the Mount Hope Museum of Bristol, R.I. [Charles A. Luther] Subscribed and sworn to before me in the Town of Warren in said State this 6th day of June 1928 A.D." The next day he also signed a separate receipt for payment for the pestle.[34]

What distinguished the Haffenreffer affidavits as innovative was not the provenience information, but the certification of authenticity that they provided.[35] Affidavits distinguish Haffenreffer's collection from some amateur collections which eschewed labels, catalogues, and other documentation and are welcomed by modern archaeologists for whom concerns of context make provenience data vitally important.[36] Nevertheless, by the 1920s most archaeologists knew that their collections should be provenienced at least by county and there were a number of widely available books and articles that recommended as much.[37] Furthermore, the affidavits contain only general locational data, and often they vouched for collections that had much more detail in accompanying catalogues. The Russell affidavit emphasizes the circumstances of the find and not its geographical location.[38]

There was a general problem with fraud in archaeology prior to and during the time of Haffenreffer's collecting.[39] Ironically this was the result, in part, of the cash value collectors like Haffenreffer put on artifacts. Gates Thruston summarized the problem while defending the authenticity of artifacts discussed in his book on Tennessee archaeology: "[R]egular dealers in antiquities are as yet unknown in Tennessee. There are but few 'collectors' and 'archaeological frauds' have rarely found their way into [the Tennessee region]. There has been no commercial market for them, and until recently but little demand for *genuine* specimens at a money value. There has, therefore,

been no advantage to be gained by counterfeiting relics, and the frauds practiced in the North and East are unknown here."[40] Frauds perpetrated for financial gain or other reasons often resulted in widely publicized debates and scandals. By taking notarized statements that emphasize personal accountability in the origin and history of the artifacts he bought, Haffenreffer may have sought to protect himself from fraudulent collectors and dealers who forged artifacts, passed on forged artifacts, or exaggerated the provenience or history of artifacts to raise their value.

The notarized affidavit for the Lincoln collection gave only general provenience information, but it emphasized the identity of the finders, the authenticity of the artifacts, and the descent of ownership. "November 23, 1923. This certifies that I William E. Lincoln of West Brookfield, County of Worcester and State of Massachusetts, would say that the following Indian Specimens were found by my brother the late David Lincoln and myself during the past sixty years on our farm located in the Town, County and State aforesaid. Twenty pestles, twelve axes, ten celts, two pipes, a cache of twenty seven arrow points, ... with other specimens that we have found on the farm."[41] Herbert Harnden, too, emphasized the origin of the artifacts and their sale to Haffenreffer when he "deposes and says that during the years 1922 and 1923, ... the said excavating was done on the East (left) bank of the Penobscot near Sunkhaze stream (left bank) in the Township of Milford and State of Maine.... the said artifacts being then and there discovered by me when the men employed by the R. H. Newell Co. were excavating for material to fill a bridge approach."[42]

Haffenreffer's goal of creating "a sanctuary for Indian history" and "memorial to King Philip" required absolute authenticity because only genuine artifacts lent their sacredness to the museum enterprise.[43] This was especially true for artifacts which had special value to Haffenreffer because they were associated with historical persons such as King Philip (whose chair, club, belt, bag, basket, and other belongings appeared on the market periodically). In fact it was true for even the meanest

arrowheads, which contributed to the Museum only the benediction of their presence in numbers. It seems unlikely that Haffenreffer collected tens of thousands of similar artifacts for their typological variety or pedagogical value.

At least four affidavits were framed and displayed in the King Philip Museum – those of the Gardner, Harnden, Lincoln, and Russell collections.[44] Because Haffenreffer provided provenience information with an "innovative number and card catalog system" and with other labels, displaying the affidavits is better seen as primarily a public assertion of authenticity – for the artifacts, for Haffenreffer as a responsible collector, and for the Museum as a worthy tribute to King Philip and Indian history.

Haffenreffer often acknowledged that he was an amateur without formal credentials. At various times he deferred to Moorehead's experience and reputation on matters that included purchasing collections, joining societies like the American Association of Museums, and supporting Moorehead's expeditions such as the one to the Merrimack River.[45] To Heye, Haffenreffer wrote "I . . . feel that you are so much the better judge of what

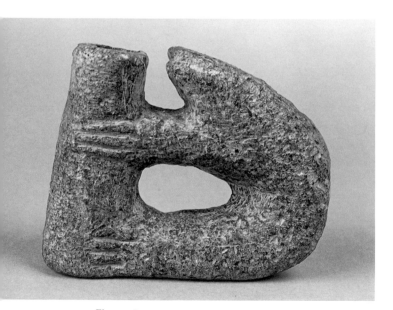

Fig. III-6
Pipe, Northeast, Woodland period. Steatite. H 10, W 4 cm.
4655

I need [in my museum], that I would suggest that if it is agreeable, you prepare a list of the items, together with their cost, which I may have for study."[46] In his competition with other institutions for special relics and large collections, Haffenreffer stressed that his museum's geography in particular made it well qualified as the "proper" place for such "relics," but he may also have wished to reinforce his other qualifications. He asked Moorehead to tell the owner of the King Philip club, "I am sure that if she has any intention of letting the club go to any place that she will then realize [after reading the enclosed clippings about Haffenreffer's museum] that it will be fully as well taken care of there [at Mount Hope] as at any other place. . . . In order to further assure her, you may inform her that the Trustees of the Warren [R.I.] Public Library and the officials of the Town of Bristol are seriously considering turning over all their Indian relics to Mount Hope. . . ."[47] Through the exhibition of the affidavits, therefore, Haffenreffer displayed credentials for himself and his museum, perhaps answering to public skepticism about small, private museums.

Saville's Acquisitions

During his tenure at the King Philip Museum, Saville collected from at least eighteen people. Some of Saville's sources were not major collectors, having only a few unremarkable artifacts.[48] For others we know only what is mentioned in affidavits. Annie E. P. Bannister sold forty-six hoe-like flaked stone artifacts found cached together in Wakefield, R.I., and Charles A. Luther, as already mentioned, sold a pestle.[49] Even Charles Champion, whom Chapin mentioned in his 1925 article and who sold Haffenreffer twenty-five hundred artifacts, left no more trace in the records than an address.[50] One of Saville's more extraordinary acquisitions bore only rudimentary documentation. It was a stone pipe in the form of a bear climbing a tree (fig. III-6). The catalogue card says only that it was found in Dighton, Mass. by "a nephew of Albert Williams" and sold to Saville by someone named Cabral.[51] Many of Saville's contacts, however, yielded better documented collections, some of which are described below.

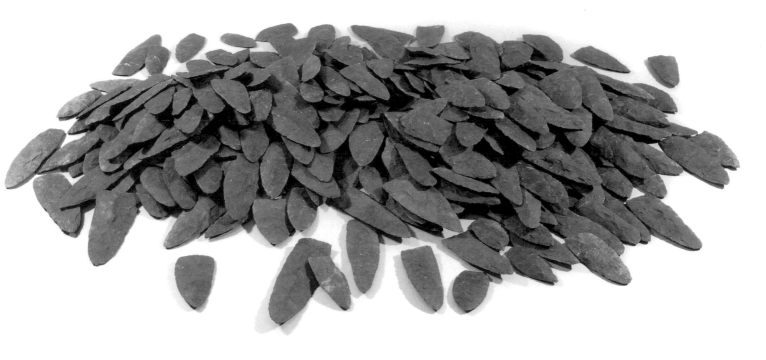

Fig. III-7
Cache blades, 319 pieces, North Hadley, Mass., Early Woodland
period. Stone. L 8–18 cm. Purchase, Russell 1928. 1/1025

The North Hadley Cache

One of the first Saville acquisitions was a cache of
319 bifacially flaked blades or biface preforms that
had been found buried on the farm of Theodore
Russell in North Hadley, Mass. (fig. III-7). The
find had been reported by the newspapers, and
Saville's correspondence suggests that Haffenreffer
had dispatched him to the site with instructions to
offer whatever it would take to secure the find.[52]
Saville wrote to Haffenreffer, "it [the cache] is the
most wonderful cache and the largest one I have
ever seen from the east, 319 knives and spear points.
The reason we did not get a definite answer was
because he had offered to sell it to the Peabody
Museum at Harvard for $319.00. When I offered
him $400.00 he was going to withdraw that offer,
and will let me know some time within two
weeks."[53] Haffenreffer finally paid $500 for the
cache.

This cache is similar to, though somewhat larger
than, typical Early Woodland-period caches.[54] Many

pieces have virtually identical proportions and con-
spicuously similar flaking patterns, including "Z-
twist" edges and unifacially thinned or "crowned"
bases. Several pieces seem to have been made on
flakes from the same core, as suggested by similar
colors and grain patterns. The Russell cache has
great potential to contribute to studies of lithic
technology and the social aspects of lithic procure-
ment and production during this time period.

Francis Drake

Francis Drake, proprietor of "Drake's Garden," East
Brookfield, Mass., sold Haffenreffer a group of
artifacts that included one of the finest known
examples of a carved burl bowl which had been
found near Congammond Lakes, Southwick, Mass.
(fig. III-8). The bowl, 39 cm by 34 cm by 25 cm
high, has two projections coming up from the rim
and each has a head with inset metal eyes, carved
on its inner side. It was illustrated by Willoughby
who attributed it to the Nipmuc or Mohegan and
is believed to date from the mid-seventeenth cen-
tury.[55] Also included in the Drake purchase was a

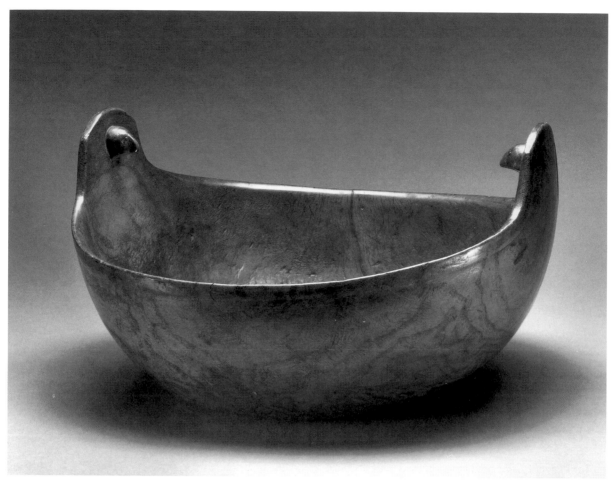

Fig. III-8
Bowl, Nipmuc or Mohegan, Southwick, Mass., early 17th c.
Wood, metal. L 39 cm. Purchase, Drake 1928. 1/1424

selection of other artifacts – particularly noteworthy are sixteen plummets, a polished bone wedge, and a Late Archaic-type tanged copper projectile point.

William and David Lincoln

According to the affidavit that came with the William and David Lincoln collection, the brothers had been collecting "Indian Specimens" around West Brookfield, Mass. since about 1870. In the 1880s David Lincoln was widely known as a collector of Indian relics and bought or was given artifacts that had been found much earlier.[56] In one case he bought two shell beads from the Worcester Society of Antiquity which were reputed to have

been collected from the Native makers in the late seventeenth century.[57] The Lincolns also owned a semilunar knife with tallies and suspension hole that was found by Albertus L. Cooley in 1838.

In November 1928 Saville bought this collection from William Lincoln (David had died earlier). In reporting to Haffenreffer he estimated the collection to contain fifteen hundred artifacts which included twenty pestles, twenty-two axes and celts, thirty-two gouges and adzes, six steatite pipe bowls and pipe fragments, two plummets, two picks, and two bannerstones. Five steatite bowls or bowl fragments, three pendants, and 528 projectile points rounded out the catalogued pieces and the rest of Saville's count of fifteen hundred pieces were uncataloged flakes, scrapers, and projectile point fragments. The artifacts were accompanied by a

sixty-seven-page catalogue which provided the collector's name, the collection date, and provenience by town or better for nearly two hundred of the most significant pieces. This catalogue also remains a valuable historical document for the information it contains on the nineteenth-century network of collectors in central Massachusetts.

Herbert A. Harnden

In December 1928 Saville purchased the collection of Herbert Harnden, then of Framingham, Mass. Although Saville was certainly interested in the approximately eight hundred pieces from southern New England, primarily from around Billerica, Mass., what really attracted his attention were one hundred and eighty Middle and Late Archaic artifacts from the Sunkhaze Ridge Site (also known as the Veazie Site) in Milford, Maine.[58] These had been recovered during sand quarrying in 1922 and 1923 by crew supervisor Harnden. Some of the artifacts were exhibited at Wellesley College where they came to Saville's attention, and some had been loaned to Moorehead for study. Moorehead strongly advised Saville to purchase the collection for Haffenreffer.[59]

Sunkhaze Ridge artifacts, such as narrow and flaring full-channel gouges, steep-bitted adzes, and ground-slate rods, represent the major diagnostic pieces of the Middle Archaic in Maine. Several rod forms found at the site are previously unrecorded.[60] Because Haffenreffer carefully preserved these artifacts and because they were well documented for the time – with artifacts grouped as found – the Harnden collection has retained significant scientific value. Additional data have recently been recovered in interviews with Harnden's descendants and with witnesses to the excavation.[61]

Harrie M. Wheeler

In his 1925 article on the archaeology of Rhode Island, Howard Chapin gave top billing to Haffenreffer's collection but also gave prominent notice to the collection of Harrie Wheeler of Davisville, R.I.[62] In the course of following leads from Chapin, Saville visited Wheeler and described his collection as "the finest private collection in Rhode Island,

over 2000 specimens. The collection is well known, and he has had an offer of $1000, but he would not consider it. He has collected most of the material himself in Rhode Island and Massachusetts. Has a good catalogue."[63] It was an important event, therefore, when Saville secured the Wheeler collection for Haffenreffer in January 1929. The thousand or so catalogued artifacts were almost entirely from North Kingstown and East Greenwich, R.I. and included ten Contact-period Native artifacts from Babbitt Farm, also known as Coccumcussoc or Smith's Castle, the probable site of Roger Williams's seventeenth-century trading post. Wheeler's collection included a striking late-prehistoric Iroquois pipe, from New York.[64] Made of slate, it bears a face with accentuated eyebrows and ears and with an incised snake coming from each corner of the mouth (fig. III-9). Also in this collection were a number of projectile points and grooved axes from the Midwest and South, provenienced by county.[65]

Fig. III-9
Pipe, Iroquois, New York, 17th c. Slate. H 7 cm. Purchase, Wheeler 1929. 78-40

Certainly the most diverse collection which Haffen-reffer came to acquire was that of Jacob Paxson Temple, purchased from his widow Ada Underhill Cheyney of West Chester, Pennsylvania. This purchase, in February 1929, was one of the last that Saville made for Haffenreffer and it stands out because Cheyney was not a local figure nor did the collection contain many local archaeological artifacts. It included approximately ten thousand archaeological and two hundred and fifty ethnographic artifacts (Hail, this volume) from throughout the western hemisphere. The collection was accompanied by a photographic catalogue that listed provenience information for many artifacts. Despite its significant contribution to Haffenreffer's collection, little is known about how the Temple collection was assembled or how Saville came to know of its existence.[66] Other than the catalogue, the records include only the bill of sale and a telegram.

> West Chester, Penn. Feb. 26, 1929
> Received by check from Chester County Trust Company one thousand dollars for Indian Collection owned by Jacob Paxson Temple and purchased on Feb. 27, 1929 by F. H. Saville for R. F. Haffenreffer Jr. of Fall River, Mass.
> Ada U. Cheyney[67]

Temple was a New York decorative arts dealer specializing in early American glass and furniture, and he probably built his "Indian Collection" from auctions and dealers he contacted while conducting his antique and collectibles business.[68]

Included in the collection were scores of large axes, celts, hoes, and pestles, as well as scrapers and knives, gorgets, discoidals, and projectile points. In addition there were cigar boxes full of projectile points, index cards sewn with beads, and clay pipe stems strung on wires. Arguably one of the most scientifically important group of artifacts came from the Susquehanna River valley of eastern Pennsylvania and northern Delaware and once belonged to several major collectors around Lancaster, Penn., including Samuel Zahm, H. L. Simon, and Charles Steigerwalt. These collections were sold at auction in Philadelphia in 1917 and were somewhat dis-

persed before Temple acquired the remainder.[69] Provenience information, often to specific sites, was provided for many of these pieces in the form of paper labels affixed directly to the artifacts. Taken together the group is an excellent representation of the range of the region's artifact types. As an added bonus, the overlay of the labels of successive collectors provides a valuable source of information on the network of amateur archaeologists existing in Pennsylvania around the turn of the century (fig. III-10).

As well as a large Pennsylvania group, the Temple collection contained important artifacts from Illinois, Missouri, Ohio, and other Midwestern states. These included six large hoes from Trigg and Pickett counties, Kentucky, which exhibit heavy use-wear from working fine flood-plain soils. From Jefferson County, Illinois came a cache of six discoidal knife-blanks and knives made on flakes with central inclusions (fig. III-11). The collection also had a number of pipes, including several from the Northeast with stylized faces or other decorations on the bowl.

Fig. III-10
Gorget with original labels from various collectors, Ohio. Slate. L 9 cm. Purchase, Temple 1929. Temple 22

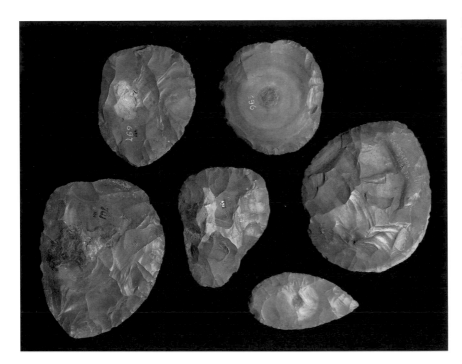

Fig. III-11
Discoidal cache blades, Illinois,
Mississippian period,
AD 1150–1350. Chert. Largest
D 17 cm. Purchase, Temple
1929. Temple 696–701

Warren K. Moorehead

Beginning sometime during Saville's tenure and continuing through 1930, Haffenreffer corresponded with and met Warren K. Moorehead, director of the Department of American Archaeology at Phillips Academy, in Andover, Massachusetts. Moorehead sought Haffenreffer's support for several collecting expeditions, and Haffenreffer hoped Moorehead could secure for him "King Philip's Club," a ball-headed club purportedly taken from the body of the Pokanoket leader in 1676. The club was in the possession of a Union, Maine couple. Although Saville was not directly involved in the exchanges between Haffenreffer and Moorehead, he may have introduced them or otherwise directed them toward each other.

Moorehead had been a prominent figure in North American archaeology since the 1890s – publishing several widely read books on Indian antiquities;[70] excavating at important sites like Fort Ancient, Ohio, Cahokia, Illinois, and Etowah, Georgia; and conducting the surveys in Maine that gave his name to the Moorehead Burial tradition or "Red Paint" burials.[71] Although he remained an important, though controversial, player on the

archaeological stage through the 1920s, in part because of his successful collecting at Etowah in 1925–27, his name had been made much earlier with excavations in Ohio beginning in 1886. He gained wide recognition for the artifacts that he and Gerard Fowke retrieved from the Hopewell Mounds in 1891 for the World's Columbian Exposition in Chicago, and he was asked to help curate the U.S. exhibit at the Columbian Exposition in Madrid in 1893.[72] After 1897 he collected widely in the South and along the Susquehanna River in Pennsylvania, and in New England.[73] Moorehead was on the Board of Indian Commissioners from 1908 to 1933 and was prominent within the Indian reform movement.[74] He involved himself in a variety of other projects such as the federal investigation of timber and land swindled from Indians in Wisconsin[75] and the reconstruction of an aboriginal village for the celebration of the Massachusetts Tercentenary in 1928–29.[76]

After leaving Ohio, Moorehead seems to have become increasingly peripheral to the mainstream of archaeological studies, although he continued to collect from important sites. In part this was due to his poor health – he spent most of three years

(1897–1900) in a Saranac, N.Y. sanatorium, with tuberculosis.[77] In large measure this change was due to the growth of academic archaeology away from Moorehead's interest in collecting "relics" and toward interpretation of their cultural and historical contexts. It was also the result of a general shift among major institutional supporters of archaeology – the American Museum of Natural History, the Peabody Museum at Harvard, and the Smithsonian Institution, among others – away from questions like the identity and origin of the "moundbuilders," which had been of high public interest in the 1880s when Moorehead first came on the scene, toward Mesoamerica, which began to attract more attention starting with the Harvard Peabody expedition to Copan in 1891.

Haffenreffer and Moorehead each benefitted from their mutual acquaintance. In February 1929 Haffenreffer contacted Moorehead and suggested that he might like to visit Bristol. Haffenreffer also proposed that Moorehead might advise him on

lacunae in the collection of the King Philip Museum. Moorehead welcomed the invitation to see the Museum and to advise Haffenreffer.[78] For his part, Moorehead was interested in enlisting Haffenreffer's support for various projects, including the reconstruction of an aboriginal village to celebrate the Massachusetts Tercentenary and archaeological "expeditions" to Maine, to the Merrimack River, to Virginia, and to Florida, Georgia, and South Carolina. In this respect, Moorehead treated Haffenreffer much the way he treated other "benefactors" from whom he collected small cash contributions in support of his expeditions and to whom he returned representative collections from the areas visited.[79]

In August 1929 Haffenreffer contributed two hundred dollars towards the expenses of a collecting trip to Canada and Maine in return for which Moorehead promised, "I shall be very glad to see that you do not lose out in the way of returns."[80] It does not appear that this Moorehead expedition

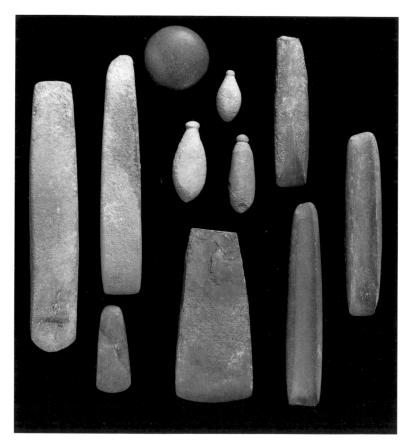

Fig. III-12
Chisels, plummets, and *gouges,*
Mattawamkeag and Alamoosook Lake,
Maine, Late Archaic period,
3100–1600 BC. Stone. Left chisel L 30 cm.
Gift, Moorehead 1929.

was successful since several months and several trips to Maine passed before Haffenreffer received any artifacts. In November he wrote to Moorehead saying, "whenever you are ready, and have the specimens shipped – which you so kindly offered to give me for my collection – I shall be pleased to make an appointment with you."[81] The first of three batches of artifacts was sent to Haffenreffer on December 9 and eventually Haffenreffer received twenty-one Late Archaic-period artifacts, including gouges, adzes, and plummets (fig. III-12). All these came from existing collections at the Peabody Museum, Andover, Mass.

Although he certainly valued Moorehead as a contact among academic archaeologists, Haffenreffer was also interested in Moorehead's connection to a Maine woman who had inherited "King Philip's war club" and from whom Moorehead had been trying to buy the club for some time (Hail, this volume). In addition to providing collections and a connection to King Philip's club, Moorehead also afforded Haffenreffer advice on exhibits. He proposed the expedition to Maine on the grounds that, "in looking over your collection I see that you have not much from the State of Maine,... you also need a little shell heap material from Maine. I could also set up for you a Red Paint grave, as found, including the ochre and objects."[82] This kind of exhibit, he pointed out, had worked well for Clara Endicott Sears at her Fruitlands Museum, in Harvard, Mass.

Haffenreffer apparently did not follow Moorehead's suggested reconstruction of a "Red Paint" burial, and he generally eschewed the life-groups and reconstructions that were popular in some museums at the time.[83] Haffenreffer did, however, exhibit an impressionistic reconstruction of a Native burial from Block Island. The skeleton was reassembled on a bed of sand in a flat case but it was accompanied by a fragmentary iron artifact and projectile points of widely different periods.

Unlike many museums that focused on excavated collections, Haffenreffer's museum had relatively few human remains.[84] Other than the Archaic "grave" from Moorehead, which did not include any bones, there were only four "complete" burials

and several miscellaneous bones that can definitely be attributed to Haffenreffer's collection.[85] The major burials included the bones of a child from Burr's Hill; an adult male skeleton from Block Island, R.I.; a skull excavated in Wickford by Louis Flanders, and a cremation burial acquired by Haffenreffer in Arizona along with the pot that contained it.

THE LONG AFTERNOON
OF THE KING PHILIP MUSEUM

After Foster Saville left, Rudolf Haffenreffer returned to a pattern of accumulation much like that of the period before 1927. Except with his dealings with Moorehead and with Heye, in which he pursued particular artifacts, Haffenreffer made less effort after 1930 to search out collections systematically, instead preferring to acquire collections of particular interest when they came his way. One new collecting opportunity which presented itself after the emergence of the Museum on the public scene was gifts or advantageous offers to buy from people who knew of the Museum and saw it as the "right" place for objects to which they attached sentimental value (Hail, this volume). The rising public profile of the King Philip Museum also brought many dealers to Haffenreffer. What the acquisitions of the post-Saville period may lack in pattern and purpose, they more than make up in the diversity and the interest of their stories, as well as in their quality.

Horace M. Grant

The source of most new archaeological material for the 1930–31 period was Providence collectibles dealer Horace M. Grant, who sold artifacts to Haffenreffer periodically from 1928 to 1941.[86] Grant and Haffenreffer shared a working relationship as trusted dealer and best customer, an association originally established by Saville in May 1928, who may have been directed to Grant by Chapin. Saville made four small purchases from Grant through October 1, 1930. These pieces, mostly from Rhode Island, included four polished axes, at least one gouge, a pestle, three hoes, a steatite pipe, and one hundred and twenty-five "arrows, spear points and blanks."[87]

Fig. III-13
Pestle, Maine, Woodland period. Stone. L 61 cm. Purchase,
Grant 1939. 10155

Beginning in May 1930 Grant appears to have dealt directly with Haffenreffer. On the fourteenth, Grant delivered to Haffenreffer a large group of archaeological and ethnographic artifacts as well as books and historical artifacts such as the bell-pull from the steamer *Portland* and the key to the "old Coles Hotel, Warren, R.I." The archaeological material included the substantial Rhode Island collections of Wellington King and Charles R. Mathewson, as well as other assorted pieces. The former collection was made in the late nineteenth century by three generations of Kings (whose relationship to Samuel King, a collector who sold to Saville, is unknown, although King was not an uncommon name in the Wickford area). As well as about a dozen larger pieces such as axes and pestles, the Wellington King collection included "21 boxes arrow heads." In February 1931, Grant sold Haffenreffer the collection of Bertram W. Vickary, which contained arrowheads, axes, pestles, and other lithics from Lynn, Revere, and Marblehead, Massachusetts; archaeological specimens from California, Florida, and Alaska; and fossils from Massachusetts and California.

Throughout the 1930s Haffenreffer made at least ten smaller purchases from Grant, and several other types of collectibles, including Indian deeds and autographs, were sent to Haffenreffer on approval but returned. Some of the items purchased are especially noteworthy. In 1933 Haffenreffer bought two Mexican ceramic vessels which Grant had purchased from Carroll Alton Means, a curator at the Peabody Museum at Yale, who had obtained them from local families in New Haven. In 1939 Haffenreffer bought a swan-headed pestle which Grant had bought from the granddaughter of Captain William J. Baker, on whose Pittston, Maine farm it had been found (fig. III-13). In 1940 Grant sent Haffenreffer a knobbed "effigy" gouge from Connecticut for his consideration. Grant had acquired it from a woman in Plainfield, Conn. who had been using it as door stop. Haffenreffer bought it on January 8, 1941.

The long-lived business association between Grant and Haffenreffer was encouraged by their shared eclectic interests. The May 14, 1930 collection and the Vickary collection, with their historical curiosities and fossils, were apparently typical of the kinds of things that passed through Grant's hands, and they would have particularly appealed to Haffenreffer, the collector of so many different things.

George G. Heye and the
Museum of the American Indian

Between 1931 and 1945 Haffenreffer received a variety of archaeological material through exchanges with the Museum of the American Indian, Heye Foundation.[88] The earliest contacts between Haffenreffer and Heye may have concerned Burr's Hill, a site that held special interest to Haffenreffer because of its putative association with Massasoit. Saville had been gathering Burr's Hill artifacts from local relic hunters for the Museum of the American Indian for many years, beginning around 1918, during which time Haffenreffer was building his collection of local artifacts.

With Heye, as he had done with Moorehead, Haffenreffer extended financial support in exchange for representative artifacts for his own collection. As a trustee of Heye's museum, Haffenreffer helped support its operations during the lean years of the early 1930s, and in 1932 corresponded with Heye about how best to round out the collection at Mount Hope.[89] Along with Iroquois and other ethnographic material, Heye offered Haffenreffer a representative collection from Burr's Hill. Sent in November 1934 this collection included 122 artifacts, among them projectile points, beads, and a variety of metal objects.[90] Heye wrote, "I am delighted that you have in your wonderful museum a representative collection from this most important Rhode Island site."

Another major exchange took place in February 1943 when Heye sent Haffenreffer a wide variety of ethnographic and archaeological artifacts, mostly from the West, in return for a large contribution to assist the Museum of the American Indian out of financial difficulties. Of particular interest in this exchange are artifacts from California, including seventy-five archaeological pieces and an assortment of several hundred shell beads. Unlike many of Haffenreffer's acquisitions, this group included only a few projectile points; the majority of the artifacts were stone mortars, pestles, bowls, and other shaped stones. Except for small groups of points from Tulare and Siskiyou counties, the artifacts were from southern California, including Santa Barbara, Santa Catalina, San Clemente, and San Nicholas Islands, and from Long Beach, San Diego, and Ventura counties. One particularly fine piece is a whale effigy plummet of steatite from San Nicholas Island (fig. III-14). Heye had a number of people collecting for him in this area during the 1920s, including Ralph Glidden and E. L. Doran to whom some of the exchanged objects are attributed.[91]

Through exchanges, Heye helped Haffenreffer fill in gaps in his collection, and also provided guidance on collections that had been offered to Haffenreffer. In 1940, Haffenreffer sent to Heye a five-inch high figure with Indian-like features and a Plains style headdress that had been offered to him by a man claiming to have found it buried in a sand bank in Seekonk, Mass. "Please tell me just what you think of this and if you advise me to buy it, what in your opinion should I pay for it."[92] Haffenreffer may have been struck by the whimsy of the piece because although E. K. Burnett, one of Heye's assistants, questioned its authenticity, Haffenreffer eventually bought the figure.

Fig. III-14
Whale-effigy plummet, Gabrielino, San Nicholas Island, Cal., Late Horizon. Steatite. L 22 cm. Exchange, MAIHF 1943. 20/3835

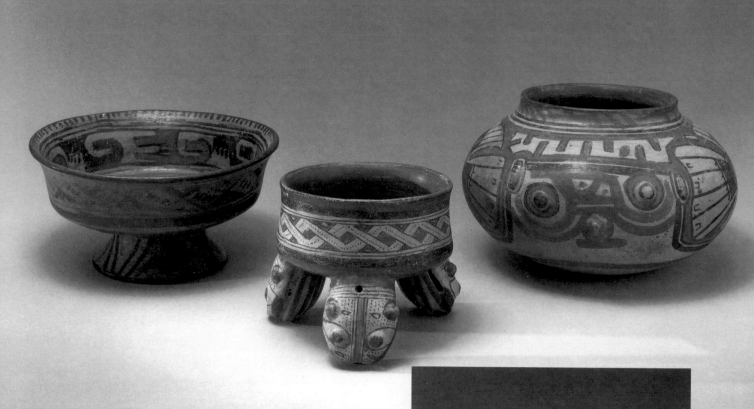

Fig. III-15
Ceramics, Nicoya area, Costa Rica, Post-Classic period,
AD 1200–1550. Jicote Polychrome. Tripod bowl D 13 cm.
Purchase, Gonzalez 1937. L to R: CR-24, CR-21, CR-14

Central and South America

In 1937 Haffenreffer sought Heye's advice on the
much more substantial matter of a collection of
Costa Rican pottery and stonework offered to
Haffenreffer by Jose P. Gonzalez. Gonzalez had
dealt with the Museum of the American Indian in
the past, and so Haffenreffer asked Heye to look at
what was offered and "to give me an idea as to
what I should pay for it."[93] With Heye's appraisal
in hand Haffenreffer purchased twenty-eight pieces,
including nineteen pots (fig. III-15 and plate 26), a
ceramic incense-burner lid with zoomorphic finial,
and seven carved grinding stones in metate and in
pedestal forms (fig. III-16).[94] All the objects came
from the Guanacaste-Nicoyan archaeological zone
although they range chronologically from Pre- to
Post-Classic.[95]

In the correspondence concerning the Gonzalez
purchase, Heye warned Haffenreffer that "if you
start collecting from Central and South Americas

Fig. III-16
Pedestal grinder, Nicoya area, Costa Rica. Stone. H 33 cm.
Purchase, Gonzalez 1937. CR-36

you will have a pretty large job ahead of you,"[96] and while Haffenreffer eventually obtained representative collections from Central America, he heeded Heye's advice and generally concentrated on North America. Besides the Gonzalez collection, Haffenreffer's Mesoamerican artifacts came mostly from Southwest trading posts – as with a miniature of a Vera Cruz ballplayer's yoke purchased at the Teestoh Trading Post (Hail, this volume) – or from collections that included such pieces among substantial quantities of New England artifacts. An example of this type of acquisition was the James Moffitt collection which Haffenreffer purchased in 1930. The collection contained around two hundred Rhode Island artifacts, including points and beads, but it also included 152 jade figurines that Moffitt had acquired from J. H. Nickerson, of Chatham, Mass. who had, himself, excavated them from various locales around the city of Oaxaca.[97] This sample of Mixtec votive figurines or *penates*[98] includes examples in a range of styles.[99]

George P. Rowell

A collection from which Haffenreffer got a sample of South American archaeological artifacts was that of George P. Rowell, an attorney and Indian artifact collector from Stamford, Conn. The collection, purchased in 1934, contained important ethnographic specimens collected by Rowell's two brothers (Hail, this volume) and South American artifacts collected by him and his wife. Also included was a quantity of North American archaeological artifacts which had been purchased in March 1919 from Paul Hunter of Nashville, Tenn., who with his partner William Edward Myer, owned a book and antiquities business. Although both had long been active in the local archaeological community, Myer was particularly prominent – serving as a source for G. P. Thruston's book, *The Antiquities of Tennessee and Adjacent States,* which was widely read as a model for avocational archaeology, and supervising the 1920 Bureau of American Ethnography excavations at the Gordon and Fewkes sites

Fig. III–17
Jar and *bowls,*
Arkansas (?),
Mississippian period,
AD 1250–1550.
Shell-tempered
clay. Jar H 17 cm.
Purchased at Zuni,
N.M. and Oraibi,
Ariz. 2/7881,
2/7879, 2/7913

Fig. III-18
Pitchers and ladle, Anasazi, Chaco. Clay. Ladle L 24 cm.
Purchase in Southwest. L to R: 2/7883, AR-36, 2/7893.

Fig. III-19
Canteen, jar with shell-shaped handle, *sieve,* Anasazi. Clay.
Sieve D 11 cm. Purchase in Southwest. L to R: 2/7911,
2/7892, 83-472.

in the Cumberland River Valley near Nashville.

Also sold to Haffenreffer by Rowell were artifacts acquired by Rowell from Moorehead in April 1918 and March 1919. These included seventy-five points from Tennessee, five miscellaneous pieces from Ohio, one adze from New Hampshire, and thirty-seven pieces from the Arkansas River valley. The ultimate source of this material is not known, but Rowell, like Haffenreffer, may have been one of Moorehead's "benefactors."[100]

Trips West

During the 1930s, Haffenreffer also continued to collect artifacts during his trips west, and both large collections and miscellaneous artifacts were purchased at the curio shops or "trading posts" that catered to the growing tourist trade and collector interest of the time. Some trading posts carried ethnographic and archaeological artifacts from other parts of the country in addition to local material (Hail, this volume), allowing Haffenreffer easily to expand the scope of his collection. Haffenreffer

Fig. III-18
Pitchers and ladle, Anasazi, Chaco. Clay. Ladle L 24 cm.
Purchase in Southwest. L to R: 2/7883, AR-36, 2/7893.

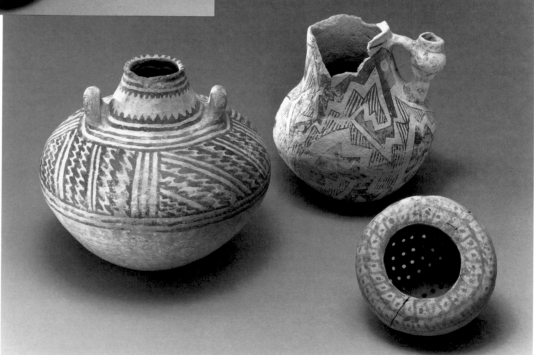

Fig. III-19
Canteen, jar with shell-shaped handle, *sieve,* Anasazi. Clay.
Sieve D 11 cm. Purchase in Southwest. L to R: 2/7911,
2/7892, 83-472.

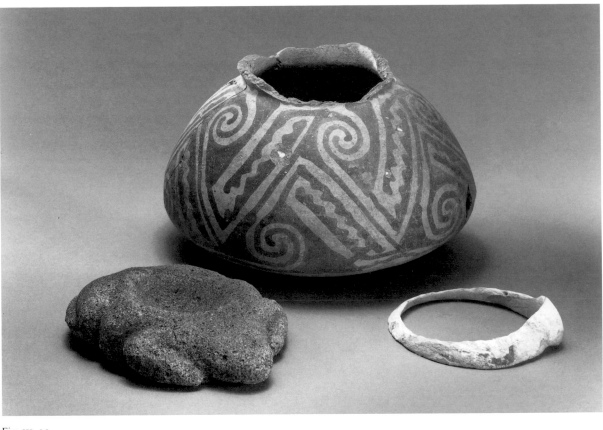

Fig. III-20
Frog effigy mortar, stone. *Jar*, Colonial period, Sacaton phase,
AD 550–1150, red-on-buff. *Bracelet,* shell. All Hohokam.
Bracelet D 9 cm. L to R: AR-57, AR-23, AR-109

gathered a variety of Eastern pottery in this way, including pieces from Georgia and elsewhere in the Southeast (fig. III-17).

In addition to artifacts Haffenreffer himself purchased, the King Philip Museum also received artifacts from the Southwest that were bought for Haffenreffer by business contacts. For example, J. A. Norden sent Haffenreffer a pestle and seven mortars purchased from the Hangtown Antique Shop in Placerville, Calif. in 1934.[101]

Many Southwestern archaeological artifacts, though not identified as to source, are listed under the somewhat later alphabetical catalogue system, which intimates that they were acquired during this time. Among this group is a fine, representative collection of Anasazi pottery (fig. III-18, III-19), and Hohokam artifacts, including incised paint

palettes, worked shell, pottery, and stone carvings (fig. III-20).

By 1954, Haffenreffer's collection contained several thousand archaeological artifacts from the West, including over thirteen hundred points, scrapers, and shaft-smoothers from Utah (fig. III-21), and about fifteen hundred uncatalogued Western "bird" or "gem" points typical of the Columbia River and Northern California region (plate 36). Although the Richardson, Temple, and Charles Miller collections included artifacts of these types most were probably purchased during the annual forays west.

Haffenreffer's acquisition of the Charles Miller collection in 1945 is an excellent example of how the good will of the community towards the King Philip Museum continued to attract collections well after major collection-building had ceased. Miller sent Haffenreffer sketches of his collection, which included fifteen grooved axes, twelve celts

Fig. III-21
Archaeological artifacts, Utah, various periods. 3–8 cm. Utah
series in HMA alphabetical catalogue.

or adzes, a perforated pebble, and 152 projectile points and other pieces. "If you want to see them and don't want to drive in I can take them out to the Highway in a wheelbarrow. I am home most all the time and if you do not want them please let me know for as my new house is so small I have no place to desplay them. These relics has never been seen by any dealors or collectors...."[102] Haffenreffer paid Miller a token thirty-five dollars. The William Gardiner collection, acquired in 1946, is another example. Gardiner, who had been an Eagle Scout and remembered visiting Mount Hope in the 1930s, offered to give Haffenreffer some of the Aleutian artifacts he had found while a Seabee on Attu Island during World War II.[103]

The last archaeological material that Haffenreffer acquired was the 1952 purchase of the collection of Perry Brooks of Providence. Again the circumstances are typical of this period of Haffenreffer's museum career. Brooks wrote to Haffenreffer, "I am planning to move to the west coast in the early summer and by so doing will have to dispose of some of my Indian artifacts. Wonder if you would be interested in aquiring them?"[104] The collection consisted of seventeen ground-stone artifacts from Minisink, N.J., including a Late Woodland pot; sixteen steatite quarry-rejects from a quarry in Johnston, R.I.; and ten pestles from various Rhode Island locales. Haffenreffer paid Brooks a nominal sum. The purchases of the Miller and Brooks collections were not important because of what they added to the collection, but because they show Haffenreffer's continued service to the community and encouragement to individuals which also saw

expression in his work with the Scouts (Krech, this volume).[105]

Haffenreffer and the Archaeology of His Day
Rudolf Haffenreffer's collecting took place in a landscape of private collectors and public institutions that was enlivened by a variety of expeditions, sales, and swaps.[106] It was a landscape that developed in the context of the popular scientific debates of the nineteenth century.[107] Antiquarians, during a time of European colonial expansion abroad and industrial development in previously unexamined rural areas and caves at home, came to study and speculate on a wide variety of archaeological phenomena.[108] Whereas these curiosities previously had been understood in Biblical terms, interpretations became increasingly descriptive, guided by the objective, comparative framework that was proving so successful for natural historians at the time.[109] Archaeologists came to feel that archaeology "should avail itself of the comparative method" because Darwin and others had shown the advances that could be made through classification and comparison.[110] This approach typified what has been called the "classificatory-descriptive"[111] period of archaeology, and although its limitations were beginning to be recognized by 1920, in some work

its effects lasted well into the twentieth century.[112]

Haffenreffer's collection, even in the 1930s, was firmly within the natural history paradigm. It was typologically narrow and geographically broad and drew but little from the cultural particularism that had been promoted by anthropologists at the American Museum of Natural History or the Peabody Museum, Harvard before 1920.[113] In his exhibits, too, Haffenreffer followed the older pattern, showing representative collections from different regions and also showing the variety within a single artifact type such as arrowheads (note the background in fig. 1-11 and fig. 111-23). The practice of arranging projectile points for display, which Haffenreffer had begun as early as 1916, was continued using Riker mounts – shallow boxes in which cotton held artifacts pressed against a glass top (fig. 111-22). Unusual artifacts were displayed as curious phenomena, as was the Riverside cache (fig. 111-23).

The character of Haffenreffer's collection and exhibits reflected the ideas of the archaeologists he was in contact with, both the professionals and the local amateurs. Moorehead, for instance, had remained a collector who focused on artifacts themselves after many academic archaeologists had begun focusing more broadly on the cultural context of

Fig. 111-22
Riker mount, with Rhode Island archaeological artifacts on cotton.
31 x 21 cm.

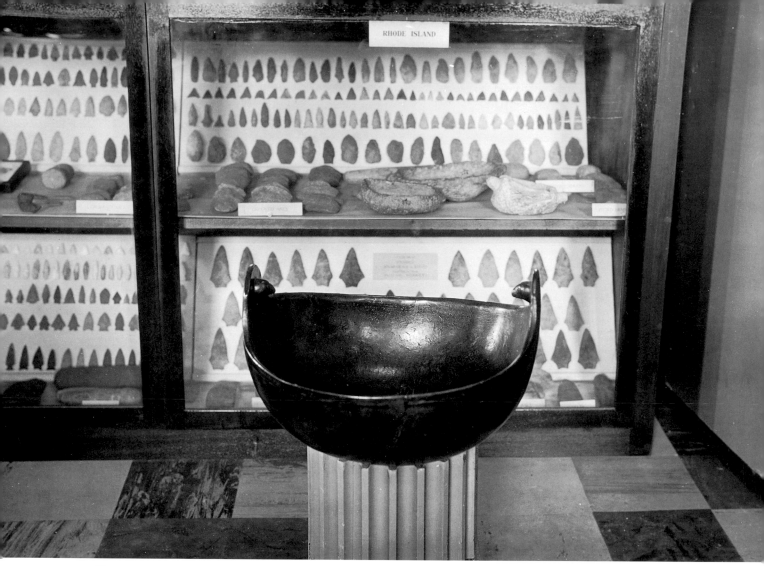

Fig. III-23
Interior, King Philip Museum, ca. 1931. *Cache blades,* 42 pieces, Riverside, R.I., Susquehanna tradition, ca. 3600 BC, is featured in the display visible behind bowl. Cache 1/339. Haffenreffer Museum of Anthropology

artifacts. Most of the local amateurs, from whom Haffenreffer first became interested in archaeology and acquainted with the idea of an archaeological collection, had been collecting for years and so they espoused, and their collections embodied, older collecting priorities and organizing principles. The Lincoln collection, Haffenreffer's oldest, had largely been amassed in the 1870s and 1880s. The Bigelow, Anthony, and Richardson collections were probably made before 1915. For suggestions on purchases and exhibition Haffenreffer sought the advice of professionals like Moorehead and Saville but they had themselves risen from the ranks of local or

amateur archaeologists beginning in the 1870s and 1880s and had remained relatively isolated from large, academic institutions. The division of local archaeology from academic institutions was compounded because in the 1930s there was relatively little academic interest in the archaeology of America's Northeast, in comparison to Mesoamerica, the archaeological hotspot of the day.[114]

Haffenreffer's archaeological collecting and exhibiting took place in a social landscape as well as a physical and intellectual one. In this social landscape, collectors, whether museums or hobbyists, may be distinguished either as primary collectors, who acquired artifacts mostly through fieldwork, or as secondary collectors, who acquired artifacts

mostly through dealers, at auction, or from primary collectors. The Richardsons, Harnden, and Wheeler were primary collectors, although they probably also bought or traded artifacts from time to time. Haffenreffer, like his friend Heye, was a secondary collector who for the most part gathered existing collections.

In the southern New England of Haffenreffer's day, there was some competition among primary collectors for lucrative sites, although not on the scale of the competition for famous Central American sites that major institutions and even nations engaged in during this period. There was, however, significant competition between secondary collectors over primary collections and spectacular chance finds. This is borne out by the bidding between Haffenreffer, the Peabody at Harvard, and other parties that drove up the price for the North Hadley cache, and by Haffenreffer's competition with Sears over King Philip's club. Additionally, letters and affidavits often contain statements about other interested parties and arguments about the propriety of sending collections to particular secondary collectors.[115]

In other parts of the country, universities, museums, and learned societies acted proprietarily against interlopers whom they perceived as infringing on their "home" territories or local "catchment areas." Henry F. Adolph, later president of the Society for Pennsylvania Archaeology, described the conflict between local archaeologists in northeastern Pennsylvania and Moorehead and Alanson Skinner who "made a boat trip" through the region to collect for the several New England museums. "Their trip was construed from 'broadsides' heralding their approach and conspicuously posted in all downriver postoffices as 'lootive' rather than instructive by local historical society authorities. As a consequence many collections were kept behind closed doors. In all seriousness, though, had it not been for the alertness of Sheldon Reynolds, Harrison Wright and Horace E. Hayden, many key specimens ...would have been lost."[116]

Also supporting the idea of local "catchment areas" is the observation that the Haffenreffer Museum and neighboring museums with archaeo-

logical collections contemporary to Haffenreffer's such as the Bronson Museum of the Massachusetts Archaeological Society, the Springfield Science Museum, and the Peabody Museum at Andover have few primary sources in common. In addition, major local collections at these institutions often focus on core areas.[117] For instance, the Haffenreffer Museum has extensive collections from areas south of Swansea, Mass., and the Bronson Museum has particularly strong collections from north of Swansea. Primary collectors believed that their local institutions were the "right" places for their collections. The depths to which regional loyalties could reach among archaeologists are revealed by remarks made by a Professor Wright to the Ohio Archaeological and Historical Society about artifacts excavated from Hopewell mounds by Moorehead and exhibited at the Chicago Columbian Exposition: "But all these treasures have gone to Chicago, and are now in the possession of the Field Museum of that city. To the patriotic citizen of Ohio all this must be exceedingly trying when it is fully brought to his notice."[118]

The cooperation and respect of local people interested in archaeology was an important part of the formula for Rudolf Haffenreffer's collecting success. He took advantage of the visibility he gained through his purchase of Mount Hope, his activities with the Boy Scouts, and his ownership of Herreshoff, to gain the good will of local primary collectors and assure himself of a strong collection from a local, core area that included Bristol, Warren, Barrington, Riverside, in Rhode Island, and Swansea, Mass. The spirit of local collectors towards Haffenreffer is attested to by the number of small collections that ended up at the Museum because it "seemed like the right place" (Hail, this volume).[119] The size of Haffenreffer's archaeological collection and the high regard given his exhibits reflects the respect Haffenreffer received from the people of the area.

Haffenreffer's archaeological collection was formed through a unique conjunction of circumstances and personalities, changing as it grew, and was affected in turn by Haffenreffer's changing ideas about museums and Indians. The Richardson col-

lection appears to have inspired Haffenreffer to make more systematic efforts at collections acquisition and management, and the warm reception received by the King Philip Museum when it opened may have reinforced Haffenreffer's valuation of the endeavor. The success of the opening may have encouraged his continued efforts to bring Native American lore and history to the public through revision and expansion of the Museum, through his membership in pan-Indian organizations, and through the Boy Scouts (McMullen, Krech this volume). Collecting and collections fed back not only into themselves but into other areas of life as well, as suggested by the Chief Gansett figure used in marketing Narragansett beer (Krech, this volume). What Haffenreffer's collection meant to him, and to his various audiences, changed during his life as the collection developed and his and other people's ideas about Indians and the past changed.

Nor has the collection remained an isolated artifact, frozen since Haffenreffer's time, perfectly preserving for our historical analysis his understandings of the parts and the whole.[120] Many material changes to the collection, including additions and subtractions, curatorial practices, and decay, can skew interpretation. To ward against such a danger this essay has treated the Haffenreffer collection like an archaeological site. The particular characteristics of both a museum collection and an archaeological site are shaped by the operation of "formation processes" – personalities and ideas, forces and events – which can be accounted for in analysis because they are patterned and their effects are predictable.[121] The activities of local, amateur archaeologists were one formation process that left a deep mark on the character of Haffenreffer's museum. For any museum, this approach offers a way to answer the question, "why is the collection the way it is?" but it is especially salutary for personal collections and small museums so directly shaped by the ideas and actions of their founders.

ACKNOWLEDGEMENTS

This analysis of Haffenreffer's archaeological collection would not have been possible four years ago, before the start of my on-going project to reorganize and rehouse the Haffenreffer Museum's entire archaeological collection; I would like to thank Shepard Krech III for the opportunity to conduct this project. For invaluable assistance in preparing this essay I would like to thank Thierry Gentis and Rip Gerry, of the Haffenreffer Museum, Andrew Veech, and my fellow essayists, Barbara A. Hail, Shepard Krech III, and Ann McMullen. I would also like to thank the following people around the country who helped me trace long forgotten collectors: Denise Antaya and Larry Fitton, Attleboro Historical Society, Attleboro, Mass.; Thomas Lux and Curtiss Hoffman, Massachusetts Archaeological Society; David Andreozzi, Narragansett Archaeological Society; James Bradley and Michael Walko, R. S. Peabody Foundation, Andover, Mass.; John Pretola, Springfield Science Museum, Springfield, Mass.; Albert Klyberg, Rhode Island Historical Society, Providence, R.I.; Jeff Chapman, Frank H. McClung Museum, University of Tennessee, Knoxville. For their help researching the Temple collection I would like to thank Charlotte Goodman; Anne Cheyney Hombach; Curtis P. Cheyney III; Vernon Gunnion, Landis Valley Museum, Lancaster, Penn.; Mark McConaughy, Pennsylvania State Museum, Harrisburg, Penn.; Jack Luce, Lancaster County Historical Society, Lancaster, Penn.; W. Fred Kinsey; and Marion Stroud, Chester County Historical Society Library, West Chester, Penn. The heading, "The Long Afternoon of the King Philip Museum" was suggested by Brian Aldiss's novel *The Long Afternoon of Earth*.

NOTES

1. For the purpose of this essay, archaeological artifacts are taken to be those, usually of stone, excavated from the ground or otherwise acquired in the absence of face to face contact with the people who made and used them. In the Haffenreffer Museum of Anthropology, certain archaeological artifacts such as prehistoric Southwestern pottery have been curated with the ethnographic collection and have accordingly been discussed by Hail (this volume).

2. This distinction between archaeological and ethnographic artifacts arose because of subdisciplinary divisions between archaeology and ethnology, different care requirements of typical archaeological artifacts, and the increasing specialization of museum staff.

3. Bruce G. Trigger, "Archaeology and the Image of the American Indian," *American Antiquity* 45 (1980), 662–76;

Robert F. Berkhofer, Jr., "White Conceptions of Indians," in Wilcomb E. Washburn, editor, *Handbook of North American Indians, Volume 4: History of Indian-White Relations* (Washington, D.C.: Smithsonian Institution Press, 1988), 522–47.

4. Although Haffenreffer moved ethnographic, archaeological, and art objects to and from his home, and some of these, such as the folk carvings, were retained or sold by his family, most of the archaeological artifacts ended up in the Haffenreffer Museum of Anthropology.

5. *Bristol Phoenix,* November 3, 1916.

6. *Providence Sunday Journal Magazine,* October 11, 1931, p. 1.

7. *Bristol Phoenix,* November 3, 1916.

8. Carl Haffenreffer, conversation with author, April 1992.

9. *Bristol Phoenix,* September 18, 1923.

10. Haffenreffer Museum of Anthropology Archives (HMAA) Card Catalogue, fractional series.

11. *Bristol Phoenix,* September 18, 1923.

12. HMAA Collections Files, old catalogue; Susan G. Gibson, editor, *Burr's Hill: A 17th Century Wampanoag Burial Ground in Warren, Rhode Island,* Brown University Studies in Anthropology and Material Culture, 2 (Providence, R.I.: Haffenreffer Museum of Anthropology, 1980).

13. HMAA Collections Files, RH:Burr's Hill – Various Collectors, letter from D. A. Seamans to R. Haffenreffer, August 4, 1927.

14. Thomas Lux, conversation with author, May 14, 1993; HMAA Collections Files, RH:C. Richardson, receipt, February 5, 1927.

15. Because there are no museum or collection related records before this date it is impossible to say how actively Haffenreffer pursued collections before the Saville period, although this letter indicates that he was initiating contacts.

16. HMAA Collections Files, RH:Richardson.

17. HMAA Collections Files, RH:Burr's Hill – Various Collectors, letter from D.A. Seamans to R. Haffenreffer, August 4, 1927.

18. Maurice Robbins, unpublished history of the Massachusetts Archaeological Society and the Bronson Museum, archives of the Massachusetts Archaeological Society, Robbins Museum, Middleboro, Mass.

19. Obituary of Foster H. Saville, *New York Times,* April 11, 1942.

20. Foster H. Saville, "A Montauk Cemetery at Easthampton, L.I.," *Indian Notes and Monographs* 2 (1920), 61–102; see also Saville's contributions in Indian Notes, 1 (1924) – 4 (1927).

21. *Indian Tepee* 6(2), 7; Foster H. Saville, "An Unusual Skull from Rhode Island," Indian Notes, 1 (1924), 141–42.

22. HMAA Collections Files, RH:Saville, letter from F. Saville to R. Haffenreffer, May 13, 1928.

23. *Providence Sunday Journal,* March 8, 1925.

24. HMA card catalogue, numerical series, summary of local collections.

25. HMAA Collections Files, RH:Saville, letter from W. K. Moorehead to R. Haffenreffer, February 27, 1929.

26. HMAA Collections Files, RH:Saville.

27. HMAA Collections Files, RH:Saville, letter from R. Haffenreffer to F. Saville, May 23, 1929.

28. Warren K. Moorehead, *Prehistoric Relics* (Andover, Mass.: Andover Press, 1905), 334–35, 484–85.

29. *Bristol Phoenix,* January 22, 1929.

30. HMAA Collections Files, RH:Rowell, letter from G.

Rowell to R. Haffenreffer, May 31, 1934.

31. HMAA Collections Files, RH:Moffitt.

32. Barbara Braun, "Cowboys and Indians: The History and Fate of the Museum of the American Indian," *Village Voice,* April 8, 1986; James Bradley, telephone conversation with author.

33. HMAA Collections Files, RH:Russell.

34. HMAA Collections Files, RH:Luther.

35. The affidavits certified the artifacts' authenticity, and in part they documented the provenience of the material. In either case they reflected Haffenreffer's strong business instincts – he liked to know where his money went and made formal receipts and accountings for a variety of museum business. The affidavits are evidence that Haffenreffer knew the value of money, a value perhaps learned as a member of an immigrant family that achieved success through enterprise.

36. Brian S. Robinson, *A Guide to Rhode Island Archaeological Collections* (Bristol, R.I.: Haffenreffer Museum of Anthropology, 1986), 5.

37. A partial list includes Gates P. Thruston, *The Antiquities of Tennessee and Adjacent States,* 2d. edition (Cincinnati: R. Clarke Company, 1897 [1890]); Cyrus Thomas, *Introduction to the Study of American Archaeology* (Washington, D.C., 1899); Thomas Wilson, *A Study of Prehistoric Anthropology: A Handbook for Beginners* (Washington, D.C., 1890); William Henry Holmes, "Classification and Arrangement of the Exhibits of an Anthropology Museum," *United States National Museum Report,* 1901, 253–78; Warren K. Moorehead, *Prehistoric Relics* (Andover, Mass.: Andover Press, 1905).

38. HMAA Collections Files, RH:Russell.

39. There is a large literature on archaeological frauds, *inter alia,* Robert Silverberg, *Mound Builders of Ancient America: the Archaeology of a Myth* (Greenwich, Conn.: New York Graphic Society, 1968); Kenneth L. Feder, *Frauds, Myths, and Mysteries; Science and Pseudoscience in Archaeology* (Mountain View, Calif.: Mayfield Publishing Co., 1990); Marshall McKusick, *The Davenport Conspiracy Revisited* (Ames: Iowa State University Press, 1991); Stephen Williams, *Fantastic Archaeology: The Wild Side of American Archaeology* (Philadelphia: University of Pennsylvania Press, 1991).

40. Thruston, *Antiquities of Tennessee,* 354.

41. HMAA Collections Files, RH:Lincoln.

42. HMAA Collections Files, RH:Harnden.

43. *Providence Sunday Journal,* January 22, 1929; *Bristol Phoenix,* January 20, 1929. Although the Museum was thus characterized by the newspapers and not by Haffenreffer directly, the similarities among the newspaper accounts suggest they received information directly from the Museum, perhaps in the form of a press release (Krech, this volume).

44. These affidavits survive framed in the HMAA, and these and others were certainly those referred to in the *Bristol Phoenix,* January 22, 1929.

45. HMAA Collections Files, RH:Moorehead.

46. HMAA Collections Files, RH:M. A. I. Exchange, letter from R. Haffenreffer to G. Heye, March 3, 1932.

47. HMAA Collections Files, RH:Moorehead, letter from R. Haffenreffer to W. K. Moorehead, September 30, 1929.

48. S. K. Brison, H. C. Carter, and Rufus Scott, among others.

49. HMAA Collections Files, RH:Bannister; RH:Luther.

50. *Providence Sunday Journal,* March 8, 1925; HMAA Collections Files, RH:Champion.

51. HMAA Card Catalogue, numerical series.

52. In a letter to Russell, Haffenreffer said, "you undoubtedly have a great deal of clippings in connection with this find." HMAA Collections Files, RH:Russell, letter from R. Haffenreffer to T. Russell, May 19, 1928; and clipped articles about the cache from *Philadelphia Enquirer*, June 3, 1928; *Boston Traveller*, September 1, 1928.

53. HMAA Collections Files, RH:Saville, letter from F. Saville to R. Haffenreffer, May 5, 1928.

54. William A. Ritchie, *The Archaeology of New York State* (Garden City, N.Y.: Natural History Press, 1965), 182, 218–21.

55. Charles C. Willoughby, *Antiquities of the New England Indians with Notes on the Ancient Cultures of the Adjacent Territories,* new edition with introduction by Stephen Williams (New York and Cambridge: AMS Press, 1973), *139, 259, 263;* Evan M. Maurer, *The Native American Heritage: A Survey of North American Indian Art* (Chicago: The Art Institute of Chicago, 1977), 98; see also Brian S. Robinson's report to the Museum on his research into the source of this piece, HMAA Collections Files, RH:Drake, B. Robinson to Haffenreffer Museum of Anthropology, May 6, 1988.

56. HMAA Collections Files, RH:Lincoln. This file includes some of David Lincoln's correspondence with other Massachusetts collectors regarding Lincoln's attempts to buy artifacts. The file also includes an unattributed newspaper clipping announcing the exhibition of David Lincoln's collection at West Brookfield Town Hall: "Mr. Lincoln's collection of relics is well worth a visit by lovers of the curious."

57. HMAA Collections Files, RH:Lincoln, letter from E. Rockwood to D. Lincoln, October 24, 1884.

58. Brian S. Robinson, "Early and Middle Archaic Period Occupation in the Gulf of Maine Region: Mortuary and Technological Patterning," in Brian S. Robinson, James B. Petersen, and Ann K. Robinson, editors, *Early Holocene Occupation in Northern New England,* Occasional Publications in Maine Archaeology, 9 (Augusta: Maine Historical Commission, 1992), 63–116.

59. HMAA Collections Files, RH:Saville. F. Saville's catalogue of collections available for purchase.

60. Brian S. Robinson, "Archaic Occupation in Maine," in *Early Holocene Occupation in Northern New England,* 86, 89, 91.

61. HMAA Collections Files, RH:Harnden, transcript of taped interview between Brian S. Robinson and John Costigan, conducted 1986; Brian S. Robinson, "Middle Archaic Mortuary Evidence and a Proposed Chronological Sequence for the Northeast Coastal Archaic Tradition," unpublished M.A. paper, Department of Anthropology, Brown University, Providence, R.I., 1987.

62. *Providence Sunday Journal,* March 8, 1925.

63. HMAA Collections Files, RH:Saville.

64. William A. Ritchie, *The Archaeology of New York State.*

65. After selling his collection to Haffenreffer in 1929, Wheeler continued field walking and by 1954 had found another four thousand artifacts. In 1986 these were given to the Haffenreffer Museum of Anthropology, by then a part of Brown University, by Wheeler's grandson (see HMAA Collections Files, Wheeler).

66. The additional information provided here has been uncovered since 1990 by tracing names and places mentioned on the labels affixed to some of the Temple artifacts.

67. HMAA Collections Files, RH:Temple.

68. Anne Cheyney Hombach, telephone conversation with author, December 16, 1993; Harold Lancour, compiler, *American Art Auction Catalogues – 1785–1942 – A Union List* (New York: New York Public Library, 1944).

69. About the sale and the loss of local archaeological artifacts see H. K. Landis, "Preserving Collections," *The Pennsylvania Archaeologist, Bulletin of the Society for Pennsylvania Archaeology,* 3 (April 1933), 11–12; for the contents of the sale see the auction catalogue, Charles Steigerwalt, *North American Indian Antiquities* (Lancaster, Pa.: Stan V. Henkels, 1917).

70. See Warren K. Moorehead, *Primitive Man in Ohio* (New York: Putnam, 1892); *Prehistoric Relics; The Stone Age of North America,* 2 vols. (Boston: Houghton Mifflin, 1910).

71. Warren K. Moorehead, *The Archaeology of Maine* (Andover, Mass.: Andover Press, 1922). Much of the early investigation of the "Red Paint" phenomenon was done before the turn of the century by Willoughby – see Charles C. Willoughby, Prehistoric Burial Places in Maine, *Archaeological and Ethnological Papers of the Peabody Museum,* 1.

72. *Report of the U.S. Commission to the Columbian Historical Exposition at Madrid: 1892–93* (Washington, D.C.: Government Printing Office, 1895).

73. David S. Brose, "The Northeastern United States," in *The Development of North American Archaeology* (Garden City, N.J.: Anchor Books, 1973), 84–116.

74. Tom D. Crouch, "Non-Indian Biographies – Warren K. Moorehead," in Wilcomb E. Washburn, editor, *Handbook of North American Indians, Volume 4: History of Indian-White Relations* (Washington, D.C.: Smithsonian Institution Press, 1988), 670; Douglas S. Byers, "Warren King Moorehead," *American Anthropologist* 41 (1939), 286–294.

75. Warren K. Moorehead, *The American Indian in the United States, Period 1850–1914* (Andover, Mass.: Andover Press, 1914).

76. Warren K. Moorehead, "A Plea for Action," *Boston Herald,* February 18, 1929.

77. John C. Huden, *Archaeology in Vermont: Some Reviews Supplemented by Materials from New England and New York,* revised ed. by William A. Haviland (Rutland, Vermont: Tuttle, 1971), 90–91.

78. HMAA Collections Files, RH:Moorehead, letter from W. K. Moorehead to R. Haffenreffer, February 27, 1929; letter from R. Haffenreffer to W. K. Moorehead, February 28, 1929.

79. Michael Walko, R. S. Peabody Museum of Archaeology, Phillips Academy, Andover, Mass., letter to author, October 4, 1993.

80. HMAA Collections Files, RH:Moorehead, letter from W. K. Moorehead to R. Haffenreffer, August 5, 1929.

81. HMAA Collections Files, RH:Moorehead, letter from R. Haffenreffer to W. K. Moorehead, November 29, 1929.

82. HMAA Collections Files, RH:Moorehead, letter from W. K. Moorehead to R. Haffenreffer, July 9, 1929.

83. Ira Jacknis, "Franz Boas and Exhibits: On the Limitations of the Museum Method in Anthropology," in George W. Stocking, Jr., editor, *Objects and Others: Essays on Museums and Material Culture,* History of Anthropology, 3 (Madison: University of Wisconsin Press, 1985), 75–111.

84. HMAA, David W. Gregg, unpublished report, Final Report of Survey of Human Remains at the Haffenreffer Museum of Anthropology, June 2, 1993.

85. There are a number of remains currently in the collection which are completely without provenience and which may have been part of Haffenreffer's collection, although it

seems more likely they belong to collections acquired since the Museum came to Brown.

86. HMAA, RH:Grant.

87. HMAA, RH:Grant, receipts H. Grant to F. Saville, May 10, 1928, June 22, 1928, June 30, 1928, October 1, 1928.

88. The exchanges and Haffenreffer's relationship to G. Heye are discussed in depth by Hail, this volume.

89. HMAA Collections Files, RH:M. A. I. Exchange

90. Gibson, editor, *Burr's Hill: A 17th Century Wampanoag Burial Ground in Warren, Rhode Island.*

91. Dean A. Decker, "Early Archaeology on Catalina Island: Potential and Problems," *Annual Report of the Archaeological Survey, U.C.L.A.,* 11 (1969), 73–84; HMAA Collections Files, RH:M. A. I. Exchange, copies of catalogue cards and other collection records from the Museum of the American Indian, Heye Foundation.

92. HMAA Collections Files, RH:M. A. I. Exchange, letter from R. Haffenreffer to G. Heye, August 7, 1940.

93. HMAA Collections Files, RH:Gonzalez, letter from R. Haffenreffer to G. Heye, January 4, 1937.

94. The twenty-eighth piece is a Colonial-period silver saucer (HMA CR-33).

95. Samuel Lothrop, "Pottery of Costa Rica and Nicaragua," 2 volumes, *Contributions of the Museum of the American Indian, Heye Foundation, New York,* 8 (1926); *Between Continents / Between Seas: Precolumbian Art of Costa Rica,* exhibition catalogue (New York: Harry Abrams, 1981).

96. HMAA Collections Files, RH:Gonzalez, letter from G. Heye to R. Haffenreffer, January 5, 1937.

97. HMAA Collections Files, RH:Moffitt.

98. Muriel Porter Weaver, *The Aztecs, Maya, and Their Predecessors: Archaeology of Mesoamerica* (New York: Seminar Press, 1972), 268.

99. HMAA Collections Files, RH:Moffitt, Elysa D. Marden, unpublished report on the Moffitt collection *penates,* May 1993.

100. James Bradley, conversation with author, May 14, 1993.

101. HMAA Collections Files, RH:Norden, receipt August 4, 1934. Norden worked for the Montezuma-Apex Mining Company, of which Haffenreffer was president (Krech, this volume).

102. HMAA Collections Files, RH:Miller, letter from C. Miller to R. Haffenreffer, October 18, 1945.

103. HMAA Collections Files, RH:Gardiner.

104. HMAA Collections Files, RH:Brooks, letter from P. Brooks to R. Haffenreffer, March 13, 1952.

105. The essay contests and the exchange of artifacts with Jimmy Arnold are also good examples (Krech, this volume).

106. A literature on collecting, organizing, and displaying archaeological artifacts was also available to Haffenreffer. See footnote 37.

107. Popular nineteenth-century debates such as those over the antiquity of the world and the human race, the relationship of man to apes, and the relative development of human societies around the world encouraged the systematizing of collections and the codification of the natural and human world in museums.

108. Explorations inspiring particularly wide speculation included Stephens and Catherwood in Central America beginning in 1839; Layard in Mesopotamia in 1845; and Squire and Davis in the Mississippi River valley in 1848. O. G. S. Crawford, in "The Dialectical Process in the History of Science" (*Sociological Review,* 1932, 165–73), described the role of industrial-

ization in the rise of archaeology and natural history but his point has been critiqued by Glyn Daniel, *150 Years of Archaeology* (Cambridge, Mass.: Harvard University Press, 1973), 53, and by Bruce G. Trigger, *Time and Traditions: Essays in Archaeological Interpretation* (New York: Columbia University Press, 1978), 55–56.

109. Jacob W. Gruber, "Archaeology, History, and Culture," in David J. Meltzer, Don D. Fowler, and Jeremy A. Sabloff, editors, *American Archaeology: Past and Future* (Washington, D.C.: Smithsonian Institution Press, 1986), 163–86; Bruce G. Trigger, *A History of Archaeological Thought* (Cambridge: Cambridge University Press, 1989), 188–95.

110. Sven Nilsson, quoted in Glyn Daniel, *150 Years of Archaeology,* 49; E. B. Tylor, quoted in George W. Stocking, Jr., *Victorian Anthropology,* (New York: Free Press, 1978), 86.

111. Gordon R. Willey and Jeremy A. Sabloff, *A History of American Archaeology,* 2d edition (New York: Freeman, 1980).

112. Trait lists in culture-historical archaeology derive from the index fossil concept in natural history. The work of James Ford was among the highest developments of the culture-historical approach. (See James A. Ford, "The Type Concept Revisited," *American Anthropologist* 56, 42–54; James A. Ford and Clarence H. Webb, "Poverty Point: A Late Archaic Site in Louisiana," *Anthropological Papers of the American Museum of Natural History,* 46, 1–140.)

113. Leslie A. White, "The Ethnography and Ethnology of Franz Boas," *Bulletin of the Texas Memorial Museum,* 6 (1968).

114. Curtis M. Hinsley, "From Shell-heaps to Stelae: Early Anthropology at the Peabody Museum," in George W. Stocking, Jr., editor, *Objects and Others: Essays on Museums and Material Culture,* History of Anthropology, 3 (Madison: University of Wisconsin Press, 1985), 69–72.

115. Of the Wheeler collection Saville wrote, "he has had an offer of $1000, but he would not consider the offer . . . as he does not want the collection to leave the state" (HMAA Collections Files, RH:Saville; also see HMAA Collections Files, RH:Lincoln, RH:Miller, RH:Perry, and letters in RH:Saville)

116. Henry F. Adolph, *Pennsylvania Archaeologist* 7 (July 1937), 20–24.

117. John Pretola, Springfield Science Museum, telephone conversation and letter to author; archives of the Bronson Museum, Middleboro, Mass. and Curtiss Hoffman, Bronson Museum, conversation with author; James Bradley, R. S. Peabody Museum, Andover, conversation and telephone conversation with author.

118. Wright, "Addresses Before the Ohio State Archaeological Society: Address of Professor Wright," *Ohio Archaeological and Historical Publications* 6 (1898), 445.

119. Archaeological examples include an exchange with the George Hail Free Library in 1929, the gift of Louis Flanders in 1942, the Lena Turner collection some time after 1933, and others.

120. While they are beyond the scope of this essay, some of the major changes in the collection since 1954 are described briefly in the epilogue to this volume.

121. Envisioned as similar to archaeological formation processes described by Michael B. Schiffer, *Formation Processes of the Archaeological Record* (Albuquerque: University of New Mexico Press, 1987).

"The Heart Interest"

Native Americans at Mount Hope and The King Philip Museum

by ANN McMULLEN

IN MANY WAYS, Rudolf Haffenreffer was a man of his time: a successful, well-traveled businessman with a passion for collecting. But in the way that he pursued what Ousa Mekin (LeRoy C. Perry) characterized as his "heart interest,"[1] Haffenreffer differed from other collectors who concentrated on American Indian material, people who built museums out of their collections, and individuals interested in Indian history and culture. Unlike other Indian artifact collectors, Haffenreffer was not simply interested in the objects that Indians produced. Rather, he was interested in the people themselves and how their lives had shaped American history and, in many cases, had been crushed by it. In the same way, Haffenreffer saw the lives of southeastern New England's Native people – Narragansett, Pequot, and Wampanoag – as a product of that history. As part of his overwhelming interest in things Native, he attempted to involve them in his museum and its operation. This included employing Ousa Mekin as an educational interpreter (fig. IV-1).

Ousa Mekin was the first Native American known to have visited the King Philip Museum. Those who followed included many of the most important Native figures in early twentieth-century southeastern New England.[2] In addition to his relationships with Ousa Mekin and the Mitchell family – descendants of the seventeenth-century Pokanoket sachem Massasoit – Haffenreffer was involved in the activities of pan-Indian organizations of the period, including the National Algonquin Indian Council and the American Indian Federation. These organizations included members of diverse Native groups and produced a synthetic "Indian" culture by drawing on traditions from across the country.

Research on Haffenreffer's relationships with Native people and pan-Indian organizations provides insight into the role that local Native people played in Haffenreffer's life and in the King Philip Museum, as well as into Haffeneffer's ideas about New England Native history and Native Americans in general. In his writings about New England Native history, it is apparent that Haffenreffer's ideas about Native people differed from others of his time (Krech, this volume). In his belief that Native people actively shaped American history – evident in his 1923 address to the Fall River Historical Society[3] – Haffenreffer resembles current historians more than he did his contemporaries. His belief in the nobility of Native people and his criticism of colonial practices reveal Haffenreffer as one of the first laymen to examine the history of Indian-

Fig. IV-1
LeRoy C. Perry in regalia, sitting in "King Philip's Chair," ca. 1931. Haffenreffer Museum of Anthropology

White relations in colonial New England.[4] While writers like Helen Hunt Jackson had decried the treatment and condition of Indians on the Plains and in the Southwest,[5] Haffenreffer gave his attention to colonial treacheries against Massasoit, King Philip, and the Pokanoket,[6] suggesting that early colonial crimes lay at the root of America's treatment of Native people. Haffenreffer's involvement with living Native people in his Museum reflects his sympathies with regard to their history. He attempted to see them as active participants in the history of Indian-White relations rather than static remnants of the past, a common characterization of the time.

In his perceptions of local Native people, Haffenreffer differed from his contemporaries, who often dismissed Indians from southeastern New England as racially mixed and therefore assumed to be devoid of Native culture. He recognized local Native people as part of an American Indian cultural whole that was worthy of respect. In his view, Native Americans, no matter how mixed or different from their ancestors, should have been honored for their contributions to American society and the sacrifices they had unwillingly made.

In the early twentieth century, most Americans put Indian, White, and African-American individuals into the racial categories of Indian, White, and Negro according to their skin color, hair type and texture, facial features, and other visible characteristics.[7] Before the Civil War, "colored" – non-White – and "mulatto" – those with recognizable African heritage – were also commonly used. In the 1860s the term "colored" shifted to become synonymous with "Negro."[8] The legal definition of "Negro" as a person with any African heritage combined with a lay understanding of genetics (which were based on the idea of "breeds" of animals), and reinforced Euro-American ideas that people could be categorized by race solely according to their appearance. Within such a setting, Native people in southern New England and elsewhere in the East and Southeast – the products of intermarriage between Indians, African-Americans, and Whites – were a confusing and ambiguous category: they often fit lay definitions of "White"

or "colored" in their appearance, yet were "Indian" by their expressed traditions, genealogies, and self-identity.[9] Members of the lay public were not alone in their misconceptions of the effects of racial heritage on culture. Many anthropologists also felt that physical appearance and the degree of racial mixture were appropriate means of gauging how well southern New England's Native people had maintained their traditional cultures. These anthropologists often limited their contact with "mixed" individuals.[10]

Rather than focusing on the historical changes in local Native cultures and the genetic composition of Native societies, Haffenreffer's King Philip Museum memorialized a romantic conception of the American Indian, in which objects and images stood for a noble past. While its exhibits emphasizing archaeology, past ways of life, and stereotypical images of Native people, including cigar-store Indians, may have tended to make living Native cultures invisible, New England's Native people appreciated Haffenreffer's efforts to build a monument to the American Indian. Since his efforts memorialized a collective Indian past, the identification of links between the Native past in New England with living Indians in the West, and the creation of a unified Indian culture, allowed New England Indians who visited the Museum to see it as an institution perpetuating that culture rather than simply memorializing it. Thus they could see the Museum as reinforcing their own notions about cultural continuity and the contemporary "practice" of culture.

Native people's approval of the Museum – expressed most clearly by Ousa Mekin's inscription in the Museum's Visitors' Book (Krech, this volume) – and their view of it as an institution that kept Indian culture alive can be seen in the actions of leaders of Native organizations who brought their memberships to the Museum, and of individuals who made multiple visits. Early twentieth-century pan-Indian organizations operating locally, such as the National Algonquin Indian Council and the American Indian Federation, drew on the traditions of the Plains and other regions for aspects of dress and ceremony in order to be recognized as

Indian by local non-Natives and perhaps western Indians.[11] Some Native people found in the King Philip Museum a validation of their own pan-Indian practices and their belief in the essential brotherhood of all Native American people.[12]

In his involvement with pan-Indian organizations, Haffenreffer was not unique: anthropologists, historians, and laymen interested in Native cultures were often active members of such groups and attended their events. Since these functioned as fraternal organizations, Haffenreffer's involvement with them may have been little different from his membership in historical societies and other social groups which also visited the Museum (Krech, this volume).[13] Nor was the King Philip Museum, which can be seen as reifying pan-Indian ideas of Native cultures, unique in the scope of its North American collections.

Nevertheless, Haffenreffer was ahead of his time in employing Ousa Mekin to speak to visitors on the Museum's grounds. During the early twentieth century, larger metropolitan museums did involve Native Americans in exhibit tours and craft demonstrations,[14] but this was not the case with smaller, regional museums. The majority of museums in New England did not employ Native people as educators on an ongoing basis until the 1970s. Ousa Mekin lived on the grounds and was available to speak to visitors and groups of school children on demand; his constant rather than occasional employment was unique in New England. It can be compared only with Native-run museums in the area, such as the Tomaquag Memorial Indian Museum in Exeter, Rhode Island and the Tantaquidgeon Indian Museum, opened in Uncasville, Connecticut in 1931, where Narragansetts and Mohegans interpreted their own cultures.

RELATIONSHIPS WITH NATIVE PEOPLE

Approximately seventy Native Americans signed the Visitors' Book between 1929 and 1954 with the overwhelming majority visiting between 1929 and 1932. During the latter period, Haffenreffer appears to have had close contacts with only a few Native individuals and families. Several individuals visited more than once – Red Arrow, Nokomis,

NATIVE PEOPLE AND PAN-INDIAN ORGANIZATION MEMBERS IN THE KING PHILIP MUSEUM VISITORS' BOOK 1929–1954

Some dates have been extrapolated. Normal text documents how individuals signed themselves; italic text provides additional information.

June 21, 1929
Chief Sachem Ousa Mekin, Yellow Feather, Wampanoag *(see biography)*

August 22, 1929
Silver Star, Chief Sachem of the Pequot Tribe *(see biography)*
Squaw Sachem Iona of the Pequots *(see biography)*

Fig. IV-2 Atwood I. Williams, Chief Silver Star, Pequot, ca. 1935. Photo courtesy Agnes Cunha.

November 17, 1929
Flora Lee *(wife of Thomas Z. Lee)*
Thomas Z. Lee *(a Providence judge advising the ICNE and NAIC)*
William L. Wilcox *(see biography)*

February 3, 1930
Lorenzo Hammond, Chief Small Bear *(see biography)*
Chief Crazy Bull *(William Jacobs, Sioux, AIF)*
Lillian R. Hammond, Princess Wood Lianna *(Mashpee Wampanoag)*

Between June 14 and August 12, 1931
Mary A. Peckham, Sweet Grass, National Algonquin Council *(Narragansett, daughter of Clara F. and Philip H. Peckham, AIF: 1934)*

Clara A. Peckham, Sweetheart (Teppekathitha), National Algonquin Council *(Narragansett, daughter of Clara F. and Philip H. Peckham)*

Edwin B. Greene, Red Jacket *(Narragansett?)*

Harry P. Peckham, Ousa Mekin, NAIC *(Narragansett, son of Clara F. and Philip H. Peckham, AIF: 1932)*

Frank M. Nichols, Chief Grey Eagle *(Narragansett)*

Lillian A. Lee, NAIC

"Wuotonekanuske," Bessie Brown Manning *(Narragansett)*

"Wooseeit," Margaret Reed Lee, NAIC *(Powwow secretary of the NAIC)*

Crawford Strong, NAIC, Red Cloud

Clara F. Peckham, Nokomis *(Narragansett) (see biography)*

Alfred C. A. Perry, Chief Sachem *(see biography)*

"Minnetonka," Marian W. Brown *(see biography)*

"Corn Blossom," Ethel Steppo

Flaming Arrow, Willie M. Onsley *(Wampanoag-Narragansett)*

"Natiesha," Annie F. Farrow *(Mrs. George R. E. Farrow, Narragansett, daughter of Alfred C. A. Perry)*

Ella W. Wilcox *("Tahoma," Narragansett-Pequot, AIF: 1931)*

William L. Wilcox *(see biography)*

Mr. and Mrs. Winfred E. Hoxie *(Narragansett)*

Mrs. Warren L. Hoxie *(Narragansett)*

Philip H. Peckham, Chief Canonicus *(see biography)*

Chief Sunset *(Edward Michael, Narragansett, AIF: 1932)*

Ernest P. Onsley, Chief Rainbow *(Wampanoag-Narragansett)*

Benjamin H. Onsley, Chief Great Owl *(Wampanoag-Narragansett)*

October 23, 1932 American Indian Federation meeting

Miss Minnie Williams *(Narragansett, AIF: 1931)*

Miss Bertha Rhodes *(Narragansett, daughter of Adeline Rhodes)*

Miss Gertrude Sater

Mrs. Elisabeth Ekstrom *(Mrs. Henry Ekstrom, AIF Associate: 1931)*

Miss Loretta V. Williams *(Narragansett, AIF: 1932)*

Miss Honora Williams *(Narragansett, AIF: 1931)*

Mrs. Clara F. Peckham, Narragansett *(see biography)*

Mrs. S. Frank Fisk

Mr. S. Frank Fisk *(Squire Fisk, Narragansett, AIF: 1932)*

Mrs. Amy Tallman

Mrs. J. C. Fisk *(Mrs. Joseph C. Fisk, Comanche, AIF: 1932)*

Miss H. Fisk

Charles Slocum

E. S. Slocum

John Leishman Smith

Marion G. Hawksley *(Mrs. Frederick Hawksley, AIF Associate: 1935)*

Frederick Hawksley *(Narragansett, AIF: 1932)*

Dorothy M. Newcomb

Sara M. Algeo *(AIF Associate: 1931)*

Jeanie C. Bachelin *(AIF Associate: 1931)*

Perseus C. Seymour, Spirit Dove *(Pequot, AIF: 1931)*

Ronald Francis (Senabah) *(Penobscot-Maliseet)*

Chief Lone Fox, Yuma *(AIF: 1931)*

Chief Crazy Bull, Sioux *(William Jacobs, AIF)*

Annie E. Brown *(Narragansett)*

Rachel A. Peckham *(Narragansett)*

Princess Dew Drop *(Rappahannock, AIF: 1931)*

Chief Black Hawk, The Powhatan *(Rappahannock, AIF)*

Theodore D. Brown *(Narragansett)*

Annie S. Doran *(Narragansett)*

Josephine Wilcox *(Narragansett-Pequot, daughter of Ella W. and William L. Wilcox, AIF: 1931)*

Stella M. Ives *(AIF Associate: 1932, daughter of Mr. and Mrs. Hurlbut Andrews Ives)*

Maybell C. Studd *(Pequot, AIF: 1931)*

Mr. and Mrs. H. A. Ives *(Hurlbut Andrews and Elizabeth J. Williams Ives, AIF Associate members, 1932)*

Mrs. Adeline Rhodes *("Pine Needle," Narragansett, daughter of William L. Wilcox)*

Lewis Wilcox *(Ralph Lewis Wilcox, "Red Fox," Narragansett-Pequot, son of Ella W. and William L. Wilcox, AIF: 1931)*

W. W. Clark *(AIF Associate: 1931)*

Joseph R. Adams *(see biography)*

Prince Leaping Deer, Atwood I. Williams, Jr. *(Pequot, son of Agnes Eunice Gardner and Atwood I. Williams, AIF: 1931)*

Ne mo shoyn, Mrs A. I. Williams, Jr. *(Helen Rose Murphy Williams, adopted Pequot, AIF: 1931)*

Irving Huntley *(AIF Associate: 1931)*

L. C. Joslin *(Leonard C. Joslin, AIF Associate: 1932)*

Mrs. L. C. Joslin *(Lillie Joslin, Nipmuc, AIF: 1932)*

Mr. and Mrs. Frederick P. Adams *("Chief Man-ni-sa-wa" or "Man-Me-Sa-War," Narragansett, AIF: 1931; Elmyra F. Adams, Potawatomi, AIF: 1932)*

Frederick A. Hawksley *(Narragansett, son of Frederick and Marion Hawksley, AIF: 1932)*

Mrs. John George *(Mildred "Jennie" Williams George, Pequot, daughter of Agnes Eunice Gardner and Atwood I. Williams, AIF: 1931)*

Mrs. Anna A. Murphy *(Mrs. William Murphy, mother of Mrs. Atwood I. Williams, Jr., AIF Associate: 1931)*

Mr. John George *(Pequot, AIF: 1931)*

Mr. Henry L. Williams *("Chief Lone Wolf," Narragansett, AIF: 1931)*

After November 2, 1932

Ne mo shoyn, Mrs. A. I. Williams, Jr.

After November 21, 1932

Prince Leaping Deer, Atwood I. Williams, Jr.

Princess Snow Feather *(wife of Chief Black Hawk, Chickahominy, AIF: 1931?)*

Chief Lone Wolf *(Henry L. Williams)*

Chee Mi Yo Gah, Al Williams *(Albert F. Williams, Narragansett, AIF: 1931)*

After March 20, 1936

Ataloa, Muskogee

After October 24, 1936

Chief Red Arrow, Algonkian *(see biography)*

May 8, 1938

Princess Nashaweena *(Sadie E. Barrie, Mohawk, AIF: 1932)*

Chief Wah-wah-taysee *(Harvey H. Stewart, Chippewa, AIF: 1935)*

March 1942

Wah Netahe, "Red Rock," Ojibway-Nokamecheni-Artic Tribes

October 12–14, 1951, R. F. Haffenreffer Boy Scout Encampment

Paul Bullock *(Wampanoag, AIF)*

Pine Tree, Lone Wolf, Silver Star, and Leaping Deer – which may indicate a bond with Haffenreffer and the Museum or a commitment to the Native organizations that visited (see biographies). A chronology of Native visitors, including groups of National Algonquin Indian Council and American Indian Federation members, is included as part of this essay.

The record of Native visitation begins in 1929, when the surviving Visitors' Book begins. This record is incomplete, however, since not all visitors were asked or required to sign.[15] Thus, the Visitors' Book may only be a record of the visits of important individuals or groups and "occasions" thought worthy of documentation. Native people who were regular visitors or well acquainted with Haffenreffer may never have signed. For instance, we know from photographic evidence that Silver Star and Pine Tree visited the Museum in October 1932 but did not sign in with other Indian Federation members. Lastly, not all Native individuals chose to identify themselves as such in the Visitors' Book: many included their tribe or affiliation with a pan-Indian organization (the one organizing the visit), and some gave "Indian names" instead of or in addition to their legal names. The use of Indian names in public was not as prevalent in the early 1930s as it is today, thus some Native people who signed the Visitors' Book may not have been identified as such.[16]

Haffenreffer also knew Native people who probably never visited his museum. The best documented example is the Mitchell family, descendants of Massasoit living in Lakeville, Massachusetts (see biographies). In November 1913, Haffenreffer and his family visited the Mitchells. A record of this visit comes from a copy of Peirce's *Indian History, Biography and Genealogy: Pertaining to the Good Sachem Massasoit of the Wampanoag Tribe and his Descendants,* inscribed "Fall River Mass, November 23rd 1913, This is to certify that this afternoon we the undersigned motored to Lakeville Mass, where we visited and interviewed Melinda Mitchell, and Charlotte Mitchell, at their residence. This book with their autographs was presented to us. [signed] R. F. Haffenreffer Jr, L. Maude Haffenreffer, Rudolf F. Haffenreffer III, Carl W. Haffenreffer, Martha C.

Haffenreffer."[17]

The interview left a tremendous impression on Haffenreffer, for he refers to it ten years later in his address to the Fall River Historical Society:

> I listened to the touching story told me by Queen Teeweelema and her two sisters, direct lineal descendants of King Philip, two of whom are now living at Lakeville, Mass., in a little hut surrounded by a few acres of land – all that the whites have left them of their glorious heritage from Massasoit. In their hearts, with the memories of those long bygone days, lives the acute sense of irresistible wrong done them by the alien in the land of their forefathers (fig. IV-4).[18]

Unfortunately, we do not know how Haffenreffer first made contact with the Mitchells or whether he kept in touch with them after his visit in 1913. But, following publication of a 1925 article in the *Boston Post* on Emma Mitchell Safford (fig. IV-3), Charlotte and Melinda's sister, Haffenreffer did write Mrs. Safford:

> I was much interested in reading the article...as I am the owner of Mount Hope, where King Philip's chair is hewn out of the rock, and also the place where King Philip was killed; and any time when either you or any of your descendants would like to visit Mount Hope, I would like you or yours to communicate with me, so as to visit the beautiful old spot. I am enclosing a copy of what I said to the Fall River Historical Society, and I hope that you will approve of my remarks.[19]

Haffenreffer's intentional contacts with Native people appear to have been confined to his interactions with the descendants of Massasoit, namely the Mitchell family. He also seemed genuinely interested in presenting their history sympathetically and sought Mrs. Safford's approval for his interpretation of Indian–White relations.

Haffenreffer's principal long-term relationship with a Native person was his friendship with Ousa Mekin (LeRoy C. Perry), Chief Sachem of the Wampanoag Nation (see biography). Since Ousa Mekin refers to Haffenreffer as a "friend" in his Visitors' Book inscription of 1929,[20] we may infer that they were already well acquainted by June of

Fig. IV-3
Mrs. Emma Mitchell Safford.
Photo by Kupsinel, Gloucester,
Mass. National Museum of
the American Indian,
Smithsonian Institution.

Fig. IV-4
Tee-We-Lee-Ma. Tinted postcard.
Haffenreffer Museum of Anthropology.

11205. Tee-We-Lee-Ma, the last living descendant of Massasoit. whose friendship and generosity saved the Pilgrims from starvation

that year. Ousa Mekin, born on the Fall River Indian Reservation (also known as Watuppa), and Haffenreffer may have known each other as early as 1914, when Haffenreffer joined the Watuppa Water Commission in Fall River. In 1907 the City of Fall River and the Water Commission had taken part of the Fall River Reservation by eminent domain to safeguard the city's water supply, thus displacing the family of Fanny L. Perry,[21] a relation of Ousa Mekin's. The fact that Ousa Mekin was said to be a "lineal descendant of Massasoit" may also have attracted Haffenreffer's interest.[22] Through his theological training, Ousa Mekin had become a student of languages, "especially the Algonquin, the mother tongue of the eastern Indians,"[23] providing a common interest with Haffenreffer, who had in his collection a seventeenth-century Bible in the Natick Indian dialect (fig. IV-5). Ousa Mekin and Haffenreffer appear to have been in contact throughout the 1920s, when Ousa Mekin was living in Providence and was active in the Indian Council of New England (later the National Algonquin Indian Council) where he held the offices of Prophet and Chief of the Wampanoags.[24] In 1929,

The Mitchell Family

Emma Mitchell Safford, Charlotte (Wootone-kanuske) Mitchell, and Melinda (Teweeleema) Mitchell were daughters of Zerviah Gould and Thomas C. Mitchell. Besides their fame as descendants of Massasoit, the Mitchells were known for a distinctive type of miniature basket made of dyed rye-straw, which they sold to local shops and tourists until about 1875.

SOURCES: Peirce, *Indian History, Biography and Genealogy;* Gladys Tantaquidgeon, "Newly Discovered Straw Basketry of the Wampanoag Indians of Massachusetts," *Indian Notes* (1930) 7(4).

Ousa Mekin – LeRoy Perry

LeRoy C. Perry was born in 1874 on the Fall River Indian Reservation, Fall River, Mass. He felt the call to preach at twenty-four, and studied languages.

Perry was active in many Native organizations. In the 1920s, he met with the "Sachems' Council," composed of leading members of the Narragansett, Wampanoag, Gay Head, Mohegan, and Passamaquoddy tribes. With its formation in 1928, Perry was elected Supreme Sachem of the Wampanoag Nation and continued as such until his death in the 1960s.

As Supreme Sachem of the Wampanoags, Perry held services in the Old Indian Church at Mashpee. From 1923 on, he spoke at the annual Narragansett August Meeting and often preached there. In 1933 he was appointed pastor of the Baptist Church on Gay Head on Martha's Vineyard.

SOURCES: *Bristol Phoenix*, July 3, 1930; July 8, 1930; Jack Campisi, *The Mashpee Indians;* Ella Sekatau, conversation with author, October 5, 1993; Paulla Dove Jennings, HMA NAAC meeting, September 23, 1993; Helen A. A. Attaquin, *A Brief History of Gay Head, or 'Aquiniuh'* (published by the author, 1970), 33; *Narragansett Dawn* 1(3):24; 1(5):114; 2(4):67.

Fig. IV-5
LeRoy C. Perry, Chief Sachem Ousa Mekin, "Yellow Feather," Wampanoag. Perry distributed signed photos like this in the 1920s and 1930s, although it appears to have been taken much earlier. Haffenreffer Museum of Anthropology.

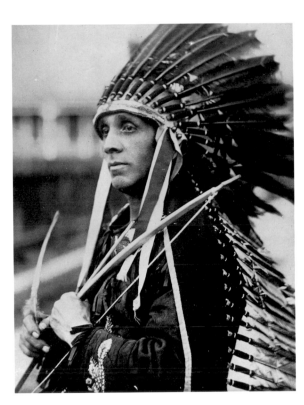

Haffenreffer became Honorary Chief Sachem of the NAIC, an office reserved for non-Natives.[25]

Ousa Mekin's involvement in interpreting items from Haffenreffer's collection began sometime around 1930. For the 250th anniversary of the Town of Bristol, artifacts from the collections of the King Philip Museum, the town, and the Herreshoff Manufacturing Company (Haffenreffer's yachting concern) were displayed at a Providence bank. "In the complete regalatio of a chieftain," Ousa Mekin was on hand to "explain the significance of the stones, weapons and other things used by his forefathers before the advent of the white man."[26] There is no record of whether Haffen-

reffer paid Ousa Mekin for this work or whether he was already engaged as an interpreter on the grounds at Mount Hope. In a 1929 discussion, archaeologist Warren K. Moorehead had suggested that Haffenreffer "secure a few real Indians anywhere in the region and have them set up an old style wigwam or two, and live there next summer."[27] By October 1931, Haffenreffer had employed Ousa Mekin on the grounds as an interpreter to speak to visiting school children and

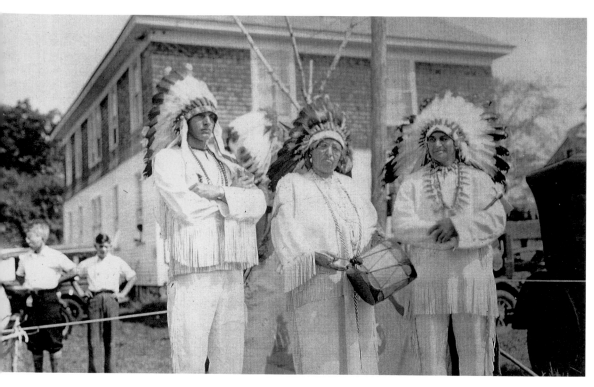

Fig. IV-6
Atwood I. Williams, Jr., Agnes Eunice
Gardner Williams, and Atwood I.
Williams, Pequot, ca. 1935. Photo
courtesy Agnes Cunha.

Squaw Sachem Iona – Agnes Eunice Gardner Williams

Agnes Eunice Gardner Williams was of Pequot
and Narragansett heritage and a founding mem-
ber of the Indian Federation. She signed the Visi-
tors' Book at the King Philip Museum on August
29, 1929 when she visited with her husband.

Silver Star – Atwood I. Williams

Atwood I. Williams was a leading voice for both
the Paucatuck and Mashantucket Pequot tribes in
their dealings with the State of Connecticut, and
was also actively involved in lecturing to Scout
groups and school children.

In August 1931, Williams, along with William L.
Wilcox, the Narragansett medicine man, founded
the American Indian Federation. He was its Chief
Sachem until the mid 1930s.

SOURCES: Jack Campisi, "The Emergence of the
Mashantucket Pequot Tribe"; Agnes Cunha, con-
versation with author, October 10, 1993; AIF
records, 1931–93, private collection.

other groups,[28] but Ousa Mekin's employment in
that capacity might have preceded Moorehead's
suggestion. We do not know how long his employ-
ment lasted, but in 1933, Ousa Mekin became pastor
of the Baptist Church at Gay Head on Martha's
Vineyard and left the Providence area.[29]

In addition to his relationship with Ousa Mekin
and the National Algonquin Indian Council,
Haffenreffer was closely associated with the lead-
ing members of the American Indian Federation
which visited the Museum for one of its monthly
meetings in October 1932. Haffenreffer's involve-
ment with the AIF appears to stem from his
acquaintance with one of its founders, Silver Star.
As early as August 1929, Silver Star, chief of the
Pequots, and his wife Iona visited the Museum,
perhaps on the occasion of the opening of the
Mount Hope Bridge from Bristol to Aquidneck
Island, across which they led a procession (see
biographies and fig. IV-6).[30]

PAN-INDIAN ORGANIZATIONS
AT MOUNT HOPE

Exploring Haffenreffer's involvement with living Native people in southeastern New England is as challenging as investigating the origins of his collections. Haffenreffer took advantage of collecting opportunities that presented themselves, and only occasionally did he actively seek out particular collections and artifacts.[31] This pattern may also have applied to his relationships with Native Americans; Haffenreffer made the Museum and the grounds at Mount Hope available to those interested in visiting, but his efforts to contact Native Americans appear to have been confined to the descendants of Massasoit.

Since the historic character of Mount Hope was important to him (Krech, this volume), Haffenreffer understood Native people's interest in visiting historic sites on the property: King Philip's Chair, a natural depression in a rock outcrop said to be the site where Philip held tribal councils, and Cold Spring, where Philip met his death at the end of King Philip's War in 1676. With its historic sites, Mount Hope simultaneously represented Native resistance to White colonialism – both peaceful and violent – and the bitter end of Native political autonomy in southern New England. It was a memorial to their history even before the museum grew.

We know nothing about Native visitation at Mount Hope before Haffenreffer purchased it. While part of the waterfront acreage was an amusement park, King Philip's Chair was still privately owned (Krech, this volume), but the trails to the Chair and Cold Spring may have been open to public access and Native visitation. As Haffenreffer dismantled the amusement park at Mount Hope and converted it to a working farm, he also allowed the clear-cut slopes of Mount Hope and the area between the Chair and the beach to regrow. As these areas returned to a closer approximation of their natural state, one could imagine the land as it had been before Europeans arrived. During Haffenreffer's ownership of Mount Hope, Native people visited the grounds with his permission.[32] At the same time, Native people appreciated the landscape

Alfred C. A. Perry

In the early 1920s, Alfred C. A. Perry – a Narragansett – was involved with Thomas Bicknell's efforts to form an intertribal New England Indian association. Alfred Perry held the position of Chief Sachem of the resulting Indian Council of New England from 1923 until the mid 1930s. As Chief Sachem, Perry visited the King Philip Museum in summer 1931.

SOURCES: *Indian Tepee* 6(1):4–5; 6(2):6–8; *Cranston News,* December 10, 1923; Ella Sekatau, conversation with author, October 5, 1993; HMAA ICNE Scrapbook.

of Mount Hope and used it in their own conceptions of the past.[33] As such it provided important opportunities for Native people to teach their children about the past: the grounds at Mount Hope were a sanctuary for the contemplation of Indian history and Indian-White relations, and parents used these occasions to tell their children about the history of King Philip's War and other events.[34]

However, if Visitors' Book records of Museum visits reflect Native visits to the Chair and other sites on the grounds, not all local Native people felt that Mount Hope and the King Philip Museum represented their history. Visiting Narragansetts far outnumbered Wampanoags, despite the fact that the museum – as a memorial to the Pokanoket Philip – should have been of great interest to them. This may be explained by several factors. During the late 1920s and early 1930s the Wampanoag – who had recently reorganized themselves as tribes within a nation – were caught up in an internal power struggle focusing on leadership and control of traditional practices at Mashpee.[35] Their sense of the past, and what needed to be emphasized in terms of historical understanding, was focused more on the relatively recent events of Mashpee history and its internal factions rather than on seventeenth-century events that articulated Indian-White relations.[36] Thus, visiting Mount Hope and other sites associated with earlier events may have been less important to most Wampanoags.

After 1930, Native Americans could visit the Chair and the Spring by simply getting permission from the groundskeeper or Haffenreffer himself. Native visitors appreciated Haffenreffer's willingness to let them visit – and perhaps his sympathy with their understanding of the past – since they knew the sites were private property to which he need not allow them access.[37] From these beginnings, Haffenreffer probably developed the relationships with local Native people that led to his involvement with local pan-Indian organizations.

On at least two occasions in the 1930s, large groups of Native people associated with pan-Indian organizations visited the Museum. The first, in June 1931, was a visit of the National Algonquin Indian Council, headed by its Chief Sachem Alfred C. A. Perry, a Narragansett (see biography). This visit followed Haffenreffer's installation as Honorary Chief Sachem of the National Algonquin Indian Council in October 1929 – his first recorded association with the NAIC – and may represent the Council's annual meeting.[38] From its inception, Ousa Mekin was an important figure in the Indian Council of New England, an earlier incarnation of the NAIC, and may have introduced Haffenreffer to the organization.[39] Haffenreffer was ambivalent about the Council but was concerned that it be reorganized "so as to be of real value, by the elimination of certain individuals whose Indian ancestry is questionable."[40] His interest in the potential of the NAIC to help Native people reflects his concern over the historical circumstances of Native Americans and their position within American society.

The history of the NAIC began in 1923, when Thomas Bicknell, a local historian interested in creating a series of monuments to the early Narragansetts, founded the Indian Council of New England with the help of an "Indian Committee." The purpose of the Council was

> to promote acquaintance, friendship, business cooperation, education, finance, protection of civil rights, benefits of aged, sick and helpless, social and moral reforms, the preservation of Indian language, folklore, traditions, history, the record of achievement of great chiefs and tribesmen and the erection of

monuments, memorials, tablets to perpetuate the memories of the events and the braves.[41]

The Indian Council was a fraternal organization with a membership composed of Natives and non-Natives. With dues, bylaws, events, and programs for members, it was similar to other fraternal organizations popular during the period, many of which emphasized national origin, such as the Sons of Italy.[42] Sometime after Bicknell's death in 1925, the ICNE changed its name to the National Algonquin Indian Council, but included the same members. Its expressed purpose may have changed to include more social gatherings and public events rather than the social good Bicknell had originally intended but which had never been realized. The correspondence of early ICNE members suggests a great concern over those who were "typical Negroes" according to the racial categorizations of the time, and efforts to exclude them. Council activities centered on powwows and other events for members rather than assistance to Native people and social reform.[43] The fact that Haffenreffer continued his association with the NAIC for less than two years after his installation as its Honorary Chief Sachem suggests that he was disappointed in its direction and perhaps also the racial overtones that characterized its operation and membership.

Haffenreffer was also involved with the American Indian Federation, which visited the King Philip Museum for a meeting in October 1932.[44] While there is no evidence that Haffenreffer was a member of the Indian Federation, he was friendly with its Chief Sachem Silver Star, a Pequot. In August 1931, Silver Star, John George, and Pine Tree, the Narragansett medicine man (see biographies), founded the American Indian Federation, a pan-Indian organization composed largely of Pequots, Narragansetts, and non-Natives during its early years (fig. IV-7).[45] Its purposes, as laid out in the bylaws, were remarkably similar to those of the ICNE:

> 1) to promote acquaintance, friendship, education, protection of civil rights, and general welfare of American Indians and their descendants.
>
> 2) to record the achievements of noted Indian

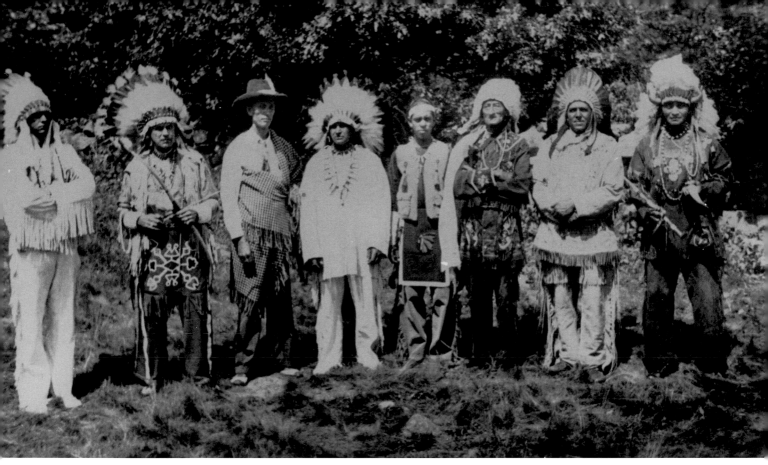

Fig. IV-7
American Indian Federation members, ca. 1932. From left: Atwood I. Williams, Jr., Pequot; Frederick P. Adams, Narragansett; unknown; Atwood I. Williams, Pequot; unknown; Edward Michael, Narragansett; Frank Nichols, Narragansett; William L. Wilcox, Narragansett. From Ernest G. Rogers's scrapbook of Indian photographs. New London County Historical Society, New London, Conn.

chiefs, tribesmen, and individuals whether or not they are Indian, Indian relatives, or their descendants, and to erect monuments, memorials or tablets to their memory and achievements.

3) to stimulate the study of American Indian languages, folklore, tradition and history.

4) for religious, charitable, literary, scientific, artistic, social, and agricultural purposes.[46]

On the occasion of their visit to the Museum in 1932, AIF members hiked to the top of Mount Hope for speeches by Connecticut historian Ernest Gorton Rogers (an Associate member of the AIF), Pine Tree, and several nonlocal Indian members of the Federation.[47] These included: Chief Black Hawk of the Powhatan (a Rappahannnock); Chief Lone Fox, Yuma; Chief Crazy Bull, Sioux; and Senabeh, Penobscot-Maliseet. All appear to have been former Wild West show performers and gave their residences as Fall River, Massachusetts and New York City. Both Black Hawk and Crazy Bull were active in lecturing on Indian subjects to Boy

Pine Tree — William L. Wilcox

William L. Wilcox was the Narragansett medicine man and was married to Ella Wheeler Wilcox. He was prominent in Narragansett tribal activities, including the tribal council and the Narragansett Indian Church. Wilcox visited the Museum in summer 1931 along with the membership of the NAIC, and in October 1932 with the AIF.

SOURCES: *Narragansett Dawn* 1(6):134-35, 151; 1(8):192; 1(10):242; 1(11):270; 2(1):12; 2(2):22, 34; AIF records.

Fig. IV-8
Ernest G. Rogers of the New London Historical Society, speaking at Mount Hope on the occasion of the AIF meeting, October 23, 1932. Silver Star (Pequot) stands behind Rogers; William L. Wilcox (Narragansett) is obscured by Rogers's figure; two unknown Indians in regalia (probably Black Hawk and Crazy Bull); Frank Nichols, Narragansett; unknown figure (perhaps Ronald "Senabeh" Francis). Rudolf Haffenreffer is the furthest to the right, leaning on the railing, and Rhode Island historian John Haley is at front left. Mount Hope Farm.

Scouts, the YMCA, and other audiences, as was Silver Star (fig. IV-8).[48]

The mid 1930s were a turning point for the American Indian Federation. During that period the leadership shifted from the founding Pequot and Narragansett members to Indians from outside New England, specifically Nashaweena, a Mohawk, and Wah wah taysee, a Chippewa. Changes in membership mirrored the leadership, and local Indians found themselves outnumbered by Mohawks, Micmacs, and Indians from western tribes.[49] At the same time, increasing numbers of Associate (non-Native) members were active at AIF powwows, sometimes to the exclusion of Native people.[50]

While Wah wah taysee and Nashaweena visited the King Philip Museum in 1938, Haffenreffer's involvement with the AIF does not appear to have continued after 1932. Nor does he appear to have continued his association with the National Algonquin Indian Council. Like the Indian Council of New England and the NAIC, the American Indian Federation did not live up to its stated purpose in its early years. Disappointment in their progress towards helping Native people and improving their perception in the eyes of the public may have led Haffenreffer to discontinue his associations with the NAIC and the AIF. However, it is equally likely that he recognized that the changes in membership of pan-Indian organizations after the passage of the Indian Reorganization Act in 1934, which encouraged the formation of tribal rather than intertribal

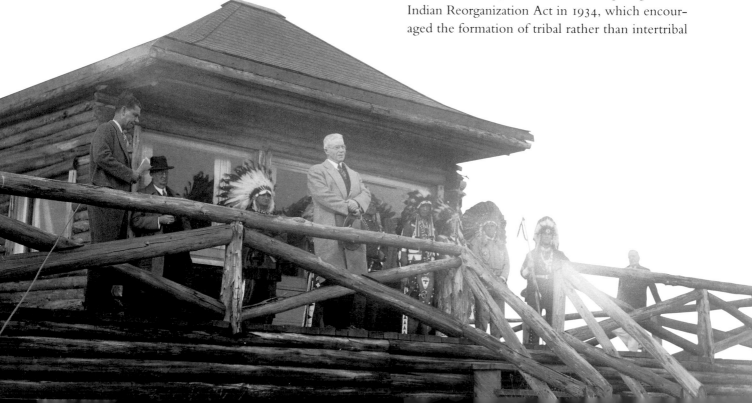

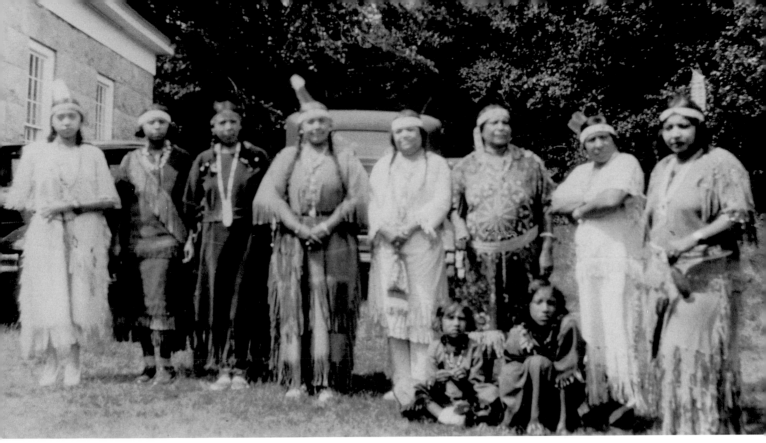

organizations and activities,[51] decreased opportunities to meet important Native individuals through these organizations (fig. IV-9).

While Ousa Mekin continued his association with the NAIC after his election to the Supreme Sachemship of the Wampanoag Nation, the emphasis of his activities shifted to that of the Nation and his pastorship of the Indian Church at Gay Head on Martha's Vineyard (see biography). Similarly, Narragansetts important in the early years of the Indian Federation became more actively involved in gaining a charter for their tribe (see Marion Wilcox Brown, Philip H. Peckham, and William L. Wilcox biographies). Silver Star also became less involved with the AIF as he was drawn into negotiations with the State of Connecticut over the Mashantucket Pequot Reservation (see biography). With these changes, Haffenreffer may have realized that his interests in local Native culture could be better served by continued associations with particular individuals rather than intertribal pan-Indian organizations which increasingly served the needs of nonlocal Indians and non-Natives interested in powwows and other Indian activities.

Fig. IV-9
Group of Narragansett women at the Narragansett Church, Charlestown, R.I., July 22, 1934. From left, standing: Josephine Wilcox, Ruth Brown, Bessie Brown Manning, unknown, Minnie Steele, Ella W. Wilcox, unknown, Marion W. Brown. Seated children are Marion W. Brown's daughters, Esther and Priscilla. From Ernest G. Rogers's scrapbook of Indian photographs. New London County Historical Society, New London, Conn.

Nokomis – Mrs. Clara F. Peckham

Clara Francis Peckham, Narragansett, was the wife of Philip H. Peckham. She was also a member of the NAIC and visited the Museum in summer 1931, and in 1932 with members of the AIF.

Philip H. Peckham – Chief Canonicus

As Narragansett Chief Sachem, Philip H. Peckham (Night Hawk) held the title "Chief Canonicus." Peckham was a member of the Tribal Council and trustee and treasurer of the Narragansett Indian Church. He visited the King Philip Museum in summer 1931 during a meeting of the National Algonquin Indian Council.

SOURCES: *Narragansett Dawn* 1(6):151; 1(9):202; 1(11):270; 2(1):12; 2(2):22, 33.

At the same time, Haffenreffer's own interests may have shifted away from local Native culture and social reforms for American Indians. His involvement with scouting, which had begun in 1913, escalated in the 1930s and 1940s, when increasing numbers of Scouts gathered at Camp Takarest and Camp Weetamoo for organized activities and camping. Haffenreffer's interest in Native Americans found strong expression in his work with Scout groups (Krech, this volume). However, local Indians and their cultures were not the focus. Instead, scouting emphasized a generic Indian culture focusing on the Plains. And, while Native people occasionally entertained or spoke to Scout groups – the Sioux Rain-in-the-Face's visit to Bristol in 1916 and Cherokee Chief Bluesky's performance of Indian dances for Boy Scouts in the area in 1919[52] – Scout troops relied on their own members trained in "Indian lore."

In 1936, however, the Rhode Island Boy Scouts sponsored a "campaign of friendship for the Wampanoag Indians," and Haffenreffer held a contest for essays on the Wampanoag.[53] The Visitors' Book shows only one obvious Native American with the Boy Scout signatures for those days: "Chief Red Arrow Algonkian LaFayette RI." Red Arrow, a Narragansett who had previously visited the Museum in 1932, was one of the leading figures in the American Indian Federation at that time (see biography).[54] Despite this, he may simply have visited the Museum then and may not have been formally engaged in work with the Scouts. In the 1940s and 1950s, local Scout leaders retained their interest in Indian lore and titles but were seldom interested in having local Indian instructors or demonstrations.[55]

Chief Red Arrow – Joseph R. Adams
Joseph R. Adams signed the Visitors' Book first during the AIF visit in October 1932 and later at the 1936 "Good Turn" mobilization of Rhode Island Boy Scouts. His 1931 AIF application was for an Associate (non-Native) membership, but was changed to Nipmuc, and later Narragansett.

SOURCES: AIF records.

CONCLUSIONS

In many ways, Rudolf Haffenreffer was unique in his relationships with New England's Native people. At a time when many students of Indian history and culture were suspicious of the racial purity of New England Indians and their adherence to traditional culture, Haffenreffer was more accepting of individuals' claims to Native heritage and welcomed them to the Museum and grounds. However, Haffenreffer appears to have pursued his historical interests in living Native people only through interviews with the descendants of Massasoit.

Haffenreffer's involvement with pan-Indian organizations in New England showed his interest and support for Native efforts to maintain and celebrate their cultures. In this regard, Haffenreffer also differed from some anthropologists of the period, who felt that pan-Indianism led to a loss rather than a preservation of local traditions.[56] Haffenreffer agreed with local Native Americans that their traditions were part of a national cultural whole. Diverse museum collections like that of the King Philip Museum helped reify the idea of "The Indian" – a synthetic and unified whole that encompassed all Native cultures. Affected by such concepts, the individuals involved in pan-Indian organizations took on traditions vastly different from those of their forebears, but which reflected and answered public perceptions of a collective Indian culture. This mutual reinforcement may have encouraged Haffenreffer to expand his collection to cover all regions of North America, while local Native Americans could borrow traditions and ideas for regalia from the objects they saw on view at the Museum.

Native people involved in the King Philip Museum and its activities did not depend on Haffenreffer and their association with the Museum for self-recognition. Many who visited the Museum came from families whose adherence to traditional practices was well known and long-standing. These include the Narragansett families of Wilcox, Brown, and Peckham, the Pequot Williams and George families – active members of Narragansett and Pequot communities – and LeRoy Perry. Their interest in their own history and culture undoubt-

edly motivated them to visit the museum and the grounds, where they could see a multitude of artifacts, learn about past cultures and those of other parts of North America, and feel proud of their ancestors. For the most part, however, the individuals from locally important Native families were well established as authorities and cultural carriers in local communities before they visited the Museum. Secure in their Native identities, they may simply have drawn on the Museum's collections for ideas about traditional dress. In their presentations of themselves to the non-Native public, however, Native people probably felt that association with the National Algonquin Indian Council and the American Indian Federation added to their recognition and credibility as Native. Before the Indian Reorganization Act in 1934, Native people might have been recognized as individuals but not as members of tribes, and membership in pan-Indian organizations was likely to have been of great importance.

Haffenreffer's Native contacts and those who visited the King Philip Museum represent only a fraction of the Native population in southeastern New England, specifically descendants of Massasoit and those involved in fraternal pan-Indian organizations. At the time, significant Native communities existed in southeastern New England: Gay Head Wampanoags on Martha's Vineyard; Mashpee Wampanoags on Cape Cod; Narragansetts in and around Charlestown, Rhode Island; Hassanimisco and Chaubunagungamaug Nipmucs in Grafton and Webster, Massachusetts; Mohegans near Uncasville, Connecticut; and Mashantucket and Paucatuck Pequots in Ledyard and North Stonington, Connecticut. Other Indian families and individuals lived in local cities and towns. Other than Ousa Mekin, visitors to the Museum were largely Narragansett and Pequot members of the NAIC and the AIF. Only two members of the Mashpee community – Lorenzo and Lillian Hammond – visited the Museum (see biography). No Mohegans or Nipmucs came, in spite of their involvement in pan-Indian organizations.[57] Thus, most Native visitors came from a circumscribed area: Rhode Island and eastern Connecticut. Restricted travel, the

Chief Small Bear – Lorenzo T. Hammond
A Mashpee Wampanoag, Lorenzo Hammond was a friend of LeRoy Perry, and visited the King Philip Museum in February 1930. After Perry became Chief Sachem of the Wampanoag Nation, he named Hammond chief of the Mashpees.
SOURCES: AIF records; Jack Campisi, *The Mashpee Indians: Tribe on Trial* (Syracuse, N.Y.: Syracuse University Press, 1991), 131–35.

Narragansett–Wampanoag focus of the collections, and Haffenreffer's interests may together explain this pattern.

It is doubtful that Haffenreffer saw Native approval and involvement as necessary to his mission and conception of the King Philip Museum. Since Haffenreffer created the Museum as a memorial to the Indian past, he did not necessarily view it as a means by which contemporary Native people in New England might perpetuate their cultures and, with the exception of Ousa Mekin, did not seek Native interpretations of history or artifacts. He sought approval of the descendants of Massasoit for his historiographic efforts on early Indian–White relations in New England, but we have no evidence that he sought contact with other Native people in the region. Additionally, he made no attempt to collect their modern manufactures for his collection.

While Haffenreffer's employment of Ousa Mekin as an interpreter is an early example of the "cooperative museology"[58] that has become relatively commonplace in today's museums, it went no further. If the King Philip Museum helped perpetuate Native cultures in southeastern New England, it was because local Indians used it to reinforce their own ideas about the unity of Native cultures and saw its collections as representing their common history. Thus, Native visits to the Museum and the grounds probably originated in the desire to see the collections and the unified Indian culture that they represented. For Haffenreffer, his relationships with local Indians appear to have stemmed from his intense interest in things Native and his willingness to allow all interested parties to visit

the Museum and view the collections. Haffenreffer does not appear to have considered local Native people as authorities on his collections or the Museum's exhibits, but instead recognized that some individuals, namely the descendants of Massasoit, might inform his historical perspectives.

Given the impact of his visit with the Mitchells, we may wonder whether Haffenreffer hoped to find an equally significant key to his historical understanding among the Native individuals who visited the Museum. As with his collecting practices, Haffenreffer often took what was offered and let time appraise its worth or usefulness to his purpose. So, too, he took the friendship Native people offered and gave back what he could: opportunities to visit the Museum and the grounds. The changing character of intertribal organizations like the National Algonquin Indian Council and the American Indian Federation after the passage of the Indian Reorganization Act of 1934 would have limited Haffenreffer's contact with important Narragansetts, Pequots, and Wampanoags. He may have abandoned his contacts with pan-Indian organizations and instead limited his interactions to individuals like Ousa Mekin and Silver Star. With his interest in social reform for Native Americans, he was probably equally disappointed by the lack of such progress made by pan-Indian organizations in New England.

While Haffenreffer appears to have been more open-minded than many others of his time in recognizing the connection of living Native people to those of the past, he may not have completely escaped his own preconceptions and expectations. With his understanding of seventeenth-century New England cultures and history, Haffenreffer knew and understood that New England Native people's cultural expressions had changed radically. He may have been disillusioned by the participation of local Indian people in early twentieth-century pan-Indian organizations, and so limited his interaction with them. Nevertheless, his attempts to include them in his "heart interest," – the study of American Indians and their cultures – illustrate his commitment to bringing together in his Museum understandings from artifacts, history, and living Native people.

ACKNOWLEDGEMENTS

Funding for research on Native historiography, twentieth-century pan-Indian organizations, and culture in southeastern New England was provided by the Wenner-Gren Foundation for Anthropological Research; the Center for the Study of Race and Ethnicity in America, Brown University; and the Haffenreffer Museum of Anthropology, Brown University, and is gratefully acknowledged.

I am indebted to the Haffenreffer Museum of Anthropology's Native American Advisory Committee for their discussions on Rudolf Haffenreffer's relationships with Native people, their visits to Mount Hope, and their contributions to this essay. They are as follows: Edith Andrews (Gay Head Wampanoag); Clifford Guy (Pokanoket); Paulla Dove Jennings (Niantic-Narragansett); Everett "Tall Oak" Weeden (Narragansett-Wampanoag); and Paul "Deerfoot" Weeden (Pokanoket). In addition, Paulla Dove Jennings's contributions on the meaning of Mount Hope to Native people, expressed in NAAC meetings during the preparation of *Entering the Circle: Native Traditions in Southeastern New England* (1990–92), have been incorporated here.

The following individuals gave their patient assistance to my efforts to identify the individuals in the Visitors' Book (HMAA, 1929–54) and in historic photographs. I gratefully acknowledge the help of Terry Bell (Mashantucket Pequot); Paul "Whirling Thunder" Bullock (Wampanoag); Agnes Cunha (Paucatuck Pequot); Eleanor Dove (Niantic-Narragansett); Anna Cesaro (Mohawk); Melissa Fawcett-Sayet (Mohegan); George "Broken Arrow" Hopkins (Narragansett); Paulla Dove Jennings (Niantic-Narragansett); Nanepashemet (Wampanoag); Ella Sekatau (Narragansett); Kenneth "Strong Horse" Smith (Narragansett); and Frances Young (Paucatuck Pequot).

I also wish to thank the anonymous collector of the American Indian Federation Records (1931–93) for allowing me to study the papers and for gracious responses to my innumerable questions.

For their discussions on this subject and their comments on earlier drafts of this essay, I thank David W. Gregg, Barbara A. Hail, Shepard Krech III, and Daniel P. Odess.

For their help with securing photographic illustrations for this essay, I am indebted to Thierry Gentis and Rip Gerry of the Haffenreffer Museum of Anthropology and to Will Hare of the New London Historical Society, New London, Connecticut.

NOTES

1. HMAA Visitors' Book, 1929–54.

2. This analysis is based on the Haffenreffer Museum of Anthropology Archives (HMAA), including the Visitors' Book, 1929–54, Haffenreffer Museum Collections Files, and the Indian Council of New England (ICNE) Scrapbook; newspaper accounts; American Indian Federation (AIF) records, 1931–93, private collection; and interviews with Native people, including descendants of individuals who visited the King Philip Museum.

3. Rudolf Frederick Haffenreffer, "Indian History of Mount Hope and Vicinity," in *Proceedings of the Fall River Historical Society from its Organization in 1921 to August 1926* (Fall River, Mass.: Fall River Historical Society, 1929), 38. In his discussion of early contacts between Massasoit and the Pilgrims, Haffenreffer states: "During the early weeks of the settlement few Indians were seen by the colonists, but from the friendly cover of trees and shrubs, the natives watched the whites and reported to their sachem Massasoit the progress of the little settlement at Plymouth. Nor did Massasoit sit idly by, as perchance it may have appeared to the Pilgrims, and let matters shape their own course. From subsequent events, it would seem clear that Massasoit thought much and deeply on a subject of vital interest to himself and his tribe. . . . Massasoit with far-sighted vision saw that an alliance with these new comers would enable him and his tribe to throw off the hated yoke of vassalage to the Narragansett sachems" (*ibid.*, 38).

4. *Ibid.*, 51.

5. William T. Hagan, "Reformers' Images of the Native Americans: The Late Nineteenth Century," in *The American Indian Experience*, ed. Philip Weeks (Arlington Heights, Ill.: Forum Press, 1988), 207–17; Frederick E. Hoxie, *A Final Promise: The Campaign to Assimilate the Indians, 1880–1920* (Lincoln: University of Nebraska Press, 1984); Frederick E. Hoxie, "The Curious Story of Reformers and the American Indians" in *Indians in American History*, ed. Frederick E. Hoxie (Arlington Heights, Ill.: Harlan Davidson, Inc., 1988), 205–30; Roger L. Nichols, "The Indian in Nineteenth-Century America: A Unique Minority," in *The American Indian: Past and Present*, ed. Roger L. Nichols (New York: Alfred A. Knopf, 1986), 127–36; Kenneth R. Philp, *John Collier's Crusade for Indian Reform: 1920–1954* (Tucson: University of Arizona Press, 1977).

6. Haffenreffer, "Indian History of Mount Hope," 52, 61.

7. American ideas on the categorization of people by appearance stem from eighteenth-century works by Buffon and Blumenbach. See Robert E. Bieder, *Science Encounters the Indian, 1820–1880: The Early Years of American Ethnology* (Norman: University of Oklahoma Press, 1986).

8. Jack D. Forbes, *Africans and Native Americans: The Language of Race and the Evolution of Red-Black Peoples* (Urbana: University of Illinois Press, 1993), 262.

9. Karen I. Blu, *The Lumbee Problem: The Making of an American Indian People* (Cambridge: Cambridge University Press, 1980); Helen C. Rountree, *Pocahontas's People: The Powhatan Indians of Virginia through Four Centuries* (Norman: University of Oklahoma Press, 1990); Ted J. C. Brasser, "The Coastal Algonkian: People of the First Frontiers," in *North American Indians in Historical Perspective*, eds. Eleanor Burke Leacock and Nancy Oestreich Lurie (Prospect Heights, Ill.: Waveland Press, 1971), 64–91; Brewton Berry, "Marginal Groups," in *Handbook of North American Indians, Vol. 15: Northeast,* ed. Bruce G. Trigger (Washington, D.C.: Smithsonian Institution Press, 1978), 290–95.

10. For instance, anthropologist Frank G. Speck, considered the preeminent authority on Eastern Indians and their cultures, chose his informants from only the "purest families" in Native New England and devoted much of his fieldwork to photography of the best examples of Indian "types" – those who fit his perceptions of what Native Americans should look like ("Territorial Subdivisions and Boundaries of the Wampanoag, Massachusett, and Nauset Indians," *Indian Notes and Monographs,* No. 44, 1928). Similarly, Warren K. Moorehead, another prominent archaeologist and anthropologist of the period, suggested that because they were mixed with Portuguese or African-Americans, most Rhode Island Indians were unworthy of consideration as Indians (HMAA Collections Files, RH: Moorehead, letter from W. K. Moorehead to R. F. Haffenreffer, October 29, 1929). Haffenreffer respected Moorehead's archaeological work and sought his advice on the museum's operation and collections. However, Haffenreffer felt evidence of Indian ancestry was sufficient to warrant his interest in pan-Indian organizations such as the National Algonquin Indian Council (*ibid.*).

11. Ann McMullen, "What's Wrong with This Picture? Context, Coversion, Survival, and the Development of Regional Native Cultures and Pan-Indianism in Southeastern New England," in *Enduring Traditions: The Native Peoples of New England,* ed. Laurie Weinstein (Westport, Conn.: Greenwood Press, 1994, forthcoming).

12. Individuals may have disapproved of some aspects of the museum, for instance the exhibition of Native skeletal material and grave goods. Theodore Dennis Brown, a Narragansett who visited in 1932, wrote in a 1935 discussion of the opening of the Narragansett/Niantic Queen Esther's grave: "It seems wrong to rob a grave, even an Indian's grave" (*Narragansett Dawn* 1[5]:122).

13. The early membership of the Indian Council of New England included a number of White anthropologists and historians: Thomas Bicknell (its founder), anthropologists Frank G. Speck and William B. Cabot, sculptor Cyrus E. Dallin, and historian Mathias Speiss. Interested laymen included Judge Thomas Z. Lee, Mabel Knight (who lectured on Indian subjects) and others (HMAA ICNE Scrapbook). The membership of the American Indian Federation included Theodore Francis Green (Governor of Rhode Island), James F. King (founder of The James F. King Museum of the American Indian in Somers, Conn.), Mabel Knight, historian Arthur Peale, the Reverend Philip Sawyer of Fall River, Mass., Frank G. Speck, and dozens of non-Native Associate members (AIF records). The AIF records include applications for membership, where individuals gave their names, addresses, tribal affiliations (if any), and the name of the AIF member recommending their application. Up until about 1935, members simply applied and paid their dues of two dollars; after that point, it appears to have become more selective, and leading members of the Federation gave their stamp of approval to individual applications, often writing "OK" and their signature on the back of applications.

Information of the fraternal nature of pan-Indian organizations appears in Hazel W. Hertzberg, *The Search for an American Indian Identity: Modern Pan-Indian Movements* (Syracuse, N.Y.: Syracuse University Press, 1971).

In addition to the visits of fraternal pan-Indian groups, a number of other groups visited the King Philip Museum, including the Fall River and Rhode Island Historical Societies, garden clubs, church groups and others (HMAA Visitors' Book, 1929–54).

14. For instance, at the Brooklyn Museum, a Native woman from Long Island gave tours of the exhibits in the early twentieth century, and in 1932 a group of Southwestern Indians demonstrated "the arts and crafts of the Desert" for several days in an "experiment in making the museum a repository for living culture" (Diana Fane, letter to author, December 8, 1993). At Clara Endicott Sears's Fruitlands Museum in Harvard, Mass., two Indians – from the Southwest and Plains – were called on to attend special events but do not appear to have been involved in education (Barbara Hail, telephone conversation with author, December 14, 1993).

15. Ella Sekatau, conversation with author, October 4, 1993.

16. My research on pan-Indianism and Native organizations from the 1920s onward suggests that the public use of "Indian names" in New England stemmed from exposure to Western Native people and from the expectations of non-Natives. While many Native people in New England undoubtedly had Indian names and used them within their families or among tribal members, they appear to have kept them private. For instance, the medicine man of the Narragansetts during this period was ordinarily called "Pine Tree" by the tribe, yet on his visits to the King Philip Museum signed his name "William L. Wilcox." Those involved in pan-Indian organizations who sought public recognition were far more likely to use Indian names. For instance, Joseph Pallen, a Yuma Indian, called himself Red Fox although Quechuan peoples never had names of this type (Nancy Parezo, letter to author, November 29, 1993), suggesting that Native people took these names to conform to non-Native expectations.

Besides the descriptive names commonly used, Native people also took the names of historical figures as Indian names, however they did not always feel bound to their own ethnicity or the history of their own tribe. Some Narragansetts adopted the names of Pokanoket and Wampanoag historical figures.

17. Ebenezer W. Peirce, *Indian History, Biography and Genealogy: Pertaining to the Good Sachem Massasoit of the Wampanoag Tribe and his Descendants* (North Abington, Mass.: Zerviah Gould Mitchell, 1878), now in the HMA library. Peirce's book included a detailed genealogy of the Mitchell family, tracing their ancestry back to the Pokanoket sachem Massasoit (*ibid.*, 210–19) and was published by Zerviah Gould Mitchell, Melinda and Charlotte Mitchell's mother.

18. Haffenreffer, "Indian History of Mount Hope and Vicinity," 34. In this quote, Haffenreffer misreads the Mitchell genealogy: they were descendants of Massasoit's daughter Amie, not King Philip (Peirce, *Indian History, Biography and Genealogy*, 210–19).

19. *Boston Post*, November 22, 1925; Haffenreffer family collection, Mount Hope Farm, Bristol, R.I., letter from R. F. Haffenreffer to Emma Mitchell Safford, November 24, 1925.

20. HMAA Visitors' Book, 1929–54.

21. Hugo A. Dubuque, *Fall River Indian Reservation* (Fall River, Mass.: City of Fall River, 1907).

22. *Bristol Phoenix*, July 8, 1930.

23. *Bristol Phoenix*, July 3, 1930.

24. HMAA ICNE Scrapbook.

25. HMAA Collections Files, RH:Moorehead, letter from R. F. Haffenreffer to W. K. Moorehead, September 30, 1929; HMAA ICNE Scrapbook.

26. *Fall River Herald News*, August 27, 1930.

27. HMAA Collections Files, RH:Moorehead, letter from W. K. Moorehead to R. F. Haffenreffer, October 9, 1929. Moorehead's remarks about "real Indians" stem from his disregard for New England's Native people based on their mixed heritage.

The practice of employing Native Americans in constructed villages was common to World's Fairs and Chicago's Columbian exposition of 1893 and was later used for commercial and entertainment purposes by trading-post operators in the Southwest and within the context of traveling Wild West Shows. By the 1930s, it was seldom used by museums. I am indebted to Nancy Parezo for clarifying this issue.

28. *Providence Sunday Journal*, October 11, 1931, Artgravure section; Edward Hail, conversation with Barbara Hail, October 1, 1993.

29. Helen A. A. Attaquin, *A Brief History of Gay Head, or 'Aquiniuh'* (published by the author, 1970), 33.

30. HMAA Visitors' Book, 1929–54; Agnes Cunha and Frances Young, conversations with author, October 10, 1993. Silver Star's involvement with the Museum was not limited to Federation activities: in 1932 he recommended the Museum to amateur archaeologists as a repository for their collections (HMAA Collections Files, RH:Collections offered for Sale, letter from George Pearl to R. F. Haffenreffer, August 31, 1932).

31. HMAA Collections Files, RH:Moorehead and RH:Saville.

32. Paulla Dove Jennings, HMA Native American Advisory Committee [NAAC] meeting, September 23, 1993.

33. Paulla Dove Jennings, HMA NAAC meeting, November 26, 1990.

34. Paulla Dove Jennings, HMA NAAC meeting, September 23, 1993.

35. Jack Campisi, *The Mashpee Indians: Tribe on Trial* (Syracuse, N.Y.: Syracuse University Press, 1991), 135.

36. Everett Weeden, Jr., HMA NAAC meeting, September 23, 1993. It has also been suggested that in their isolation, Mashpee Wampanoags seldom traveled over the Bourne Bridge from Cape Cod (Nanepashemet, telephone conversation with author, October 4, 1993).

37. Paulla Dove Jennings, HMA NAAC meeting, September 23, 1993; Paul Bullock, telephone conversation with author, October 4, 1993.

38. HMAA Collections Files, RH:Moorehead, letter from R. F. Haffenreffer to W. K. Moorehead, September 29, 1929. Haffenreffer commissioned an eagle-feather bonnet for his installation ceremony (*Providence Sunday Journal*, October 11, 1931, Artgravure Section).

39. HMAA ICNE Scrapbook; McMullen, "What's Wrong with This Picture?"

40. HMAA Collections Files, RH:Moorehead, letter from R. F. Haffenreffer to W. K. Moorehead, September 30, 1929. Although Haffenreffer does not specify which individuals he was referring to, it is likely he meant those with little claim to Native heritage and who were not active participants in Native communities of the time. The reputation and public perception of Native associations depended on the integrity of their members and their claims to Native ancestry, thus Haffenreffer may have felt that it was in the NAIC's best interest to eliminate those who represented themselves as Indians

and profited from careers in lecturing on Indian topics. The best example of this is Mabel Knight (Princess Ta-Di-Wi), a member of both the early Indian Council of New England and an Associate (non-Native) member of the American Indian Federation, who was known for Indian performances and lectures (HMAA ICNE Scrapbook; AIF records). Haffenreffer's support of Ousa Mekin as an interpreter on the grounds at Mount Hope illustrates his concern over having Native people interpret their own history.

41. HMAA ICNE Scrapbook.

42. Hertzberg, *The Search for an American Indian Identity.*

43. McMullen, "What's Wrong with This Picture?"

44. HMAA Visitors' Book, 1929–54.

45. AIF records.

46. *Ibid.*

47. Photographs documenting the speeches exist in the Haffenreffer family collection, Mount Hope Farm, Bristol, R.I. Unfortunately, no records of these addresses have been found.

48. Black Hawk identified himself as a Rappahannock on his AIF membership application (AIF records). Information on Senabeh may be found in Lee-Ann Konrad and Christine Nicholas, *Artists of the Dawn: Christine Nicholas and Senabeh* (Orono, Maine: Northeast Folklore Society, 1987). Accounts of Crazy Bull and Black Hawk's lecturing come from issues of *Narragansett Dawn* (Oakland, R.I., 1935–36) and Kenneth "Strong Horse" Smith, conversation with author, September 11, 1993. Information on Silver Star's work with Scouts comes from Agnes Cunha, conversation with author, October 10, 1993, and newspaper clippings in her possession.

49. The influx of new nonlocal Indians in the AIF appears to have caused problems within the membership. Narragansetts in particular appear to have felt discriminated against on the basis of their skin color which resulted from intermarriage with African-Americans. While AIF membership records do not record when individuals left the organization, the decline in the involvement of local Native people can be seen in photos and newspaper accounts of AIF events. By the late 1950s, few participated in Indian Federation activities (AIF records).

50. In July 1936, Theodore Dennis Brown, a Narragansett, wrote to *Narragansett Dawn,* complaining bitterly that he and other Indians had not been allowed to dance at the Indian Federation powwow. He urged the Narragansetts to abandon membership in the AIF and "join the great national war against impostors of Indians" (*Narragansett Dawn* 2[5]:6). Up until July 1936, the American Indian Federation had been cooperatively involved with the Narragansett Celebration of the Rhode Island Tercentenary at Camp Ki-Yi, Oakland, R.I. (*ibid.,* 1[12]:277). Divisions about the nature and direction of the festivities undoubtedly occurred and may have contributed to Narragansetts' feelings that they were being discriminated against. However, the decline in the involvement of important Narragansett individuals in the activities of the AIF could stem from the growth in importance of their own tribal activities after the passage of the Indian Reorganization Act in 1934 rather than perceptions of racial discrimination within the American Indian Federation.

51. Philp, *John Collier's Crusade for Indian Reform;* Lawrence C. Kelly, *The Assault on Assimilation: John Collier and the Origins of Indian Policy Reform* (Albuquerque: University of New Mexico Press, 1983).

52. *Bristol Phoenix,* July 11, 1916; *ibid.,* January 3, 1919.

53. *Providence Journal,* October 25, 1936; *Bristol Phoenix,* October 27, 1936.

54. HMAA Visitors' Book, 1929–54; AIF records.

55. Paul Bullock, telephone conversation with author, October 4, 1993.

56. HMAA ICNE Scrapbook; McMullen, "What's Wrong with This Picture?" Frank Speck was particularly strong in his reactions to pan-Indianism, Native intermarriage with non-Natives, and what he felt was the resulting cultural disintegration: "Anybody who advocates total tribal disintegration is manifestly advocating race murder. For the moment that any band of Indians gives up at least some semblance to tribal organization, whether it be an actual tribal government or merely an incorporated body bearing a tribal name, on a par, for instance, with some fraternal or social orders, at that moment it seals its own fate. As each tribe or group of tribes is a unit, so they must hold out or else fade away" (Frank G. Speck, "The Ethnologist and the Indian," *Quarterly Journal* [of the Society of American Indians] 2[1] [1914], 64–68).

57. HMAA ICNE Scrapbook; AIF records.

58. James Clifford, "Four Northwest Coast Museums: Travel Reflections," in *Exhibiting Cultures: The Poetics and Politics of Museum Display,* ed. Ivan Karp and Stephen D. Lavine (Washington, D.C.: Smithsonian Institution Press, 1990), 212–54.

BROWN
ALUMNI MONTHLY

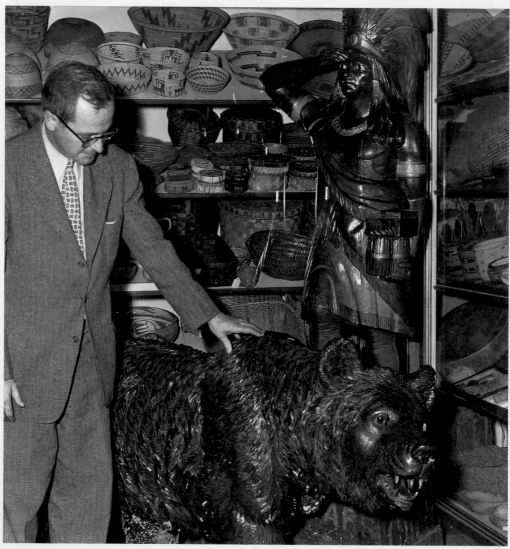

INDIANS AND THE BEAR

FEBRUARY 1956

Epilogue

by SHEPARD KRECH III

AFTER BEING IN failing health for some time, Rudolf F. Haffenreffer died on October 9, 1954. The services were held at St. Paul's Evangelical Lutheran Church in Providence and attended by many in public life in Rhode Island.[1]

As they had following Haffenreffer's purchase of 1912, questions arose almost immediately concerning the fate of the Mount Hope lands. The Director of the Rhode Island Department of Agriculture was interested in using federal and state monies to purchase the property for a fish and game preserve, despite the problems of pollution in Mount Hope Bay. In the fall of 1955, discussions over what to do with the land (though not the Bradford House or museum) were intense. In the meantime, the U.S. Army acquired part of the top of Mount Hope for a Nike missile site.[2]

These speculations came to an abrupt end in December 1955, when Rudolf Haffenreffer's widow, Maude, and sons, Pete and Carl, decided to donate both a substantial amount of land and, through the Rudolf F. Haffenreffer Family Foundation, the King Philip Museum to Brown University, which had been the recipient before of graduate fellowships in internal medicine, undergraduate scholarships, and

President Barnaby Keeney in the Haffenreffer Museum of the American Indian, *Brown Alumni Monthly,* February, 1956. Haffenreffer Museum of Anthropology.

other gifts from Rudolf Haffenreffer.[3] This donation fulfilled the spirit of the 1949 transfer of the Museum's collections to the Rudolf F. Haffenreffer Family Foundation in order to guarantee their perpetuation.[4] In all, a total of approximately four hundred and fifty acres including Mount Hope itself was given to Brown in several separate gifts from 1955 to 1958.[5] In 1958, Maude Haffenreffer died at age seventy-nine. Her son, Pete, and his wife, Virginie, and their family moved into the Bradford House at Mount Hope Farm. Pete died in 1991, and his widow still lives at Mount Hope Farm. Next door is the property now known as the Mount Hope Grant and the Museum now known as the Haffenreffer Museum of Anthropology, both part of Brown University.

When the Haffenreffer Family Foundation offered the collections of the King Philip Museum to Brown, certain items were excluded so that the Haffenreffers could favor with donations other organizations in which their interests were strong. In this way the Rhode Island School of Design Museum was given a totem pole and other ethnographic items; the Roger Williams Park Museum, Uganda materials collected by Emma Shaw Colcleugh; and the Rhode Island Historical Society, a variety of historical documents.

Also excluded from the gift to Brown were all but one of the cigar-store Indians. Some were

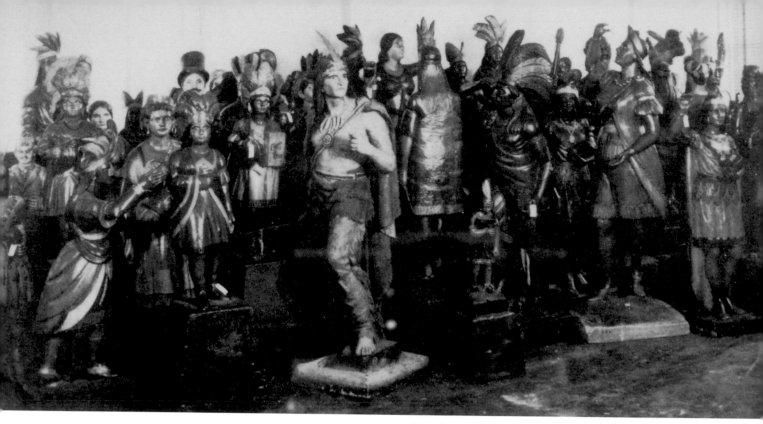

Part of the Haffenreffer collection of cigar-store Indians before the auction at Parke-Bernet Galleries, New York, in October, 1956. Photograph by Taylor and Dull, New York.

donated to organizations like the Bristol Historical Society and the Rhode Island Historical Society, but almost all were assigned to the Narragansett Brewing Company Foundation, which had been established for charitable and educational purposes.

In the spring of 1956, the cigar-store Indians were shipped to New York for auction at Parke-Bernet Galleries. Several years before, twenty-two cigar-store Indians had been exhibited at MIT, and their value was remarked upon at the time. An article in *Time Magazine* brought Haffenreffer more national notice than he ever received for his Native American collection. After Haffenreffer's death, three were auctioned as a test and did very well, and so the interest shown in them, which was intense for an auction of folk art, was not entirely a surprise. On two days in 1956 — April 11 and October 10 — all 164 of the wooden Indians and tobacco-store signs were sold, and the proceeds from the sale were used to enable the Narragansett Foundation to continue to fulfill its charter.[6]

With approximately four hundred and fifty acres of land and the Museum and its contents, and more than fifteen other buildings on the property,

Brown University was the major beneficiary of Haffenreffer generosity. The King Philip Museum itself held approximately 2,300 ethnographic and 42,000 archaeological objects. Brown renamed it the Haffenreffer Museum of the American Indian, and the first year it was open to the public it attracted seven thousand visitors.[7]

One year later, in 1957, Brown hired J. Louis Giddings as a professor of anthropology and director of the Museum. An Arctic specialist, Giddings was the first full-time anthropologist at Brown and found a home in the Department of Sociology. As a result of Giddings's own archaeological excavations in Alaska and his strong encouragement that students make field collections, the Museum's archaeological and ethnographic holdings began to expand as they had not since the 1930s. Since 1955, when the King Philip Museum was given to Brown, the archaeological artifacts (including Arctic materials excavated from U.S. Park Service lands

for which the Museum is the designated repository) have more than doubled in number, and ethnographic objects have increased more than threefold. Moreover, the collections of the Haffenreffer Museum of Anthropology have become global in their scope.

One final consequence of the gift of the King Philip Museum unfolded over several years. Other anthropologists soon joined Giddings and the Department of Sociology became the Department of Sociology and Anthropology. Both bachelor's and master's degree programs in anthropology were developed, and within a very short time anthropology became firmly established at Brown University. In 1972, it amicably divorced sociology and became an independent Department of Anthropology, and promptly developed a doctoral program.[8] This, then – the birth and subsequent independent development of anthropology at Brown University – is the final result of the gift of Rudolf Haffenreffer's heirs, of what had indeed been his most "passionate hobby": the King Philip Museum and its collections.

NOTES

1. *Providence Journal,* October 9, 13, 19, 1954; *Bristol Phoenix,* October 9, 19, 1954; *Fall River Herald News,* October 9, 1954; *New York Times,* October 10, 1954.

2. *Providence Journal,* July 27, 1955; *ibid.,* August 5, 1955; *ibid.,* September 10, 1955.

3. *Providence Journal,* December 22, 1955.

4. *Providence Journal,* December 31, 1949.

5. In several donations in 1955, 1956, and 1958, Brown received between 443 and 470 acres. *Providence Journal,* January 12, 1956; *ibid.,* April 16, 1958; Brown University, Department of Planning and Construction, Log of Deeds for Haffenreffer Property, Bristol, R.I.; *Brown Alumni Monthly,* February, 1956.

6. *Time Magazine,* May 12, 1952; Vernon Tate, *Trade Signs and Wooden Indians* (Cambridge, Mass.: MIT Press, 1952); *The Haffenreffer Collection of Cigar Store Indians and Other American Trade Signs. Part One and Part Two.* (New York: Parke-Bernet Galleries, 1956); *Providence Journal,* April 8, 1956; Fall River, *Boston Sunday Herald,* May 20, 1956.

7. *Bristol Phoenix,* October 11, 1957

8. For information on the growth of anthropology at Brown, I am indebted to Douglas Anderson (telephone conversation with author, November 10, 1993) and Dwight Heath (telephone conversation with author, December 14, 1993).

The Rudolf F. Haffenreffer Collection
A Tabulation

by THIERRY GENTIS

	ARCTIC	SUBARCTIC	NORTH-WEST COAST	CALIFORNIA	SOUTH-WEST AND BASIN	PLAINS AND PLATEAU	SOUTH-EAST
bags, cases, and pouches	4	30	–	1	6	66	1
fishing and hunting gear, and weapons	18	3	3	–	4	42	–
objects of transportation	–	2	–	–	5	26	–
pottery	–	–	–	3	217	–	27
basketry and bark containers	5	17	64	49	58	–	2
clothing and accessories	5	39	2	34	134	149	–
objects of ritual and ceremony	–	1	1	14	10	89	10
tools, utensils and furnishings	36	25	20	–	21	55	1
objects of games and play	66	3	1	–	–	12	2
musical instruments	1	1	1	–	5	12	1
archaeological projectile points	–	–	30	200	1546	387	5312
other archaeo-logical lithics	–	–	–	77	550	300	637
TOTAL	135	121	122	378	2556	1138	5993

NORTHEAST	MESO-AMERICA	SOUTH AMERICA	AFRICA	ASIA	OCEANIA	UNKNOWN	TOTAL
39	—	—	—	—	—	—	147
6	—	4	473	—	4	—	557
2	—	—	—	—	—	—	35
4	24	90	3	—	—	—	368
35	3	11	12	2	17	—	275
49		5	1	—	—	—	418
46	318	6	—	—	—	—	495
77	8	14	—	—	4	—	261
1	—	—	—	—	—	—	85
1	—	1	—	—	—	—	23
26369	20	23	—	—	—	4683	38570
2057	75	16	—	—	—	—	3712
28686	448	170	489	2	25	4683	44946

Passionate Hobby was designed and typeset by
Gilbert Design Associates, and printed by Meridian
Printing on Gleneagle paper.

Five thousand copies for the Haffenreffer
Museum of Anthropology on the occasion of the
exhibition, April 1994.